THE NEW JOY OF DIGITAL PHOTOGRAPHY

THE NEW JOY OF DIGITAL PHOTOGRAPHY

Jeff Wignall

A Division of Sterling Publishing Co., Inc. New York / London Art Director: Tom Metcalf Cover Designer: Thom Gaines Production Coordinator: Lance Wille Editors: Kevin Kopp and Frank Gallaugher

Library of Congress Cataloging-in-Publication Data

Wignall, Jeff. The new joy of digital photography / Jeff Wignal. p. cm. Includes index. ISBN 978-1-60059-568-4 1. Photography--Digital techniques. I. Title. TR267.W55 2010 775--dc22

2010015674

10987654321 First Edition

Published by Lark Books, A Division of Sterling Publishing Co., Inc.

387 Park Avenue South, New York, N.Y. 10016 Text ©2011 Jeff Wignall.

Photographs ©2011 Jeff Wignall unless otherwise specified. Digital Photography Timeline (pages 58-63) ©Lark Photography Books. Cover photographs ©Jeff Wignall except: Lighthouse ©Jim Zuckerman; Jumping boy ©Thom Gaines; Pink flower ©Kevin Kopp; Girl in doorway @Martha Morgan. All product images courtesy of their respective manufacturers unless otherwise noted.

Distributed in Canada by Sterling Publishing, c/o Canadian Manda Group, 165 Dufferin Street Toronto, Ontario, Canada M6K 3H6

Distributed in the United Kingdom by GMC Distribution Services, Castle Place, 166 High Street, Lewes, East Sussex, England BN7 1XU

Distributed in Australia by Capricorn Link (Australia) Pty Ltd., P.O. Box 704, Windsor, NSW 2756 Australia

The written instructions, photographs, designs, patterns, and projects in this volume are intended for the personal use of the reader and may be reproduced for that purpose only. Any other use, especially commercial use, is forbidden under law without written permission of the copyright holder.

Every effort has been made to ensure that all the information in this book is accurate. However, due to differing conditions, tools, and individual skills, the publisher cannot be responsible for any injuries, losses, and other damages that may result from the use of the information in this book. All product names are trademarks of their respective manufacturers. Because specifications may be changed by manufacturers without notice, the contents of this book may not necessarily agree with software and equipment changes made after publication.

If you have questions or comments about this book, please contact: Lark Books 67 Broadway Asheville, NC 28801 (828) 253-0467

Manufactured in China All rights reserved

ISBN 13: 978-1-60059-568-4

For information about custom editions, special sales, premium and corporate purchases, please contact Sterling Special Sales Department at 800-805-5489 or specialsales@sterlingpub.com.

Acknowledgements

Thanks to Kevin Kopp, editor of this edition, for his long hours, good humor, and fine editing skills. Thanks Kevin—hey, it's finally a book. And thanks to Frank Gallaugher, as well.

Thanks also to all of the gifted photographers whose work contributes so much to this new edition, including: Kara Arndt, Julia Cutter, Derek Doeffinger, Joe Farace, Michelle Frick, Frank Gallaugher, Thom Gaines, Robert Ganz, Ralph Lee Hopkins, Doug Jensen, Dan Kohanski, Kevin Kopp, Emin Kuliyev, Jim Langone, Ferrell McCollough, Martha Morgan, Ron Niebrugge, Boyd Norton, Jack Reznicki, Rebecca Saltzman, Rob Sheppard, Marc Tkach, Vera Sytch, and David Vala.

Many thanks also to Ellen Hoverkamp and Troy Paiva for allowing me to interview them.

Thanks to United House Wrecking (UHW) in Stamford, Connecticut for allowing me to photograph their very cool collection. And to the National Park Service and Liberty State Park for maintaining one of the finest landmarks in the world—the beautiful Statue of Liberty. And to Caramoor (www. caramoor.org) in Katonah, New York, for maintaining such beautiful gardens.

Grateful appreciation, as well, to the kind and creative folks at these companies: Adobe, Shana Rae at the FloraBella Collection, Lensbaby, Quest Couch and friends at LumiQuest, Manfrotto, Nik Software, Software Cinema, and F. J. Westcott Company.

Many thanks to Jesse Thompson, Jim Wilson, Ray Sarapillo, and everyone at Milford Photo.

Finally, thanks to all of my radio friends at WPKN (www.wpkn.org), including: Phil Bowler, Ken Best, Ken Brown, Doug Echols, and Walter Wagoner for their support, encouragement, and creative genius. And, of course, to Lynne: storyteller and cat rescuer extraordinaire.

--J.W.

Adobe www.adobe.com

Caramoor Gardens www.caramoor.org

Joe Farace www.joefarace.com

Flora Bella Collection www.florabellacollection.com

Michelle Frick www.michellefrick.com

Robert Ganz www.robertganz.com

Ralph Lee Hopkins www.ralphleehopkins.com

Ellen Hoverkamp www.myneighborsgarden.com

Doug Jensen www.dougjensen.com

Dan Kohanski www.dankphotoart.com

Emin Kuliyev www.em34.com

James A. Langone www.langonephoto.com

Lensbaby www.lensbaby.com

Liberty State Park www.libertystatepark.org

Lumiquest www.lumiquest.com

Manfrotto www.manfrotto.com

Ferrell McCollough www.ferrellmccollough.com

Milford Photo www.milfordphoto.com

Ron Niebrugge www.wildnatureimages.com

Nik Software www.niksoftware.com

Boyd Norton www.wildernessphotography.com

Troy Paiva www.troypaiva.com

Jack Reznicki www.reznicki.com

Rob Sheppard www.robsheppardphoto.com

Software Cinema www.software-cinema.com

Statue of Liberty www.nps.gov/stli

Marc Tkach www.marctkachphotography.com

United House Wrecking www.unitedhousewrecking.com

Jon Van Gorder www.jonvangorder.com

Westcott www.fjwestcott.com

ntroduction	. 11
Γhe New Joy of Digital Photography Is	
Exploring the Digital Frontier	. 12
Dancing with Your Creative Muse	. 14
Perfecting Your Vision	. 16
Flickring Your Way to Fame (and Maybe Fortune)	. 18
Pursuing Your Passion	. 20
Celebrating the Family Album	. 22
Directing Your Own Motion Picture	. 24
Winning a Digital Photo Contest	. 26
Becoming Your Own Publisher	. 28

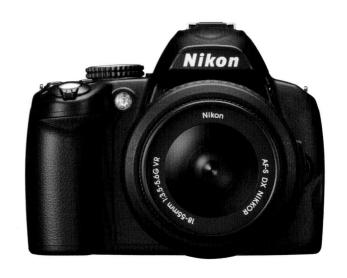

1	The Camera Revisited	30
	Introduction	31
	How Digital Cameras Take Pictures	32
	Pixels, Megapixels, and Some Old Math	34
	Buying a Digital Camera	36
	Types of Digital Cameras	37
	Basic Point-and-Shoot Compact Cameras	38
	Advanced Compact Cameras	39
	The Missing Link	40
	Digital SLR	41
	Memory Cards	44
	Types of Digital Memory Cards	45
	How Much Memory Do You Need?	46
	Caring For Memory Cards	47
	Transferring Pictures to the Computer	49
	Camera Accessories	50
	Electronic Flash	52
	The Basic Flash Modes	54
	Accessory Flash	56
	A Look at Lenses	58
	Normal Lenses	59
	Wide-Angle Lenses	59
	Telephoto Lenses	60
	Zoom Lenses	60
	Digital Technology Timeline	62

T	aking Great Digital Pictures6	8
	Introduction6	9
	Getting to Know Your Camera7	0
	Choosing a File Format	′3
	JPEG	
	RAW7	' 5
	Setting ISO Speed	'8
	Setting White Balance	30
	Camera Handling	32
	Hold the Camera Steady8	32
	Use a Tripod (or Monopod)8	32
	Focus Carefully8	34
	Battery Management8	37
	Measuring the Light	88
	Exposure and Exposure Modes9	90
	Basic Exposure Modes9	2
	Reciprocal Exposure Settings9	93
	Exposing Difficult Subjects9)4
	A Depth-of-Field Primer9	96
	A Shutter Speed Primer	8
	Developing a Shooting Workflow10	00

D	Design	102
	Introduction	103
	Releasing Your Inner Artist Let Chaos Reign	104
	Let Chaos Reign	107
	Showcasing the Main Subject	108
	Get Closer	109
	Get Farther Away	110
	Use a Simple Background	111
	Use Selective Focus	112
	Experiment with Subject Placement	113
	Create a Silhouette	114
	Choosing a Format	115
	Placing the Horizon	117
	A Sense of Balance	118
	Simplicity	120
	Lines, Shapes, and Textures	122
	Patterns and Repetition	124
	Foreground Frames	126
	The Depth Illusion	128
	Linear Perspective	129
	Diminishing Size	130
	Upward Dislocation	131
	Aerial Perspective	
	A Sense of Scale	133

Photographer Interview: Troy Paiva134

A	
Light	142
Introduction	143
Time of Day	144
Light Direction	146
Light From the Front	147
_	148
Light From the Side	150
Light From Above	151
The Colors of Daylight	152
Going for the Gold	153
The Quality of Light	155
Dramatic Light	157
Existing Light Indoors	159
Outdoors at Night	160

People	162
Introduction	163
Babies	164
Kids	166
Relationships	168
Moods	170
Photographing Weddings	172
The Ceremony	172
The Reception	173
Group Photography	174
Action	176
People at Work	178
Travel	179

© MARTHA MORGAN

Nature	
Introduction	183
The Natural Landscape	184
Interpreting the Land	185
Beaches and Shorelines	188
Deserts	191
Desert Light	192
Desert Plants	195
Waterfalls	200
Birds and Animals	203
Telephoto Lenses	203
Wildlife Face to Face	206
Underwater	212
Close-ups	214
Lighting for Close-ups	216
Close-up Focusing	219
Weather	220
Rain	222
Snow	222
Fog and Mist	224
Sunrise and Sunset	226
Rainbows	227
Time Passages	228

Photographer Interview: Ellen Hoverkamp230

The Image Enhanced	236
Introduction	237
Cropping	238
Keeping Things Level	240
Improving Exposures	
Brightness/Contrast	242
Using Levels	243
Curves	244
Enhancing Color Processing	245
Auto Color	245
Variations	246
Hue/Saturation	246
Color Balance	247
Sharpening Filters	248
Fixing Dust and Blemishes	250
Tears and Creases	251
Step-By-Step Guide to Eliminate	
Dust, Blemishes, and Cracks	252
Eliminating Red-Eye	254
Replacing Skies	255
Black-and-White Conversions	256
Selective Corrections	258
Making Great Selections	260
Creative Blur	262
Layers	263
Adjustment Layers	264
Layers for Composite Images	264
Improvising on an Idea	266
Introduction	267
Hue and Saturation	268
Gradient Mapping	270
Posterization	271
Color Infrared	272
Filters	273
Texture Overlays	276
Creative Background Replacements	277
Shape Distortions	278
Combining Images	280
Indov	004

for Lynne & the miracle cats

Introduction

When this book was first published in 2005, digital cameras were still a relative novelty and the big question that photographers—professional and hobbyists alike—asked one another was: "Have you gone digital yet?" The question was asked as if it was a kind of coming-of-age journey, akin to asking: "Have you been to Disneyworld yet?"

Indeed, it was hard to take a camera out in public—film or digital—without re-igniting the debate or getting cornered into a discussion on the relative merits of film vs. digital. Discussions about whether digital would ever "catch" film in image quality were common. But who could blame people? The idea of pictures existing mainly in the ether of a computer's memory, rather than sitting in a physical album, seemed not only foreign, but totally untested. Photography without film—what odd new alchemy was this?

No one could have guessed how passionately the public would embrace digital photography over the next several years. In fact, if you're under the age of 15, chances are you've never taken a picture with a film camera, and hearing your parents reminisce about film is kind of like hearing them swoon fondly for the days of rotary-dial phones. It's been so long since I've loaded a film camera, in fact, that even though I have probably shot a few hundred thousand rolls of film, I'm not sure I could do it today without thinking it through.

The reasons that digital cameras took off like a sudden gust of wind on a calm summer day are easy to see in hind-sight: For one, there is the inescapable fact that, once you own the camera, digital photography is free. And the quality of digital images has long since surpassed film in virtually every respect. Even the simplest point-and-shoot camera is in the 10-megapixel range, and easily capable of making superb-quality prints of 20 x 24 inches (50.8 x 61 cm) or larger. And there is the undeniable fun of seeing your photos immediately and sharing them with friends and strangers around the world instantly. I have a good friend that often sits in his car in Manhattan traffic jams and emails me photos of interesting street scenes from his cell phone camera. Photo-sharing community sites like Flickr (see page 18) have totally changed the way we share photos, too. One of my photos, of my friend Sarah making a peace sign with sparklers, has been viewed nearly 40,000 times on Flickr.

Today it's impossible to watch television news coverage of a major news event that hasn't been captured by a dozen citizen journalists who happen to be at the scene. When pilot Chesley "Sully" Sullenberger miraculously brought his airplane in for a safe landing on the Hudson River, eye-witness photos of the rescue operation were being broadcast seconds later around the world. We could never have fathomed such a thing (the landing or the amateur photo coverage) even a few years ago.

Digital cameras and photo-processing software have rebirthed the entire world of photography and made picture taking—and picture sharing—more popular than it has ever been. In this new and complete revision of this book, I've tried to share not only what it is about digital photography that is so fun and enticing, but also all of the things that I've learned (and re-learned) about taking great pictures with a digital camera. On a personal note, digital photography has had a profound effect on my energy level for taking pictures. The price of film and processing and the hassles of carrying film as professional travel photographer were deeply eroding my love of the craft. Had it not been for the invention of digital cameras, I'm not sure I would have remained in photography.

In the introduction to the original edition, I wrote: "In the past year I've shot more than 6,000 digital photos—and I've never had so much fun taking pictures!" Today I can say that since that first edition was published, I've shot well over 100,000 new digital photos (and bought six new hard drives on which to store them all), and I'm having more fun than ever. And I think my photos have improved exponentially. Yours will too.

Here's to the joy of digital photography and to the joy of living a more creative life!

--Jeff Wignall Stratford, Connecticut www.jeffwignall.com

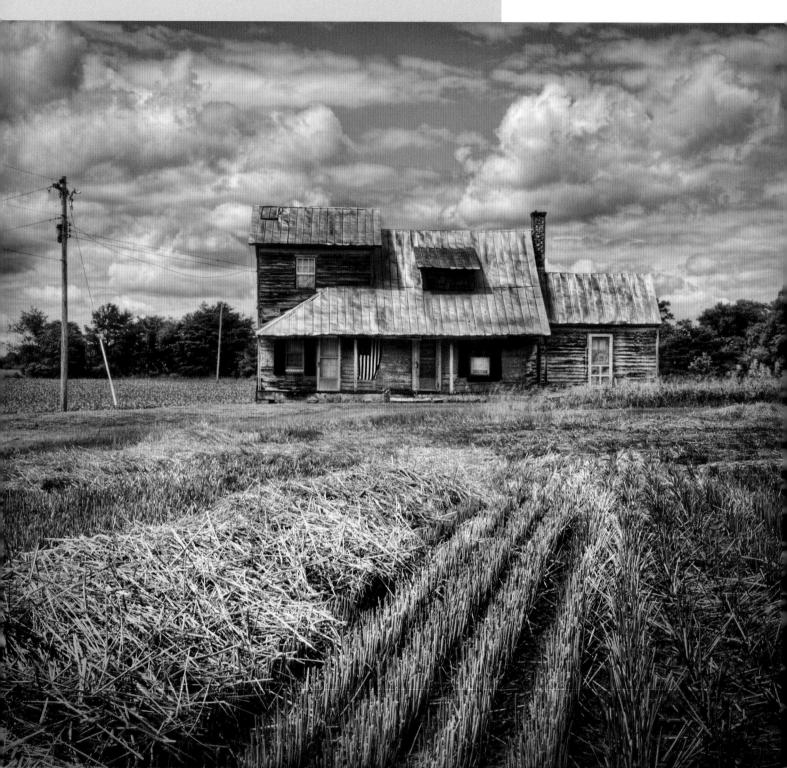

©FERRELL MCCOLLOUGH

© FERRELL MCCOLLOUGH

Exploring the Digital Frontier

n the early 1980s my father, then already retired from a career in photographic research, came home one day with a small black box that had a touch-sensitive keyboard attached to it. It was the first personal computer I'd ever seen (a Sinclair ZX81, for the cyber historians out there) and, even though he had never touched a computer in his life, he was determined to understand, if not how it worked, at least what it could do. It was the first of several computers he would own and, as near as I could tell, his main interest in them remained simply to find out just what—if anything—a computer could add to his life.

For many of us, that curiosity is a large part of our interest in digital photography—to explore a new technology for the pure joy of it and to see what, if anything, it can add to our lives. To delve into digital photography doesn't require the ambition to be a great digital photographer or the desire to become a master at image manipulation, but rather that you live this moment in history a little more fully—to ride the learning curve of the digital world rather than to merely observe it.

You are a pioneer in a virtual Conestoga wagon heading across the digital plain—be brave, be bold, and explore with courage. And know that the images you make will become a part of the illustrated history of a brand new medium. Above all, enjoy.

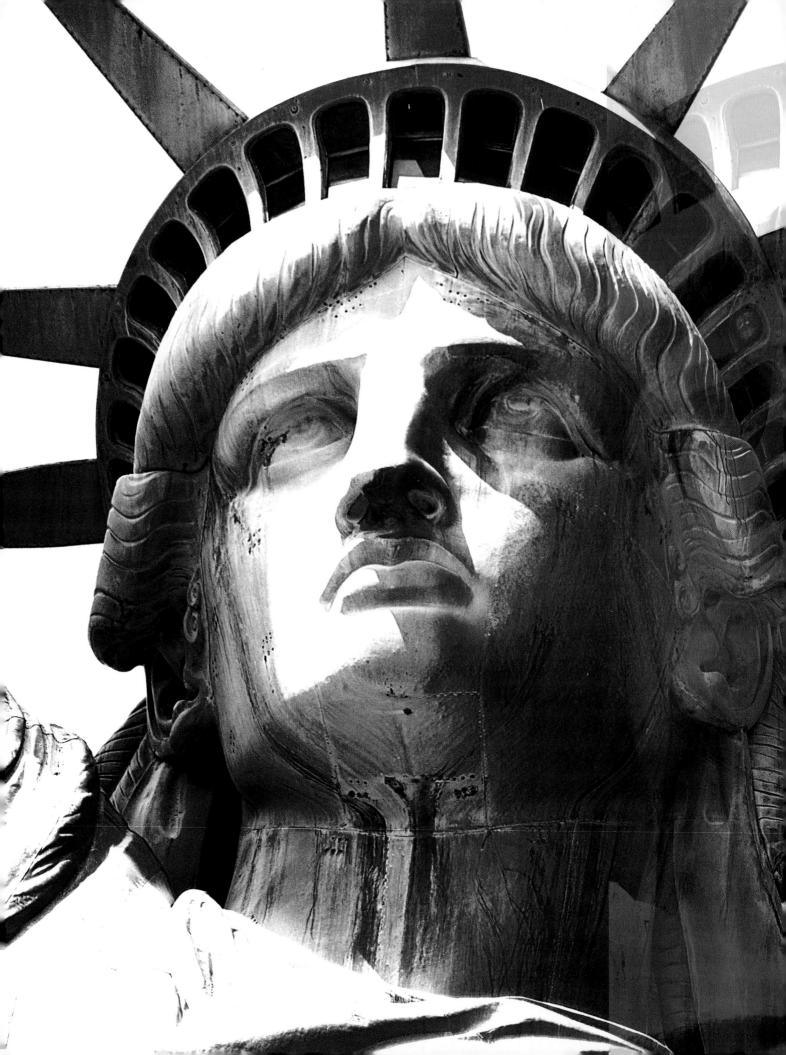

Dancing with Your Creative Muse

It seems odd that something as deeply rooted in technology as digital photography could birth a visual

revolution—yet that is

exactly what

has happened. Out of the dimness of the research labs has risen a radiant beam of artistic inspiration. From the moment that Adobe's Photoshop image-editing software was introduced in the early 1990s—a decade before the advent of the first massmarket digital SLR cameras—photographers seized its creative potential.

And almost overnight that brilliant light of imagination changed our perceptions of both photography and reality. Schools of neon-colored fish fled their watery confines to soar through the skies, lightning storms were captured in mason jars and visions of angels shimmered in the windows of Spanish mission churches. It was as if the lyrics to the Beatles' Lucy in the Sky with Diamonds had suddenly become a photographic

anthem—or an instruction manual. And just as these absurd and surreal visions flowed into the mainstream of our visual language, digital cameras and simplified picture-editing software came to the masses. And now you are a part of the digital revolution.

For as long as you are able to manipulate a mouse and read a series of software menus, there is nothing that your mind's eye can conceive that you—with the help of your computer—can't create. Whether you envision a waterfall pouring from a wine glass or your family's history in the New World marching across a virtual collage, you have the tools to realize your visions.

All that you need to thrive here are a fearless imagination, a corruptible sense of reality and a few extra hours in each day to woo your creative muse.

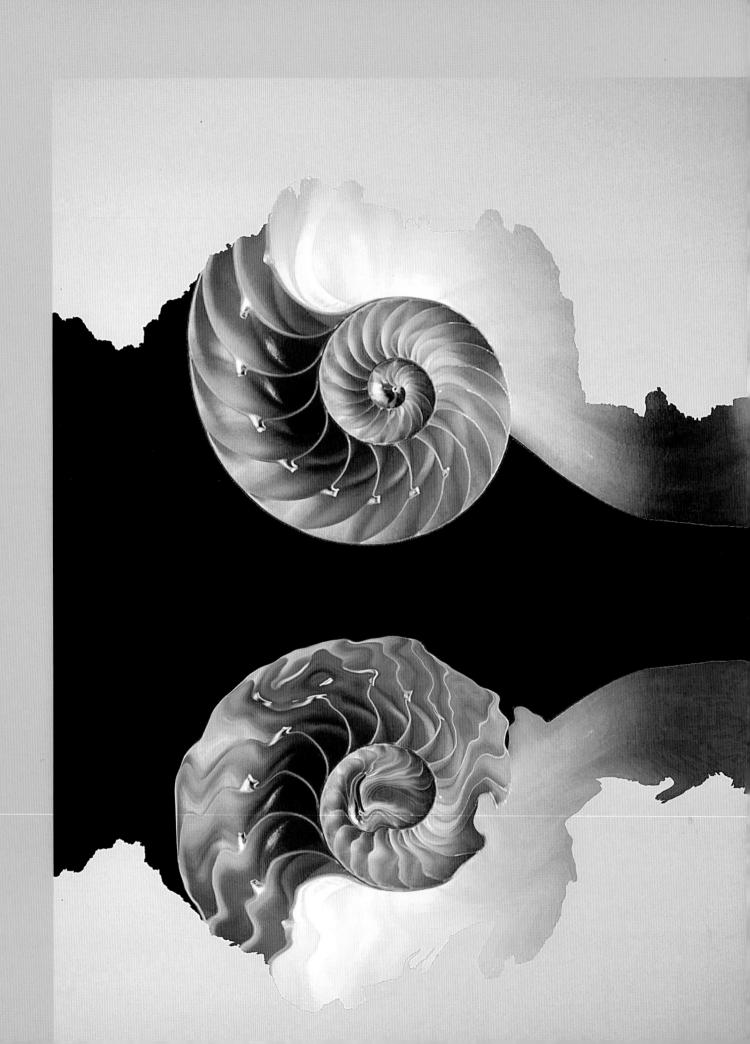

The New Lov of Digital Photography S.

Perfecting Your Vision

hh, perfection—the elusive siren song of every artist who has ever laid brush to canvas or, perhaps, lens to a landscape. It comes, so the saying goes, with practice, but for those of us who have practiced taking pictures much of our lives, perfection appears, at times, not a single millimeter closer.

But in digital photography, perfection seems, if not entirely attainable, at least much nearer at hand. Which is good news for those of us who are tragically afflicted with the compulsion to straighten, crop, organize, sharpen, tweak (and twitch), align, revise, prune (and plant), paint, repaint, add and refine texture—only to begin anew the next day.

From the ability to instantly review (and just as quickly erase and reshoot) your images in-camera to the almost infinite level of enhancement that image-editing software provides, digital photography was created for the compulsive fixer. If perfectionism is in your blood, you have come to the right place.

And perhaps that is the most alluring aspect of digital imaging: the entire process remains in your hands from concept to final product. Here you can literally rearrange molecules (or the digital equivalent—pixels). Here, at long last, you can pluck stray hairs, extract dust specks, turn grins into smiles, digitally botox wrinkles, turn gray skies blue, or perhaps bring out the sun on a cloudy day. Here your pursuit of perfection is acknowledged and encouraged.

Of course, this passion for the absolute image does not come without a price. There is a little sign on my computer that says, "Welcome to Photoshop, here time has no meaning."

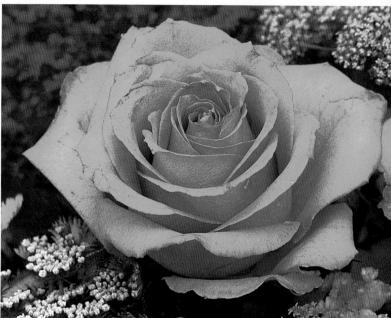

Flickring

Your Way to Fame (and Maybe Fortune)

Tho would have thought that an online photo-sharing community with the oddly misspelled name of "Flickr" would become one of the driving forces in the digital photo revolution? While the Internet abounds with photo-sharing and social networking sites (as you'll see on the coming pages), none can hold a candle to Flickr in terms of the sheer volume of photos. As of January 2010, the site was home to more than four billion photos. (The population of planet Earth at the same time was just under seven billion—so there's a photo on Flickr for roughly every-other person on the planet.) And the popularity of the site swells by the second.

Why is Flickr such a glowing success? Largely, I think, because of its inspired and extraordinarily simple-to-use interface: It takes just minutes to set up your own personal "photostream." Your photos can then be seen (and commented on) by anyone with a computer. Better still, you can add your images to subject-oriented "pools," set up by fellow users, on a plethora of topics ranging from the pedestrian (rainbows) to the downright curious (New Jersey Manhole Covers). You can also create "sets" of your own images

based on whatever categories you choose—the color orange, your Fiestaware collection, macro shots of frogs, or, if you happen to have the pictures, lemurs in a lemon tree.

Exploring images on Flickr is nothing short of addictive. You might start out looking for photos of a Cape Cod beach and end up (hours later) looking at photos of Indonesian batik designs. It's like swinging from picture vine to picture vine in the biggest photo jungle ever created.

And, if you have ambitions to sell your photos, you'll be interested to know that photographers aren't the only ones warming themselves over the Flickr flame: I've been contacted by photo buyers at magazines, ad agencies, book publishers, and tourism bureaus inquiring about photos in my photostream. Indeed, a lot of industry watchers believe that Flickr is the future of stock photography—the ultimate photo-selling democracy.

How brightly can your flame shine on Flickr? I have one shot of a "blue" rose (creatively colored in Photoshop, of course) that has been viewed nearly 40,000 times. Short of taping one of your prints up to a signpost in Times Square, I can't think of a way for more people to see your photographs.

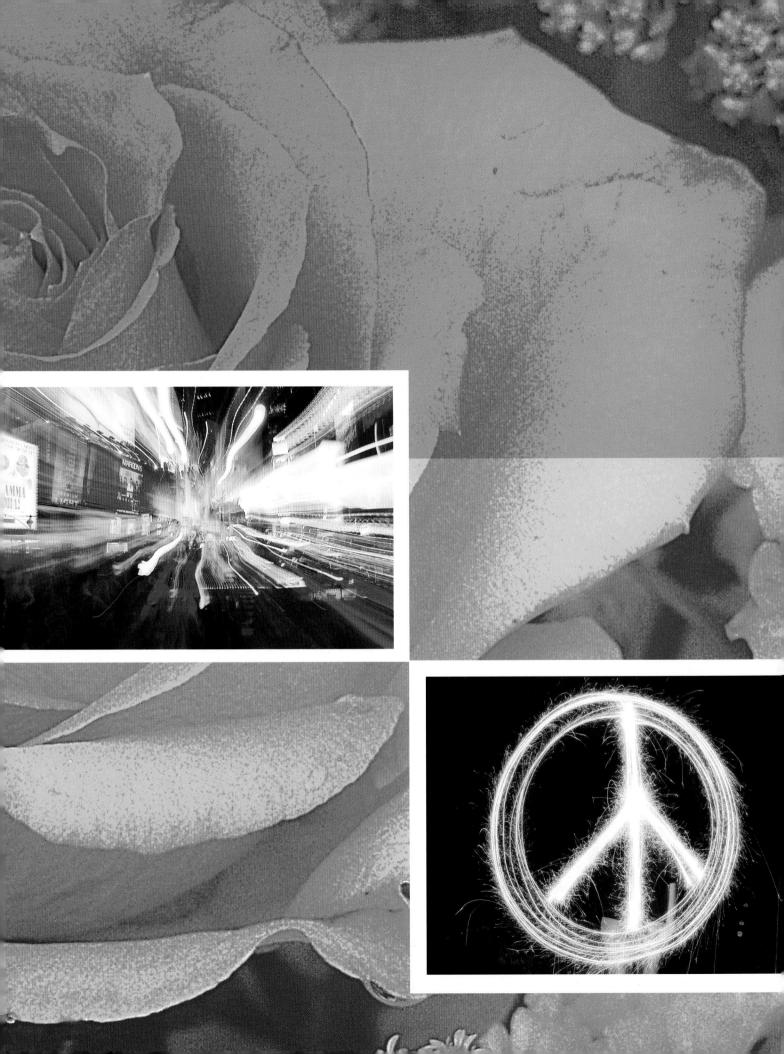

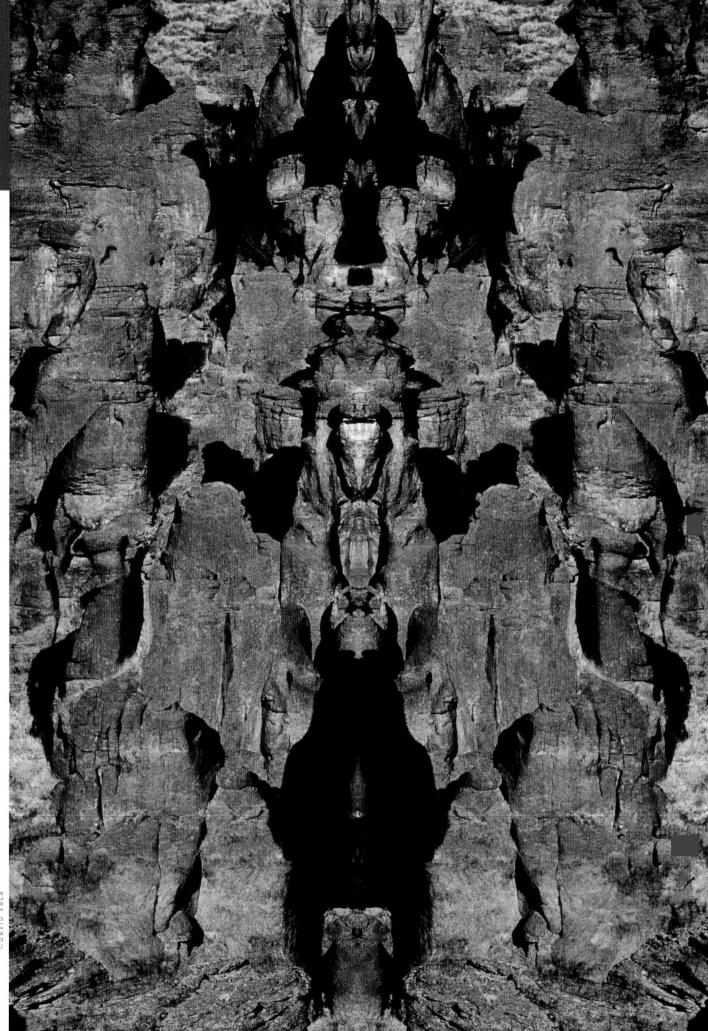

Pursuing Your Passion

DRAVID VALA

"Those who danced were thought to be quite insane by those who could not hear the music."

hat intriguing quote has been floating around the Internet for some time and it is attributed to a woman named Angela Monet. The curious thing is that no one seems to know exactly (or even approximately) who she is, or was, or where the quote came from. It's just one of those peculiar things that pops up in cyberspace and then develops a life force of its own. In any case, I think it makes an important artistic point: There is an underlying passion beneath all creative pursuits that, while perhaps invisible to others, remains the driving force of all art. Without passion, creative expression has no air to breathe, no fuel for energy, no strength to dance. Art feeds on one thing and one thing only: the passionate desire to express yourself.

For some of us, mastering photography is a self-fulfilling accomplishment: The craft is the passion. But for many others there needs to be an additional underlying enthusiasm, a stronger motivation, to push toward the deepest level of creative photographic commitment. If gardening is your weekend obsession, then your desire to grow—and photograph—the prefect rose will

drive your camera skills forward. If you're a fanatical follower of all things football, then the need to take your camera to the sidelines of the Fridaynight lights will drive you to be a better sports shooter.

In 1885, a Vermont farmer named Wilson Bentley adapted a microscope to the bellows of a glass-plate camera and became the first person to photograph a snowflake. It took "Snowflake" Bentley years of trying (and failing) to get his photograph, but his passion for the beauty and delicacy of small crystals of snow drove him forward, and in the decades that followed he successfully photographed more than 5,000 snowflakes.

Photographer David Vala, a landscape architect, avid hiker, and sea kayaker, always keeps an eye out for rich, textured landscapes that he can use to create his "Nature Spirit" mirror-images. "For these images," he says, "I selected a subject, photographed it, and created a duplicate image, which I then flipped and layered over the original to create a mirror image." The result is a distinctive and stunning style that beautifully reflects Vala's passion for nature.

For you, whatever the passion of your life—your kids, horses, figure skating—photography will enhance your enjoyment of it, your understanding of it, and the time you spend with it. Neighbors of Bentley thought he was quite insane for spending so much of his time photographing snowflakes. "I guess they've always believed I was crazy, or a fool, or both," he once wrote. But Snowflake Bentley heard music his neighbors could not hear; and to the world's great benefit, he danced.

© WILSON BENTLEY

celebrating

the Family Album

he nuclear family, the extended family, the human family—and now the digital family. How do you define family? Better yet, how do you show family? With digital photography, family pride can swell like never before. And its arms can spread across the world or reach far back into time-perhaps beyond the invention of photography itself.

For family scrapbookers, family historians and proud moms, digital photography offers an ultra-energized dose of inspiration that can turn your sapling photo history efforts into a strong and mighty oak. And it can salvage moments and memories nearly lost to the seasons of time. Even your great-grandparents, who may have been photographed on glass plates before the advent of modern film, can now come to life again in your digital archives.

And what of memories nearly lost? Did freeloading field mice nibble away Lincoln's stovepipe hat and disguise his identity in the picture of your great aunt shaking his hand outside Ford's Theater that fateful eve-forever stealing your family's link to history? Has Mom's wedding photo displayed on the wall of the sunroom faded? Has mildew spoiled the picture of great granddad climbing on the running board of his rumrunner?

A MERRY XMAS. A HAPPY NEW YEAR

Doris, Harry and David Wignall

Let digital imaging rush to the rescue. Just scan the pictures, restore them with easy picture-editing software, and add them to the family album (or perhaps ship that shot of Lincoln down to the Smithsonian).

Did a recent Internet search on your family name uncover new relatives? Armed with the Internet and family history software, you can turn the family tree into a forest of ancestors and create a visual display of likenesses, connections, and milestone events. From headstones to hometowns, everything about your family's history can be witnessed anew.

My cousin, recently traced the Wignall clan to its first known ancestor-Jeffrie Wignall (some coincidence, isn't it?) back in 1696. From the refrigerator door to the unabridged Wignall family history website—digital photography helps put faces on our personal history. Your opportunities to celebrate your own family lineage have expanded exponentially. It's up to you to take advantage of them.

ALL PHOTOS ©DOUG JENSEN

Directing Your Own Motion Picture

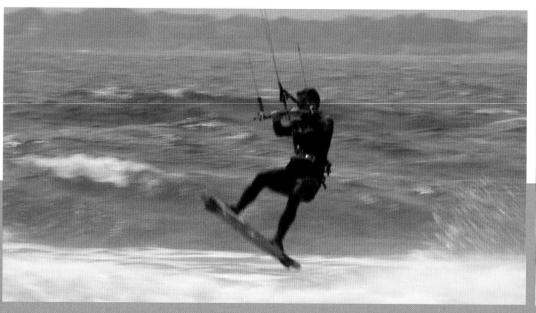

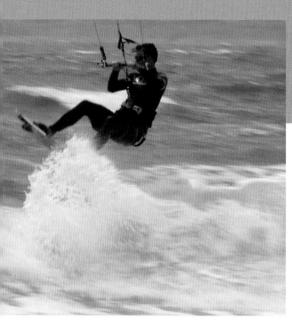

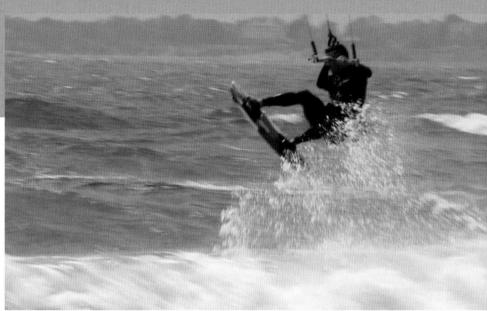

ights, camera, action! If you've ever dreamed of directing your own low- or no-budget film and bursting onto the indie film scene but thought you lacked the necessary gear (namely a high-definition camera), look again. Your cinema destiny may be at hand—and you may already own all the camera gear you'll need to get started. A growing number of both point-and-shoot and D-SLR still cameras include an HD-quality video-recording mode.

While most early generation still cameras had primitive video recording capability, today's digital cameras—even at the consumer level—are employing larger sensors than most dedicated camcorders and redefining video resolution. What was once a novelty mode at most (and limited to short bursts of low-reso-

lution video recording) is now shaking up the video production world and turning hardcore still shooters into film visionaries. Successful longtime still photographer Vincent Laforet, for example, is now at the cutting edge of commercial video production—often using still cameras as his tools.

But why shoot with a still camera when you can buy a video camera? Price, for one. A good quality HD camcorder takes a Hollywood-studio budget to finance. With still cameras, you get the video tossed in as a bonus. There's also the optical flexibility factor: you can shoot with all of your existing lenses. That means wider lenses, longer lenses, faster lenses—and absolute control over exposure and depth of field.

Your video ambitions don't have to stop at the camera, either. Using affordable video editing programs like Apple's Final Cut Express and Adobe's Premiere Elements, you can do studio-quality edits on your home computer. And once your films are finished? With membership in online sites like Vimeo.com or YouTube, you can share your video visions with millions of people around the world. No more bribing the family with brownies and hot cocoa to get an audience.

Most important though, shooting highquality video' is just plain fun. Imagine cruising down the Las Vegas Strip in the back seat of a cab recording the ultimate rush of neon glitter in high definition. Just a quick spin of the mode dial and you suddenly you're producing your own high-def location film. Hollywood, eat your heart out.

a Digital Photo Contest

Why not you, indeed? Maybe it's the lust for competition or just the thrill of being recognized (or maybe it's the purely mercenary quest to win great prizes), but whatever the calling, photo contests are great fodder for photographic daydreams. And just as with every other aspect of the hobby, the popularity of digital photography has had an enormous impact on the revival of photo contests. In fact, there are probably more and better photo contests to enter today than ever before.

Part of the reason that contests are so popular is the ease of entering them. No more hours spent in the darkroom making perfect prints (or writing checks to the local lab to make them for you); no more rushing off to the post office to make contest deadlines. With most digital contests you simply upload your images to a site and in seconds you've entered. And though some have small entry fees, the majority of contests are absolutely free.

Digital photo contests range from simple "Picture of the Day" competitions (or POTD contests as their known in online lingo) that are a popular mainstay on photo websites like www.digitalimagecafe.com, to more

grand annual events hosted by major magazines like *Popular Photography* or *National Geographic*. While many contests offer only modest prizes or simply the prestige of winning as its own reward, some of the larger contests offer vividly enticing prizes including cameras, trips, and—most alluring of all—publication.

But hey, I'm just whetting your appetite here. So popular are photo contests these days that I've written an entire book on the subject: Winning Digital Photo Contests. The entire book is illustrated by more than 100 prize-winning photos shot by hobbyists just like you. And when you see the exciting quality and creativity of those winning photos (like the samples on these pages) you'll realize your friends were right—you do belong in that company.

© DAN KOHANSKI

Becoming Your Own Publisher

sk almost any photographer (including most pros) what their ultimate fantasy is and one reply you're sure to hear is: "A coffee-table book of my work." Who wouldn't want to see their most impressive personal photos or their most exciting travel adventures gathered between the covers of a hardbound book and laying on their coffee table (or someone else's) for all to see?

Far-fetched as the idea would have seemed a few short years ago, that flight of fancy is easier to materialize than you might think. Using any of a number of online sites (www.mypublisher.com, for example) creating a book of your work is as simple as choosing the photos, laying out the pages in an online template and clicking the "order now" button. In a few days you'll be flipping through the pages of your own handsomely produced book with visions of an Oprah appearance (not to mention her book club) dancing in your head. Cost for a basic book? About \$30.

If you have even loftier publishing ambitions, "print on demand" sites like www.lulu.com can not only publish your book to professional standards, but they can help you design, edit, and distribute your book to major retail chains. I can tell you firsthand, until you've walked into a bookstore and seen someone perusing one of your books (hopefully in line at the register), you have no idea the thrill that's waiting for you. And it's an attainable goal that begins with the simple click of a digital-camera shutter.

Even if you limit yourself to more modest daydreams, imagine handing your parents a professionally produced book depicting their 50 years of marriage, or closing out the school swim season with a memory book of your daughter's winning dives. Not long ago I taught an online class at BetterPhoto.com, and at the end of the semester my students rewarded me with a beautiful self-published book of their best assignment shots. Talk about handing the teacher a basket of shiny red apples.

When it comes to venturing into selfpublishing, take the advice of Goethe: "Whatever you do, or dream you can, begin it. Boldness has genius, power, and magic in it. Begin it now."

The Camera Revisited

"I really believe there are things nobody would see if I didn't photograph them. -DIANE ARBUS

Introduction

Had you been alive back in 1826 and happened to find yourself wandering the French countryside among the rows of crops and farmhouses, you might have spotted an intense looking Frenchman pointing an odd contraption out of his bedroom window at the yard below. About eight hours later (had you sat patiently and watched), you would have seen him retrieve the device with the urgency of a mother cat fetching her wandering kittens. In addition, you probably would have noticed what most likely was a look of utter astonishment on the man's face as he witnessed the result of his experiment.

That man was Joseph Nicéphore Niépce—a French inventor with a passion for experimenting with light-sensitive emulsions—and what you would have witnessed him doing was recording the very first photograph ever made from nature. Niépce made the picture by coating a polished pewter plate with a mix of bitumen and lavender oil and placing it in a camera obscura, a device invented centuries earlier. He named his process Heliography—or writing with the sun.

Niépce's original photograph (View from the Window at Le Gras, c. 1826) still exists today (it's owned

by the University of Texas at Austin) and, though the subject's details are not very clear, that eight-hour exposure gave birth to photography. Although cameras have certainly come a long way since then (and exposure times have become noticeably shorter), essentially the device that Niépce used is little different in principle from today's digital cameras. Strip away the electronics, the expensive lens and frilly doodads like the exposure meter, and what you have is what Niépce had: a lighttight chamber, a means for focusing the image, and a light-sensitive receptor for recording the image.

Digital cameras, of course, are a tad more complex and contain a small universe of technological marvels that few of us could have envisioned just a few years ago. But as you read about the various types of digital cameras and their many options and accessories, it helps to keep in mind their origins. The digital camera was born in the bedroom window of a French visionary whose goal was the same as yours: to lock images of light and shadow in a box from which they could not escape, but through which could be witnessed—by all who had the curiosity and imagination to look inside the story of our existence.

How Digital Cameras Take Pictures

(and how getting all shook up over Elvis rocked the camera world)

One of the great things about digital photography is that you don't need a clue about how the technology works in order to take great pictures. Even if you never understand one iota of the science behind how a digital camera records an image, no one will ever know and (honestly) it won't change a thing about your pictures. (Of course, knowing how to use a digital camera is an entirely different—and very important—matter.)

Let's review the basic technology. It's actually interesting and besides, you never know when some wise guy will approach you at a party and flaunt his digital knowledge. You can say proudly, "I already knew that." Then you can stun him by revealing your unique theory that proves how the birth of digital imaging sprang from none other than The King, Elvis Presley.

Although the practical ability to take pictures without film is only a couple of decades old, the roots of the technology actually go back to the late 1940's—or specifically to December of 1947. It was then that three scientists-John Bardeen, Walter Brattain and William Shockley—working at Bell Labs in New Jersey, invented the transistor. Without tracing the entire history of that invention, the chief attribute of the transistor was that it replaced vacuum tubes as a means to amplify and modulate electrical current and opened the doors wide for the development of integrated circuits—which paved the way for microprocessors—which are at the very heart of digital imaging technology.

The invention of the transistor not only made your digital camera possible, but also your computer, your cell phone, your stereo, your microwave oven and your Xbox—all of which contain countless armies of transistors. The transistor, in fact, is considered by many of the people who think about such things as the greatest invention of all time. As one Internet writer put it (I'm paraphrasing): Your house may contain a few dozen light bulbs, but it has tens of millions of transistors.

From the moment that Bardeen, Brattain, and Shockley unveiled their 1956-Nobel Prize winning invention to the world, photography was headed for a digital destiny. The challenge to film began long before anyone associated transistors with Kodak moments. And nothing could have popularized the invention of the transistor more than (this is where Elvis comes in) the introduction of the transistor radio in 1954. With everyone under eighteen getting all shook up over that swivelhipped boy from Tupelo, Mississippi blasting out of a palm-sized transistor radio, it was only a matter of time before transistors invaded cameras with Cyborg-like efficiency.

In most respects digital cameras work like film cameras: a lens lets light into the camera and a shutter controls the duration of light. The main difference between film and digital cameras, of course, is how the camera records that image. Film cameras use a piece of silver halide film to capture a latent image that is later processed chemically. Digital cameras, on the other hand, have a silicon computer chip—also called an image sensor—to record the image. The sensor that most cameras use is called a CCD (charge-coupled device) though some cameras use a CMOS (complementary metal oxide semiconductor) sensor.

The surface of CCD and CMOS sensors is made up of millions of tiny lightsensitive receptors (known as photosites or pixels) that are arranged in a grid pattern. Each of these microscopic photosites contains a diode that records the intensity of the light striking it and converts the quantity of light to a number. In scientific terms what the CCD is doing is converting photons to electrons, but that's going way too far into high school physics. Incidentally, the light-sensitive sensor itself is actually an analog—not a digital—device. It takes a processing gizmo called an ADC (analog to digital converter) to translate the analog information to the numerical language that your computer can interpret.

Because your camera's sensor records only light intensity, not color, it is essentially colorblind. To create color images, a precise pattern of color filters are laid over the photosites. The filters (most often arranged in something called a Bayer pattern) represent the three colors of the primary spectrum: red, green, and blue. From these three colors all colors can be created. Light passes through the filters to the photosites. Electronics interpret the intensity of the light that was transmitted to accurately reveal the colors of the original scene. Because any one photosite can record only one color, your camera uses a process called interpolation and combines information from each photosite with information from adjacent photosites to create accurate image colors. (And unless you're a science student, that's as far as you need to go down that road.)

When you download your images from your camera's memory card to your computer, your computer is actually reading series of numbers that give it information about color and brightness from which it recreates—with astounding accuracy—the daffodils in your garden or your spouse's smile or whatever you aimed your camera at. In a way a digital photo is like an intensely accurate electronic paint-by-numbers system.

If most of this has left you confused, bleary-eyed, or just plain bored, turn the page and we'll get down to the real fun of digital photography: buying and learning to understand a digital camera. The King would want it that way.

Pixels, Megapixels, and Some Old Math

If you were to blow up any digital photograph on your computer screen to its maximum magnification you would see the picture break down into a pattern of identically sized (but different colored) squares (below). Those squares are pixels (short for picture elements) and, though they look very large when they're blown up like that, they are the tiny building blocks of digital images. In fact, they are the smallest element of any digital photograph. As discussed on the previous pages, when exposed in the camera each of these pixels captures information about brightness and color that your computer translates into photographs.

Because pixels on a sensor are so tiny (about 6 microns or 0.000006 meter wide, it takes literally millions of them to create a sharp and detailed image. A million pixels are called a megapixel, and that is the term that is used to describe the resolution of a digital camera. The more megapixels (usually written as MP) a camera has, the higher its resolution, and often the more it costs. When it comes to selling digital cameras, megapixel counts are the simplest way for manufacturers to describe a digital camera's resolution.

When digital cameras were first introduced in the early 1990s (see Digital Technology Timeline, pages 62-67), their resolution of one or two megapixels was considered an astounding technological accomplishment. And the cameras weren't cheap—the Kodak DCS 100 1.3MP camera cost around \$20,000. Today. of course, even the most basic of compact digital point-and-shoot cameras typically offers from 8 to 10 megapixels and beyond, and some professional digital SLRs contain very large sensors (e.g. full frame, which usually means the sensor is the size of a frame of 35mm film) that have in excess of 24 megapixels. This is a quantum leap in technology that has all but put film cameras into the realm of photographic dinosaurs. When you consider that some scanning backs for professional studio cameras have resolutions in excess past decade are astonishing—and so is the quality of the images they produce.

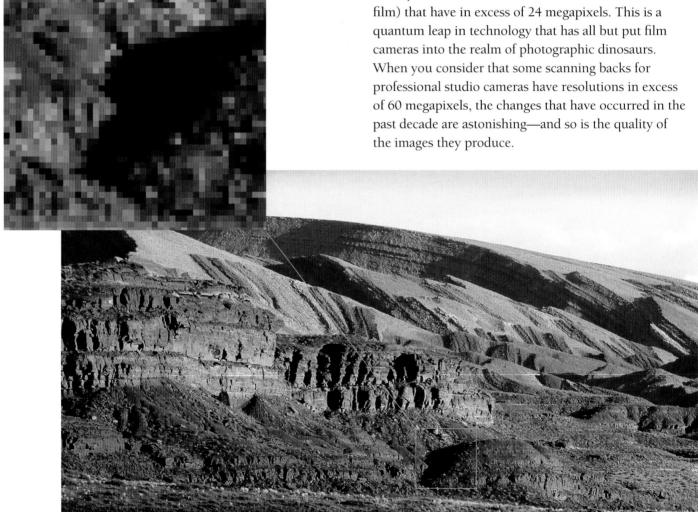

Though there really isn't an exact equivalent with film, ISO 100 film is generally considered to have a resolution of approximately 10 megapixels. With other factors being equal, in a head-to-head competition between an ISO 100 film and any camera below say, 8 megapixels, the image quality of the film would probably win at high levels of enlargement. But once you pass the 8-megapixel threshold, the quality differences begin to evaporate rapidly and, in fact, the digital images can begin to exceed the film in both sharpness and color fidelity.

As you might surmise, all other things (lens resolution, exposure modes, etc.) being exactly the same, a higher megapixel count will create a better image (see the Pixels and Image Quality section, below). Keep in mind though, I said that everything else was equal: if you put a second rate lens on a higher megapixel camera, or shoot with a camera that has packed a large quanitity of tiny photosites onto a small sensor, you won't necessarily get a better image than a camera with a smaller megapixel count. And if you don't hold the camera steady, it won't matter if you're using film or a 30-megapixel camera, you'll get a blurred image.

Resolution

Like square footage, the total number of a camera's megapixels-the sensor's resolutionis determined by multiplying the width of the sensor (or chip) by its length-in pixels, of course.

For example:

A 10-megapixel sensor might be 3872 pixels wide and 2592 pixels high: 3872 x 2592 = 10,036,224, or approximately 10 megapixels.

Although the number of pixels on a sensor is fixed, most cameras let you choose a lower resolution setting so that you can store more pictures on a memory card.

Incidentally, it's not necessary that you carry any of these numbers around in your head (you might get distracted and trip over a log if you walk through the woods thinking about pixel counts) because you'll find them displayed in your camera's menus.

Pixels and Image Quality

A major factor that determines image quality is the area resolution, or the number of megapixels on a camera's sensor. Generally speaking, the more megapixels the better, but not all pixels are created equal. Of particular importance is sensor size and thus, pixel size. Cameras with larger sensors, such as digital SLRs, generally have larger pixels that produce better images, particularly at low light levels. Smaller pixels are more susceptible to digital noise (random color specks), especially at ISO 400 and higher. Finally, like car engines, DVD players, and toasters, not all image sensors are created equal. Some are clearly better than others.

The in-camera processing of image files also affects image quality. Unless you use only the RAW file format, your camera's built-in software is manipulating the pictures you take even before you download them. Its JPEG compression might be too severe or poorly implemented, resulting in artifacts. Images might be excessively sharpened or saturated. Or one camera might have built-in software that effectively reduces digital noise and another might not.

Buying a Digital Camera

here you are at the threshold of a dream. You've been studying the photo magazines, reading online reviews, talking to your friends at work and you know exactly which camera you're going to buy. But on Saturday morning, just before you leave for the camera shop, the latest photo magazines arrive in the mail. You discover to your dismay that a young techno upstart with hot new features and a sexier zoom has replaced the camera of your affections. And there you go, back to the den to reconsider the purchase—for the hundredth time.

It's easy enough to understand your being hesitant if you're upgrading from, say, a point-and-shoot digital to a more advanced camera, but it's even tougher when you're shopping for your very first digital camera. Not only is the technology relatively new and unfamiliar territory, but it changes so fast you can get mental whiplash just keeping up with the ever-evolving upgrades. Just when you thought a 10MP (megapixel) camera was the crown of point-and-shoot creation, suddenly there is a 12 or 14MP upstart being splashed across magazine covers. Digital manufacturers replace modes—or even entire camera lines—more frequently than most of us replace the roll of paper towels in the kitchen. Trying to buy a new digital camera can be quite

The good news is that a good camera is a good camera even when a newer and "better" model appears. If it takes great pictures and fills your needs when you buy it, you can't ask for anything more. The best advice then is to study your own needs carefully and buy the best camera you can afford—and remember, the sooner you buy the camera, the sooner you'll be a participant instead of a spectator.

In the mid 1990s, I borrowed a digital SLR from Kodak for testing, and had to insure it for \$50,000. (I'm not joking when I say I literally slept with it every night while traveling.) Today, a camera of far greater sophistication and several times the resolution costs under \$500. And, in terms of just pure megapixel count, I carry a point-and-shoot today that provides twice the resolution and cost me less than \$200.

On the following pages we'll look at the different types of digital cameras, their features and useful accessories.

Basic Point-and-Shoot Compact

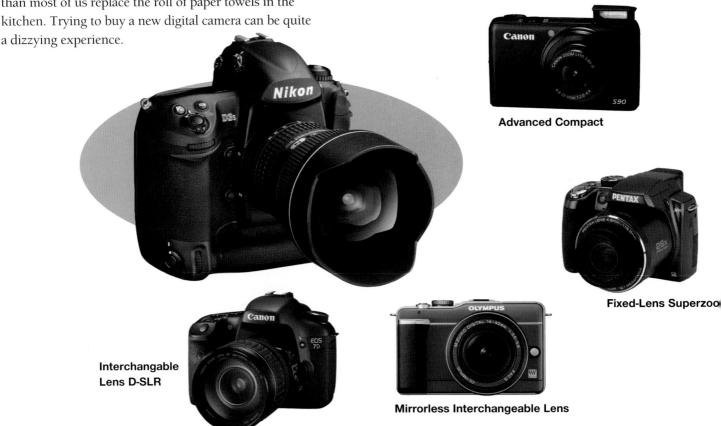

Types of Digital Cameras

There's a scene in the movie *Broadcast News* where William Hurt and Holly Hunter are arguing about the ever-shifting line between honest journalism and good ratings. Hunter's character accuses Hurt's of crossing over that line and he retorts angrily: "It's hard not to cross it; they keep moving the little sucker, don't they?"

In a lot of ways, trying to draw a clear line between digital camera categories poses a similar dilemma. Just when you think you understand the features that make each category distinct, a new wave of cameras is introduced and, voila, your existing guideposts have vanished—only to hop across an invisible boundary and reappear elsewhere.

On the following pages, you'll find that I've classified digital cameras into four categories (if you can call *The Missing Link* a category, see page 40). But dividing cameras into rigorously unambiguous groups is, of course, largely a marketing device because manufacturers do need to target their audiences. It's silly to advertise Corvettes to grandmothers (most grandmothers, anyway). But understanding how these categories differ can help you decide which camera group is right for you. And, don't confine your camera search to one category. It is better to look for the features you need and can afford and then find a camera—in whatever category it happens to be—that fits your needs. Let's not take these classifications that follow as hard and fast boundaries, but as guidelines.

The camera you end up purchasing should be based on what you expect from your photography, with features that match the type of pictures you want to take. It doesn't make a lot of sense to spend a large amount of money on a D-SLR if you only email photos to friends and merely make an occasional print enlargement. Similarly, you can't expect to wring poster-sized images from an entry level, basic point-and-shoot compact camera—though you certainly can make fine smaller-sized prints. (Enlargement size is primarily, though not exclusively, a matter of resolution, or pixel count, which we'll talk about in the next section.) However, if you want to record your son's or daughter's high school sporting events, you'll want a camera, perhaps a D-SLR, with no shutter lag and continuous autofocusing along with a high frame-per-second rate and long focal length so you can sharply capture peak action.

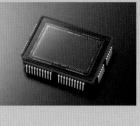

Your camera's sensor records light intensity, not color. To create color images, a precise pattern of color filters are laid over the photosites. The filters (usually arranged in something called a Bayer pattern, above) represent the three primary colors of the spectrum—red, green, and blue. From these three colors all others can be created. Light passes through the filters to the photosites. Electronics interpret the intensity of this light to produce the colors of the original scene. Because any one photosite can record only one color, your camera interpolates this information and combines it with information from adjacent photosites to create accurate image colors.

BASIC POINT-AND-SHOOT COMPACT CAMERAS

 ${
m T}$ his is the most basic entry-level digital camera, because, for the most part, you will not have to fiddle with camera controls. But don't be fooled, compared to cameras in this category only a few years ago, recent models offer a whopping bit of technology and flexibility for prices that head down toward \$100. For example, there are many of this type available today in the 10MP range. That's enough resolution to easily make 16 x 20-inch prints (40.6 x 50.8 cm) of good quality. A few years ago you would have to spend considerably more to get a camera of just 3 or 4 megapixels. And while you're still getting a relatively modest zoom range in this category (typically 3x to 5x), many of the cameras offer a 3-inch LCD (7.6 cm) that provides a breathtaking view compared to point-and-shoots made just a few years ago.

Small, thin and weighing hardly more than a butterfly, these basic compacts are great everyday companions for that very reason—they are easy to have with you at all times. And despite their very basic ease of use, these cameras frequently offer some advanced features, including motion detection (the cameras detects moving subjects and automatically increases the shutter speed), face priority features (the camera knows when you are photographing a face and adjusts accordingly), red-eye reduction (a flash mode designed to eliminate ghostly-looking red eye, see page 254) and even some far-out bits of shooting technology like Nikon's "smile detection" (yep, it knows if your subjects are smiling or not) and blink warnings to keep you from shooting when your subject's eyes are closed. There's also a "Santa Warning" feature on some cameras, so it knows if they've been bad or good (OK, I made that part up).

Flash power is somewhat minimal in the most basic cameras (expect a range of about 1-10 feet), of course, but since they tend to be used for snapshots at the dinner table or to record outdoor photos in bright light, that's a minimal concern. ISO ratings can typically range from a default ISO of 100 or 200 up to an amazing ISO 1600 (enough light-sensitivity to shoot photos inside a dark cathedral with no flash, for example).

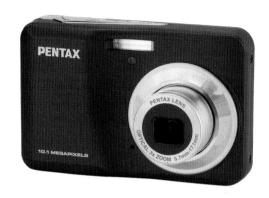

Basic Point-and-Shoot Compact Camera

pros -

- + Ease of point-and-shoot operation
- + Easily fits in pocket or handbag
- + Affordable but still good quality

cons

- Smaller image sensors mean smaller prints
- Minimal zoom range
- Fewer if any exposure or metering modes
- Built-in flash has short range

Optical VS. Digital Zoom

All but the least expensive digital cameras offer an optical zoom lens. And most also have digital zoom. Optical zoom is what you want-and, generally, the greater its range the better. Digital zoom is almost worthless. Ignore it when buying a camera, because it is simply an in-camera method of cropping the picture to make it seem like you're magnifying it. In reality you are reducing the quality of the picture, because in cropping you are throwing away pixels-that are part of the picture.

However, a good and powerful optical zoom can be an invigorating creative tool. Digital cameras can have an optical zoom capability of anywhere from 3x to 26x (4x and 5x being the most common). What does that mean? It simply expresses the focal length range of the lens. For example, a 35-70mm zoom lens would be 2x. A 35-105mm would be 3x. A 28-280mm would be 10x, and so on. For general photography a 3x, 4x or 5x zoom lens works well. But I like zooms with a range of 8x or more for their great versatility.

ADVANCED COMPACT CAMERAS

As you would expect, this next echelon of digital cameras offers several important added features. Primary among them are a bigger sensor and higher megapixel count, typically in the range of 12 to 14MP—which is a fantastic amount of resolution. (Bear in mind, however, that pixel counts alone don't dictate image quality because not all pixels and sensor designs are equal—see page 35). The increased pixel count enables you to make even higher-quality prints, easily up to 20 x 24-inches (50.8 x 61cm), and also lets you make more radical crops of your images without losing image quality.

Probably more importantly, cameras in this range usually feature not only a better quality lens (glass rather than plastic elements, for instance), but also a longer optical zoom—14x is not uncommon—meaning, in this case, that the maximum telephoto zoom has a focal length 14 times longer than the wide-angle setting. And the wide-angle setting is also typically wider than on a simpler camera. Also, to help you steady the camera when shooting with such an extreme zoom range, these cameras may have an image-stabilization system.

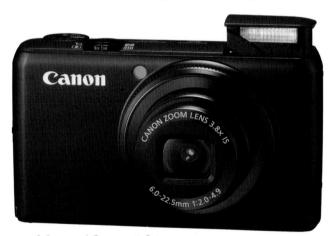

Advanced Compact Camera

pros -

- + Bigger sensor
- More exposure and metering options
- Choice of special subject modes
- + Programmable white balance
- + Extended zoom range
- Longer flash range

- More expensive than basic point-and-shoot compacts
- Potentially uses more battery power

The cameras in this group usually offer a full range of exposure modes, including Program, Aperture-Priority, Shutter-Priority, full Manual mode (sometimes, not always), and a plethora of scene modes for special subjects, including modes for sports, portraits, landscapes, night, and people who are smiling, people who are winking at you, etc. In other words, you're covered in just about any shooting situation.

The benefit of having more sophisticated exposure modes, of course, is that you're able to take full advantage of the various shutter speed and aperture combinations (see the chapter on Taking Great Digital Pictures for more information on exposure and metering modes). For example, having control of the aperture means that you can control depth of field (the near to far range that's in sharp focus), while controlling the shutter speed means that you can decide how motion is captured.

You should also expect to find user-programmable white balance, an extended ISO range (up to 6400—which is probably enough sensitivity to shoot a black bat in a very dark cave), a multitude of flash modes (a great feature to have), multiple close-up modes, etc. You might also find some other quirky features like a "best photo" feature that automatically fires off as many as ten frames when you press the shutter so that you can decide which one you like best.

Advanced compacts are, of course, slightly bulkier than basic compacts, but still small enough to carry anywhere, and you'll find that the added zoom range and sophisticated exposure control are worth the slight increase in camera size.

THE MISSING LINK

 ${
m B}_{
m ack}$ around 2002 through 2005 or so, there was a class of camera that was referred to by the somewhat awkward-sounding term "prosumer," a name invented (by the camera companies, not me) to describe a type that landed somewhere between advanced compact cameras and full-fledged D-SLRs. The name, of course, comes from the idea that these cameras represent something of a morphing between pro-featured D-SLR cameras and your everyday run-of-the-mill consumer camera. Though the term prosumer has fallen out of favor, these cameras have evolved into models that have many high-level features and functions, along with superior image quality. One style is known for having zoom lenses with a very wide focal-length range, and another type has interchangeable lenses but no reflex mirror. It is not always easy, as we've noted, to classify these cameras, so we'll just call this group "the missing link."

Fixed-Lens Superzoom

While these cameras look and handle very similarly to a D-SLR, the primary difference is that you can't change lenses—you're stuck with the lens that is mounted to the camera (of course there are exceptions, as described in the paragraph that follows about mirrorless cameras with interchangeable lenses—I told you it is not easy to make clean classifications!). While this might seem to be a drawback, in fact, many of these cameras have zoom lenses with a super long range, some up to 30x and that cover (in 35mm terms) a focal-length range of 28-840mm. Except for quite wide focal lengths, this

range will certainly cover most shooting needs. I think these cameras are a wondrous invention and solve a lot of problems for serious photographers who want a substantial (to say the least) zoom range but don't want to lug a shoulder bag full of lenses for a D-LSR. These lenses will not, necessarily, equal the lenses of a true interchangeable lens in optical quality, but hey, when was the last time an SLR photographer was able to shove an 840mm lens in their daypack and forget they were carrying it?

One other major difference between this camera design and a true SLR is that you are not seeing your subject directly through the viewfinder. These cameras view the subject through the taking lens (not through a separate viewfinder) so they do offer a true direct view of your subject, but rather than looking through a pentaprism, you are looking at a video display. In other words, you're seeing a movie of what the camera is seeing. Is this OK? In earlier cameras I found it to be something of an annoyance, with the video view sometimes having trouble presenting a sharp, steady image. But recent models have refined this viewing capability tremendously. Still, before you decide that a 26x or 30X zoom solves all of your optical and logistical problems, you should visit a camera store and try out the electronic viewfinder.

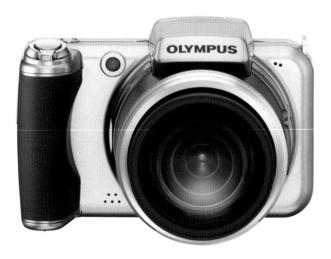

pros +

- + High zoom ratios
- + Sophisticated metering and exposure modes
- + Built-in flash has better range/some take accessory flashes
- + Wider ISO range
- + Added features such as shadow adjustment
- + Often records RAW files and may have image stabilzation
- + Ability to change lenses on newer mirrorless camera

cons -

- Higher price
- Not as compact
- Typically use much more battery power
- Smaller sensor size than most D-SLRs (except for four-thirds mirrorless camera)

Other features that are common to the higher end of cameras in this group include the availability of accessories, such as flash units, lens filters, and others; more advanced subject modes (like motion detection); and sensitivity ranges up to ISO 3200.

These cameras usually offer full-featured metering options, including multi-segment, center-weighted, and spot metering, as well as high-speed burst rates so that you can shoot action subjects at speeds of 10 frames-per-second (fps) or higher (in some cases much higher). They often offer added features such as art filters, face detection, and shadow adjustment technology, as well as things like image stabilization and custom white balance.

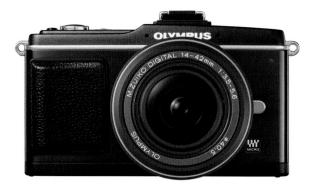

Mirrorless Interchangeable Lens

Now, to blur distinctions even further, and not counting the Leica rangefinder style, there is a currently evolving category (or sub-category—it's hard to keep track) of camera that has eliminated the reflex mirror but still features interchangeable lenses. The scene is viewed live electronically by keeping the shutter open and relaying the live feed from the sensor to either an LCD screen or an electronic viewfinder (EVF). Pioneered by Panasonic and Olympus, this style has left the industry seeking yet another term to describe such an interloping camera design.

As a final note, among the most amazing recent innovations in digital still cameras is the ability to shoot true HD-quality movies at extremely high resolutions and very fast frame rates. While early digital cameras featured basic video recording modes, these advanced cameras, and their D-SLR cousins, can produce absolutely stunning video quality. In other words, you can come home with vacation videos that will rival the image quality that Martin Scorsese is getting in his films.

DIGITAL SLR

f If you take all of the other features that are found on the previous types of cameras described so far, and then add two powerfully distinctive features to the mix, you arrive at the top of the digital camera heap, which represents the iconic dream of most serious photographers: the true D-SLR camera. The two features, of course, are direct though-the-lens pentaprism viewing and the ability to physically change lenses. Both are features that pros couldn't live without and that, if you are devoted to the craft of photography (as I know you are), you might not want to exist without, either.

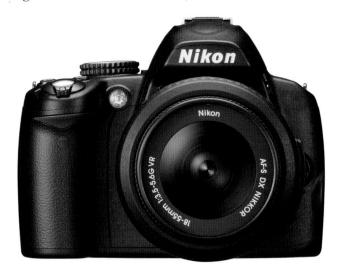

- + Ability to change lenses and add accessory flash units
- + Through-the-lens viewing and metering
- + Complete range of sophisticated exposure and metering modes
- Capable of shooting several continuous frames without pausing
- + Minimal or nonexistent shutter lag
- + More white balance controls, including full manual settings
- + Largest sensor sizes and high pixel counts
- + RAW recording format

- Larger and more expensive
- Requires much more battery power
- Image sensors may eventually need cleaning because dust builds up when changing lenses

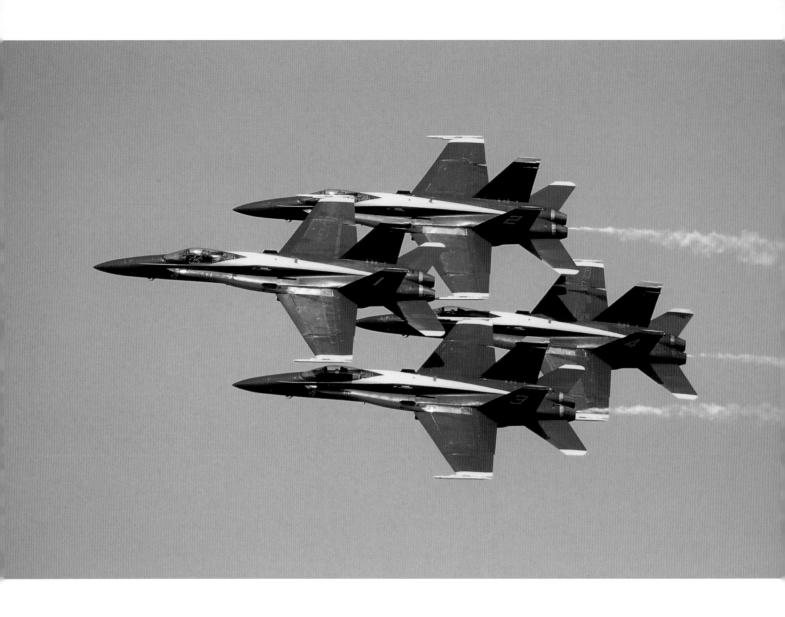

Having a direct viewfinder is extremely important in several types of photography, particularly sports and action capture where any type of delay (such as you will find with an electronic viewfinder camera) is just not acceptable. You can't photograph the Blue Angels moving past you at 450 mph if you have to wait for a video display to play catch up with the image. The jets will be in the next county before the camera shows you the images you just missed.

Direct viewing is also critical for close-up work where incorrectly framing a scene by a few millimeters could mean getting the web and not the spider. A quality D-SLR with 100-percent accurate viewing will show you exactly what you are photographing. But, just so we have full disclosure here, be aware that not all D-SLR viewfinders are 100-percent accurate, so that's something to read about as you research your purchase.

Next is the optical consideration. Yes, while those cameras with a fixed super-zoom lens will provide you with mind-boggling optical flexibility, they do not deliver the same optical quality you get from first-rate SLR lenses. But that's only if you do buy first-rate lenses and they are not cheap. When it comes to certain lenses for your D-SLR, you may be forced to decide between your kids' college fund and your desire to photograph birds close up. No joke. But beyond just quality, a D-SLR will also avail you to a wide selection of specialty lenses, including but not limited to: ultra-wide-angle lenses, fisheye lenses, super-fast super-telephoto lenses, and dedicated macro lenses.

There is also the matter of accessories: while the "missing link" cameras are catching up to D-SLRs in this regard, there are things that you can get more easily for a D-SLR, such as microscope and telescope adapters,

sophisticated remote flash components, and timelapse and intervalometer devices. Just flip through the back pages of any photo magazine like Popular Photography or Shutterbug and you'll see what you're missing by not owning a D-SLR.

In all seriousness, even an entry level D-SLR is a wonder to behold and it will unfurl your photographic wings in ways you never imagined possible. And considering how affordable the basic one-lens kits have become, they are hard to resist. Other advantages of a D-SLR (other than just looking really cool walking around with one) include having overrides for virtually every metering and exposure control. Many D-SLRs, for instance, have a spot-metering mode that lets you take light readings from very specific and extremely small subject areas. Typically, they are also very durable and designed to take the abuse that a very active photographer will give them.

Speed of use is also drastically improved with D-SLRs. They have larger and faster memory buffers that enable you to fire a burst of shots in rapid succession without waiting for the camera to play catch up. For sports, news, and wildlife photographers, this is a paramount concern because they can't be waiting for the camera to write the previous frames while the action peaks and disappears.

Megapixel counts continue to escalate, ranging from about 8MP at the low consumer end, to over 24MP in highend professional cameras. And while megapixel counts are not the be-all and end-all in terms of image quality, they certainly are a primary consideration in choosing a camera. Remember, in terms of sheer resolution, more is usually better. More importantly, the bigger sensors in D-SLRs enable larger pixels, which improve the image by lowering digital noise (random colored pixels caused by electronic interference) at higher ISOs and for longer exposures.

One factor inherent in most digital cameras is the so-called magnification factor, or cropping factor, imposed by the size of the the sensor. If the camera's magnification factor is 1.5x, for instance, a 100mm lens acts as a 150mm lens $(1.5 \times 100 = 150)$ on a 35mm or full-frame camera, and a 300mm lens produces images the equivalent of a 450mm lens. Other digital camera types with smaller sensors have a larger magnification factor.

The reason for the cropping factor is because many D-SLRs are based on the design of a 35mm SLR film camera and use lenses created for 35mm cameras. The sensor, however, is smaller than a frame of 35mm film,

so it doesn't "see" the entire image being transmitted by the lens-rather it sees just the central area of that image. This, in effect, creates a longer effective focal length. Because of this design quirk, your wide-angle lenses will not have as wide an angle of view as they would on a 35mm camera. But the opposite is also true: All lenses used on this type of D-SLR produce a longer focal length, thus giving all of your lenses a longer effective focal length. The longer inherent focal lengths are great if you're a sports or wildlife shooter, but not so great if you're a landscape or architectural photographer and want wider views.

D-SLRs also offer the versatile RAW file format and are packaged with special software for handling RAW files. The cameras are often bundled with other manufacturer-specific software to improve handling of files. (See page 75 for more on RAW files.)

Memory Cards

Once informally referred to as "digital film," memory cards are the digital media that your camera uses to record and store images until you download them to your computer. Their great advantage over traditional film, of course, is that as soon as you've downloaded your images to your computer, you just pop the card back into the camera and you're off and shooting again. And you can download your memory cards whenever you like—whether you've taken one picture or dozens.

There are several different types of removable digital media (see next page), and none is necessarily better than the other. The reason that so many formats exist is because manufacturers have yet to settle on a single system for storing images. And given the competitive nature of the camera industry and the desire to constantly improve (and outsell) existing products, it's likely there won't be an exclusive standard in the near future. Manufacturers continue to search for higher capacity as well as smaller and lighter media card formats—which is a great thing as long as they don't get so small that keeping track of them is like looking for a lost contact lens.

The exact number of images that you can fit onto any card depends entirely on the file sizes of the images you're capturing and, of course, the storage capacity of the card—the higher the resolution and the less compression that you use, the fewer images will fit onto a card. Capacities have recently increased dramatically, and you can now buy a single card that will probably get you through your entire vacation trip—even if you are planning an around-the-world jaunt.

Manufacturers continue to produce higher and higher storage memory. A 64 gigabyte (GB) card is enough memory to hold upwards of 5,000 full resolution RAW files—or more than 320 minutes of HD video recording (it's the video recording that really calls for such huge-capacity cards). As reliable as memory cards are, however, you'd be taking a pretty big gamble to put your entire vacation on just one. What happens if you lose the card or it corrupts? Better you should lose one card with part of your trip than be ripping apart a hotel room in the Caribbean looking for the whole trip.

TYPES OF DIGITAL MEMORY CARDS

I he type of memory card that you need is dictated entirely by the type of camera you have; in most cases (not all) cameras only take one type of memory card. A few cameras take two different types of cards (for reasons that have never been completely clear to me). That said, however, there are still choices you will have to make in purchasing cards, including size, speed, and a few other special features. The guide below is just an introduction to the various types of cards that exist.

CompactFlash (CF)

Two or three times bigger in physical size than other memory cards, CF cards are popular because of their relatively low cost, high capacity, durability, and extreme reliability. CompactFlash cards were first introduced by SanDisk Corporation in 1994 and today are one of the standards among

memory cards. You pay for two things when you buy a CF card: capacity and record/write speed. While there are still some smaller-capacity stragglers on the market today, in practical terms the capacities range from 1GB to 64GB (see How Much Memory Do You Need? on the following page).

Speed is usually described in terms of an "x" factor that is a multiple of the reading speed of a typical CD drive (about 150kB per second, or .15MB/s). Typical speeds range from 6x to 600x and, all other things being equal, faster cards provide better recording (in your camera) and transfer (to your computer) speeds, which is especially useful if you shoot lots of large files (RAW format with a 14MP camera, for example). There is, as you might expect, lots of debate in online forums about just how much speed you will gain, and whether that speed is worth the substantially higher prices. If you're the type that enjoys a robust online debate, have at it.

Secure Digital (SD)

Jointly developed by Matsushita, SanDisk, and Toshiba. Secure Digital cards—or SD as they are usually called—are becoming more and more popular because they are quite small

If you happen to shoot a lot of HD video with your digital camera, or you're planning to sail around the world in a large thimble and want to save weight by carrying only one memory card, you might want to consider the SD card variation called SDXC (Secure Digital Extra Capacity). The XC cards have capacities ranging from 4GB up to a whopping 2TB (two terabytes).

SanDisk # MEMORY STICK PRO Duo **32GB**

Memory Stick and **Memory Stick Pro**

Developed by Sony for its digital cameras and camcorders, the format is now also manufactured by other companies.

The PRO version has faster write speeds but is not compatible with some older Sony digital cameras. Newer still are

the Memory Stick Duo and Memory Stick PRO Duosmaller and lighter versions for use primarily in compact devices such as cellular phones with built-in cameras and very small digital cameras.

HOW MUCH MEMORY DO YOU NEED?

 $oldsymbol{1}$ he simple answer to that question is that you need more memory than you think—especially if you are mixing still photos and HD movies or shooting all of your files in RAW (and especially if you are recording both JPEG and RAW simultaneously, as many cameras allow). In the formative years of digital shooting, memory was still very expensive, so one of the answers to how much memory you needed was: How much can you afford? I can remember being on a shooting trip to the Everglades and running out of memory and paying \$150 for a 1GB card at a local camera shop. Today I can buy a card with eight times as much memory for less than \$25. In fact, I always keep an extra 8GB card in my pocket just in case.

Theoretically, if you typically travel (even around town) with your laptop, then the number of cards you carry isn't that big an issue since you can always pause and download some images. But downloading big files takes longer than most of us want to wait, and let's face it, if you're photographing friends on the beach, you really don't want to have to run back to the car to clean off a card. Your friends will find a new friend who brought more memory along and there you'll be at the beach, all alone with your laptop.

Another option, especially if you're traveling, is to carry a portable download device (see page 51). They're about the size of a deck of cards and provide hundreds of gigabytes of storage space. But again, you can probably fill a several cards with the same amount of memory for about the same price—and cards are smaller to carry around.

for a week of shooting, I carry 10 cards of that size. If you really need to be compulsive about math, you can roughly estimate how much memory you'll need if you know the file size that your camera creates for a given format. You have to keep in mind, however, that the card needs a certain amount of space for organizing your images—so the math is never exact. My 12MP camera, for example, creates image files of approximately 10.8MB each in RAW (about half that in JPEG) which means that I can fit a rough minimum of 133 images on a 2GB card $(10.8 \times 133 = 1,436 \text{ bytes, or})$ about 1.5GB; and the rest of the space is used for various mysterious functions). Having 133 photos available may be fine for a birthday party in the backyard, but if

Your camera manual will provide a chart of how

many images different sized memory cards will hold

(depending on which format you are shooting), or you

can just go by the counter on your LCD (or viewfinder)

display that tells you how many images you still have

room to shoot. I would suggest always having enough

or two, just do the math to figure out how many more

cards you'll need. I can fit about 500 RAW images on an

8GB card when using my 12MP camera body, and on a

good day I will fill most of that card. If I'm going away

you're going on a weeklong vacation to Martha's Vine-

yard, you're going to need a bigger boat.

memory to record several hundred images if you're going on a daytrip, and if you're traveling for a week

One of the best things about traveling with a laptop (other than being able to shop on eBay from your hotel room) is that you can download your pictures, back them up on a CD, and even email them to friends at home.

© ROB SHEPPARD

CARING FOR MEMORY CARDS

Memory cards of all types (with the exception of rarely used MicroDrive-type cards) have no moving parts and are rugged and easy to care for. As long as you don't drop them in the ocean or let the dog chew on them for too long, you will probably never experience a card failure. On the other hand, there's no reason to tempt fate, so it's a good idea to keep them in a storage case (available at any camera shop) or a zipper bag. Interestingly, digital media cards are unaffected by current airport metal detectors and X-ray machines, so you really don't have to worry about them at the airport (your bottle of water, however, will probably draw all sorts of attention).

Memory Card Tips

- · Always store memory cards in their original plastic cases or in a wallet made for that purpose.
- Protect cards from extremes of heat or cold and keep them away from moisture-including wet fingers on a rainy day. Never leave them in a hot car or near a sunny window.
- Keep cards away from strong magnetic fields.
- · Let cards adjust to large changes in temperature before shooting with them or downloading them.

To capture details in both the brightly-lit city and the darker, nearby mountains, this photo combines no fewer than seven different exposures, totaling over 100MB of memory. A large memory card ensures that there is plenty of room for experimenting with varying compositions without worrying about running out of space on the card.

Transferring Pictures to the Computer

 ${
m T}$ he object of getting digital photos into your camera, of course, is to eventually move them to your computer and presumably from there to enhance them using an image-processing program, to see them in their greater glory on your blog or personal website, etc., and to move them even further along and transform them into prints. So step two in the digital transaction is the infamous download. My friend Phil taught himself how to do this at the very young age of about 75, and he now downloads images on an almost daily basis. If he can do it with such casual ease, so can you. (By the way, this is a guy who took up digital photography as a hobby at that same age and is now his family's most talented photographer.)

There are a number of simple ways to move your pictures from your digital camera to your computer. One method is to connect your camera to your computer using the cables that came with it (go look in the box the camera came in, you'll find them). The only, albeit tiny, inconvenience of using the cables to do a download is that you can't use the camera while it's tethered and downloading to the computer. Also, I personally don't like to have any extra cables confusing me on my desk—there are already enough wires whose purposes I can't identify. A simpler method, I think, is to just purchase an inexpensive card reader (see the sidebar) that you can leave permanently attached to your computer; mine plugs into an open USB port on my keyboard and that's where it lives.

One other option might be wireless download, which requires little more than turning on your computer or connecting to a wireless digital network (via a cell phone connection, for example), and telling the camera it's time to download. If you have a cell-phone camera, you've no doubt already done this without even realizing what an incredible techno-leap you were making. You shot photos of the sunset on Long Island Sound and beamed them to your friend's cell phone as she hiked up a hill in San Diego—and neither of you got anywhere near a wire or a computer. It is my guess that in the future, all photos will download wirelessly to computers, printers, websites, and photo-sharing communities (like Flickr).

Using a Card Reader

Unless you have wireless downloading capability, using a card reader is, I think, the simplest and least obtrusive method of downloading images. Card readers are small, inexpensive, and you can attach it to your computer and just leave it there. Most laptops these days have built-in slots for memory cards, so if you're traveling with your laptop, this is a non-issue.

The advantage of using a card reader is simple: You don't have to go through the bother of hooking up your camera to the computer each time you want to download. Just pop the card in the reader and this will usually launch a download program, so all you have to do is click "OK" and you're on your way. Most card readers don't even require you to install software, so nothing could be simpler.

Digital Labs

And just in case you still enjoy occasional trips to the camera shop or the local drugstore lab, yes, you can take your memory card there to be downloaded and have your images printed (or emailed to you or burned to a DVD). If you're over 40, of course, the kid at the counter will probably impatiently explain that you could have just sent your photos in via their network and had prints waiting for you when you arrived, but just ignore their taunting. Teenagers can be so cruel.

Most labs have business partnerships with online photo services, so once you pick up your prints, you can go home and find your images on their website and order more prints or enlargements, post the photos to a photo-sharing site, or just gaze at your screen and ponder the wonder of it all.

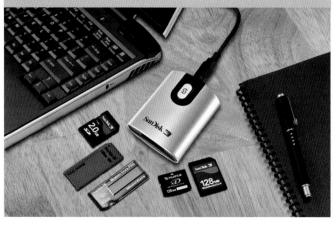

Camera Accessories

Part of the fun of owning a camera is that you get to buy all sorts of neat toys to go with it. And if you choose them carefully, they will make your picture-taking life a lot easier and improve your photos.

Tripods and Monopods

I think of tripods as being indispensable to good photography and regard owning a good one as more of a necessity than an accessory. A good tripod should be light enough so that you'll actually bring it with you but heavy and solid enough so that it can hold your camera and its longest lens. It's also important that a tripod be tall enough to use at eye level without having to extend the center column more than a few inches. The knobs that control the leg length and other functions should be easy to use-even with gloves on.

Metal tripods are far steadier than plastic tripods but weigh more. Carbon-fiber tripods are strong and lightweight, but very expensive.

Monopods-one-legged camera supports-are a good alternative to a tripod when you simply don't have the time or the room to set up a tripod. Monopods are good at providing support when space is limited or when you're in a location (like a botanical garden) where tripods are prohibited.

Ball Heads vs. Pan-Tilt Heads

The tripod's head holds the camera. Pan-tilt heads and ball heads are used to mount your camera to either a tripod or a monopod. I strongly prefer ball heads. With a single control, they let you quickly adjust the camera in all directions. The multiple handles of a pan head slow you down because each must be separately loosened and adjusted. Buy the best ball head (like the Manfrotto 324RC2 pictured above) you can afford because it will last for many years and make using a tripod a pleasure.

There are camera bags available for all tastes and requirements, including different colors, shapes, and fabrics.

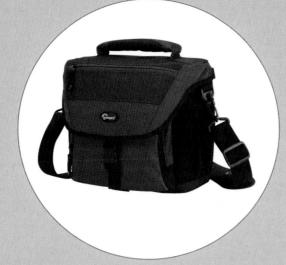

The 4-inch (10.2cm) LCD screen on this storage device from Epson lets you zoom in on details of your photos to determine the "keepers" when you don't have a computer with you.

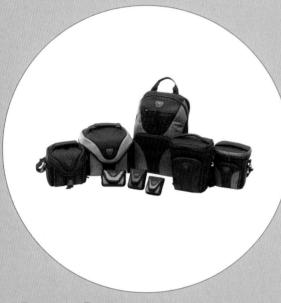

Camera Bags

Camera bags come in every size, shape, price, and style imaginable. The size and style that you buy will depend largely on the amount of equipment you own. If you have a digital SLR and several lenses, choose a shoulder bag with individual lens compartments; it will protect your investment and put your equipment at your fingertips. Even if all you own is a compact zoom camera, a well-made camera bag is a good investment because it will keep dirt and rain and sticky fingers away from your precious camera. The five most important things to look for in any camera bag are superior protection, exceptional organization (so you can easily access equipment), convenience (zippers and flaps open easily), durability, and light enough weight so that you'll use it.

Portable Digital Storage Devices

Portable digital storage devices are small hard drives that enable you to download images in the field for safe storage. They are typically small enough to fit in a jacket pocket. Many now have a relatively large LCD screen so that you can review your images after you've downloaded them; a few even have a CD burner attached so that you can burn CDs in your hotel room at night (or sitting on the beach admiring the sunset you just shot, for that matter).

The beauty of these devices is that they let you empty your memory cards in a matter of minutes so that you can reuse the cards and continue shooting. The alternative is to carry a laptop. A laptop adds editing capability but also is more fragile, heavy, and expensive. It's a good idea to read online reviews or do a test run at the camera shop when you're buying a portable storage device because ease of use can really vary from brand to brand.

Electronic Flash

 ${
m M}$ ost of us take for granted the ability to walk into any room, regardless of how dark it is, pop on the electronic flash and take a well-exposed picture. It wasn't always so easy and, in fact, photographic pioneers wrestled with the problem for more than 80 years before a solution was found.

As early as 1850 William Henry Fox Talbot (who invented the basic concept of negative-positive photography on which film photography is based) was experimenting with using electrical charges and crude capacitors to light subjects with a brilliant instantaneous spark of light. What Talbot was trying to find was a source of light that was bright enough to illuminate fast-moving subjects in dim light and that had a short enough duration to stop their movement—and he did have some remarkable successes.

It wasn't until the 1930s, however, that an MIT faculty member (and former student) named Harold E. Edgerton really solved Talbot's riddle. Edgerton developed the first practical means of creating high-speed portable lighting—the portable electronic flash. He was able to create bursts of light bright enough and fast enough (measured in millionths of a second) to reveal, for the first time, the intricate beauty hidden in moving subjects that were simply too fast for the human eye to discern—drops of water splashing in a pan, hummingbird wings flapping, and bullets frozen in midair. If you've never seen any of "Doc" Edgerton's amazing photographs, they're worth investigating.

Today, of course, Edgerton's extraordinary invention is built into virtually every digital camera in the form of a small electronic flash—a miracle of technology and a landmark scientific breakthrough that is available at the push of a button. And though on-camera flash is rarely the most attractive form of photographic lighting, it does provide bright, convenient light. It also provides the extremely short-duration bursts of light (measured in thousandths of a second) that both Edgerton and Talbot were searching for and is often used by professional sports photographers for that very reason—to stop action.

Using flash with compact digital cameras is simple. In fact, by setting your flash to Auto mode, you can even leave the decision entirely up to the camera. The camera will turn the flash on when it thinks the existing light is too low to create a good exposure. The only indication

you'll get that you're about to take a flash picture (other than the flash popping up if you have a pop-up style flash) is the small amber flash indicator flickering in the viewfinder.

Because built-in flash provides such a harsh beam of light, however, and because it comes directly from the camera, it tends to produce a flat, featureless light that renders most subjects devoid of the attractive subtleties of texture and form that existing light provides. Still, if you use flash judiciously, study some of the advanced techniques and pay attention to your surroundings, you can get some very pleasing pictures. And besides, if you're at an indoor birthday party and it's too dark to shoot without flash, you really don't have many options.

On Camera Flash Tips

Stay within the flash range

You've no doubt seen baseball and football stadiums at night twinkling with the light of a thousand electronic flashes. The effect is pretty to watch on TV and the battery manufacturers must absolutely love it, but not a single one of those thousands of flashes is helping anyone get a better picture of an event happening hundreds of feet away. Typically most built-in flash units have a range of about 4-16 feet (1.2 to 4.9 meters); beyond that range (either closer or farther away) the flash isn't very helpful.

Because the light from the flash falls off (gets dimmer) the farther it gets from the camera, subjects that are farther from the camera may look darker than those that are closer. If you are shooting a group at a long dinner table, for instance, it might be best to have them all gather on the opposite side of the table from you as if they were in a police lineup so they're all roughly the same distance from the flash.

When using the camera's built-in flash, the subject may appear too dark (underexposed) if you are not close enough. Either move closer or add exposure by using your camera's exposure-compensation feature.

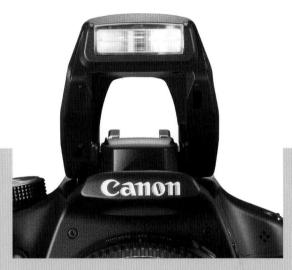

OMARTHA MORGAN

Use additional lights

Whenever you're shooting indoors with flash, turn on several room lights, too. Your built-in flash will provide enough illumination for a good exposure of the main subject and the room lights will lighten shadows to give a more natural-looking atmosphere. During the day, open curtains or doors to let more light inside, but try not to shoot directly into a bright light since this may cause the flash to shut off prematurely.

· Avoid reflective surfaces

Never aim the flash directly at mirrors or windows or any other highly reflective surface. Light from the flash will bounce directly back to the camera. In addition to creating glaring hot spots in your pictures, the reflected light may also cause your automatic exposure system to underexpose the scene by fooling it into thinking there is more ambient light than really exists. Conversely, a very dark wall behind your main subject will fool the camera's exposure system into thinking it needs more light and will overexpose your subject.

The Basic Flash Modes

Many digital cameras offer several modes for flash photography that you can select from the flash menu or by pressing a button on the camera (or both). The mode you're in will normally be displayed in the viewfinder and/or in the camera's LCD control panel. How these modes work vary somewhat from one camera manufacturer to another, and some digital SLRs offer additional modes for accessory flash units. The list that follows is an overview of some of the more common choices for flash photography. Make sure you check your camera's manual to see exactly which modes are available to you and how they work.

Also, it is always best to take some test photos before any big event where the pressure will be on to produce great photos. Take these practice shots a week before the event in similar surroundings, trying out different flash modes and techniques. And remember, you don't have to worry about the cost of test film, plus you can see the results instantly and try another technique if the picture doesn't look as good as it could.

Automatic

In this mode the flash will automatically turn itself on whenever the camera's exposure system determines a scene is too dark. The flash will almost always pop on indoors in this mode, but may also turn itself on when you are working outdoors in deep shade or as the sun begins to wane late in the day. Any time that the flash turns itself on, you have to decide whether you indeed want the flash on or whether it would be best to shut it off. You can tell if the flash is set to Automatic by the lightning bolt symbol somewhere on your camera's displays, often accompanied by a letter "A" or the word "Auto."

Flash Off

In this mode the flash will not fire, regardless of the lighting conditions. This is a very useful mode if you're trying to take pictures in a concert or nightclub and don't want to be bounced out by security or glared at by nearby audience members. More importantly, shutting the flash off enables you to take photos by existing light onlyindoors or out-so that you can photograph a city skyline at twilight, for instance, without flash. This mode is usually represented with a lightening bolt/arrow icon in a circle with a line drawn through-the international "No" symbol.

Sometimes the blast of on-camera flash is too harsh. After shooting this "candlescape" with flash (above), I saw how cold it looked on the LCD monitor. So, I turned off the flash and made a handheld exposure (one-half second), resting the camera on the arm of a couch. There's no question about which is the more romantic shot.

Fill Flash

Sometimes the icon for this is the same "bolt and arrow" that signifies Automatic. While the flash is engaged, the fill mode makes it fire every time the shutter is released, whether the exposure system senses the need for added light or not. It is useful to lighten distracting shadows when you're photographing people outdoors in sunlight on very bright days, particularly if the light is coming from overhead. It might seem a bit backwards to use flash in bright sunlight, but that is when you see dark shadows in eye sockets and under noses, and using a small amount of flash opens these shadows nicely. With some more sophisticated accessory flash units, the camera's exposure system balances fill flash with the ambient light. You can also use an exposure compensation feature that lets you create a more natural balance between the existing light and the flash-typically providing a flash fill that is about one stop less than the existing light. Read your manual to see if your flash offers a compensation feature or some other method for adjusting flash output.

Fill flash can also be used to fill faces when using strong backlighting from the sun for outdoor group portraits (or even for backlit close-ups of flowers or plants, etc.). By arranging your subjects so that the sun is behind them, you can use the sun's light to create a halo or "rim" light around their head and then use flash to open up their faces. Again, fill flash will only work within your flash unit's normal working range, so be sure to check your manual for the useable distances. Finally, remember that for fill flash to work, your shutter speed cannot exceed the camera's flash sync speed.

Red-Eye Reduction

Red-eye is that rather demonic-looking red glow that occurs in people's eyes when they've been photographed head on by a built-in flash unit. The effect occurs because when you're photographing people in dim settings their pupils open very wide and light from the flash bounces back from the retinal surface (which is filled with tiny blood vessels) at the back of the eye, creating that strange glow. Traditionally, red-eye reduction has worked by designing the flash to fire a series of rapid low-powered pre-flashes that cause the pupil to contract. Red-eye reduction flash can be a bit annoying because during the time it takes to fire the series of mini-flashes, the spontaneity of the moment is lost. Some cameras are worse than others

(and some are a lot worse), and you'll sometimes see people at weddings or parties making their subjects hold a pose while they blister them with a flurry of flashes. Incidentally, turning on more room lights will also lesson the risk of red-eye because it causes the pupils to contract naturally.

Nowadays some cameras have built-in software that actually detects and eliminates the red-eye from your pictures before you download them. Regardless of how the camera attacks red-eye, you can always remove it after the fact in postproduction. We'll talk about techniques for doing this in The Image Enhanced chapter.

Slow-Sync

Normally when you take a flash photograph, the shutter opens, the flash fires, and then the shutter closes immediately. In the Slow-sync (sometimes called Night Flash) mode, the shutter remains open slightly longer in order to gather more light from the background.

Slow-sync photos have a more natural look because the background receives some ambient exposure. I find this a tremendously creative flash mode and I use it almost constantly when I'm working outdoors at night. If I'm shooting street pictures, for example, the flash will provide enough light to record friends standing on the street corner, and the delayed closing of the shutter records the color glow of neon and traffic streaks in the background. I've also used this mode indoors to create a more natural balance between the flash exposure and the existing room light; you will absolutely notice an improvement with indoor shots if you use this mode.

Because the shutter is staying open longer in this mode, however, anything that is moving in the background (people, cars, sparks in a fireplace) will record as motion streaks. If you're concerned about sharpness, you have to hold the camera very steady in the Slow-sync mode (or use a tripod) because any camera movement will also record background lights in a streaky way (see this used for creative effect on page 160).

ACCESSORY FLASH

Digital SLRs (and many higher-end digital compacts) have a feature called a hot shoe that enables you to attach an accessory flash to your camera. The accessory flash is used in place of your camera's builtin flash. If you do a lot of flash photography, there are many important benefits to owning and using an accessory unit.

The two main advantages of owning an accessory flash unit are power and flexibility. While the built-in flash has a maximum range less than 20 feet (6m), a good quality accessory flash can illuminate subjects at several times that distance. It's not like you'll be stumbling around in the dark looking for things hundreds of feet away to photograph, but the extra power/distance will come into play using techniques like bounce flash (see Bounce & Diffused Flash on the opposite page) or when photographing birds and wildlife with long telephoto lenses. Having extra power means that you can also set a smaller aperture (using the Aperture-Priority exposure mode) to get greater depth of field in flash photos.

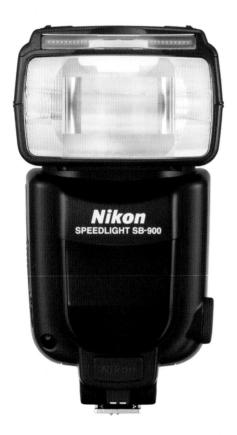

Accessory Flash Features

Flash units come in a variety of price and power ranges, from small, portable models the size of a deck of cards, to larger units capable of lighting up a large room. The interesting features found on accessory flash units include the ability to tilt and swivel the head (for bouncing light off of walls or ceilings), wide-angle adapters (for spreading a wider pattern of light when using wide-angle lenses), and wireless slave capability (which enables you to fire several flash units simultaneously without any hardwire connection to the camera or between flash units). When using slave flashes with digital cameras you have to be careful about the pre-flash, common with on-camera flashes, setting off the slaves. The pre-flash is used by digital cameras to help set exposure and/or white balance. You need to either be able to shut off the pre-flash (this might not be possible on some cameras) or you need to purchase a slave that will ignore pre-flashes. In addition, you can purchase a wide variety of diffusion and light-control devices for your flash to further help you control light (it's nice to know you can buy accessories for your accessories, isn't it?).

Guidelines for Use

Accessory flash units that are made by your camera's manufacturer (for your digital camera) will integrate seamlessly with your digital camera's electronics and, in fact, carry on a silent and complex conversation from the moment you connect the flash to the camera. Subject distance, ISO setting, and lens focal length information (even when using a zoom lens), for instance, are constantly fed to the flash.

Despite what may sound like a complicated set of options and controls, getting a good exposure with an accessory unit is very simple. Virtually all digital SLR cameras use a sophisticated light-measuring system called TTL (through-the-lens) exposure control that measures light coming through-the-lens of the camera. In the TTL mode, the light from the flash is measured after it enters the camera and the camera then tells the flash when to shut off. This is the most precise method of measuring flash exposure and in most situations exposure is flawless and simple. However, these units are also capable of performing highly sophisticated light and exposure control.

Comparing and Buying

The power of an accessory flash unit (which is one of the main differences between different models) is described by a guide number that is stated for a particular ISO speed and lens focal length, typically ISO 100. In general, the higher the guide number, the more powerful the flash unit and—as you might expect where features and power go, price follows and it's not uncommon for a good pro flash unit to cost several hundred dollars. All other things being equal (availability of accessories, bounce and tilt/swivel range), buying a flash with a higher guide number is usually beneficial.

Is an accessory flash something you should consider owning? If you are known among your family and friends as "the photographer" and frequently find yourself shooting pictures of friends' weddings ("Hey, we'd love to have you at our wedding—please bring your camera!"), you would probably benefit from a more powerful flash. Also, if you find yourself dissatisfied with the lighting in your pictures shot with built-in flash, being able to bounce the light or soften it might be a good investment. And though most of us tend to associate flash with people and interior photography, a good flash is a great accessory for nature and close-up photographers.

Whatever flash unit you buy, take time to learn its myriad features (and trust me, the electronic geeks that design these things just love to toss in lots of intricate features). Take time also to run tests on various subjects and in different situations; knowing how to use flash well is the mark of a dedicated and sophisticated photographer and you will continue shooting long after others have put their cameras away.

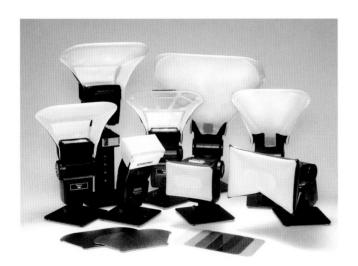

Bounce & Diffused Flash

The problem with aiming a flash unit directly at your subject is that the lighting is horribly unflattering, to say the least. In addition to looking like deer caught in the headlights, your subjects' faces will likely lose that gentle ruddy glow that you (and they) so admire. And any facial flaws (not that your friends have any) are just laid bare for all the world to examine when illuminated by direct flash.

Many accessory flash units, however, have the ability to tilt and/or swivel the flash head that lets you bounce the flash off of a ceiling or nearby wall. Bounced flash provides a gentler, more diffused lighting source that is far more flattering to your subjects than direct flash. Your friends won't know why your bounced-flash pictures make them look so nice, but they'll praise your photographic skills forever.

Shooting with bounce flash requires substantially more flash power than direct flash. The distance from camera to subject is greatly increased because the light goes from the flash to the ceiling (or wall) and then back to your subject. Also, in any bounce situation, some light will be absorbed or dispersed by the surroundings. If you anticipate doing a lot of bounce lighting, therefore, it's important to buy a unit that is powerful enough to handle the distances involved. You can increase the effective power of the flash by setting a higher ISO, but this comes with the price of increased digital noise.

For an even more sophisticated approach to bounce flash, you can purchase a flash diffuser that mounts to the flash head. These diffusers soften the light in one of two ways: Either by aiming the flash through a diffusion material or by bouncing the light from a small reflector surface. By dispersing the light over a broader area, they create a much more flattering light but don't require as much power as bouncing off of a ceiling or wall.

A Look at Lenses

Strictly speaking, you don't need a lens to take a picture. As anyone who has taken a basic photo course and built a pinhole camera knows, a tiny hole poked in a piece of thick aluminum foil will focus an image just fine, a principle that Aristotle wrote about in the 4th Century BC, incidentally—and one that the Chinese were mulling over about 100 years before that. But since your digital camera does use a lens (or lenses) to form its images, understanding something about how camera lenses work and how they differ is useful knowledge to have.

Unlike your eyes that have a set angle of view, camera lenses are made in a wide assortment of viewing angles—from ultra wide-angle lenses that take in the whole horizon in a single glance, to telephoto lenses that have a narrow view but magnify the subject. Exploiting these differing angles of view can be a fun and creative exercise and can lead to startling visual discoveries. By expanding or contracting space and distorting apparent perspective, for instance, lenses are able to show us views of the world that we've never actually seen in reality. And the ability of close-up or macro lenses to reveal intimate details of, say, a bug's knees, is like a journey to a hidden world within a world—one that we probably step on more often than we notice.

All lenses are identified by their focal length (stated in millimeters) that describes not only the their angle of view, but also their magnification. The shorter the focal length is (the smaller the number), the wider the angle of view: A 28mm lens, for example, provides a wider angle of view than a 100mm lens. Once again, to get a better handle on this, it's helpful to step back into the world of film for a moment (you can look, but don't buy).

In 35mm photography, lenses that have a focal length of roughly 50mm (in practice it's anywhere from about 43 to 60mm) are considered normal lenses, because their angle of view and representation of a scene is fairly close to what we see with the naked eye.

Technically, a lens is considered "normal" when its focal length is equal to the diagonal measurement of the film or sensor. Since the diagonal of a frame of 35mm film is 43mm, that's the focal length of a normal lens for that format. Now, remember that most D-SLRs have a lens magnification (cropping) factor and you add a new twist to the concept of a normal lens. If you have a

D-SLR with a magnification factor of 1.5x, then a 28mm or 35mm lens when multiplied by 1.5x would give effective "normal" range focal lengths of 42mm and 52mm, respectively. But the whole concept of normal is only to classify the different types of lenses.

Lenses that are shorter than the normal range in focal length are considered wide-angle lenses because they have a wider angle of view than a normal lens. Conversely, lenses with a longer focal length fall into the category of telephoto lenses because they have a narrower angle of view than normal and magnify the size of your subjects. Zoom lenses, of course, include many focal lengths in a single lens.

Lens Focal Lengths in the Digital World

Here's where things take a slight turn in the digital world. Way back at the turn of the millennium (oh so long ago), most photographers buying digital cameras were familiar with the measurements and terminology used to describe lenses for 35mm film cameras. But because digital sensors at that time were smaller than a frame of 35mm film (36mm x 24mm), lenses at particular focal lenghts produced different angles of view than when mounted on a film SLR. This confusion was compounded by the fact that various digital cameras had different-sized sensors, so that a lens with a focal length of, say, 50mm, produced an angle of view that was different depending on whether the camera was a compact, an advanced superzoom, or a D-SLR (and sensor sizes further differ among D-SLRs depending on who the manufacturer is).

To standardize this dilemma, the photo industry invented the idea of expressing lens focal lengths for digital cameras in metrics that were equivalent to 35mm camera focal lengths. You will still see the somewhat clunky phrase "35mm equivalent" tacked onto most descriptions of digital camera lenses. For example, the zoom range of a basic digital camera might be 7mm to 35mm, but because its sensor is so small, the angle of view is equivalent to placing a 28-140mm zoom lens on a 35mm film SLR.

NORMAL LENSES

Because normal lenses have approximately the same viewing angle as your eyes, pictures taken with a normal lens have a familiar appearance—perspective and spatial relationships are rendered much as we would expect. If you photograph a park scene with a picnic bench in the foreground, a set of swings in the middle ground, and some trees in the distance, the scene will look "correct" in your photographs.

Of course, merely looking correct is no ringing creative endorsement, but a normal perspective is useful when you're photographing groups of friends (sitting at the picnic table in the park, for example) or simple landscape scenes. And the very familiarity of the view can lead to a heightened intimacy between viewer and subject. The great photographer Ernst Haas, one of the true pioneers of 35mm color photography, had a particular fondness for working in the normal focal length range because it reflected his personal vision and not some optical exaggeration. Haas had a wonderful way of accepting the world at face value and the normal lens helped him present that vision faithfully. You can see some of his wonderful pictures and learn more about him at www.ernst-haas.com.

WIDE-ANGLE LENSES

Like arms flung wide to embrace the world, wide-angle lenses are able to record views well beyond even our widest peripheral vision, and are often used by landscape photographers for that very reason. They are also useful in landscape work because they expand the spaces between nearby and more distant subjects, making the scene seem deeper and wider. When you combine this spatial exaggeration with the intrinsic close-focusing ability (often as close as a few inches) and their inherently rich deep depth of field, you can create some very interesting compositions.

Wide-angle lenses, particularly in the 14-18mm range, are especially handy indoors. They become essential for shooting architectural interiors, or when you are in a tight spot and simply cannot physically back away from a subject.

This comparison, with both pictures taken from the same location, clearly shows the effect of using a zoom lens.

TELEPHOTO LENSES

Unlike wide-angles that exalt space, telephoto lenses (also called "long" lenses) compress it, while making far-off subjects seem closer and larger. In fact, the longer the focal length of a lens, the narrower its angle of view, the more compressed space appears, and the greater the magnification of a subject. With your zoom lens set to 100mm and pointed at a deer standing in a meadow, for instance, the deer will appear twice as large in your viewfinder as it would when seen through a 50mm lens setting.

Wildlife and sports photographers are particularly fond of long lenses because, without them, they couldn't take pictures of their favorite subjects. Digital telephoto lenses range from 55 to 500mm and longer for D-SLRs, and are often categorized in two groups: medium telephotos in the 55 to 200mm range, and super telephotos in the 200mm and longer range.

While super-telephoto lenses were once strictly the province of SLR cameras (and usually owned only by pros because they are "super" expensive), today that has changed. As we've discussed, there are a growing number of cameras on the market that have noninterchangeable zoom lenses that push well into the super-telephoto range. A zoom with a range of 26x, for example, might have a maximum focal length of nearly 800mm (the exact focal length depends on the specific lens). The great thing about compact zoom cameras with this huge telephoto range is that they're small. Today you can get a zoom camera with a 600mm maximum reach that's small enough to fit in your jacket pocket. (Compare that to a 600mm lens for a D-SLR that might need its own hard-shell suitcase just to transport—and that's not an exaggeration.)

The most useful everyday telephoto lenses are in the range of 55-90mm. These are typically referred to as portrait lenses because they provide an attractive perspective and a comfortable working distance for head-and-shoulder type portraits. Also, the inherent shallow depth of field of longer lenses helps to toss backgrounds out of focus and concentrate attention on your subject's face.

Finally, even in the moderate telephoto range, longer lenses magnify and exaggerate camera shake and subject motion and require the use of a tripod or other image stabilization in most situations.

200M LENSES

Most compact digital cameras, of course, have a zoom lens that contains a range of different focal lengths, usually in a range between 3x and 12x. A 3x zoom covers from moderate wide-angle to a moderate telephoto. A 12x zoom ranges from moderate wide-angle to long telephoto-typically over 300mm. The broader the range of focal lengths, of course, the greater your photographic versatility—and the more you'll pay for the camera.

In most instances, the wide-angle focal lengths of zooms are fairly similar: It's the telephoto range that gets more powerful with wider-range zooms. If most of your photography consists of taking snapshots around the house or informal people pictures, a 3x to 4x zoom range will probably be adequate. If you travel a lot and want versatility, or if you frequently shoot high school sports or any type of distant subjects, you'll appreciate the magnifying ability of a more powerful zoom.

I find that an 8x zoom is the perfect travel companion because it enables me to get the same wide shots as a milder zoom, yet lets me isolate more distant subjects such as people or architectural details. On the other hand, I often carry a camera with a 3x zoom that takes terrific landscape pictures and is excellent for group portraits—and it's a much more compact camera.

Of course, all of these observations about the advantages and disadvantages of various focal lengths are based on how lenses are traditionally used. There's nothing in the instructions for wide-angle lenses that says they are only useful in landscape photography, or that telephoto lenses are only meant for far-off subjects. Your vision may be entirely different—think of how many great artists have defied convention and shown us new ways to see. Did Seurat discover Pointillism or Picasso unearth Cubism in a textbook on how to paint well? Personal vision comes from experimenting—so take everything you read about what you're supposed to do with certain lenses with a grain of salt.

The Lensbaby accessory lens is available only for D-SLRs, and is a fun tool to use for expressing your creative impulses. There are several different styles available, along with additional accessories, that can help you record unusual selectively focused images.

Lensbaby: The Joy of Unsharpness

While most photographic lenses are designed to provide as sharp an image as possible, at least one accessory lens has been designed to intentionally deconstruct sharpness: the very popular Lensbaby (www.lensbaby.com). Creating images that look something like a hybrid between a real lens and a toy-camera lens, the Lensbaby has a unique quality: It lets you capture sharpness where you want it, and to soften it where you don't. In other words, you can keep one part of the image sharp, the center for example, while tossing the sides and/or the top and bottom out of focus. In creative hands, it can produce striking results.

The Lensbaby uses a pivoting main element to simulate the effects that can be created using a traditional large-format camera (because those cameras let you shift the planes of the film and lens independently) or a 35mm tilt-shift lens (a sophisticated lens often used in architectural photography). With the

lens elements in a parallel position, you focus on an object or portion of the scene that you want to be sharp, then use the pivot to throw the remaining areas out of focus.

Lensbabies come in different styles and they mount on your D-SLR like a regular interchangeable lens. However, there is no aperture control, and you must focus manually, so you have to use your camera in the Manual exposure mode. I shoot a series of exposures under the current lighting conditions until I get an exposure that looks good, and then keep that setting until the scene or lighting changes. By the way, if you get addicted, there are tons of accessories to create even more unusual effects.

Fascinated? Go to Flickr sometime and do a search on "Lensbaby" or "tilt-shift" lenses, and you'll find lots of playmates.

digital technology 1947-1984

• The transistor is developed by John Bardeen, Walter Brattain, and William Shockley at Bell Laboratories. The discovery leads to a Nobel Prize for the three men and initiates a revolution in the electronics industry, replacing large vacuum tubes and mechanical relays with the small amplifying device.

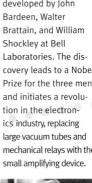

- . UNIVAC I, the world's first commercial computer, is put into service by the U.S Census Bureau. Remington Rand builds less than fifty units of this computer, the size of a small garage.
- No film! The Video Tape Recorder (VTR) is developed at Bing Crosby Laboratories, It uses electrical impulses to record images on magnetic tape.
- Shockley Semiconductor Laboratories experiment with the creation of silicon crystals at Beckman Instruments in Palo Alto, California, giving rise to a nascent industry as well as the term, "Silicon Valley."
- A picture of the infant son of Russell A. Kirsch at the National Bureau of Standards is recorded as the first photo to be scanned, using an early mechanical drum scanner.

 The computer revolution gains momentum with the invention of the integrated circuit by Fairchild Semiconductor manager Bob Noyce, who would later co-found Intel Corporation.

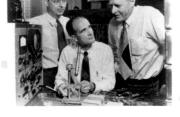

• Using new integrated circuit (IC)

technology, the first CCD Flatbed

Scanner is introduced by Kurzweil

Character Recognition (OCR) tech-

nology is undertaken to serve the

pioneering work in Optical

needs of the blind.

Computer Products, Inc. Kurzweil's

introduced, Customers build their own cases to enclose the circuitry.

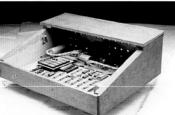

 A scientific team from The University of Calgary, in conjunction with Fairchild Semiconductor, helps develop the Fairchild All-Sky Camera, perhaps the earliest digital camera actually used in the field. It is used to photograph auroras.

- David Paul Gregg invents a Videodisk Camera. Although the camera could store only several minutes' worth of images, the technology is recognized as a precursor to digital photography.
- · Video cameras on board the Mariner spacecraft transmit electronic images of Mars back to NASA's Jet Propulsion Laboratory in Pasadena, California.
- While working at Bell Laboratories in October 1969, Willard Boyle and George Smith design the Charge-Coupled Device (CCD), now used to sense and process light and record images in digital cameras, among other media.
- The Advanced Research Projects Agency (ARPA), a branch of the U.S. Military developed ARPAnet, the grandfather of the Internet. The first computers to exchange data over the net belong to UCLA and Stanford University.
- Ray Tomlinson, a computer engineer, sends the first email message. Tomlinson also adopts the @ symbol to represent "at" in email addresses.
- The first patent is filed for a filmless electronic camera by Texas Instruments.

- In what is considered a true milestone in the development of digital photographic technology, Sony Corporation announces the Mavica (Magnetic Video Camera) Electronic Camera. Not truly a "digital camera," the Mavica is actually an SLR, interchangeable-lens TV camera that can record still photos in analog video format onto magnetic disks.
- Though a number of companies have marketed small computers for individual users, the "PC Age" is truly launched with the introduction of the IBM 5150.

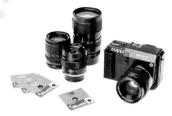

• Apple Computer, Inc. runs their famous "1984" ad during January's Super Bowl, introducing the Macintosh. This personal computer features a speedy and friendly interface using a mouse and emphasizes the use of graphics.

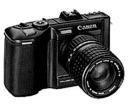

• Canon Inc. uses their newly minted RC-701 still video camera to test the analog transmission of digital images via phone lines from the Los Angeles Olympics back to Japan. The resulting pictures are received in only 30 minutes and printed in a Japanese newspaper, giving Canon the technical confirmation needed to begin full-scale development of their Still Video System products.

digital technology 1985-1999

• This year marks the introduction of the breakthrough Commodore Amiga A1000. This sophisticated PC offers superior capabilities for graphics and sound. Users can multi-task in an environment that includes Graphical User Interface and a 4096-color palette.

- · Letraset launches the grayscale image-editing program ImageStudio. developed by Fractal Technology for Macintosh computers. This software later inspires the development of Adobe Photoshop.
- · Joint Photographic Experts Group develops and implements standards for an image compression format (JPEG) that will enable digital cameras to efficiently utilize available memory.
- The DS-1P from Fuji Photo Film Co., Ltd. is the first electronic still camera to record digital images on memory cards. The camera uses an internal 16MB card developed by Toshiba, but it is not marketed or sold in America.
- Hewlett Packard introduces the first massmarket inkjet printer, the HP DeskJet. It uses plain paper.

• Using a Sony Mavica stillvideo recording system to capture images in conjunction with Sony's DIH 2000 (digital image handler) to transmit them, CNN circumvents Chinese news censors to deliver current images of the famous Chinese student political uprising at Tiananmen Square. Though the movement is violently suppressed by authorities, the images inform and stun the world.

· The Personal Computer Memory Card International Association (PCMCIA) is an international organization established to develop and sponsor standards for Integrated Circuit memory cards and to promote interchangeability among personal computers.

- Kodak integrates the disparate components of its DCS line to offer the Kodak Professional DCS 200 digital SLR, the first pro digital camera combining hard drive unit and
- The first widely accepted third-party plug-ins for Adobe Photoshop, Kai's Power Tools developed by Kai Krause, are introduced by Harvard Systems Corporation (soon to become HSC Software).

· Mosaic is released

for Supercomputing

by The National Center

Applications (NCSA). This

early browser is the first to

graphs over the Internet.

allow users to see photo-

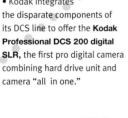

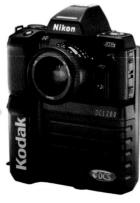

- HSC Software introduces their LivePicture image manipulation software.
- · Adobe Photoshop becomes available for MS-DOS/Windows computer . .
- · The CompactFlash (CF) memory card is introduced by SanDisk Corporation.
- · The Apple QuickTake 100, at a price tag of less than \$1,000 and resolution of 640 x 480 pixels, is reputed to be the first consumer-oriented color digital camera.

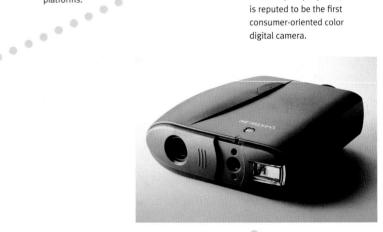

- . This is it! The first entirely digital camera for consumers: Dycam Model 1 (Logitech FotoMan). Recording in black and white, the Dycam's photo resolution is 90,000 pixels (or less than one-tenth megapixel).
- · The Eastman Kodak Company releases a prototype electronic camera back intended to suit the needs of photojournalists.
- PhotoShop 1.0 is released by Adobe Systems Incorporated for use with Macintosh computers, quickly followed by version 2.0.

 The Eastman Kodak Company presents its Photo CD system to show images on TV screens, converting negatives or slides to CD. The system offers an international standard for color definition in the digital environment

The Hubble Space Telescope captures images from far in space using four high-tech Charge-Coupled Devices (CCDs), each containing 640,000 pixels. (The Hubble possesses a 2.5-megapixel camera).

 Launching what is often considered the first genuine useful digital camera for general sale, Kodak presents its DCS (Digital Camera System) 100. It uses a modified Nikon F-3 body with a 1.3-megapixel sensor. The cost is approximately \$20,000.

0000

by Gulf War photojournalists to transmit pictures of their onsite coverage.

• The Fujix DS-100 is an early true digital camera that uses a removable memory card for image storage.

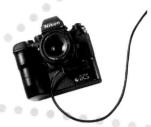

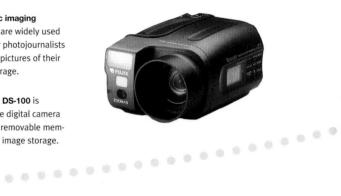

- Casio Computer Co., Ltd. markets the first digital camera furnished with an LCD monitor, the QV-10.
- · Seiko Epson Corporation introduces the Epson Stylus Color, an ink jet printer with a printing resolution of 720 dpi. It is one of the first home printers to produce true photo-quality prints.
- The Vancouver Sun and the British Columbia Province become the first major newspapers in North America to convert from film to all digital photo capture, adopting Nikon N9o-based 1.3 megapixel NC2000 camera, which was developed jointly by the Associated Press and the Eastman Kodak Company.

00000000000

• The first digital camera to utilize removable CompactFlash cards is Kodak's DC-25.

• Intel Corporation announces that, in order to achieve mass-market penetration, the industry needs a good digital camera at a price point of less than \$200. Intel's "good quality" guidelines call for a resolution value of 640x480 pixels (o.3 megapixel).

· Nikon Corporation produces the

D1, a professional model that is the first digital SLR to be designed and manufactured by a single camera company, not as a joint venture. It lowers the cost floor for this type of equipment, and features a sensor of 2.7 megapixels, allowing for larger prints and higher quality output than previously available.

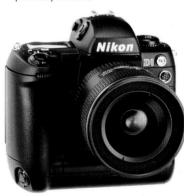

digital technology 2002-2010

 The Eastman Kodak Company breaks the 10-megapixel barrier with the DCS Pro 14n digital SLR with a CMOS sensor that is the same size as a 35mm film frame (full-frame). The 14-megapixel full-frame sensor eliminates the focallength magnification effect caused by smaller sensors. Photographers using 35mm SLR lenses can now get true wide-angle coverage

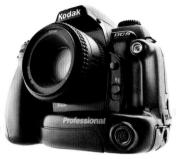

· The Epson Stylus Photo 2200 desktop printer is considered a breakthrough because of its use of pigment inks to extend longevity of prints to approximately 100 years.

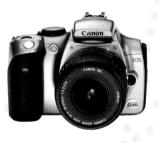

· The 3.4-megapixel Sigma SD9 digital SLR is the first generally available digital camera equipped with the Fovean X₃ CMOS imaging chip, in which every pixel

"sees" all the colors without

needing a color filter array

over the pixels.

- The quantity of digital cameras purchased this year exceeds for the first time the number of conventional cameras purchased.
- Canon Inc.'s 6.3MP EOS Digital Rebel, is introduced as the first D-SLR for under \$1,000. This is a watershed product, making a major impact on the consumer market. High resolution D-SLRs become increasingly affordable and popular for amateur photographers.

- After the merger of Konica and Minolta in 2003, Konica Minolta decides it will exit from the business of manufacturing cameras. The company transfers its digital imaging assets and technology to Sony, who launches the Alpha line of D-SLRs.
- Nikon announces it will cease production of most of its film cameras to focus on the digital end of the market. With sales of film SLRs declining and the successful reception of digital products such as the D70 and D50 and lenses, the company decides it will manufacture only the F6 and FM10 SLR bodies.
- · Live image preview comes to D-SLRs. Hailed in some circles as a solution looking for a problem, the ability to preview and frame the scene on the LCD of a D-SLR is introduced on the EVOLT 330 by Olympus. Soon D-SLRs from nearly every major manufacturer will also come

equipped with this feature.

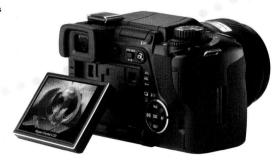

- The Nikon D90 is the first D-SLR to incorporate the ability to record video as well as still pictures. It offers 720p HD format with mono sound, with the capacity to make movies for up to five minutes at full resolution, or longer if recording at smaller resolution settings.
- · Micro Four Thirds is announced by Panasonic and Olympus, using a 4/3 sensor but with a lens mount possessing a much shorter flange focal distance and a simplified optical path, eliminating the single-lens reflex mirror, to incorporate electronic live view. The enhanced format and new design allows for smaller and lighter camera

bodies and interchangeable lenses, while still delivering D-SLR image quality. Panasonic's Lumix DMC-G1 is the first camera body to employ the Micro Four Thirds format.

• The E-1 D-SLR from Olympus is the first Four Thirds camera. A joint venture of Olympus, Kodak, and Fujifilm, the Four Thirds standard is designed as a Digital SLR system for sensor and lens mounts, rather than being based on legacy 35mm film models. The standard's smaller sensor size allows for potentially smaller camera bodies and lenses that still deliver high-resolution, highquality images.

• In-camera stabilization is pioneered by Minolta with its Anti-Shake technology. The Dimage A1 bridge model includes a CCD sensor mounted on a platform that shifts to compensate for any motion it senses in terms of camera shake. A year later this technology will find its way into the Konica Minolta Maxxum 7D, its first application in a D-SLR, so that internal stabilization is achieved in the body of the camera rather than through specific lens models.

• Several major camera manufacturers produce 8-megapixel "prosumer" digital cameras, all-in-one models with long-range, builtin, zoom lenses.

• A "consumer-oriented" full frame sensor (35mm sized) is realized in the photo market with Canon's introduction of the EOS 5D. Photographers no longer have to mentally convert the focal length crop effect of sensors that are smaller than 36 x 24 mm, with a camera that offers high resolution (12.8 MP) with outstanding image quality.

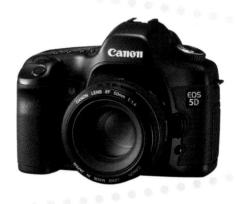

- Eastman Kodak Company announces in June that it will discontinue the manufacture of Kodachrome color film after 74 (mostly) steadfast years in the market place.
- Nobel Prize. Willard Boyle and George Smith receive the prestigious award for physics in recognition of their breakthrough developmental work on the Charge-Couple Device (see 1969).

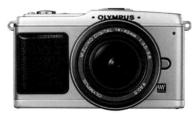

• Olympus realizes the promise of smaller cameras inherent with the Micro Four Thirds format when it introduces the E-P1.

• Panasonic's G2 D-SLR is the first system to employ a touch control system using its fold-out LCD. View the scene and touch an object within to direct the camera's focus, including auto tracking. Also use the touch technique to adjust a slider for exposure compensation.

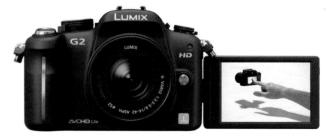

Taking Great Digital Pictures

"A great photograph is a full expression of what one feels about what is being photographed in the deepest sense, and is a true expression of what one feels about life in its entirety."

-ANSEL ADAMS

Introduction

Presumably as you're reading this it's dark outside, the winds are howling, there's a black driving rain, and the local news anchor has reported there is officially nothing outside (or inside) worth photographing. Ah, but tomorrow the sun will rise, your kids will be playing in the yard, rainbows will arch behind every cloud—and photo opportunities will blossom everywhere. Now is the time to get to know your camera, think about what you might be photographing and create a game plan for your adventures into digital photography.

Whether this is your first digital camera or an upgrade to a more sophisticated one, the real fun begins once the initial excitement has subsided a bit-when it is time to start taking great photographs. And your digital camera makes that easier than ever before, as long as you've taken the time to get acquainted with all of its creative potential.

While the technology and features used for recording digital images (things like "face detection" and "in- camera HDR," for example) seem to burst forth on an almost daily basis, most of the basic camera controls remain the same. The fundamental mechanics and techniques used for getting sharp, well-exposed images, haven't really changed much since camera manufacturers first started hawking their wares in the mid 1800s. Sure, the photographer who made portraits of your great grandparents had to poke his head out from

under a dark cloth to see if his subjects were smiling or not (as opposed to using "smile detection" technology), but he still used a shutter and a lens aperture to expose the images.

Like using your cell phone or any number of electronic devices, you will use a menu system to navigate among your camera's functions. Of course you may be dealing with some totally new concepts that are going to seem alien the first time you encounter them, like choosing the image resolution, selecting a white balance option, or setting in-camera tone balance (if your camera has that option). But really, you will catch on quickly.

On the following pages we'll take a closer look at how some of the features of your new camera workand how to use them to get good quality pictures. We'll also talk about building good shooting habits. You might want to have your camera and manual handy. The specifics of every camera will be different—and who knows, you might just get inspired to put the book down, turn on the camera and shoot a picture of your dog napping by the fire.

And won't he (not to mention the rest of your family) be impressed in the morning when there's a brand new picture of him hanging on the refrigerator door.

Getting to Know Your Camera

Although manufacturers have made much progress in making digital cameras simple to use—even for the absolute novice—there is little that is intuitive about some camera controls. You aren't any more likely to guess your way through digital menus, for instance, than you would be to wing your way through programming your DVR's timer controls (try as we might). As impatient a person as I am when it comes to playing with a new toy, I always take time to study camera controls before shooting any pictures. I also read every piece of paper that comes in the box. I even read the dumb questionnaire that wants to know how much education I have (why don't they ask that before you buy the camera).

Before you start taking pictures, get to know your camera so you can get a good picture the first time you press its shutter button.

Tips for Learning More about Your Camera

Read Your Manual

Granted, reading some digital camera manuals is like deciphering instructions written in a long-dead language on knitting a sweater for an octopus, but muddle through it the best you can. And always keep your camera handy while you're reading so that you can identify camera parts and try different things. Some manuals are surprisingly lucid, and good manuals are a treasure trove of useful information. I think there should be an annual award for the folks who write the good ones.

Never force any type of control on your camera, but never be afraid to try any feature. If you fear the camera, you won't use it-and you're unlikely to break anything by touching it gently (but you wouldn't touch the surface of the lens, right?). After you've read the manual a few times even the obtuse language of camera designers will become clear and a hint of logic will begin to emerge. Become familiar with the names of various camera features and understand the icons on the displays.

A lot of manufacturers sell cameras with an abbreviated print manual and include a more complete manual in PDF format that you can download from a CD included with your camera. Unless you carry a laptop computer everywhere you go, the PDF manual will do you little good. In fact, you should always ask to see a camera's manual before you buy any camera; at least that way you know what you're getting into.

Read More Online

You can find a lot of excellent model-specific information for free by doing a simple search on the Internet using the camera's brand and model name as keywords. Many manufacturers' websites, such as Nikon, Canon, Epson, and Eastman Kodak, provide extensive educational material. There are also several fine review sites where you'll find in-depth information on camera controls and techniques (see www.pixiq.com).

You'll also find many sites devoted to particular brands and models of cameras that address specific user issues. Joining a "user group" for your camera is an excellent idea. There are also publishers (among the best are Magic Lantern Guides) who publish much more detailed and model-specific instruction manuals.

If you take a class before you own a digital camera, you'll get to hear a lot of other folks' thoughts on their cameras that may help you in choosing your own camera. And if you take it after you've bought a camera, you'll have a captive instructor to answer your cameraspecific questions.

Take a Course

Camera shops and community education organizations offer basic courses in digital photography. If photography or internet communications are a part of your company's work, they may be willing to pay to train you in basic digital photography, so it's worth inquiring at work, too. The classes are usually informal, basic, and inexpensive.

Take Small Bites

Trying to learn to use every feature of a digital camera all at once can feel overwhelming, so try to digest information in small pieces. Once you've got the basic features down and can get an acceptable picture in the programmed mode, try experimenting with one new control each time you use the camera. You're far more likely to master things like macro modes, different flash modes, and special effects modes if you delve into them one at a time. The same goes for accessories like tele-extenders or accessory flash units-add one new tool to your repertoire each time you go shooting.

Choosing a File Format

One of the first things you have to do before you can take any photos with a digital camera is to tell the camera in which file format you want to record the images. A file format is basically a language used by digital devices (including cameras, computers, and scanners) to read, write, and transmit image data. Without some standardization in formats, every device would be speaking its own unique language and none of them would understand any of the others-kind of like the United Nations having a heated debate in many different languages without the benefit of translators (they do have translators, don't they?). There are a number of different file formats in existence, but fortunately for those of us who would rather take pictures than make format choices, camera manufacturers have settled on just a few, with many of the current models offering options for two: JPEG and RAW.

This leads to the obvious question: "Which format is better, RAW or JPEG . . . ?" That is one of the most intensely debated topics in photography, second only to the "Which camera brand is better?" argument. In fact,

unless you have a strong desire for a lengthy conversation, you'd be better off avoiding the topic of formats, at least in public. Let it be a private conversation between you and your maker (your camera maker, that is).

Both RAW and JPEG formats have existed for quite a while, but until fairly recently, RAW was mostly considered for use by professionals, while JPEG was for amateurs. However, when consumer-level D-SLR cameras (and even some simpler models) began to offer a RAW-shooting option a few years ago, a debate about which format was best to use soon followed.

The truth is that choosing one format over the other is not a question of one being better so much as it is a decision about which format is right for you. And I will tell you up front, if you don't process your own images and have no desire to start doing so, you can skip this discussion entirely and turn the page—because RAW requires software to view and nearly always involves a degree of post-processing.

When it comes to choosing file formats and compression, ask yourself this simple question: What is the ultimate use of this photo? Image files used exclusively for email or web posting can be much smaller than ones that you want to print at a size larger than 6 x 4 inches (15.2 x 10.1 cm).

f In order to make a good decision about which format is best for you, it's helpful to know how they differ. Choosing the one that meets your needs really depends on how finicky you are about image quality, what your shooting habits (and storage needs) are, and how involved you like to get with image processing.

Let's look at JPEG first (pronounced "jay peg"). Whenever you shoot a photograph in IPEG format, it is automatically processed by the camera to enhance such image attributes as color balance, color saturation, and sharpness. If you simply prefer to drop your memory cards at the local one-hour lab and don't really care about how that card is magically milked to churn out perfect photos, then shooting JPEGs is probably a great choice. The quality of the images is quite high (even though data is thrown away, see the sidebar to the right), and the photos are bright and colorful. That may be the end of the imageprocessing story as far as you are concerned.

Recording JPEGs in this manner is convenient, but the downside is that you must live with certain quality decisions that are out of your control (because they have been preprogrammed by your camera manufacturer's engineers), as well as certain mistakes you might have made while shooting. You are, for example, pretty much stuck with the exposure that you set in the camera. Yes, you can use tools like Levels and Curves in post-processing (see pages 243–244) to correct some minor exposure errors, but there is precious little wiggle room if your exposures are not close to optimal. The same is true for things like white balance (see page 80): If you inadvertently set that control to Tungsten and are shooting outside on a sunny day, you're going to have yourself a whopper of a color correction to make later on-and one that your local lab will likely be unable to fix perfectly.

But perhaps more importantly, JPEG is actually a compression standard for digital files—its purpose is to shrink file size by tossing away pixels that it calculates are unnecessary. It does a very good job of maintaining picture quality while doing this, but nevertheless, it is still known as a lossy format because it discards digital information during the camera's processing. The advantage is that the JPEG files are smaller and more manageable than other types, allowing devices (remember, that includes your camera) to process them faster, transfer them more quickly, and store more of them. The disadvantage, of course, is that you have less digital data to work with should you choose to enhance the photos yourself.

JPEG Options

To shrink file size, the JPEG compression algorithm discards redundant color and brightness information from the image data. Most cameras offer a choice of JPEG quality, meaning the level of compression applied to the file. Typically following a "good, better, best" format, these selections may be called different names depending on your camera manufacturer. But the key thing to remember is that image quality typically goes down as the amount of compression goes up. Generally, you will use the low-quality setting (highest compression) for images intended for web use or email, and the medium setting to save space on your memory card or hard drive. But to shoot the best quality photos, make it a practice to record using the setting that offers the least amount of compression.

In addition, many cameras also offer a choice of resolution, or quantity of pixels, at which to record. You can use all of the pixels offered by your camera's sensor, or a choice of fewer pixels. This too, can save memory space. To complicate matters, you can usually select a quality setting within whatever resolution offering you choose. Again, I would suggest you most often choose the highest resolution to go with the best quality setting for your shooting, especially if you want to make prints larger than snapshots.

m With RAW format, nothing is lost or left behind in translation. What you shoot is what you get—the camera passes the image to the memory card exactly as it is recorded without any enhancements or embellishments, and also with no compression (that is referred to as lossless). There is no Oz-like wizard behind the curtain making things appear sharper and more vivid than they originally were. All of the "raw" (thus the name), unvarnished data is there to be modified or enhanced as you see fit during the editing process.

The real beauty of RAW reveals itself during the processing phase—or, to be accurate, in the extra step that comes before processing. Whenever you open a RAW file, you are taken through a "conversion" process that enables you to change some of the photo's fundamental qualities, including exposure, white balance, tint, contrast, sharpness, luminance, and color saturation. And these are not minor changes or tweaks, but wholesale recreations of the original capture. (Even more exciting, the initial settings for the image are always retained in the RAW file so that you can go back to the original and rethink your choices ad infinitum.)

For instance, your in-camera settings might be under or overexposed by a full stop or more. But not to worry, because you can simply adjust a slider to alter that exposure. You're not just making a correction, as you can do with a JPEG file, but you're actually changing the exposure. You can do the same thing with the white balance setting. If, for example, you had the white balance set incorrectly for the dominant lighting source (you had it set to Daylight, while you were shooting under fluorescent lamps in your kitchen), you can simply push a slider left or right and reset an accurate white balance. You can also alter the hue/ saturation/luminosity of each individual color before you even begin to edit the image. In other words, even if you make a real mess out of things while you're out shooting, you can still come up smelling like (and looking like) a rose. It's quite extraordinary.

It was, in fact, this ability to go back and rethink my exposure and white balance choices that convinced me, after several years of shooting almost exclusively in JPEG, to make the switch to RAW. I now shoot nearly 100 percent of my images in RAW, and though there are some inconveniences, they are small prices to pay for the immense flexibility and quality improvement.

One other factor to consider (particularly if you're of the geekish nature) is that RAW images are edited in 16-bit depth (as opposed to 8-bit depth for JPEGs), which provides smoother tonal and color gradients and superior image quality when making alterations during processing. Also, when you edit in 16-bit, the software doesn't toss out pixels as it does in 8-bit JPEG processing. (Look at your histogram after you've edited an 8-bit JPEG sometime and you'll notice a lot of blank white stripes—those are areas where the software simply dumped groups of pixels—information that is now gone, never to be seen again.)

The Downside of Paradise

So, are there any downsides to shooting RAW? A few. The biggest one is that RAW files are large (they haven't thrown any information away), so therefore take up relatively large amounts of space on both memory cards and hard drives. But that is much less of a concern than it used to be because the price of memory has plummeted over the past several years, so it is much more affordable. Also, since the files are considerably larger, your shooting is slowed down; it simply takes the camera longer to transfer the images from the sensor to the buffer and to your memory card. You can overcome this by buying a camera with a larger buffer and faster image processing and by using high-speed memory cards (all for a price, of course), but unless you're a sports or wedding photographer, you may never notice the difference.

You will notice the difference in the dwindling free space on your computer's hard drive. I now have two terabytes of external drives to serve as backup memory, holding my photo library—and those drives are always nearly full. But hey, I rarely toss out my second-rate images (I should, and you probably should too). So expect to invest in more storage if you shoot a lot of RAW files.

Finally, there is that extra conversion step in processing that you must go through to open your RAW files that actually requires RAW conversion software. Personally I don't see this as an inconvenience, since the level of control I'm able to exercise over the files far outweighs the few extra moments.

Probably the worst aspect of shooting RAW is that I feel the urge to jump in when I hear people debating about the two formats. But whenever that happens, I quickly shove a fistful of M&Ms into my mouth and just nod in agreement.

Setting ISO Speed

One of the great luxuries of owning a digital camera is that you no longer have to grapple with the insidious issue of choosing a film speed—well, not entirely anyway. No longer do you have to stand flat-footed at the film counter pondering the eternal question: "What speed film should I buy?" You do, however, still have to consider the issue of light sensitivity and ISO speeds as they apply to your digital camera's light sensor. To understand these numbers, we have to jaunt back into the film world.

All photographic films are given a rating known as an ISO number (ISO stands for the International Standards Organization) that reflects their relative sensitivity to light—the higher the number the more sensitive the film is to light. Films that are more sensitive to

light (and have a higher ISO number) are referred to as faster. Films less sensitive to light have a lower ISO number are referred to as slower. A film with a rating of ISO 200, for example, is faster (twice as fast, in fact) than a film rated at ISO 100. The advantage of having a variety of film speeds is that you can match your film to the amount of available light. The brighter the light is, the slower the ISO you can work with and, conversely, when the light gets dimmer, you can switch to a faster speed (higher ISO) film. Typically films with a lower ISO produce better quality images (they have less film grain) than those with a faster ISO.

Now back to digital. Most digital cameras have a variable sensitivity ISO setting, usually called Auto ISO, that can increase or decrease the sensor's electronic

Many cameras have a self-adjusting ISO setting that increases in dim lighting. The splendid interior of the San Xavier del Bac mission south of Tucson, Arizona was so full of beautiful detail, however, that I set the ISO at 100 for maximum image quality and used a two-second exposure. The camera was on a monopod and held tightly against a pew for steadiness-sometimes you just have to improvise.

response to light. And in an effort to bridge the technological leap from film to digital, digital camera manufacturers have kept the same sensitivity numbering system as used for film cameras. When your digital camera is set to ISO 100, therefore, you are telling the sensor to respond to light with a sensitivity that imitates ISO 100 film.

Most cameras have a default ISO setting. From

the moment you first take the camera out of the box, that setting is already programmed into it. For many cameras this is ISO 100 or 200, or it might be the self-adjusting Auto ISO setting.

Given normal lighting conditions, the lowest possible ISO setting usually provides the best picture quality. There will be times, though, when the light is too dim, or when you decide to take pictures indoors without flash, and you'll want to increase the ISO. Digital technology is producing ever increasing ISO choices, with selections going up to 6400 and beyond (some cameras even claim ISO of 102,400!). And even though sensor manufacturers have made great technological strides in recent years so that good quality is quite possible at high ISOs, there is more chance to produce digital noise as you increase the ISO setting, especially with small sensors. Noise degrades image quality, appearing as splotchy or speckled patterns of color, especially in darker or shadowed areas of the image. Though noise can sometimes be addressed using software, and may not always be devastating to your photo, it can be quite unattractive when present in excess.

Often when you're shooting indoors by available light, as in this shot of the late blues harmonica great Junior Wells, you'll find yourself desperate for a higher ISO setting. Otherwise you're better off sticking with your camera's ISO 100 setting for maximum image quality.

Unless you're really desperate for a faster ISO setting (if you're shooting indoors by available light, for instance), you're better off sticking with the camera's default ISO setting—particularly if you plan to make substantial enlargements from your files. When the light gets dim, however, if your subject isn't moving, you can use a tripod and make longer exposures; or, if you happen to own a digital SLR, you can switch to a faster aperture lens. If your only opportunity to get a picture is by switching to a faster ISO, give it a chance—after all, you're not wasting any film. Better yet, test different ISO settings before you get into a crucial shooting situation and you'll know what to expect.

Finally, if you're only posting pictures on the web, the noise produced by faster ISO speeds really isn't that much of an issue—but you will still see some quality difference as you go higher in speed.

Setting White Balance

If you've ever sat inside reading by a lamp and then got up to take the dog for a walk, you might have noticed that the daylight seemed very blue compared to your reading lamp—and you were correct. While every source of light has its own particular color, our visual system is so good at adjusting to the existing lighting that unless we make a sudden transition from one source to another we almost never notice the color shift.

But in reality, every light source emits a specific type of color. The most common types of lighting are fluorescent, incandescent, and sunlight. Most of us think of light from fluorescent lamps as cold and a bit unpleasant (although it is very energy efficient). Tungsten lamps seem warm and comfy. And, of course, sunlight is bright and cheerful. We may not consciously perceive the different colors of these types of light, but we feel and react emotionally to them.

Science offers a more calculated way of discussing the color of light based on a unique use of the word "temperature." Different light sources each have their own color temperature—described in degrees

Experimenting with different settings will help you find the best possible white balance. These three images, shot on a cloudy day, show the variety of tonal ranges that various white balance settings can produce. The first shot (top left) was made in the Auto mode and produced a cool-toned image. The second photo (bottom left) was made using the Cloudy setting which warmed the image up noticeably. I still felt the image could be warmer though and made the third exposure (above) by taking a reading from a #2 WarmCard and manually setting the white balance.

Kelvin or "K." Daylight, for example, has a color temperature of approximately 5500K. It's typically considered white light, because it carries a full and equal range of colors. As the temperature of light goes down, it becomes more reddish. As the temperature goes up, the light becomes more bluish. Tungsten lamps (household light bulbs), for example, are rated at about 3200K and are very reddish in color—as you know if you've taken a picture with daylight-balanced film using indoor lights. Again, our brain adapts for the color shifts of different light sources so we tend to see most light as acceptably white.

In film photography, differences in color temperature are handled either by using filters over the lens (to make the light match the balance of the film), or by using a film that matches the light source. Digital cameras, on the other hand, handle color differences electronically, using a control called white balance. This is basically an electronic setting that tells the color processor in the camera the color of your lighting source.

Auto White Balance

Most digital cameras have an auto white balance feature that measures the light around you and automatically sets white balance. Although this feature works well, it isn't perfect. It is best suited for snapshots. If you're satisfied with the colors you get in the Auto mode, you really don't need to look further. However, the auto white balance control almost always shifts the colors in your picture to some degree and if large uniform color areas dominate your picture (imagine a close-up of a pumpkin) then the auto white balance will shift the colors unacceptably far from reality. After all, the camera's brain doesn't know it's a pumpkin you're photographing. In these situations you'll get better color and do less color-correction work in post-processing if you manually set the white balance control to match the light source.

Source-Specific Settings

All but the simplest compact zoom cameras have source-specific settings, such as sunlight, tungsten, cloudy day, fluorescent and flash. By setting your camera to the specific light source, you have a much higher chance of getting accurate color balance. You can experiment with these settings by placing your camera on a tripod and then photographing the same scene using each of the different white balance settings. Once you've downloaded the images you can compare and see which gave you the most pleasing results.

Preset or Manual Mode

Advanced cameras offer an even more precise method for setting white balance called the Preset or Manual mode. It lets you create an exact match for the existing light. Different cameras handle this procedure differently, but basically it consists of aiming your camera at a white card or white sheet of paper and then taking a manual white balance measurement. The camera will hold this reading in memory until you either change

the setting or create a new manual setting. At least one company, VortexMedia (www.warmcards.com), makes a custom set of white-balancing cards that enables you to select from either a neutral color balance or a series of warm-tone white balance settings. In landscapes, in particular, I've found these WarmCards to be extremely accurate and useful.

While setting the white balance manually won't be necessary in most average situations, it's a good tool to have when there are mixed sources of lighting or when the predominant subject color might affect the camera's ability to measure color temperature. Also, because the color of sunlight changes rapidly, it's important to rebalance as the light changes or as you change your camera position. It's important, too, that you fill the frame only with the card you're using and that there are no shadows or reflections on the card.

Creative White Balance Tip

White balance settings are designed to give you correct color. But guess what? You can also use them creatively to color your scenes.

For example, if you're taking daylight pictures, you could set the white balance to the Tungsten setting and tone your pictures blue. Such blue tones could heighten the mood of a rainy day, give a moonlight effect to a landscape, or create a moody atmosphere for a portrait.

Conversely, you could use the Daylight setting under tungsten light and add a rich yellowish-orange color to the scene. Of course, you can do the same with your software, but doing it in camera preserves the full range of tone values.

Next time you're on vacation and tired of waiting for the kids or friends to finish souvenir shopping, tinker with the white balance settings. You might just get lucky.

Note: Make sure you're not using the RAW file format to experiment with these settings, because it won't work!

Camera Handling

As magical as taking pictures with a digital camera seems at times, you're still working with a camera and you still have to pay attention to some basic camerahandling techniques. If you've ever watched professional photographers work, you've no doubt seen how methodically and carefully they approach each picture—and how natural the camera seems in their hands. They've developed a system of good work habits that ensures that every picture will have the same high quality. You should develop the same good habits.

HOLD THE CAMERA STEADY

Finding a comfortable and steady stance is important for getting sharp pictures—there's no sense paying for a camera capable of great resolution and then shaking the sharpness out. If your pictures continually seem to have a bad case of the jitters or just lack the crisp focus you expect from a good camera, it's probably because you are giving your camera the shakes.

Holding a camera sometimes feels like holding a baby for the first time—it's small and delicate, and there aren't many good handholds. A camera, though, is a lot more rugged (and a lot less wiggly) than a baby, so don't be afraid to hang on tightly—being sure to keep your fingers clear of the lens, the flash and the metering window.

One interesting thing that has happened since the introduction of the digital camera is that an entirely new picture-taking stance has evolved—I call it the digital gaze. In the pre-digital days holding a camera meant pressing the camera to your forehead and squinting into a tiny viewfinder window—a posture that actually provided some stability to the camera. Today framing a picture often means holding the camera a foot or more from your face and using an intent stare (the gaze) to compose the image on the camera's LCD screen. And it seems to work for a lot of people. Still, by planting your left elbow against your body and spreading your feet a bit you'll keep the camera much more steady. You might also find it helpful to lean your body against a tree or to rest your elbows on a nearby fence rail or car hood.

You should be able to safely handhold a camera at shutter speeds of 1/125 second or faster but anything slower is getting onto shaky ground—particularly with telephoto or close-up subjects. And that brings up the subject of tripods.

USE A TRIPOD (OR MONOPOD)

 I f I were asked what one thing you could do to improve all of your photographs, my answer would be simple: use a tripod. Most digital cameras—both compact and SLR models—are capable of shooting at shutter speeds slower than should be handheld. By using a tripod you extend the range of useable slow shutter speeds into full seconds or even minutes and hours (for nighttime skyline shots, for example). The introduction of image-stabilization systems, found in some interchangeable lenses and in some camera bodies, has raised (or I should say lowered) the bar for the minimum shutter speed at which you can get a sharp picture—but a tripod makes all shutter speeds available to you with equally sharp results.

Besides providing a steady platform, a tripod allows you to be more precise when it comes to composition; you're much less likely to get tilted horizons and errant foreground objects if you take the few minutes needed to use a tripod. Tripods also give you more latitude with exposure combinations—enabling you to use a small aperture and a long shutter speed to enhance depth of field, for instance—and to use longer shutter speeds to creatively blur motion.

Most importantly, tripods force you to slow down and consider your decisions; after all, you've spent all day looking for a good picture, why rush the shooting to save five minutes?

Another alternative is a monopod. This is a onelegged support that can save the day when the light starts to fail and you're in situation when a tripod would be inappropriate. A lot of public gardens and zoos, for instance, won't allow a tripod but will let you shoot with a monopod. It's not as steady as a tripod, but it enables you to safely shoot at shutter speeds far lower than you could handhold.

FOCUS CAREFULLY

Most compact digital cameras focus so quickly and accurately we barely notice it happening. It's important though to pay attention to what your camera is focusing on—or you may end up getting a sharp picture of a tree in the background and turning your kids posing in the foreground into an unsightly blob.

Your camera will focus on whatever is behind the selected focus indicator (one of a group of small, illuminated boxes that displays in the viewfinder or on the LCD panel). It's important to pay attention to where these indicators are in relation to your main subject. If your focus indicator is in the center of the frame while your main subject (a person, for example) is off to one side, you will be focusing on the background and not your subject. I've done this a gazillion times—and I should know better.

With many cameras, you can place the focus indicators at specific places within the frame, or you can let the camera make an educated guess about which are the important areas of the scene you're shooting. Also, while older digital cameras may have only a few focus indicators (or maybe only one), many recent cameras can look at a dozen or more areas simultaneously making it all the more imperative that you understand where your camera is focusing and why. Be sure to read the pages in your manual that cover the focusing system. Also, if you are shooting off-center subjects, be sure to check you LCD occasionally (OK, not occasionally, but after almost every frame) to be sure you are getting sharp focus on your main subject and not something in the foreground or background.

Regardless of whether your camera has one or several focus indicators, most digital cameras have a focus lock feature (which may or may not be married to the camera's metering system) that also enables you to focus on an off-center subject. Once you've focused, you press the lock and reframe the scene; the focus will remained locked until you press the shutter or release the lock. Focus lock can be particularly good with close-ups where you want to focus on a particular subject plane and prevent the autofocus from wandering.

Focus lock is more than a fail-safe system for getting sharp focus, though—it can be used as a creative tool to prevent you from nailing all of your subjects to an imaginary target in the center of your viewfinder.

The freedom to move your main subject off-center means that you can place emphasis on a particular area of your scene by selecting it to get the sharpest focus. If you combine careful focusing with selective focus, you can lead viewers right to the important part of the frame.

If you combine careful focusing with selective focus, you can lead viewers right to the important part of the frame.

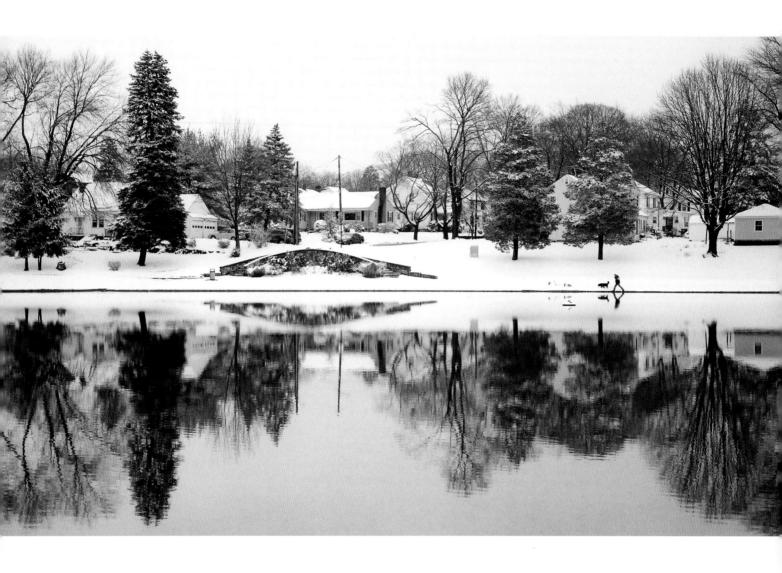

If you're shooting in cold weather, keep your main and backup batteries in an interior pocket (under a parka) and load up only when you're about to shoot.

BATTERY MANAGEMENT

Cone are the days when you could put a battery in your camera and forget about it for a year or more or until the bottom of your camera started to corrode and you found a puddle of battery acid on your closet floor. Digital cameras drink up battery power like a thirsty sailor and when they run out, all you have is an expensive reminder that you should have bought more batteries. Even a brand new battery will run down in a few hours in a digital camera and, unless you commit to using rechargeable batteries, single-use (throw-away) batteries will become an expensive vice—and fast.

Most digital cameras come with a battery charger and one rechargeable battery to get you started, but the per-charge life of a rechargeable battery may be only a few hours, so having a few on hand is a good idea. How long the charge will last depends on several factors, including how good your camera is at managing power, how many camera features you're using and the ambient temperature. If you zoom around a lot looking at potential subjects and like to use the LCD more than an optical finder, your battery power will go much faster.

Most cameras do operate with standard disposable batteries, of course, but they're very expensive to be tossing away. Unless you own stock in a battery company and are trying to see profits grow, it's a good idea to be conservative with battery usage.

Tips for Getting the Most from Your Batteries

Use the Right Battery. Your manual will tell you what batteries are safe to use; you risk damaging your camera if you use the wrong type.

Keep Batteries Freshly Charged. If it's been a few weeks since you've shot any pictures, test the battery the night before you plan to use it and recharge if necessary. If your batteries can safely be charged in a trickle charger you might want to keep a spare battery constantly charging (just don't forget to pack it in your bag when you go out to shoot pictures).

Use Your LCD Sparingly. LCD panels gobble up a lot of battery power. If your camera provides both an optical and an LCD viewfinder, try to use the optical finder as much as possible. Some cameras, of course, only have an LCD, so it's a moot point.

Review Pictures Sparingly. Even though one of the main advantages of digital cameras is the ability to instantly review and/or delete pictures, using the LCD to constantly review pictures drains batteries quickly.

Don't Play between Shots. It's tempting when you're walking around with a camera to point it at everything that looks interesting and zoom in and out to test compositions, but such behavior will drain the batteries. As much as possible try to shut the camera down between shots and avoid unnecessary zooms.

Protect Batteries from the Cold. Extremely cold temperatures drain batteries quickly and can sap all battery power. If you're shooting in cold weather, keep your main and backup batteries in an interior pocket (under a parka) and load up only when you're about to shoot.

Keep Spares Handy. Even if you have to spring for a single-use battery as a backup, stashing an extra battery in your camera bag could save the day. Lithium batteries, in particular, have a long shelf life and provide a tremendous amount of power. Of course, it kills me to toss \$15 in the garbage when they're used up-but it's better than not getting the picture.

Measuring the Light

Pity the poor photographers (myself included) who started taking pictures back when a light meter was something you strung around your neck on a strap and you practically had to press it into the face of your subject to get a good light reading. Today light meters are built into all cameras and metering happens the instant you tap the shutter release button. It happens so effortlessly, in fact, that sometimes we forget it's still an important part of the picture-taking process.

What a light meter does, of course, is measure the amount of light reflecting from a particular scene. It doesn't care what color the light is, what its source is or how provocative it makes your subject look—it simply wants to know one thing: How much light is there? That information is fed into the exposure system and your camera sets (or suggests) a good exposure. And most of the time the exposure is darn accurate, even in complex situations.

Good as it is, though, your camera's light meter is most reliable when you're photographing subjects of average reflectance in an average amount of light coming mainly front the front of the subject. In other words, you won't have any trouble getting a good exposure for kids playing on the backyard swings on a sunny afternoon. But once you dip your toes into the waters beyond the realm of average subjects or lighting, your camera's meter can get all wet in a hurry. So knowing how a meter works can come in handy.

Multi-Segment Metering

Virtually all digital cameras use this type of metering, also know as Matrix or Evaluative, as the default means of measuring light. Using algorithms that would make a high school algebra student's eyes spin, this metering mode measures and compares the light from a set pattern of segments of a scene. The camera compares the brightness of each segment to thousands of exposure examples stored in its memory. Some sophisticated D-SLRs even use subject distance and size information supplied by the autofocus system to help the metering system determine a good exposure.

When a multi-segment meter sees an area of brightness toward the top of the frame, for instance, it makes an educated guess that you're outdoors and that the bright area is the sky. A good guess, usually. It assumes that the foreground is the more important subject matter and it gives preference to setting exposure for that area. The system works breathtakingly well-most of the time.

But what happens when the important part of your scene occupies only a tiny part of your composition? Let's assume you've gotten very creative and you're shooting a portrait of a fair-skinned, platinum-haired person in front of a moderately dark background (the side of a deep red barn, for instance); the meter may do a fine job of exposing the background but your subject might be considerably overexposed.

Center-Weighted Meters

Once again, technology comes to the rescue. To help you cope with important subject areas, many cameras offer alternative light-metering modes. Center-weighted meters, for instance, measure the light from a portion of the scene in the center of the viewfinder, typically an area that represents about 60% (depending on the focal length of the lens you're using) of the entire scene. Switching to this mode is useful when the center part of your scene is important—for instance, a lone sunlit sunflower standing in front of a deeply shaded background.

The concept of center-weighted metering, of course, assumes that you want your main subject in the center of the frame—which is rarely the most interesting place to put a subject. To get both the exposure and composition you want, use the camera's exposure-lock feature to set and hold the meter reading, and then recompose the scene.

Spot Meters

Spot meters are more refined than center-weighted meters; they measure an even smaller area of the viewfinder—often a tiny circle as small as 3% of the viewfinder. Spot metering is a very accurate method of measuring light because it enables you to read from an extremely precise area—or to read small areas from great distances. Using a spot meter takes patience and experience. You have to determine the correct target to measure and then you have to "hit" that target when you take a meter reading. Choosing the wrong target or missing it can create a poor exposure.

Shutter speed affects the degree to which subjects will appear frozen or blurred. Aperture size affects depth of field: the front-to-back sharpness in a picture.

 ${
m H}$ uman vision has an amazing ability to make all scenes seem like they have just the right amount of brightness. Even though we may perceive some scenes as dim (the gloomy innards of a trendy restaurant) or exceedingly bright (high noon in the mall parking lot), our brain ratchets the light levels up or down so that we can see details and colors in both shadows and highlights. It's a great system and one that keeps us from tripping over waiters in the restaurant and playing bumper cars in the parking lot.

Digital cameras, on the other hand, rely on a sophisticated battery of electronic gizmos to capture acceptable exposures and for the most part they do an exceptional job. Even in relatively tricky situations, such as backlighting or dim light, they are able to record detail in both highlight and shadow regions with a fair amount of accuracy. When you combine this with the ability of image-editing programs to fine-

tune exposure, technology has largely chased away the bugaboo of bad exposure that haunted so many of us with film photography.

The two controls that determine exposure are shutter speed and aperture. The shutter speed (measured in fractions of a second for normal exposures) determines how long the camera's sensor will be exposed to light. The aperture (the opening in the lens that lets light

into the camera) determines how intense the light will be. When your camera sets exposure automatically, it selects a combination of these two controls. For any particular exposure, however, there are a number of combinations of shutter speed and aperture that will provide the exact same exposure. But while each of these exposures may be correct, the specific camera settings chosen will have a visible effect on certain aspects of your images.

BASIC EXPOSURE MODES

 $oldsymbol{1}$ o give you control over exposure settings, many digital cameras offer a choice of several basic exposure modes, including:

Program Mode (P)

In this mode (sometimes referred to as Programmed AE or Programmed Autoexposure) the camera chooses both aperture and shutter speed. The exposure is not biased for either shutter speed or aperture, but the camera will typically select a shutter speed that is safe for handholding (provided there's enough ambient light) and a corresponding aperture. Program mode is fine for shooting ordinary subjects in bright light (your dog napping on the front lawn) where an extreme shutter speed or aperture is not required.

A souped-up version of the Program mode is the Program Shift mode. With this mode, you can quickly shift through the series of reciprocal exposures (see next page) to adapt quickly to a fast-breaking special situation. Imagine you're leisurely focusing on your benchwarmer offspring, when suddenly she leaps from the bench and dashes pell-mell down the field. You have an instant need for a fast shutter speed. Enter the Program Shift mode (let's say it's a sunny day), and you can instantly choose a fast shutter speed from these reciprocal exposure combinations (1/4000 second at f/2.8, 1/2000 second at f/4, 1/1000 second at f/5.6, 1/500 second at f/8) to freeze her action as she heads the ball.

Aperture-Priority Mode (Av or A)

In this mode, you select the aperture and the camera chooses a corresponding shutter speed. The advantage of selecting your own aperture is that you control depth of field. By selecting a larger aperture (f/4, for example) you can focus sharply on the main subject (a person, for instance) but toss the background totally out of focus. If you're shooting a landscape where you want as much as possible in sharp focus, you can select a very small aperture (f/22, for instance).

Many pros use Aperture-Priority as their default mode, except when controlling motion is important. The reason is that unless your subject is moving, depth of field is usually the overriding creative concern. By leaving the camera in Aperture-Priority mode, you can manipulate depth of field and let the camera handle shutter speed.

Shutter-Priority Mode (Tv or 5)

In this mode you select shutter speed and the camera selects the aperture. Use this mode any time that motion is an inherent part of your subject. If you're trying to blur the water of a rushing river, for instance, you can select a relatively long shutter speed of 1/2 second or more and the camera will choose a corresponding aperture. If your subject is moving—a high jumper at a track and field meet or a three-year-old on the backyard swing—you can choose a fast shutter speed (perhaps 1/500 second) to freeze the motion.

Manual Exposure Mode (M)

In the Manual mode you set both aperture and shutter speed using the camera's exposure meter (or a separate handheld meter) as a guide. The benefit of manual exposure is that you can override the camera's settings when you believe it's being misled by the subject (a very dark or very bright subject, for example) or when you want to depart radically from the recommended exposure for creative effect.

Exposure Tip

I often switch to Manual mode when photographing stage events indoors because the contrast between the brightly lit performers and the black background often fools even the best meters. By switching to Manual and then using the camera's spot-metering mode, I set exposure from a reading taken from an important subject area-such as a performer's face or costume.

RECIPROCAL EXPOSURE SETTINGS

m Your camera produces the exact same exposure for any number of aperture and shutter speed settings because these two controls enjoy a reciprocal relationship. You can alter either the shutter speed or the aperture in either direction and, as long as you make an equivalent change in the other setting, the exposure will remain the same. It may sound complicated at first, but it's really a very logical and simple system—it's a concept Mr. Spock (or any other Vulcan) would just love.

One important thing to remember about exposure settings is that each time you alter either the aperture or the shutter speed by one stop, you either halve or double the light reaching your sensor. If you open the aperture from f/16 to f/11 (a one-stop increase in aperture size), for instance, you double the light. Conversely, if you change it from f/16 to f/22 (a onestop smaller aperture opening), you halve the light hitting the digital sensor.

The exact same relationship exists with shutter speeds. Each time you slow the shutter by one stop (from 1/125 to 1/60 second, for instance) you double the light hitting the sensor. If you speed up the shutter speed by one stop, you halve the light.

Let's assume, for instance, that your camera's meter selects an exposure of 1/125 at f/11—a nice middleof-the-road exposure setting. But let's say that your subjects are involved in a fast-moving volleyball match, and you know that you're going to need a shutter speed of 1/500 second to stop the action and get a sharp picture. If you increase the shutter speed by two stops (to 1/500 second), you'll be able to stop the action—but your image will be two stops underexposed. If you now open the lens by two stops (from f/11 to f/5.6), however, your exposure (the amount of light the camera allows to reach the sensor) will remain exactly the same, except that you'll now have a sharper picture of your skater.

Remember, though, because you opened the lens two stops, you've lost considerable depth of field. In this example, however, the sacrifice would be worth it since throwing the background out of focus would emphasize the players even more.

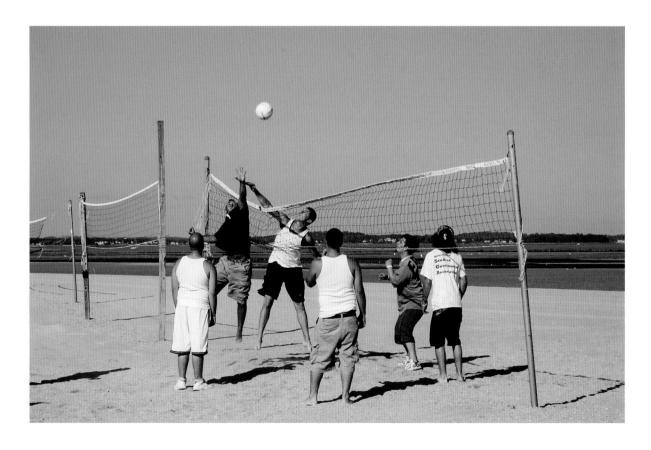

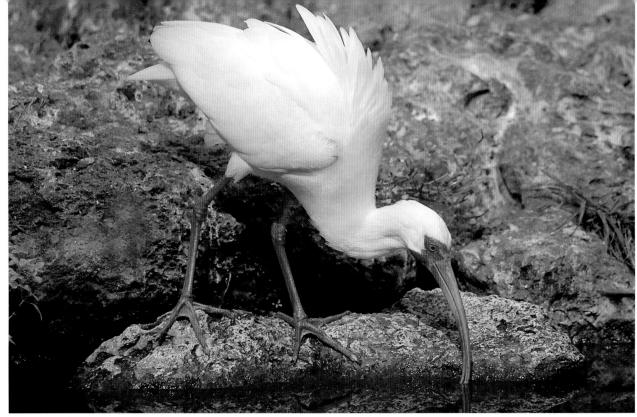

In the case of a bright white subject like this white ibis on a fishing expedition, meter the scene and be ready to add plus exposure compensation so the beautiful whites don't appear as dull gray.

EXPOSING DIFFICULT SUBJECTS

One of the inherent problems you'll face in dealing with a light meter is interpreting tonalities—particularly extreme tones such as blacks and whites. Our eyes are constantly adjusting and modifying their interpretation of tonalities so that we see a more or less accurate rendition of subject tones—white sheep are white, black sheep are black, and gray sheep are gray.

Meters, on the other hand, are calibrated to presume that the entire world is one lackluster shade of middle gray—about the color of a deeply overcast sky.

Since most scenes contain a generous mix of different tonalities, the metering system can provide accurate exposure information. Difficulties begin when your subject's brightness departs radically from the average tones that your meter is biased to record. In an effort to see all things equally, it will give the same exposure to a white swan as it will to a black cat—turning them both a medium shade of gray in your final image. You and your camera may bounce merrily along through a winter landscape anticipating getting a wonderful white snowfall for your holiday cards only to discover the snow has turned gray.

One solution is to use your exposure compensation feature to add or subtract light from the recommended exposure setting. Conversely, if you're photographing a close-up of your black lab's soulful face, you should subtract light (again, you might try with one stop at first) to give the fur its rich black tones and not washed out gray ones.

Determining the actual amount of compensation is a matter of experimentation and experience because meters and subjects are all different. Of course, a lot of exposure compensation can be performed using your image-editing software and the levels or brightness controls, but it sure is nice to open an image right out of the camera and have it be exposed perfectly.

A Photographer's Notebook: Exposure Notes

Left The delicate white petals of this cereus plant (which always remind me of swan feathers) presented a particularly difficult exposure challenge: Not only is the entire blossom white, but it is a night-flowering plant. The plant only blooms for one night a year and the blossoms (which are the size of dinner

plates) fade by dawn.

I initially tried using the camera's built-in flash to illuminate the flowers, and a -2 stop exposure compensation to keep the highlights from blowing out. But, the direct flash was kind of boring so I supplemented it with light from a pair of ordinary flashlights-one placed behind the blossom for backlighting and one placed to the side to create random highlights.

Right Dappled sunlight can be a tricky exposure subject because you have a pattern of competing highlights and shadows. If you expose to get good detail in the shadows, the highlights blow out; if you expose for the highlights the shadows fade to black.

The solution? In this instance I took a center-weighted meter reading from the green leavesa good average subject-and used the camera's exposure lock feature to hold that exposure while I recomposed the scene. Even so, I used the Levels tool in Photoshop Elements to bring down the highlights a touch while keeping the shadows open.

A Depth-of-Field Primer

Although you seldom notice it, your eyes continually adjust focus to make everything—whether near or far—appear to be fairly sharp. A camera lens, however, can focus on only one thing at a time. If you focus your camera lens on a bottle of milk sitting on the kitchen counter, for example, it can focus sharply only on that bottle. There is, however, an area in front of and behind the bottle that is acceptably sharp and that zone is called the depth of field.

The depth of field in any given photograph can range from just a few millimeters in a close-up photograph of a flower, for instance, to great distances—even miles—in a landscape shot. Depth of field is not like the edge of the earth; foreground and background details

gradually soften as they get farther from the point of sharp focus. Remember, we are talking about acceptable sharpness.

By manipulating depth of field and, therefore, sharpness, you can emphasize and subordinate subjects in a scene. It is a primary creative control. By focusing carefully on the eyes in a head-and-shoulders portrait and intentionally keeping the depth of field shallow, for example, you direct attention to the eyes. By maximizing depth of field in a landscape shot, on the other hand, you emphasize the great distances involved by simulating how our eyes would view a scene. You can, of course, shoot a landscape with a very limited depth of field and, in fact, that's a great method for focusing viewer attention on just one part of the picture.

The Three Keys to Depth of Field

Focal Length

Focal length has a great effect on depth of field, and the shorter the focal length (the wider the lens) the more inherent depth of field it provides. A wideangle lens, equal to a 28mm lens in 35mm photography, has much more depth of field at a given aperture than a 100mm medium-telephoto lens. When maximizing depth of field is important to an image, zoom to a wider focal length (or switch lenses with a D-SLR) to provide more depth of field.

Aperture Size

The smaller the aperture (the higher the number), the greater the depth of field-regardless of the focal length of the lens. If you want to increase the range of sharp focus, then you can switch to Aperture-Priority mode and choose the smallest aperture available for the existing light. Conversely, if you want to limit the depth of field-to isolate a single rose in a garden shot-you can select a larger aperture. The ability to set a specific aperture can be critical. When buying a camera, try to choose one that offers an Aperture-Priority mode.

Your Focus Distance

Assuming you're using the same focal length and aperture, the farther you are from your focus point, the greater the depth of field in the picture. As you focus closer, depth of field decreases. Keep in mind that as you change your relative position to your subject, the scene's perspective also changes something that does not happen by merely changing focal lengths.

Because of the magnification involved, depth of field decreases very noticeably in close-up photography and, depending on focal length and aperture, you may be limited to having just fractions of an inch in sharp focus. Similarly, depth of field diminishes quickly as focal lengths get longer.

With most zoom cameras, it's tough if not impossible to visualize just how great or how shallow the depth of field will be, so it's largely a matter of experience. Some D-SLR cameras have a depth-offield preview button that lets you view the area of sharp focus in the viewfinder; but it's a feature typically found only on expensive professional cameras.

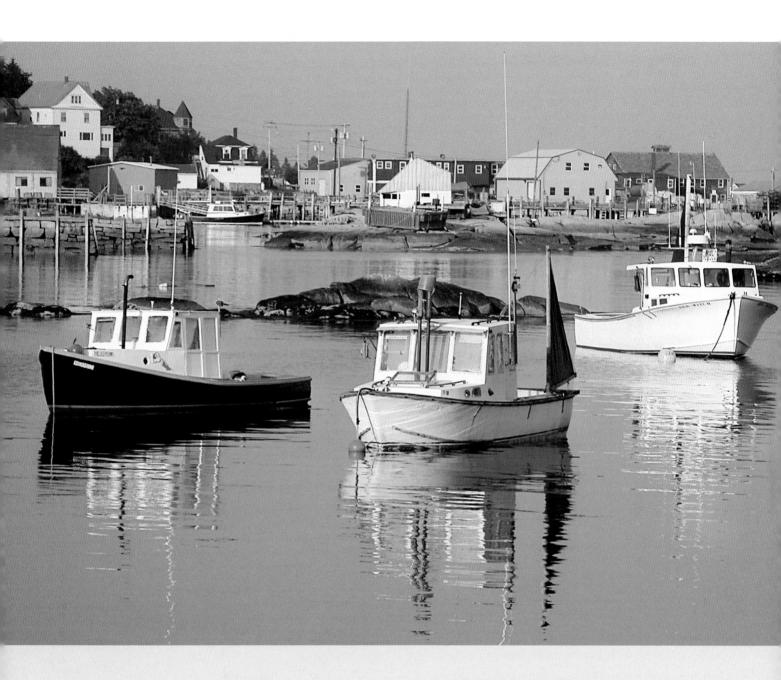

By maximizing depth of field in a landscape shot, you emphasize the distances involved by simulating how our eyes would view a scene.

A Shutter Speed Primer

 $V_{\rm ery}$ few things that we photograph are absolutely still. People, pets, rivers, traffic, and the stars in the night sky are all in constant motion. Some subjects, like landscapes, have very subtle movement in their fluttering leaves, waving grass, or meandering streams. Others, like kids racing around a playground or ocean waves crashing to shore, have motion at their very cores. How you interpret motion in your photographs profoundly affects the creativity of your pictures. And the way in which you interpret motion is through the duration of the shutter speed.

Your camera's shutter opens and closes to let in just the right amount of light for a good exposure (in tandem with your aperture). Typically your camera will have a shutter speed range of several seconds to several thousandths of a second (1/2000 second is a common top speed—fast enough to stop a bullet). But, as we saw in the previous section on aperture, there is no one correct combination of shutter speed and aperture.

In Program mode, your camera selects a shutter speed safe for handholding, with no consideration of subject motion and certainly no consideration for your creative intentions. Your camera has no way to know if you want to freeze the motion of your cat leaping after a moth or exaggerate it. Using your camera's Shutter-Priority mode, however, you can control precisely how long the shutter will be open—and just how sharply your cat will be recorded. Understanding how exposure times will affect different subjects will provide you with some terrific creative options.

The more extreme the shutter speed you choose, the more obvious the results of freezing or blurring motion will be. Using a shutter speed of 1/8000 second to record horses racing around a track, for instance, will freeze not only the horses' legs but every tiny clod of turf that kicks up around their hooves—perhaps even the droplets of sweat flying from the jockey's brow. An exposure of a half second, on the other hand, will turn the thundering herd into a motion-filled blur of colorful jockey silks and graceful equine shapes.

To see how time effects motion in a photograph, experiment with various shutter- and subject-speed combinations and study the results. Find a motion subject you can control (like the bicycle wheel of an upturned bicycle) and photograph it using half a dozen different shutter-speed settings. Take notes on the

exposure times (or check the metadata for exact shutter speeds when you download the images) and you can compare their effects.

Other factors will influence just how motion is recorded, including subject direction (relative to the camera), your distance to the subject and the focal length of the lens you're using. The direction of motion is particularly important because you can enhance the movement of slowly moving subjects, or freeze the motion of quickly moving ones at slower shutter speeds, by altering your shooting position. Subjects moving toward or away from the camera are much easier to halt, for instance, than those moving side-to-side in front of you.

Because the size of the moving subject in the frame exaggerates the perception of motion, the closer you are (physically or optically) to your subjects, the more motion you'll capture. If you're trying to blur the movement of an ice skater spinning, for example, the more you fill the frame, the more apparent the motion will become. Similarly, if light is low and you're shooting at a slower shutter speed than you'd like, you can enhance the perception of sharpness by not working so closely.

Remember that the subject doesn't have to be the only thing moving in your picturesyou can also put yourself in motion. In the photograph below, I was a passenger in a car driving down the Las Vegas Strip and shot a two-second exposure as we cruised past the neon signs. Viva ideas.

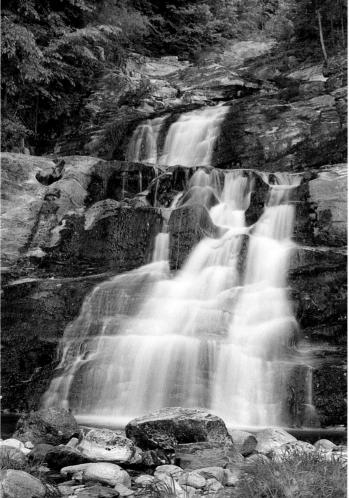

Sports and action subjects are the most obvious targets for playing with shutterspeed effects, but other action subjects can be equally enhanced: a spray of fireworks, colorful carnival rides, or the rush of a mountain stream. There's no way to predict the effect that different shutter speeds will have on motion, so it's entirely a matter of experimentation.

Developing a Shooting Workflow

No one will ever accuse me of being an overly organized person (it looks as though it would take a team of Sherpas and a clairvoyant just to locate my car keys most of the time), but when it comes to taking pictures, I have learned that having a routine is of great value. I am somewhat like a robot when it comes to setting up and working with a camera—the routine rarely varies. Professional photographers use the term workflow to describe the progression of steps used in capturing and processing images—creating your own workflow (both before and after you shoot pictures) will make your life much easier.

A good shooting workflow like the one outlined in these pages should begin before you're actually taking pictures and shouldn't end until you've downloaded your images and printed a few favorites. Let's assume, for instance, that you're going to take a nice Sunday drive in the country looking for landscape pictures

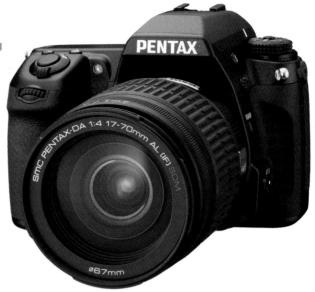

(or "cruisin' for snaps" as I like to call it). The more organized you are before you leave home, the more time you'll spend shooting pictures as opposed to fumbling with cameras and manuals.

The Night Before you Shoot...

1 Charge Batteries

Be sure to charge your batteries the night before you plan on shooting pictures. If you have several rechargeable batteries, it's a good idea to number them so that you can keep track of which ones are used up while you're shooting. I have a special section of my camera bag where I toss used batteries so I know without glancing that they're depleted.

2 Reformat Memory Cards

Once you've downloaded your pictures and have backed them up onto a CD or a secondary hard drive, reformat your memory cards. Reformatting erases the images you've already downloaded and readies the cards for your next shoot. If you fail to erase the previous shoot, you're not only wasting precious card space, but you'll also find yourself downloading images you've already downloaded. Trust your computer: download, backup, and then reformat the cards.

3 Review Your Manual

Bringing your manual into the field is a great thing to do, but it's not always the best time to stop and review it. If you're planning on using a technique that's new or that you don't use often (like the Close-up mode), take the time to review your manual and look over your camera controls. I often take notes for setting certain camera modes or menu routines on 3 x 5-inch cards so that I can refer to them quickly, particularly if it's a new camera or a feature I don't use often.

4 Clean Your Camera

Take a few moments to look over your camera the night before a shoot and, if necessary, use a microfiber cloth to clean filters, your LCD monitor, and optical viewfinders. Use a small can of compressed air to blow dust off of the front element of your lens; wipe the glass itself only when it absolutely needs it.

At Your Location...

1 Prepare Your Tripod

The minute I get into a shooting area I set my tripod to height and leave it extended the whole time I'm shooting. Outdoor lighting changes quickly and it's a shame to miss a picture while you're messing with a tripod.

2 Select a Quality Setting

Choose the resolution and file format settings based on what you plan to do with your images. For general shooting, choose the highest quality JPEG setting and the highest quality resolution setting if available on your camera. Periodically check the settings to be sure you haven't inadvertently changed them.

3 Select an Exposure Mode

Switching exposure modes is pretty simple, so you should always select a mode to match a specific subject. Be sure when you first start shooting that you know which mode you're in—and how to get out of it.

4 Select an ISO setting

Choose the ISO to match shooting conditions. In bright daylight, use a lower ISO, such as 50 or 100. ISO greatly affects image quality, so a lower ISO gives better results, except in dim lighting when a slow shutter speed could lead to blurred pictures.

5 Set the White Balance

Set the white balance to the type of lighting you're in. If you will be shooting in mixed lighting (for example, an interior lit by both daylight and lamplight), use the auto white balance setting.

6 Recheck Battery Level

If you've been shooting with a rechargeable battery for more than an hour or two, check the battery power. Rechargeable batteries tend to die suddenly.

Back at Home...

1 Download Your Images

I'm one of those photographers that tended to hang around the lab counter waiting for my prints in the old days—so I download immediately after a day of shooting. Then, using the iPhoto slide show feature on my Macintosh computer, I watch a slide show of my day's work. It's the most relaxing time of the day.

2 Organize Your Pictures

The minute you've looked them over, use your organizing software to give the pictures at least a blanket keyword name, such as "Vermont, Tractors" or "Volleyball, Beach." If photography is your hobby, you'll have thousands of pictures in no time and adding keywords to them is vital if you ever hope to find them again.

3 Back Up Your Pictures

The minute you've looked at and organized your pictures, back them up. I back up my images in two ways: on CD and on an external hard drive. Label the backups carefully. Backing up takes less than 10 minutes and it's a good feeling to know your images are safe.

4 Make a Few Prints

I can't resist making one or two prints at the end of the day. It's the reward you should give yourself for all of your hard work.

Later...

5 Display and share your pictures

The real joy of digital photography comes from letting others see your work, so pass your pictures around. Hang them up on the refrigerator, pop them into a desktop frame, email them to friends, or post them to a website for the whole world to see.

Design

"You can't compose gratuitously; there must be a necessity, and you can't separate form from substance."

-HENRI CARTIER-BRESSON

Introduction

I grew up with a mother to whom the exact placement of a flower vase on a table was nearly a matter of national concern. There were times when she would leap up while reading a book to move a candlestick three-quarters of an inch and then go back to her reading knowing that *now* everything was right with the world. It's only natural then that I am sensitive to the arrangement of subjects within a picture.

As neuroses go, being a compulsive composer is probably a good thing because each small variation that you work into a photo's design can impact how your subjects are perceived. The graphic impact, the conceptual theme and the emotional content of your images all hang on your ability to cleverly arrange and display the various elements of your compositions. Each time you snap the shutter you are describing a unique moment in your life's journey, so it's important that you take the time to present your vision clearly.

Even the simplest of compositions—a flower vase on a table, for instance—can be composed in many different ways, and each offers its own distinct visual statement. By placing the vase far to the left of an otherwise empty frame, you emphasize the sense of space to the right of it; by placing it dead center you emphasize symmetry. By cropping the vase tightly you remove it from its context, forcing the viewer to focus solely on the vase. And by cropping even further, you fragment the subject and leave the viewer with questions about your intent.

There are many elements that go into the design of an image: organization, balance, depth, orientation (vertical, horizontal, or skewed), subject position, and subject characterization. These are the areas you must address each time you compose a photograph; the decisions you make help define you as both a photographer and a person.

Releasing Your Inner Artist

The first step in designing an image is deciding where to put everything. A photograph is a lot like an over-filled closet—a lot of stuff seems to sneak in there when you're not looking. It's your job to decide which stuff gets to stay and which stuff to toss out—and to arrange what remains so that the design you choose seems intentional rather than happenstance. You don't want strangers glancing into your visual closet and wondering what in the world you had in mind when you filled it. You want them to pause and admire the contents.

Where do you stand? That's the common question faced (or danced around) by politicians on a daily basis. Or, keeping to the political metaphor, should you even stand? Rolling over may not work well for photography, but lying down (biting my tongue here on further political metaphors) or kneeling can reveal a new perspective. For photographers, where you position the camera in a scene is the primary determinant of how the design of a picture turns out.

Where you place the camera establishes the general organization of your composition. The relationships of size, scale and perspective, and the dominance that you give to one subject element over another, shift rapidly as you alter your position. As scenes grow more complex, your choice of viewpoint becomes even more critical because subjects quickly begin to overlap and hide (or reveal) one another with each shift of your position.

Where you position the camera in a scene is the primary determinant of how the design of a picture turns out.

Even in simple scenes, small changes of camera position can drastically alter composition. By holding the camera high overhead, low to the ground, or shifting it from one side to another of a subject, you will discover that it pays to take the time to examine a scene from many different vantage points. When I'm out shooting photos, I often walk around with the viewfinder to my eye, looking at the scene as if I were making a movie, waiting for the best organization to click into place. If I look at a scene and think it would make a great establishing shot for a film, then I know I've linked the main elements of the theme.

Remember, too, that the vantage point you choose helps reveal and define the theme of a photograph. And like a film or a painting (or a greeting card illustration, for that matter) all of the elements of a photograph should play to the same theme. Image-processing programs aside, as a photographer you don't have the total freedom that painters enjoy in picking and choosing which elements to include and which to discard. But by carefully choosing your vantage point (and your lens) you emphasize those elements that help carry the theme.

Keep in mind that while only a change in your physical position can truly alter perspective, you can modify the apparent perspective by changing to a different focal length lens. Using a wide-angle lens, for instance, elongates the distance between foreground and background subjects, exaggerating the foreground ones, while a longer focal-length lens compresses space.

Also, the number of elements you decide to include in a composition is another aspect of organization. As they say in political-activism circles (or at least they used to say it in the 1960s), you're either part of the solution or you're part of the problem. The same goes for those objects that you choose to include in your image: either they strengthen it or they dilute it.

Whether you choose to include many elements or just a select few, organizing them into a cohesive and powerful arrangement is perhaps the toughest compositional challenge you'll face. And no doubt one evening your kids will see you get up from a good book to walk across the room and inch a knick-knack across the mantle to a better position. They'll know instantly, of course, that you've been thinking about photography again.

KEVIN KOPP

Taken with the camera placed on the ground, this photo emphasizes the reflective puddles and the pattern of the floor boards.

©FRANK GALLAUGHER

Let Chaos Reign

Without discounting all of those nice thoughts about careful organization and obsessive order, there are times when it's worth implementing Plan B: Let the chaos of the moment take over. Often tossing aside your preconceptions of what a scene should look like is a good approach to unveiling the true nature of complex subjects. Instead of trying to get all your visual ducks marching in neat rows to your beat, let the madness of the moment invent its own design.

While it's possible to carefully craft an angle and a point of view that organizes a busy city street scene,

that effort may not convey the mood and emotion of the location. Sometimes foregoing formal design and shooting from the hip (literally) is the best creative choice.

In the early 1960s a brave band of street photographers (led by great talents such as Joel Meyerowitz and Garry Winogrand) waded into the busy city streets of Manhattan with wide-angle lenses and equally wideopen minds. They were less concerned with traditional concepts of composition and design than with things like uncovering unexpected physical juxtapositions and capturing passionate—and absolutely spontaneous—

glimpses of the human parade. Artfully dodging from pillar to post in an almost ballet-like approach, they used their cameras to absorb the visual commotion of urban life.

As the photographers discovered, amazing things can happen when you seek out the soulfulness of the moment. I captured the feeling of Times Square at night—it's vibrant energy, motion, and colorfulness—in the photo above by handholding my camera while using a shutter speed of one-second.

You can apply the same technique to almost any subject—from a kids' birthday party to a Saturday morning dog wash. By using the swiveling feature on your LCD panel (if it's available), for example, you can hold the camera at very high or low angles to get a general sense of the composition and then just let the natural flow of the moment rule. To some of my friends' great annoyance, I'll often sit at a restaurant table and, with the lens set to its widest focal length, hold the camera overhead and shoot pictures around the table without glancing at the viewfinder. The images are a

bit offbeat looking and there are a lot of near misses (chopping friends' heads off is something they've come to expect from me), but the fun and informality of the compositions are really refreshing.

Of course, such a freeform approach to photographic composition does lead to a higher percentage of unusable images—but you may just make some great visual discoveries. Let your imagination go and let your camera go with it—after all, it doesn't cost you anything to delete and reshoot images.

Showcasing the Main Subject

In the same way that a novel relies on a main character to pull your heartstrings and dampen your brow with trepidation, so too, your photographs need a leading player. Without one important element upon which viewers can hang their attention and invest their emotions, you're likely to create an uncertain—if not confusing—storyline. And the success of the "Seinfeld" ("it's a show about nothing") philosophy aside, your photographs should strive to be about something.

Creating a center of interest not only provides a visual focal point, but if chosen carefully, it helps to punctuate the overall theme (there's that word again) of the image. If you're trying to show just how messy your kitchen table is on a Saturday afternoon, for instance, placing a half-eaten hotdog in the foreground provides a thematic center of interest, and the piles of dirty dishes and used napkins in the background reinforce the theme.

Even abstract subjects need a dominant visual element—an interesting intersection or combination of color, lighting, pattern, or just a break in the visual rhythm. Interestingly, too, while the center of

interest is often the destination where the eye lands, it also helps lure the eye into exploring the other aspects of the composition more carefully. In looking at a photograph of a lone cross-country skier tracking across a vast field of snow, for instance, the eye goes immediately to the skier, then returns to examine the overall context. Where did the skier come from? Is she heading toward the woods or coming out of them? Without the center of interest to grab your attention you might never give the setting more than a cursory glance.

In order to emphasize the center of interest, you first have to identify it. Sometimes that decision is easy: a butterfly lands on a nearby zinnia and becomes a great focal point for your garden photograph. In more complex scenes, like a landscape, you often have to hunt around to find one element dynamic enough to serve as the visual centerpiece. In a forest scene, for instance, you might find one tree that is lighter in color or tone than those around it, or one whose unusual shape breaks the pattern of the others.

Fortunately, finding a good center of interest is a bit like appreciating art: it's hard to describe what you're looking for but once you see it, you'll know it. One way to test a center of interest is to hold your hand up in front of you and block the center of interest from your view—if the scene seems diminished by its absence you've found a likely candidate.

Within a larger scene, small objects often become the most interesting subjects. When shooting detail shots, pay attention to the background and shift your position until it is right—this will often make the difference in whether or not the photo is successful.

Finding ways to emphasize your main subject is an important consideration. On the following pages we'll look at some of the more common ways to do this.

GET CLOSER

There is a reason that Hollywood invented the close-up (other than to suffer the vanity of leading actors). Filling the frame is a powerful and immediate device for directing someone's attention to the main subject. The minute the camera closes in on the gunslinger's belt, you know there's going to be some shooting—there's little doubt about what the director wants you to notice.

Moving closer—either physically or optically—isolates your subject and is like saying to the viewer, "This is what I want to show you."

GET FARTHER AWAY

Getting closer and making your center of interest larger is usually a good idea, but it's not always the solution. Sometimes giving your focal point a lot of space provides the right kind of emphasis. By drawing back to include the whole schooner within its nautical setting (below), I could show the picturesque marina as well. Placing the boat in context from a distance gives it a feeling of belonging it might not otherwise have.

110 the new joy of digital photography

A plain black background not only provides simplicity, it can also offer striking contrast. By exposing for the sunflower, the shadowed background area went completely black.

USE A SIMPLE BACKGROUND

Placing your subject in front of a plain background eliminates any doubt about what your point of interest is, and it also makes for a cleaner-looking image. Finding a clutter-free background isn't always easy, but often a simple shift in your viewpoint will reveal one. By climbing up on a porch to photograph your kids running through the sprinkler, for example, you can eliminate things like the neighbor's clothesline or the pile of garden tools leaning against the fence (the ones you were supposed to put away yesterday) and isolate the kids against the lawn. Similarly, by kneeling to photograph kids (or by spotting a fireman high above in a bucket), you can isolate them against the sky.

USE SELECTIVE FOCUS

Another way to simplify and soften backgrounds is by restricting sharp focus to your main subject. Using a moderate telephoto lens or zoom setting with a wide aperture enables you to restrict the range of sharp focus to just a few feet. Shallow depth of field is a particularly effective tool for shooting individual portraits. In the photo of the little girl blowing bubbles (above) I used an f/4 aperture setting and focused carefully on just her eyes. Because I tossed the background totally out of focus, your attention goes directly to the little girl and her bubble.

Of course, there are times when finding a simple background isn't possible—which is where your post-production skills come in handy. By selectively adding a Gaussian blur to the background (right), you can isolate your subject even more than you can by restricting depth.

© JACK REZNICKI

EXPERIMENT WITH SUBJECT PLACEMENT

For some odd reason we often take the term "center of interest" a bit too literally and feel obliged to put the main subject square in the center of the viewfinder, as if we were shooting it with a rifle instead of a lens. Dead center in the frame, however, is probably the worst of all choices because it surrounds your subject with equal amounts of space creating a stagnant composition. Instead, shift your main point of interest to the left or right of center, and/or slightly above or below the center of the frame, to establish a more dynamic use of space and a more natural feeling of balance.

One of the reasons we tend to center the main point of interest is that the autofocus and light-metering indicators are in the center of the viewfinder and so we center the subject to get sharp focus and good exposure. You can do an end run around this, however, by pressing and holding your shutter-release button halfway down to lock both focus and exposure. You can then re-compose your image and still get a sharp, well-exposed picture.

CREATE A SILHOUETTE

Silhouettes command attention. They attract the eye. Why? Because of the stark contrast between your subject and its surroundings. They also reduce your subject to its purest shape.

In the photo to the right, I positioned myself so the water tower and hilltop were between my camera and the rosy light in the sky as the sun was setting. Backlighting produces a contrast that makes ordinary subjects become more dramatic. Creating the actual silhouette exposures for this photo and the one below was easy: I took a reading from the bright sky areas and then exposed for that. I also enhanced contrast and tweaked the color a bit in post-production.

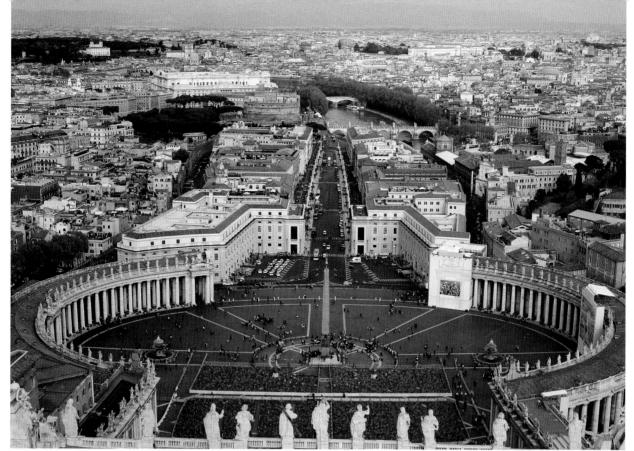

DJULIA CUTTER

Choosing a Format

Because most digital cameras are designed to be comfortable when held horizontally, many photographers ignore the option of turning them on end to compose pictures vertically. And that is often a big mistake because frequently the best way to compose a photograph is to use the tall and narrow format of the vertical rather than the wide view of the horizontal.

If nothing else, tilting the camera vertically once in a while gives your pictures some variety. I'm always impressed when I look at someone's pictures and see a good mix of verticals and horizontals because I know they spent time examining their subjects and trying to give their pictures more impact.

Some subjects, of course, call out for a vertical framing—tall buildings, waterfalls, and even tall basketball players. It's simply more natural to fit LeBron James into a vertical frame than a horizontal one (unless you happen to catch him laying on a very long beach towel). By using the vertical format with very tall subjects, you not only emphasize their height, but you also encourage the viewer to study and examine that height. And by combining a vertical format with a wide-angle lens, you can use interesting foreground lines or patterns to lead the viewer deeper into the scene.

© JULIA CUTTER

Certainly, too, many subjects are much more impressive when they are allowed the full and unrestrained width of the horizontal format. Psychologists will no doubt tell you that the reason we instinctively frame things horizontally is because it creates the feeling of stability—as do floors, level horizons and (let's not forget) psychologists' couches.

Deciding which way to orient the camera is based on a variety of considerations. Since it doesn't cost any more to shoot it both ways with a digital camera, it's worth experimenting with format—particularly with subjects that seem obviously destined for one format or the other.

Sometimes, too, you can catch viewers' attention by intentionally photographing a vertical subject horizontally and vice versa. By placing the subject in an unconventional framework you can startle and unsettle viewers. Challenging preconceptions is always a great thing for visual artists to attempt.

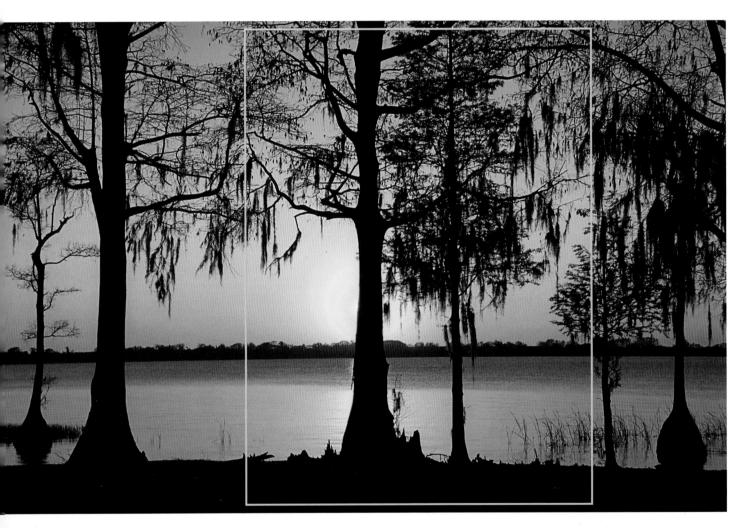

Here's an interesting experiment to try. Next time you go out shooting, take a piece of cardboard (8 1/2 x 11 inches—21.6 x 28 cm, works well) and cut a 4 x 6-inch (10.2 x 15.2 cm) opening in the center. As you walk around looking for potential subjects, hold the card up at arm's length and view your subject through the opening, both vertically and horizontally. It's intriguing to see how differently the same subject looks when viewed in both formats—and it will help you to visualize how differently your prints will look later.

Placing the Horizon

The horizon is kind of like the "heavy" in a Hollywood western: the minute it enters the frame it becomes a dominant character in any storyline. No matter how you dress up the rest of the frame with pretty dancehall ladies, there's that horizon, patiently laying low in the background—waiting for you to make your move: "Go ahead, design me—make my picture." Well, you get the point.

Whether you're photographing a Manhattan skyline, a wilderness landscape or a sunrise at the local beach, you'll use the horizon to define the spaces involved. The primary thing that the horizon tells us, of course, is where land ends and the sky begins. You can use that information not only to manipulate how the spaces in the photograph are perceived, but also to help emphasize your main subject in dramatic ways—which hopefully is what you want to do.

Imagine, for instance, that you're photographing a lone olive tree in a large open field in Tuscany (as long as we're fantasizing, we may as well make it inviting). What you have is a basic composition with just three main elements: foreground, tree, and sky. Placing the horizon low in the frame heightens the isolation of the tree by diminishing its size in relationship to the sky. By placing the horizon high and aiming the lens down at the foreground, you exaggerate the distance between your vantage point and the tree, and emphasize its physical environment—the tree becomes punctuation for the landscape. With a simple tilt of the camera you've shifted the entire emphasis of the composition.

Sometimes an extremely low or high horizon can add just the drama a scene needs.

There are no right or wrong placements for the horizon; it is an entirely subjective and often instinctive decision. Sometimes an extremely low or high horizon can add just the drama a scene needs—using an extremely low ribbon of horizon to emphasize a spectacular sunset, for instance, or using a very high placement to accentuate the path of a stream passing through a landscape.

Again, it costs nothing extra to take as many pictures as you want with a digital camera, so experiment and break rules if the setting calls for it. It's considered a "mistake," for instance, to use the horizon to divide the frame exactly in half but, in the right situation, it can be very effective.

Finally, sometimes the best placement for the horizon is to put it out of the frame entirely—eliminate it and see what happens. By photographing outdoor scenes without a horizon, you force the viewer to examine your subject without a strong spatial context.

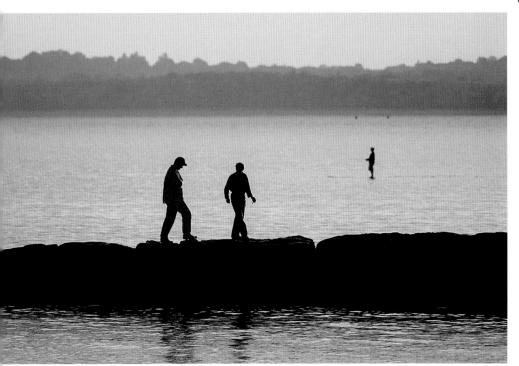

By contrasting small, darker subjects against a large, light background, you can maintain the darker subjects' importance within the frame.

A Sense of Balance

In the same way that a musical composer uses quieter moments to offset crescendos, percussion to punctuate strings, so, too, visual compositions benefit by contrasting elements of differing visual strengths. By composing a careful mix of bold and subdued elements or playing stronger ones off weaker ones, you create a sense of visual harmony—a feeling that nothing about the composition is lopsided or strained.

One way to create balance is to arrange objects by their visual weight. Dark-colored objects are perceived as being heavier than light-colored objects. By contrasting a small heavy subject against a large light background, the smaller and darker subject is able to maintain its importance in the frame. Imagine that you're photographing a black bull standing in front of a large yellow barn; even though the barn is far larger than the bull, if you composed them together, the bull

would still retain its own space and significance in the picture. A tawny colored horse photographed in front of the same barn, while roughly the same size as the bull, would seem overshadowed by the building.

The rule of thirds is a simple composition technique (see example at right) to help create a balanced division of space within the frame. The rule of thirds is also useful in finding a balanced location for secondary subjects. If you were photographing a still life with a basket of fruit as the dominant subject at the lower right intersection, for example, a small vase or perhaps a candlestick placed diagonally opposite would keep the composition from seeming too heavy in one area.

Of course knowing how to create a sense of balance means that you also know how to upset the visual apple cart by intentionally placing heavy items to dominate lighter ones or using subject placements that create discord rather than harmony.

DKEVIN KOPP

The Rule of Thirds

Painters have long solved balance dilemmas by using a simple compositional technique called the "rule of thirds" in which the frame is (mentally) divided into thirds, both horizontally and vertically. By placing important key subject information at any intersection of thirds, you create a balanced division of space within the frame.

Simplicity

There's an old Shaker hymn that begins "Tis a gift to be simple..." and there's no question that in almost every creative endeavor there is a lot to be said for simplicity. In the same way that the spare and functional design of Shaker furniture and tools created practical yet elegant pieces, keeping your visual designs simple gives them a certain power and grace.

Simplicity works well as a design device for a simple reason: the fewer things you include in your pictures the more important each becomes. By paring away superfluous bits and pieces and keeping only what is indispensable, you create a direct message for the viewer. In the very simple shot of the pear sitting on the window ledge, for instance (at right), there's little question about what the photographer wanted to show you—and there is nothing in the frame that isn't a part of that message.

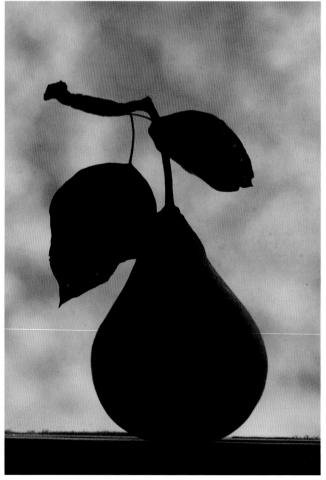

© DEREK DOEFFING

However, simplicity in photography is arguably difficult because arriving at a simple composition is a matter of subtracting things that already exist. Potters, painters, sculptors and even candlestick makers typically take the opposite route: They add only those things that are necessary to make their statement. An artist isn't likely to suddenly sketch a few telephone poles into a pretty landscape

without good cause even if they do exist in plain sight. You on the other hand have to find some way to keep those poles and power lines out of your image.

Keep in mind that how near or far you are to a subject (physically and in terms of zoom setting) plays a huge role in creating simpler and more organized designs. In photographing the large, carved planter (right), I knew that I wanted the carving and the plant to be the stars of the shot. But when I filled the frame with just the planter, it lost a bit of its context in front of the ornate gate and surrounding gardens. When I moved back too far, the planter got lost in the scene. So, like Goldilocks trying to find the right bed, I experimented with both my shooting position and zoom setting until I found the composition that was "just right." The solution: Simple but not cryptic, and inclusive enough to at least hint at the setting.

If deciding what is and what is not important becomes a problem, try using a trick that screenwriters often use: expressing (usually to a bored and jaded producer) the plot of an entire film in a single sentence. For example, "Jaws is a movie about a shark that terrorizes a summer resort island." If you can look at a scene and reduce it in your mind to a single sentence and then translate that to a simple visual thought, you'll know what you need and don't need to express your idea. Try it next time you are out shooting. You'll find it's a fun exercise and, if you can't finish the sentence, you have more thinking to do.

Of course, simplicity can be a double-edged sword: The very methods you use to emphasize essential elements can also raise the stature of less important ones. If you move in tight to photograph a pair of old milk bottles sitting on a barn ledge, every detail of the composition—including the dead spider resting on the ledge—will scream for attention. The spider may or may not enhance the design, but it will get increased attention.

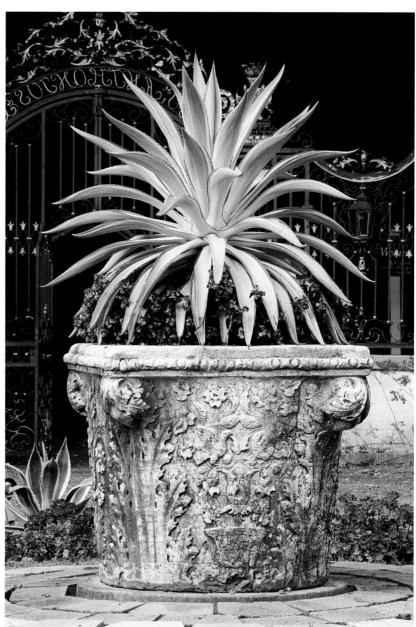

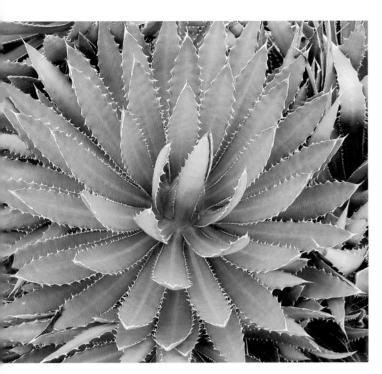

Interesting shapes, lines, and textures are everywhere—you just have to take a moment to notice them. You can develop an eye for composition by taking the time to consider the world all around you.

Lines, Shapes, and Textures

Although artists are often accused of looking at the world through rose-colored glasses, it actually helps to have an acutely analytical eye when it comes to designing images. Bicycle wheels, leaping children, lampshades and nearly all subjects are a hidden trove of lines, shapes, forms and textures. These are the basic building blocks of graphic design. Identifying and revealing these graphic elements is an important aspect of building any composition.

While most people might look at a woman and see a face, a neck, shoulders and a torso, artists like Picasso and Georges Braque saw a banquet of squiggly lines, spatial planes, and bold shapes. By rendering subjects in terms of just those elements—and viewed from many angles simultaneously—they quite literally invented the Cubist style of art. What most of us see as distorting reality, Picasso, Braque, and others saw as clarifying it.

Much of your job as a photographer is to do the same thing: to reveal the primary graphic elements that

hide in ordinary subjects. These elements exist in all subjects, but uncovering them—and exploiting them to enhance your compositions—is at the heart of good design. There are other secondary design elements—shadows, reflections, patterns—that you can use to build or embellish your compositions.

In many potential subjects, one element will dominate the others and, in fact, it may be that exact element that drew you to the scene: the long curving arc of the shoreline on a tropical beach, or the familiar shapes of several palm trees in silhouette at sunset. It's important then that you find a vantage point, choose a zoom setting, or even set an exposure that reveals the dominance of that element. By using a wide-angle lens,

for instance, you can exaggerate the long sinuous curve of the shore; by exposing for the colorful sky you can turn the palm trees into black silhouettes, boldly revealing their shapes.

Rarely, though, are the main graphic elements isolated from one another; more often they exist in a mingled conversation that you must decipher and interpret. Your sweet grandmother (a shape) walking up her garden path (a line) made of gravel (a texture) is a great example of how graphic elements are blended together to provide a realistic two-dimensional rendering of a three-dimensional world. Finding a way to organize these visual components so they reinforce rather than conflict with one another often makes the difference between a so-so composition and a great one.

Of course, unraveling a pretty scene down to its graphic skeleton may seem like a horribly diagnostic reward (especially for your dear grandmother) for having inspired you in the first place. But for the world to appreciate the more soulful qualities of your subject, you first have to design an enticing framework to show it off.

One way to discover the power in graphic elements is to seek them out as subjects unto themselves. Instead of shooting landscapes next time you're out for a Sunday drive, look for pictures of shapes or lines. Or, if you see an interesting old barn, see how many patterns or textures you can pull out of it. You may discover that a whole new world of subjects has been hiding right before your eyes.

Patterns and Repetition

I love patterns because it really doesn't matter what the subject itself is. If the pattern is strong, it will be visually interesting. Some patterns—like the arches and windows reflected in the water above—shout out to be photographed. Other patterns are subtle, or even somewhat hidden, and reveal themselves only to the observant.

Patterns exist whenever any of the familiar elements of design—lines, shapes, colors, or textures—repeat themselves in an obvious way. Nature in particular is a boundless source of interesting patterns, but human-made creations are also rife with repetition. Sometimes you can photograph the connection between nature and what man has constructed, as in the spiral patterns on the opposite page. From the colorful diamonds and squares of patchwork quilts to the lines of the Eiffel Tower, we use patterns as a motif whenever we can.

©FRANK GALLAUGHER

Some patterns, like the stairs that you climb from your living room to your bedroom are obvious (not to mention useful) and others, like the pattern of spots on an insect, have to be sought out. Once you become aware of patterns though, they seem to pop up everywhere. And because they're so prevalent, it's great fun exploring for new ones.

You can use patterns to build compositions in many ways. By choosing the right vantage point, you can use them to direct attention to your main subject—letting newly tilled farm rows lead the eye to a distant farmhouse, for example. Or, if they're obvious and interesting enough, patterns can transcend a supporting role to swoop in and take over the leading role. In the shot of the chambered nautilus shown here (at right), for instance, the pattern of spirals becomes the main subject.

The key to building a composition from a pattern is to isolate it from its surroundings—either by cropping tightly or by finding just the right angle to emphasize the repetition of elements. Anything that isn't a part of a pattern usually distracts from it, so be ruthless in excluding extraneous material.

OKEVIN KO

Foreground Frames

Foreground frames help isolate and focus attention on your center of interest. Chosen carefully, they can also reinforce a visual theme.

Frames also have a functional use because they can hide extraneous background material. One decision you'll face in using foreground frames, however, is whether to keep the frame in or out of focus. By using a relatively wide lens and a small aperture, for instance, you can get enough depth of field to bring both into sharp focus. By using a longer lens or a wide aperture you can toss the frame out of focus to further emphasize your main subject.

In the classic example of a tree branch being used to frame a landscape or travel scene, an out-of-focus branch will enhance the feeling of distance between it and the rest of the scene—but it can also be a distraction. In general, having both parts of the scene sharp is less distracting than a totally unfocused framing device.

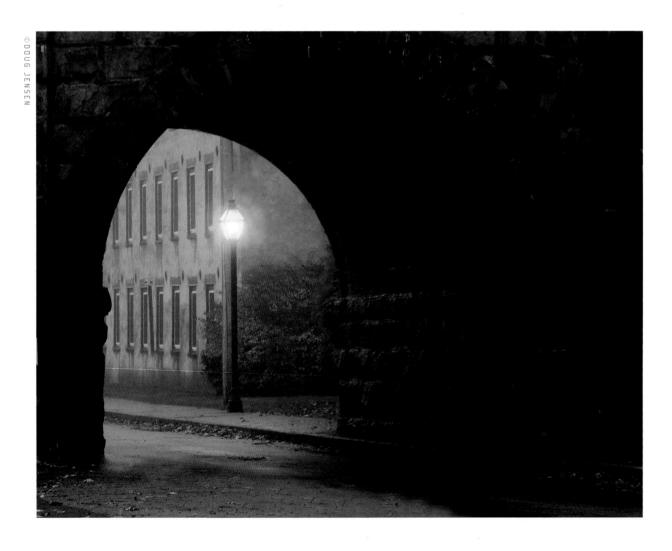

As a rule (and rules, as you know, were meant to be broken) you should also try to choose a frame that is darker than the main subject. If the frame and subject are too similar in brightness, the impact of the frame is diminished. It's important to take your light reading without the frame in place and then use your exposure lock feature to lock that exposure while you recompose the scene to include the frame.

©KEVIN KOPP

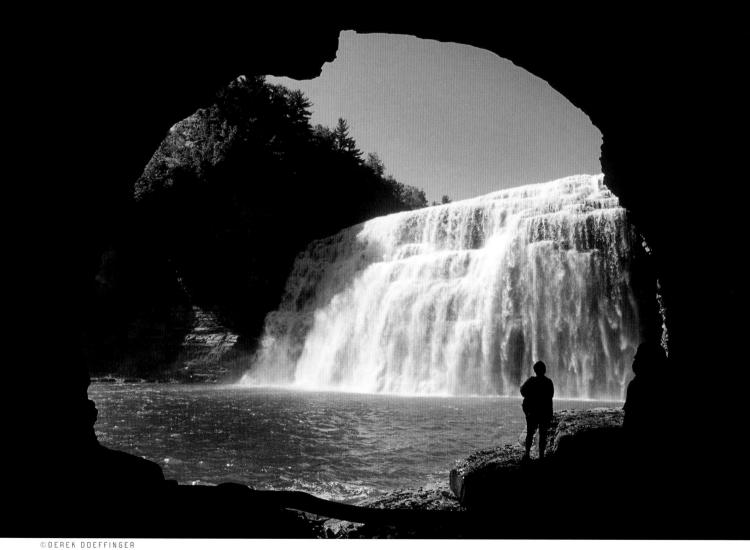

The Depth Illusion

From the time we're two or three months old, the ability to perceive distance and depth becomes an increasing part of our visual reality. In fact, you can almost tell the moment some babies discover depth because they start reaching into space, testing distances, and discovering that their toes are very handy for playing with and that their sister's nose is much closer than the clock on the wall.

Perceiving depth, of course, is a wonderful skill to possess (as both a baby and an adult) because it enables you to make judgments about all sorts of important things, like how far you can crawl before you tumble down the stairs and just how far you'll have to reach to swipe a cookie from the kitchen table. Humans are able to perceive distance because we view the world through a pair of front-facing eyes set about

two and a half inches apart. Each eye provides its own separate visual signal to the brain. Using a system called binocular vision, our brain sorts the differences in the slight offset of the two images, compares them, and then formulates a sense of distance.

Since photographs are only a two-dimensional interpretation of a threedimensional world, we have to rely on a little visual trickery to create the appearance of depth in our pictures. And while no one has ever bumped their nose trying to step into a photograph, the imagined sense of depth and distance can be quite believable. We know that objects get larger as they get closer, for instance, so if we see a car heading toward us and getting larger, we know it's time to hop out of the road.

In composing a photograph then, it's important to be aware of and use the various visual cues that help establish depth in a two-dimensional plane. By exploiting (or eliminating) these cues, you can greatly exaggerate (or remove) the sense of depth in any type of scene.

LINEAR PERSPECTIVE

If you've ever driven across the American West and found yourself on a road that seemed to stretch on forever and diminish to a tiny vanishing point in the distance, you've experienced the classic example of linear or "one-point" perspective. Linear perspective occurs whenever parallel lines—railroad tracks, highways or even split-rail fences—converge as they recede. Our brains know that the lines are, in reality, parallel—so it perceives the convergence as an indicator of distance.

You can exaggerate linear perspective and heighten the feeling of distance by carefully choosing your lens and your vantage point. By using a wide-angle lens from a vantage point that clearly reveals the convergence—as in this shot of a state highway in the Arizona desert—you can intensify the illusion of distance.

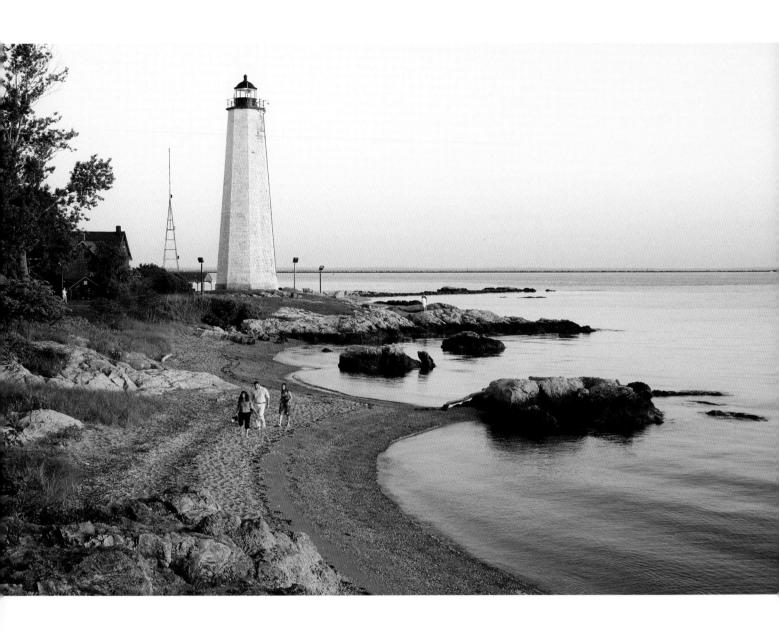

DIMINISHING SIZE

Exploiting our common knowledge of the size of known objects is another powerful way to depict distance. We know how big a person looks when they're standing eye-to-eye with us, so when we see a tiny human figure in a photograph we can assume that the person is quite a distance from the photographer. When you include a series of similar objects at different distances from the camera—a line of telephone poles along a country road, for instance, the illusion becomes even more obvious. On the contrary, eliminating any references to size helps to remove that sense of distance when you're trying to create more abstract pictures.

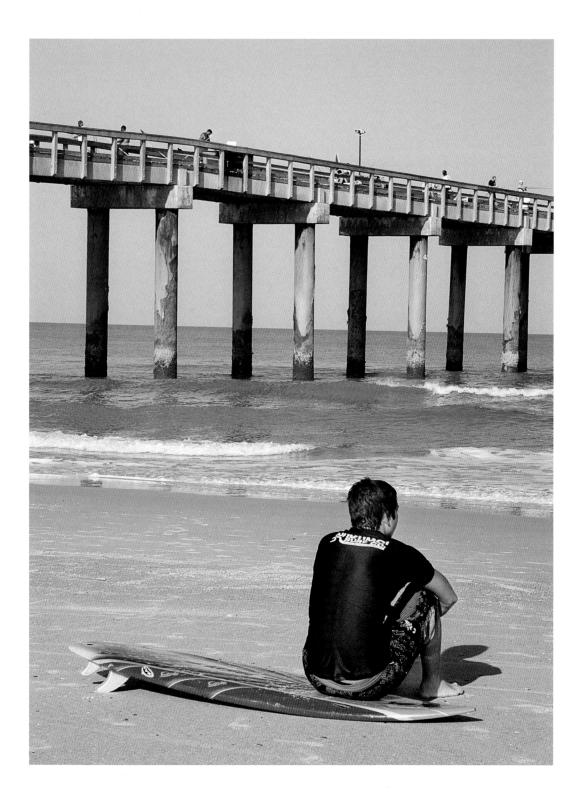

UPWARD DISLOCATION

Subjects that are higher in the frame enhance the appearance of distance because they emphasize the expanse of the foreground in comparison to the smaller subject size. If you're photographing a runner on a track, for instance, by using a low shooting angle and placing the runner at the top of the frame, you make the runner seem more distant than if you were to shoot at eye level and place him in the center of the frame. Landscape photographers often use this technique—placing the horizon high in the frame, for example—to exaggerate distance in outdoor scenes.

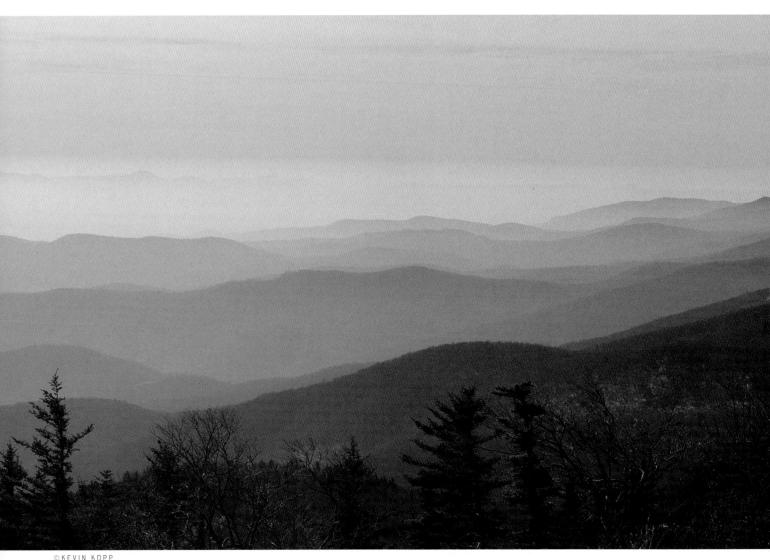

©KEVIN KOPP

AERIAL PERSPECTIVE

Aerial perspective happens when atmospheric haze or fog lightens distant objects more than nearby ones. You can see the effect clearly when you're looking at a mountain range from an overlook and the nearby peaks seem dark and then get progressively lighter as they fade into the distance. You can help create the effect by using a long lens that, while compressing apparent perspective, exaggerates the tonal contrasts by bunching them closer together. Aerial perspective works best when you include both nearby and more distant objects and when there are several layers to the composition. Hazy or foggy days make the illusion that much more real.

A Sense of Scale

Among the most famous postcards to ever come out of the American West were the shots of cars and trucks driving through the trunks of giant redwoods. While the habit of hewing tunnels through these magnificent trees (which thankfully is no longer practiced) certainly didn't do the trees much good, it was an eloquent way to prove one point to the folks back home: these are big trees.

Short of carving up a monumental work of nature to make a point, placing something of known size in your photos to reveal a scene's true scale is very important. Even with a subject as grand as the Grand Canyon—or perhaps especially with a subject so grand—it's important for your viewers to have something of known size for making visual comparisons.

The best measuring stick for expressing scale, of course, is another person—everyone is familiar enough with the size of the human figure to make a good judgment about the size of the surroundings. While hiking in the magnificent landscape to the right, my companion hiked ahead of me to an overlook. Thinking quickly, I put her into the shot to illustrate the scale of the landscape and to add an element of human interest to the scene.

At times, particularly if you're shooting natural pictures, you may not want to introduce something that isn't an inherent part of the composition. Instead, try getting close to one object—a rock or an outcropping of ferns, for instance, so that the viewer at least has one familiar object for comparison. Even if the exact size isn't known, having something familiar in the foreground does provide a sense of proportion.

Of course, there may be times when you want to pervert the sense of scale in a scene by providing wrong size cues. Hollywood film directors frequently do this by creating special room sets where the scale of common objects has been shrunk or enlarged by a small percentage to play tricks with perspective. Another way to do it is by using a wide-angle lens close to a small object and letting it tower over larger, more distant subjects—making a mushroom tower over distant trees, for instance. Or you may want to eliminate all hints of size and scale to create a more abstract view.

One of the most common complaints from photog-raphers who return from trips to mountainous areas is that the feeling of space and grandness so overwhelming in person disappears in their photographs.

Photographer Interview

Troy Paiva

Troy Paiva's Lost America

In many ways, Troy Paiva approaches his craft from an entirely different perspective than most other photographers. Unlike those who seek the inherently beautiful, the perfect, and the pristine with their cameras, Paiva intentionally—and aggressively—searches for the ragged, frayed, and discarded. Shooting mainly in the Southwest United States, he chooses locations many of us never see and barely realize exist: auto junkyards, aviation graveyards, ghost towns, and abandoned amusement parks—to name just a few. And yet, in these forsaken, derelict, and often dangerous locales, he is able to find (and to a large degree fabricate) the strangest and most enchanting of images. Even more interestingly, he creates all of his photographs at night. He is, in fact, exclusively a night photographer.

Interestingly, Paiva didn't learn his craft in daylight and then morph into a night shooter. "Unlike every other night photographer I've ever spoken to, I was not a regular photographer first," he says. "My first SLR was bought specifically to do night shooting. Because of this, my perspective on it was unhampered by the limitations and expectations ingrained from traditional techniques."

Using a combination of portable artificial light sources (mainly small flash units and flashlights) to "paint" his subjects, along with the light of the full moon, Paiva transforms the remnants of the industrial past into an otherworldly, and often hauntingly beautiful, landscape. It is a world of color, mystery, and imagination that will forever change the way you look at photography, the nighttime landscape—and junkyards.

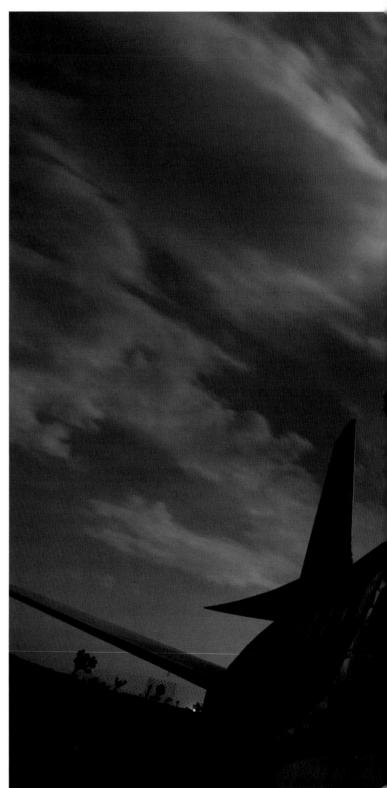

©TROY PAIVA

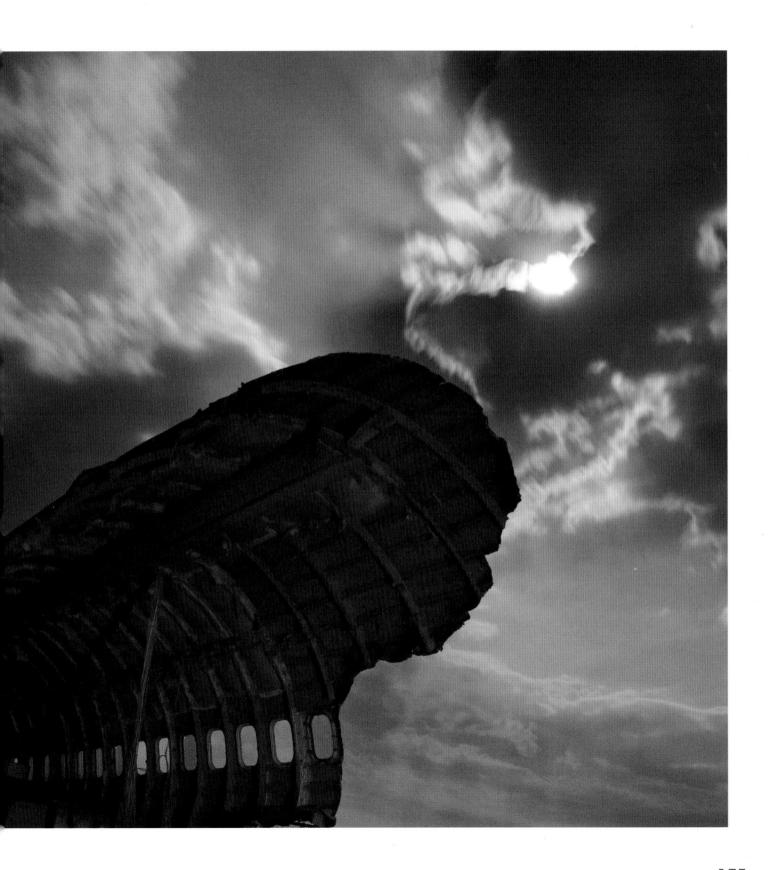

©TROY PAIVA

When did you first get interested in night photography?

I saw night photography for the first time in 1989 when I was 29. At the time, I was a designer and illustrator for a toy company and I was looking for a type of artistic expression that was as far removed from the techniques of my day job as possible. I fell for the idea of abandonment-based, light-painted, night photography. Hard. Seeing that original concept through has been a 20-year obsession for me.

You describe what you photograph as the "underbelly" of America. Tell me what these subjects are and how you got started photographing them.

Visiting abandoned places and transportation junkyards simply for the adventure and to soak in their atmosphere was just something I did from a very early age. As a teenager, I started out 'ghost towning' in the deserts of the west, and that evolved into exploring any other kind of lapsed locations. When I discovered light painting and night photography, I immediately saw it as the perfect way to capture the surreal, haunting vibe of these forgotten and ignored places that are at the ends of their lives.

What attracted you to these subjects?

The solitude and that "last man on earth" feeling. The adventure and thrill of being someplace that few people get to see, or even think to visit. The beauty of decay, of nature reclaiming these places and objects. The melancholia, the pathos, the drama—and all deeply enhanced by the dark of night.

Waiting eight minutes for your exposure to burn in, alone in the middle of an entirely abandoned subdivision or a massive decommissioned military base under a full moon, in the middle of the night, is truly an epic experience.

Do you ever feel threatened or in danger when shooting?

Yes, quite often. The thrill is part of the attraction, but the danger is real. Anyone doing this kind of photography needs to be smart about it. Don't go alone, wear appropriate clothes and don't over-reach your physical capabilities. If you get caught trespassing, don't run. Relax and put the authorities that found you at ease. Carry samples of your night photography done in similar types of locations as proof of your intentions. I've been caught countless times and have never been arrested or even cited. Better yet, find the owners beforehand and get permission.

Approximately when did you make the switch from film to digital?

October 2005. After shooting film at night for 15 years, I was frustrated by lab closures and the quality of processing during the decline of the film era. Digital technology just wasn't there yet, mainly because of sensor overheating, creating massive noise issues during time exposures. In frustration during this technology-gap, I stopped shooting for about a year. Right around middecade I saw some butter-smooth digital night work that made me realize that the new CMOS sensors could finally allow minutes-long exposures with little or no noise.

In what ways has shooting digitally helped your work?

The move to digital was like throwing creativity-fertilizer on me. The biggest advantage is the ability to instantly see the image on the camera's LCD screen; for me that was a revelation. Many factors can—and will—ruin night shots: camera movement, misestimating lighting intensity or f/stop, lens fogging, and exposure-length-induced reciprocity failure. With film, you wouldn't know if you were even close to getting the shot until the next day when you picked it up from the lab. With digital, you can just reshoot and relight it until you're 100% satisfied with the preview—it was a sea change.

What are your favorite types of location?

I love a good junkyard, the bigger the junk the better. The airliner bone yards are always amazing; there's nothing quite like standing next to a 747 that's been chopped in half, laying in the sand, weeping fluids, like a gutted fish. In 2008,I was lucky enough to get access to shoot a derelict ocean liner for a few nights, days before it was towed to Asia for salvage. That was a once in a lifetime experience.

Do you return to the same places over and over, or are you constantly looking for ones?

Yes, there are locations that I like to return to. The process of night photography can be slow and painstaking, so it may take a series of nights until I feel like I've done what I need to do to tell the story of the location. One of the things I like about reshooting junkyards and salvage operations is that they are constantly changing as objects come and go. That said, I am always on the lookout for that next great location.

Talk about how you actually create an image. How long is a typical exposure?

Anywhere from a few seconds to eight minutes, with most full moon-lit exposures running between two-to-four minutes at f/5.6, ISO 100. Generally, I stick to f/5.6 because f/stop changes the fall-off from strobes and flashlights. I like the predictability of working at the same f/stop, it's just one less thing to go wrong. Because my work is shot with a wide lens and I mainly shoot expansive exteriors, I can get away with the reduced depth of field. If I do need more depth of field, I'll do two exposures at two focal distances and combine them in post-processing.

Because these exposures are minutes long, I can walk through the scene, right in front of the camera and not appear in the finished image.

Do you bracket exposures?

I don't, in the usual sense. I have a good idea of exposure length through experience, and I rely on the LCD to judge the image. Just like shooting during the day, if it's too dark, double the exposure length, too light, cut it in half. The difference is that instead of going from 1/125 to 1/250 to 1/500, you're going from two minutes to four minutes to eight minutes. One way that I do bracket is that I'll try a series of different lighting looks and effects and see which one I like the best.

What is the sequence of the exposures? Do you start with a long existing light exposure and then paint—or are you painting from the start?

I'm light painting right from the first exposure. I initially assess the scene as I set the camera up. If I plan on light-painting the image, I walk around with a flashlight and experiment with angles and colors of light before I open the lens. Once I get a sense of what I want to accomplish, I jump right in with a multi-minute exposure, with all my lighting.

Do you check the progress of exposures on your LCD?

Constantly. I study every exposure to see what aspect worked and what didn't, incorporating the technique that worked in one section of the frame into the next exposure, and trying something else on the other section I wasn't happy with. I keep doing it until I'm satisfied with the overall effect. I also make sure not to move the tripod once I get the exact composition I want. That way I can easily stack and combine parts of different exposures in post-processing in case I don't get it right in the camera.

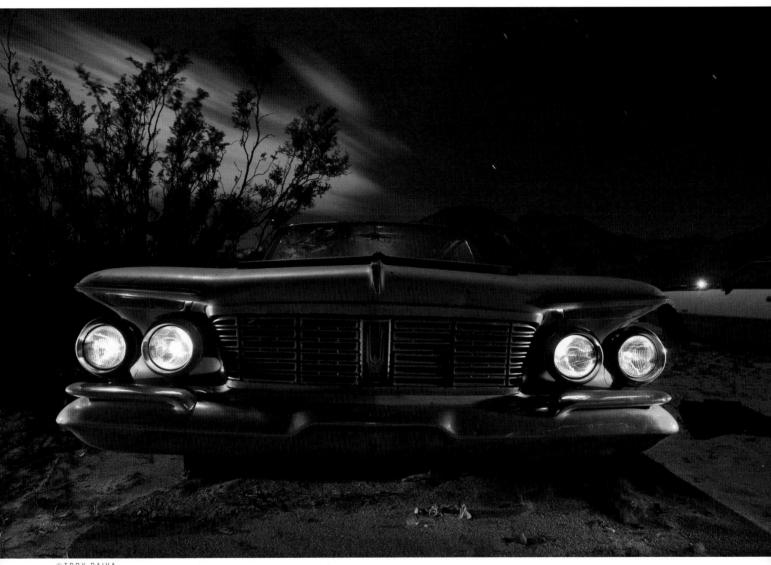

©TROY PAIVA

"I love a good junkyard, the bigger the junk the better... One of the things I like about reshooting junkyards and salvage operations is that they are constantly changing..."

What are you using as your light sources for painting?

The predominant light source of all my exterior images is the full moon. I only do this work in about a sevenday period around the full moon. This is what gives a lot of my work that skewed daylight quality. Remember, moonlight is really just reflected sunlight, so it reacts in the camera the same way, there's just a lot less of it.

My light painting is done with a few flashlights of varying intensity and a hand-held strobe flash, fired manually. A flashlight produces a softer look than a strobe because you're moving it, which can blur the shadow edges, while the strobe, with it's instantaneous burst of light, casts very strong and delineated shadows. Strobes can light a very large space evenly in a single burst, while the light from a flashlight gives a highly controlled area of coverage, but can get streaky and blotchy when you're painting a large area. I also use a snoot sometimes to concentrate the light into a very narrow beam to isolate only a small area of the image. Flashlights can vary wildly in color cast, depending on the bulb type. LED flashlights look white to the eye, but tend to have a strong blue cast in the final image. Incandescent lights are much warmer, often shifting more toward yellow or orange.

Frequently, I use colored gels over the light source to change the color cast even further. Gel sheets can be bought at theatrical supply houses and cut into small, easily manageable swatches. I only use six different colors (red, blue, green, purple, orange, and lime) for all my work, but the ability to shift these colors by using LED vs. incandescent light vs. strobe and then adjusting the white balance setting in post gives me an almost unlimited variety of colors at my disposal.

Do you change the colors of gels if you don't like what you're seeing?

Yes, I'm always experimenting with different colors and angles of light in every setup. Strong color will distract from the details of some subjects, or prevent a dark object from being lit enough, so I keep the light as natural as possible in those situations. Other subjects are a strong color already, so I try to stick with that same range of color, i.e. if a car is blue, I'll light it with cool colors; warm colored wood looks best with yellows and reds, etc. The idea is to enhance the tones of your

subject rather than fight them. A neutral-colored subject gives you an open palette to work with. Then you look for colors that will contrast or compliment the rest of the scene.

How many shots do you try to do in a night?

Depending on the location, I can do about 30 setups in a six-hour night, but I've been doing this a long time and can work pretty fast. I find most students at my workshops do 10-15 setups in a night. It's better to slow down and do just a few great shots than a whole pile of shots that are only OK. When I was first starting out, getting only one or two good images from a whole weekend of night shooting was pretty typical.

Do you feel that you are breaking ground with your photography or just continuing a tradition?

The first photograph ever taken was an eight-hour time exposure, and night photography as we know it dates back to the 1880s. Conceptually, light painting is simply an offshoot of studio-strobe lighting, and that was invented in the 1930s. Lighting with constant-source lights, like flashlights, is as old as the movies. Photographing ruins goes back to the beginning of the medium— and a thousand years or more when you consider paintings of ruins. So, I didn't really invent anything here. I just combined some things that hadn't been combined before, like the Reese's® Peanut Butter Cup, and then popularized it by having a strong web presence with a detailed technique page practically begging people to go out and try it. But I had no idea it would become the pop culture phenomenon it has.

For more about Troy Paiva, see www.lostamerica.com.

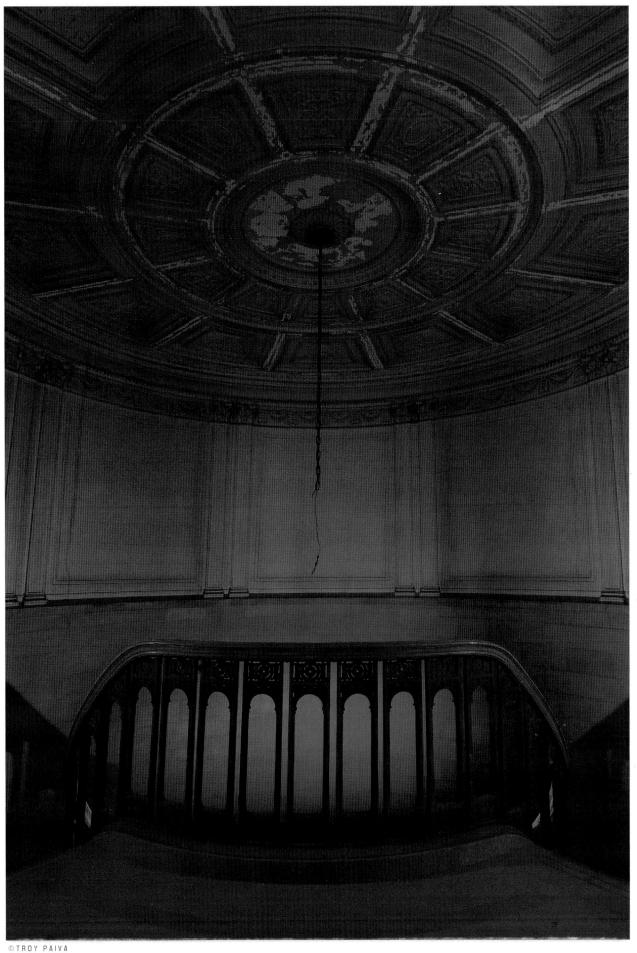

"In photography there are no shadows that cannot be illuminated."

-AUGUST SANDER

Introduction

Ancient alchemists believed there was a magic substance called the philosopher's stone that could turn lead into gold and, as the legend goes, they believed it to be a common substance, found everywhere but neither recognized nor appreciated. For photographers, that enchanted touchstone is light. Though we often take its beauty and power for granted, by its very presence the right light can turn a crowded city street into a temple of gold, a rusting tractor into a bucolic antiquity—or restore the glint of youth to the fading eyes of age. Call it the photographer's stone.

No matter how often we witness the beauty of light, because it is so fleeting and so infinitely variable, it almost always has the power to surprise. Scenes to which our visual and emotional receptors have grown numb suddenly demand our appreciation. Out of the blue a neighborhood pond you've driven past a hundred times mirrors the shimmering dawn and your inner-artist slams on the brakes to record it—a good argument for always having your camera handy (and for wearing your seatbelt). Without warning, light has beckoned and you must respond.

Training yourself to appreciate the many moods and whims of daylight is the starting point. Though the sun that lures us to the morning garden with its buttery caress later sends us dashing for cover in the brilliant blaze of noon, we rarely take notice of the thousand faces of that transformation. As mercurial and transitory as light is though, you can—and must—study not only its charms but the very qualities that make it special: its color, its direction, its quality and its intensity.

Photographic light is not limited to the light of the sun; the moon, the stars (of which the sun is one), city lights, campfires, or candles can each be a fascinating source of illumination. And both indoors and out, artificial lights offer their own special beauty.

Whatever the light source, whatever the subject, once you become aware of the qualities of light, you'll discover your own philosopher's—or photographer's—stone and begin turning ordinary moments into golden ones.

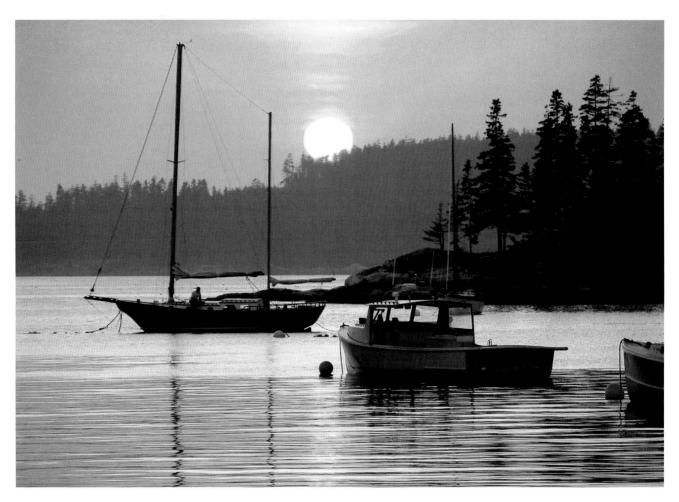

Time of Day

If you were really ambitious (or incredibly lazy, depending on your perspective) and sat in one place from dawn until dusk and every fifteen minutes shot one picture of the exact same scene, you would create an amazing visual study of how light changes throughout the day. You would also, no doubt, acquire a seriously sore backside, but the pictures you produced would show exactly how changes in daylight affect the look of a particular place. You would see those changes from only one perspective, of course, but you would still learn a tremendous amount about the nature of daylight.

The most important thing you would learn in studying your images is that as the earth spins merrily on its axis and revolves lazily around the sun, light perpetually changes the appearance of everything it strikes. Naturally, a high percentage of pictures from an experiment like that would be rejects—even if the scene itself

If you know what to look for, you can call upon even subtle changes of light to improve virtually any scene.

were interesting and attractive. Some would have the light coming from the wrong side of the subject, or hit it at the wrong angle; some would be lit too flatly and others too harshly. And in some shots the lighting might be adequate but boring.

But in that collection of pictures, you would find a few that were aglow with a beautiful illumination graceful and gentle in quality, elegant in color, and flattering in direction. And those would be the pictures that were created for you by the sheer beauty of the lighting. After all, if nothing but the light had changed and a few images rose above all of the others, you would have to give credit where credit was due.

Because daylight changes gradually, we simply don't notice it (kind of like the way a few cookies a day end up changing our waistlines). Only when lighting changes suddenly—when storm clouds part and a ray of golden light ignites the landscape—do we really become aware of the presence of light. But if you know what to look for, you can call upon even subtle changes to improve virtually any scene.

Most of us, of course, don't have the time (or the patience) to sit beside one scene and watch it morphing from sunup to sundown. But next time you're walking around your neighborhood or driving in the country and you suddenly become aware that light has muscled its way into your consciousness, try to analyze why that particular light is so special. Is it the color of the light? The intensity? The direction?

In the following pages we'll take a look at some of the ways in which light changes—and how you can use it to capture ordinary places at extraordinary moments.

©KEVIN KOPF

Light Direction

Light seduces when it surprises, and one way to surprise your viewers with light is to have it strike your subject from unexpected directions. Though most of us have been conditioned to keep the light over our shoulders and flush on the front of the subject, there's no reason not to put the light behind or above or to the side of your subject. Changes in lighting direction (as well as your position relative to the light) have a tremendous impact on your subject's appearance. In fact, virtually every aspect of a subject's shape, form, color and texture is affected by direction of the light striking it.

As the direction and angle of light changes, so does the personality of your subject. A tulip safely (and predictably) lit from the front is bright and colorful, but when lit from behind its translucent petals glow as they radiate light and color; lit from the side it becomes a brief and beguiling hesitation in light's meandering journey. Still-life photographers may spend hours positioning lights so that each tiny nuance of their composition is shown to its best advantage.

Of course, one of the nice things about using the direction of light as a creative tool is that you can change how your subject looks by simply walking to a different vantage point or, if you're using artificial light, moving the light source. Outdoors, even if you can't physically move around your subject (it's kind of tough to walk around a mountain peak sometimes), you can always take on the sun as a partner and wait for its position to change. And, of course, with some subjects (your dog when he's feeling cooperative, for example), you can change your subject's position relative to the light.

Keep in mind that the direction of light also affects the mood of a photograph. The bright, strong colors produced by front lighting remind us of cheerful and carefree summer afternoons, while the long, low light from the side creates a more contemplative tone. Backlit scenes exude warmth and, particularly with landscapes, often kindle recollections of summer days gone by.

LIGHT FROM THE FRONT

Although not particularly interesting or dramatic, front lighting does have a few redeeming qualities, and excels at some visual tasks. Front light acts like a spotlight, stripping away all modesty and mystery and revealing great amounts of detail. By lighting all areas of the scene equally, it encourages the eye to explore every facet and fold of a scene. Front light buffs colors into brash brilliance, allowing you to emphasize color as a design element.

The biggest drawback of front lighting is that the near absence of shadows diminishes depth and dimensionality. Falling away from the camera, shadows are hidden by the objects casting them. Without shadows to help sculpt objects, scenes lack three-dimensionality. On the other hand, the absence of shadows crisscrossing your scenes prevents your designs from becoming too busy.

Late afternoon front lighting (above) is particularly good for architecture and city scenes because it brings warmth to otherwise cold subjects. For this photo of an urn, I waited until the sun was almost at the horizon and level with the building so that the normally gray limestone was bathed in a rich orange glow that revealed the fine detail of the filigree. One small problem you may encounter when using a low sun for front lighting is keeping your own shadow out of the composition.

LIGHT FROM BEHIND

One of the marks of a very experienced photographer is the use of backlight, where the main light is coming from behind the subject. It takes some practice and experience to get the exposure right, but when it's handled well, backlighting can be very dramatic.

When you place the light source behind your subject, particularly if it's a strong directional light like late-afternoon sun, several interesting things happen simultaneously. The most obvious visual effect is that opaque subjects suddenly turn into silhouettes and translucent subjects (tree leaves and people's hair, for instance), begin to glow. If you combine these

two concepts, a gnarled old oak tree in its autumn foliage, for example, you get a lovely dark shape of a tree set afire by a crown of glowing leaves. And you just can't beat glowing leaves and black tree trunks for drama in an autumn landscape.

Shooting directly into the sun also creates a great sense of depth in landscape scenes because all of the shadows are coming directly at the camera, an effect you can exaggerate with a wide-angle lens. It's best if you hide the sun itself behind a solid object like a tree limb, building, or a cactus; otherwise, the sun's rays will obliterate foreground detail and wreak havoc with your exposure system.

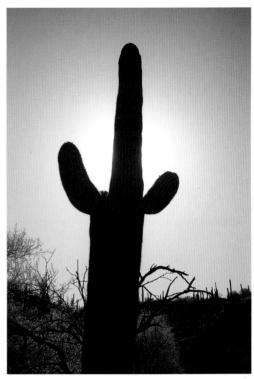

Not only does backlighting place the front of your subject in relatively deep shadow, but it also permits the rays that make it past the subject to go directly into your camera's lens.

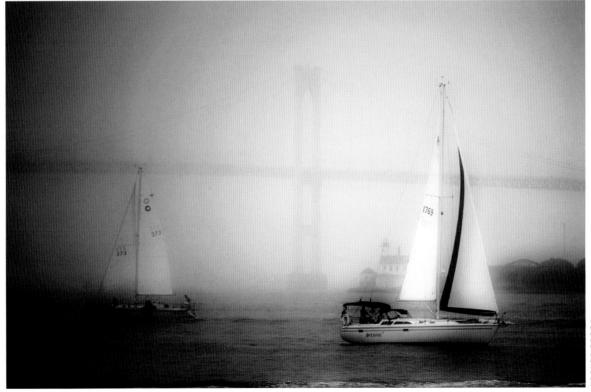

UG JENSEN

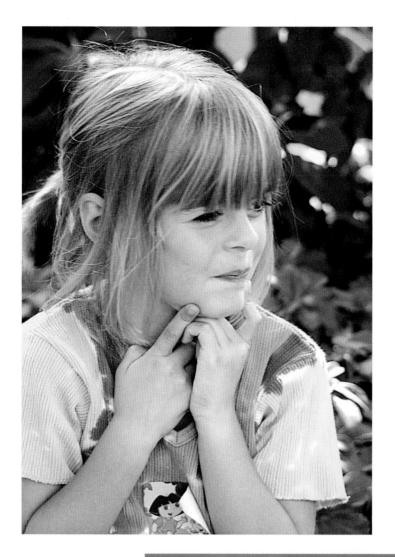

You might want to experiment with exposures by manually bracketing in one-stop increments, or by using your camera's auto bracketing feature. If you're lucky enough to get a strong sun coming through a morning mist or fog, however, the effect can be positively magic—that's exactly what photographer Doug Jensen did in the beautifully lit scene in the bottom photo on the opposite page.

If your subject is relatively close, like the girl in the picture to the left, you can use your camera's fill-flash mode to open up the shadow areas. Alternately, you can simply aim a small reflector at the subject and use the sun's rays to brighten dark areas.

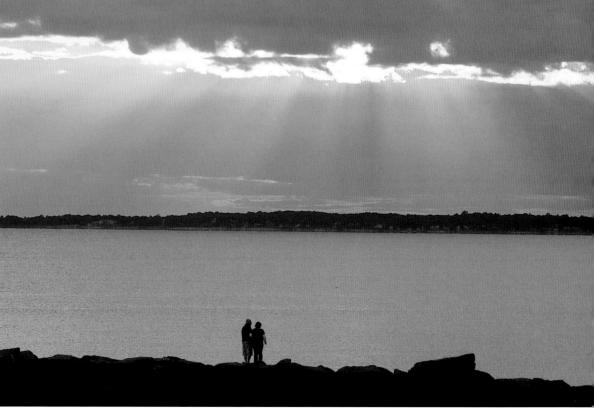

With broad scenes, you'll have to experiment with exposure compensation to control exposure. In most cases you're better off adding just enough to record some foreground detail while not burning out the highlights entirely.

LIGHT FROM THE SIDE

Of all the directions that light can strike your subject, light coming from the side gives subjects a very tactile appearance. As the light steals across surfaces, shapes and forms expand and contract while surface details ignite in the passing light or hide in newly created shadows. Whether you're photographing a broad scene like a landscape or a more intimate subject like a portrait or a still life, side lighting brings the third dimension to photographs.

In landscapes, side light lays out a patchwork of shadows that, like backlighting, adds depth and a three-dimensional feeling. The length of the shadows, of course, depends on the time of day (and in part the time of year), but the lower the sun is to the horizon, the longer the shadows are. A benefit of photographing outdoors in side light is that on a clear day you get

two chances at it: if you're working early in the day you'll see long shadows shrink as the sun rises, only to lengthen again—traveling in the opposite direction at sunset. Side light works best if you have just a few dominant features: a row of trees at one side of a meadow casting shadows across the field, for example.

Sidelight from an early or late sun can create a pleasing portrait because its yellow color and softer shadows flatter subjects.

Exposure Tip

For high contrast scenes, you may have to notch up the exposure compensation to +1/2 or even +1. If your camera has a histogram display function, study it to see if the contrast appears too extreme. The histogram graphic is a more accurate measure of contrast than looking at an LCD display.

LIGHT FROM ABOVE

Light from the overhead midday sun creates top lighting. Our first response? Ugh. So let's get the negative things about midday sun out of the way: it's harsh, it creates deep shadows, it hides textures and it sunburns the peaks of some of my middle-aged male friends (not me, of course). There's no reason to make a blanket apology for top lighting, though, and simply put the camera away. While I wouldn't say high noon was my favorite time of day to shoot pictures, top lighting is light after all and, personally I'll take its dominating brightness over a gray day anytime. Like any bully, midday light has its charms—you just have to peer a little deeper into the shadows to uncover them. Mad dogs and Englishmen aside, going out in the midday sun can be a very interesting time photographically.

©KEVIN KOPP

Exposure can be tricky at midday because the harsh light produces dark shadows. But sometimes you can use that bright, overhead light to your advantage when the shadows themselves become an interesting aspect of the picture.

One of the redeeming qualities of a brilliant blast of daylight is that it emphasizes the texture of surfaces.

From the first
pinkish rays at
sunrise until the
sun disappears in
a brilliant blaze of
glory, the color of
daylight endlessly
morphs itself.

The Colors of Daylight

Although there are many sources of light on earth—some manmade, some not—our main source of illumination for outdoor photography is the one that travels approximately 93,000,000 miles (at 186,000 miles per second) to get here. Day after day, eon after eon, the sun illuminates every corner of our waking world with enough energy left over to warm our faces on a winter's day. As one astronomical website put it: you've really got to admire a light that travels that far and is still bright enough to hurt your eyes.

Though we refer to the sun's light as "white" light, daylight is, in fact, made up of virtually every color in the visible spectrum—violet, blue, green, yellow, and red are all a part of the ultimate rainbow coalition. If you doubt that the sun's light bears all colors, just hold a prism in its path or chance onto a rainbow glinting in the spray of a lawn sprinkler. There, spilled out before you, is the visible proof of the symphony of electromagnetic wavelengths that engulf us.

During most daylight hours, the blend of wavelengths in sunlight is equal enough so that we see daylight as a neutral color. But as anyone who has walked out into the first yellow rays of morning knows, there are times when daylight takes on some pronounced hues. As it passes through the atmosphere, pollution, and the morning mist, portions of the light's energy are deflected or scattered causing the color of the light to change.

Indeed, from the first pinkish rays at sunrise until the sun disappears in a (hopefully) brilliant blaze of glory at sunset, the color of daylight endlessly morphs itself. It can scorch the landscape with the scarlet vengeance of an African sunset, or retreat sullenly in the purple glow of an urban dawn. And as its color changes, of course, so does the color of virtually anything that it illuminates—a white barn sits awash in yellow in the early morning light, a figure walking on the beach is bathed in orange from the setting sun.

©ROBERT GANZ

GOING FOR THE GOLD

The color of daylight is perhaps most dramatic—and changes fastest—closest to dawn and dusk because the light is at such an extreme angle to the earth. In the last moments before sunrise, as the black night sky yields to the coming daylight, the landscape is cool and violet, inhabited only by the dark shapes of barely recognizable objects. Within moments, though, as the sun slips over the horizon, its pastel light washes the landscape.

Painters and photographers often refer to the first hour or so after sunrise and before sunset as the "golden hours," and you'll find a lot of travel and landscape shooters who work only during these hours. And who can blame them? Given the choice between a bright but coldly-lit midday shot of a lighthouse and one glowing in the bronze light of the day's last rays, editors will go with the "glow" every time. Because the light is changing so quickly at this time, however, picture opportunities don't last long. I've spent many mornings photographing swans on a river near my home and found that 30 minutes after the sun pops over the horizon the light loses its alluring blush. Within an hour the light has become pale and top heavy with far too much contrast.

Fog and mist tend to exaggerate the golden colors of dawn and dusk.

Weather, of course, has an impact on the color of light. Fog and mist tend to exaggerate the golden colors of dawn and dusk, but they can also smolder with an almost platinum iridescence at the middle of the day. Cloudy days steal away all trace of warmth and paint the earth in a cool, bluish wash. The amount of pollution in the atmosphere will also have an effect on the color of light because, as the sun's light reaches the last miles of its epic journey, it encounters atmosphere particles that cause the light to refract and scatter, intensifying colors.

The color of daylight profoundly affects the mood and emotions of a scene. The transient light of the golden hours gives pictures a cozy and inviting radiance, while the cooler light of a cloudy day or of the pre-dawn and twilight hours lends an air of mystery and perhaps even foreboding. The environment of a misty field on a glorious morning might seem wonder-

fully comfortable when photographed as the sun's rays warm the grass with yellow light; but captured in the cool light of a stormy afternoon or during a spring snowfall, the atmosphere is altered completely, to seem cold and less inviting.

White Balance Tip

White balance is an important camera control when considering the existing light. Ironically, Auto white balance will tend to neutralize strong color biases—assuming that what you're after is "correct" color. In effect, this strips away much of the heightened color or muted, cool mood that you found so attractive.

© KEVIN KOPI

To record the daylight accurately, set the camera's white balance to the Daylight setting or, if your camera allows, set it to 5500K.

The Quality of Light

When photographers talk about the quality of light, they're referring to its softness or hardness. Light quality can be a wonderful tool in establishing the mood and look of a photograph, especially when you carefully match it to the right subject. There's nothing like the crisp light of a sunny day to fire up the colors of a meadow full of wildflowers, for example, but there's also nothing quite as flattering as the soft sensual illumination of a north-facing window to light an indoor portrait.

The quality of light depends on a single factor: the size of the light source. Smaller light sources—like the sun on a clear day or your camera's built-in flash—create a hard and directional light. It seems odd to think of the sun (which has a diameter of a mere 870,000 miles) as a small light source, but because it is so far away, it has the same effect as a tiny, sharply focused point light source here on Earth. Larger sources—like the sun diffused by a large cloud or a flash bounced off of a ceiling—create quieter, gentler light. The larger the light source, the softer the light.

As light quality changes, even the same subject can evoke radically different emotions. The mood of a land-scape changes dramatically (and quickly), for instance, when a thin cloud veils the sun. In the hard bare light, shadows are deep and distinct, colors are vibrant, and highlights are luminous. As the cloud diffuses the light (creating a larger light source) the lighting softens, shadows lighten or disappear, colors become more muted, and rough textures soften, revealing subtler, more delicate surfaces.

Look for a setting with overhead leaves. Trees work wonderfully to diffuse and soften bright daylight sun so you can take pictures that have subtler tones.

Hard lighting usually provides a very cheerful feeling. It reveals textures and accents the strong lines of geometric subjects like modern architecture. Hard lighting also emboldens colors, though you run the risk of blowing out delicate tonal gradations.

Softer lighting is ideal when you want to create a soothing and inviting atmosphere. It caresses curved forms and shapes and softens shadows, romanticizing portraits, figure studies, and landscapes.

If you're photographing people or some other moveable subject in harsh sunlight, you can often find

a pool of softer lighting by taking your subject into an area of open shade—the shadow side of a building or under a canopy of trees. With light from the blue sky illuminating shady areas, its color, not surprisingly, is a bit bluish. You may want to reset your white balance to a "cloudy day" setting to warm up the colors or use a slight warming filter.

Controlling the quality of artificial lighting—flash or lamps—is fairly simple because you can often diffuse the light source itself. You can soften the harsh light of a flash, for example, by putting a layer of white fabric (a handkerchief, for instance) in front of the flash. Or, if you're using an accessory flash with a tilting head, you can soften the light substantially by bouncing it off a white ceiling or bouncing it into (or shooting it through) an inexpensive accessory diffuser. Indoors, lampshades soften the tungsten light bulbs beneath them, but you may want to turn on more room lights to lighten deep shadows.

Light quality can be a wonderful tool in establishing the mood.

DRAMATIC LIGHT

 F_{ew} sights pump up the pulse of a photographer faster than light shows erupting across the sky: the brilliant angelic rays of golden sunlight piercing through storm clouds, the gold and black wildness of churning storm clouds, or the last rays of scarlet sun pouring across a cornfield. These are the moments photographers lust for. And though discovering such moments is largely a matter of luck, you can increase your odds of experiencing them if you know where and when to look. (Or, as Edward Steichen replied when asked by a writer if he thought there was luck involved in creating his images:

"Yes, there is, but isn't it amazing how often the same photographers get lucky?")

Approaching and departing storms often unleash a torrent of platinum rays as the cloud formations begin to break up. Such rays typically begin to appear when the sun is at about a 45-degree angle to the horizon and gather intensity as the sun gets lower. Because the surrounding skies are usually a rich gray just before rays begin to burst forth, it's important that you use your exposure compensation feature to underexpose the scene by a stop or more from your camera's meter. If you were to expose for the dark clouds at the recommended exposure, the clouds would lighten in tone and the glory of the rays would evaporate.

Windy days also present opportunities for capturing wild light because clouds swirl and whirl into crazy formations that, when combined with the rising or setting sun, can produce spectacular displays. One of the few (very few) times I set my alarm to go off before the sunrise is when a nighttime storm is expected to begin clearing by dawn. Seeing the colors and shapes of the parting clouds painted by the first rays is like witnessing the world's creation—beautiful indeed (you thought I'd get up early for something mediocre?).

Interestingly, you can also find dramatic sunbeam effects in large interior spaces—cathedral interiors or large train stations—where high windows funnel the light into the dark interior. The great thing about finding the effect indoors is that you can go there on almost any sunny day if you know what time to arrive and see the phenomena repeated.

Exposing in this situation is difficult because the rays are so bright and the interior is so dim. You'll almost always want to expose so that you get some detail in the interior and then let the rays burn out. It's best to shield the lens from the rays when you take your initial reading and then use your exposure-lock feature to hold that setting while you recompose the image (typically, just holding the shutter-release button halfway down locks the exposure). Also, because the interiors of these places are pretty dark, it's sometimes hard to make a handheld exposure. In most places tripods are welcome if you ask for permission.

Finally, be patient enough to wait for great light events. If you're out shooting landscapes or scenic travel shots, wait until you're sure the sun has finished its performance before you pack up and leave. Often there will be a spectacular afterglow just after the sun has slipped away and the landscape ignites with a rich warmth reflected from the sky. After shooting Maine's much-photographed Nubble Light one summer evening, I noticed that all of the other photographers packed up when the sun hit the horizon. Suspecting they were leaving a bit soon, I left my camera set up. A few moments later a beautiful orange light painted the lighthouse (above). By the time the other photographers scrambled out of their cars the show was over.

In some ways, taking pictures indoors by existing light is easier than working with daylight, since the lights remain in constant position...

EXISTING LIGHT INDOORS

When you move inside it's tempting to simply pop the electronic flash on and let it rip—but rarely is oncamera flash as pretty as the existing light. Whenever possible, suppress the urge to use flash and go with the available light; whatever you lose in ease of shooting or action-stopping ability, you gain in atmosphere.

In some ways taking pictures indoors by existing artificial light is easier than working with daylight since, at the very least, the lights remain in a constant position (unless, of course, you move them). You also don't have to worry about dodging a passing squall or waiting for a cloud to pass over the light source. On the downside, most interiors are lit solely to keep people from tripping over the furniture (and other people) and rarely will you find any inherent charm in the lighting.

Since indoor light levels are typically low, you'll either have to raise the ISO setting (which increases digital noise) or increase the light level—assuming you can adjust the existing lights. If you're shooting an entire interior space—friends gathered in your living room, for instance—the simplest way to increase the existing light level is to turn on all of the room lights. Not only will the additional lights boost the light level, but also the added light will help fill dark voids. If you're photographing a person or a pet, you can often gain a stop or two of light by moving them closer to the light source and (in the case of people or very cooperative pets) having them face the primary light.

When you lack control of the existing light, such as inside a public building, often the best you can do is mount your camera on a sturdy tripod (or monopod, if either is allowed), or find something stable to lean on and use image-stabilization to extend your shutter-speed range. To get this photo of one of my favorite burger joints (right), looking from the outside in, I leaned my back against a fence rail and handheld the camera at 1/6 second. Had I not been so hungry I might have grabbed the tripod out of my car and done the job properly, but burgers were calling.

Unless you know the color temperature of the existing light, your best bet is to use manual or custom white balance and do some test shooting. If you're shooting familiar interiors—houses, hotel lobbies, restaurants, etc.—you should probably accept a certain amount of warmth in the images in order to help

capture the real feel of the location. Again, the Auto white balance will make some limited corrections, but it won't compensate for mixed lighting or an unusual light source.

Speaking of which, these days many interiors are lit by vapor lamps whose odd colors can be distracting in photographs. By shooting and examining a few test shots you'll be able to tell if the lighting is simply warmtoned or if it's turned a sickly green or yellow. In either case, by setting the white balance manually you can correct for most—though not all—light sources. If you happen to come across a particularly difficult source, you're better off setting the white balance as close as you can to neutral and making fine-tuned corrections in post-production.

You can create interesting effects at night using the Slow-Sync with Rear-Sync flash mode. Also called "Second Curtain" sync, this mode fires the flash at the end of an exposure, providing some sharp detail in contrast to the blur created by the longer Slow sync exposure, which is how I photographed one of New York's finest on patrol in Times Square.

OUTDOORS AT NIGHT

One of the nice things about the sun going down is that once it's dark out you can flip on the television and forget all about this photography nonsense, right? Wrong! While the sun may have slipped below the horizon to get a good night's rest, for photographers the nighttime world provides a whole new set of subjects and opportunities.

In fact, taking pictures after dark can be a lot of fun because there is such a wide variety of subjects and interesting light sources. From the full moon hanging over a harbor to streaks of taillights zooming along city streets, the nighttime world provides a great number of visual challenges. Shooting night scenes while you're traveling—particularly if you're in a city—is a great way to add some variety to your travel album. And since so few photographers make an effort to shoot after dark, your photographs will be sure to catch people's attention.

Because there is an almost infinite variety of artificial light sources, it's impossible to know what the color of a particular light source will be without making test exposures. Many cities have switched over to sodium

vapor lamps for streetlights, for example, and they provide a warm-toned coloring. But there are many other vapor-type lamps out there that create crazy color shifts in the green and purple regions and, again, you won't know which is which until you shoot a few frames. Spotlighting on buildings and monuments can also vary widely in both color temperature and attractiveness and again, it's best to experiment. One of the nice things about shooting these subjects digitally, of course, is that you can correct odd color shifts with your editing software.

Urban areas are particularly rife with interesting night subjects—neon signs, traffic streaks, theater marquis, and floodlighted buildings all make great subjects. Exposure tends not to be critical for most subjects (floodlit buildings, statues, etc.) but it's worth experimenting because as you increase or decrease exposure times the look of the subject will change—shadows will open with longer exposures, for example, and highlights may start to burn out. Try for an exposure that provides both good shadow and highlight detail.

You can vary exposure settings using either your exposure compensation feature (adding +1 and +2 stops, for example) or by using your autobracketing feature (or by putting the camera in its manual exposure mode if it has one). Keep in mind though that if stopping motion is important to you, it's best to use a wide aperture and the fastest available shutter speed. The LCD screen of your camera can be used as a rough exposure guide, but often it can be misleading—making highlights appear more washed out than they really are, for instance. Be aware though that long exposures use up more battery power and using the LCD only compounds that problem—so use it as little as possible or carry several extra batteries.

Because most nighttime subjects require a long exposure, you'll need a tripod to keep the camera steady. Long exposures can work to your creative advantage because any lights that are moving during the exposure (taillights, fireworks, stars) will record as streaks of color and light. But even if you don't have a tripod handy, it's worth experimenting with exposures that are long enough to capture those lights in motion and just let the camera shake become a part of the composition. Carnival rides, traffic patterns, and fireworks are just some of the motion subjects you'll find and all create very colorful and light-filled images.

Again, the length of exposure is really very experimental, but try to keep the shutter open long enough for the light to write an interesting pattern—letting a Ferris wheel make a complete revolution, for example, to get a circular light pattern.

You can also get some interesting night effects by using long exposures and moving the camera during the exposure. I love shooting photos of bright city lights from the windows of moving cabs. You can even just

jiggle the camera during a long exposure because sometimes wild things happen. In the shot of the Christmas tree (right), I kept the camera steady for most of the several-second exposure and then arced it skyward at the end of the exposure. You never know what shots like this are going to look like, but they rarely disappoint.

people

"It is by great economy of means that one arrives at simplicity of expression."

-HENRI CARTIER-BRESSON

Introduction

The great photographer Edward Steichen once said that photography's job was, "to explain man to man and each man to himself." And each time we photograph another person, whether we are aware of it or not, we are fulfilling Steichen's credo. By the simple act of photographing another person, we begin to examine not only the people with whom we share our homes, our town, and our planet, but who we are as well.

It's not surprising, then, that the one subject we photograph more than any other is people. Whether it's at special events like birthdays and weddings, the family vacation, or just the kids racing along on their bicycles, we record almost every aspect of our personal relationships. In fact, for many of us, our very first interaction with a newborn baby is to photograph it.

Photographing people can be more challenging than other types of photography because it requires trust between photographer and subject. The instant you raise a camera to your eye to photograph another person, you leave the safe-distant world of the camera as mere observer and become part of a dialog between you and your subject. And if you've ever tried to photograph a shy child, you know how fragile the threads of that bond can be. The success of people pictures depends not so much on a mastery of f/stops and shutter speeds as on the grace and wit with which you handle this intimate interaction with your subject.

Not surprisingly, photographing other people intimidates us most. After all, people are the only subjects we photograph that can talk back to us—or, like

wildlife, can run away from the camera. But confidence comes with practice and, at least with the people we know well, photography eventually becomes a seamless and invisible aspect of our relationships. And once you and your subjects reach that level of comfort, your portraits will move past superficial likenesses and begin, as Steichen believed, to reveal more about your world and yourself.

The success of people pictures depends not so much on a mastery of f/stops and shutter speeds as on the grace and wit with which you handle this intimate interaction with your subject.

© MICHELLE FRICK

Babies

The great thing about photographing babies is that there is almost no one who doesn't think every baby is completely cute. Even if they don't know the baby, people will coo and purr over how cute she is. And if they do happen to be related to the baby, then naturally, it's not only cute, it's the cutest baby alive. So if you're lucky enough to have a new baby, or know someone who does, taking good photos of her can only enhance your status as a fine people-photographer.

In many ways babies are ideal subjects because, until they reach the age of mobility, they have no choice in the matter. Even more importantly, they have no idea what a camera is or that you're doing something they may eventually grow to find annoying. Taking pictures of babies is kind of like, well... taking candy from babies. I had to say it.

From almost the instant they arrive home, babies begin to display an array of moods and behaviors that will eventually be described as personality traits. In addition to funny smiles and soulful eyes, babies have a profound range of facial expressions and even physical mannerisms, and capturing them is probably the most fun you'll ever have with a camera.

How you photograph a baby will vary with its age. Newborns spend most of their time either sleeping or letting you know that they're not sleeping. And if you are too noisy in getting pictures of the former, you'll get ample opportunities to photograph the latter. And though flash may or may not wake a sleeping baby, it's not the most attractive light on their soft, smooth skin, so shoot with available light when you can and the results will look much more natural.

As babies get older and begin to move about, new photo opportunities arise. At about six months, no longer confined to their cribs or parents' arms, babies begin to crawl and explore the physical world on their own terms. Because virtually everything is new to them, what you're really photographing is an explorer experiencing a brave—and overwhelming new world. To get the best shots of this world, you have to enter it by getting down on the floor (or the lawn) with them. By keeping the camera at their level, you'll be revealing their world and their explorations from a very natural and interesting perspective.

Perhaps the best photos of babies are those that show the interaction between them and their parents or siblings. You can't force or create such moments, but you can be prepared for them by having your camera nearby and ready.

Once babies start to walk, you will still find quiet, intimate moments to photograph them, but they'll be interspersed among the hours you'll spend on your knees chasing a very unpredictable moving target. Keeping up with babies on the move (photographically speaking) is a lot simpler if you

have a second person helping to corral your subject so that you can concentrate on taking pictures. Usually if a baby is let go by one parent, it will charge to the waiting arms of the other—which gives you a quick second to snap a picture and then catch your subject before they run past (or crash into) your camera.

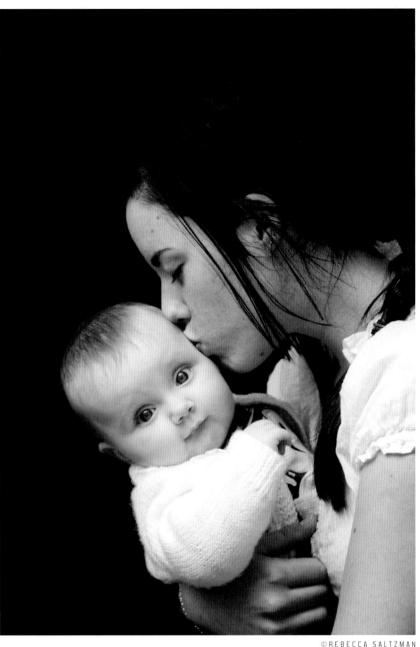

© REBECCA SALTZMAN

Perhaps the best photos of babies are those that show the interaction between them and their parent.

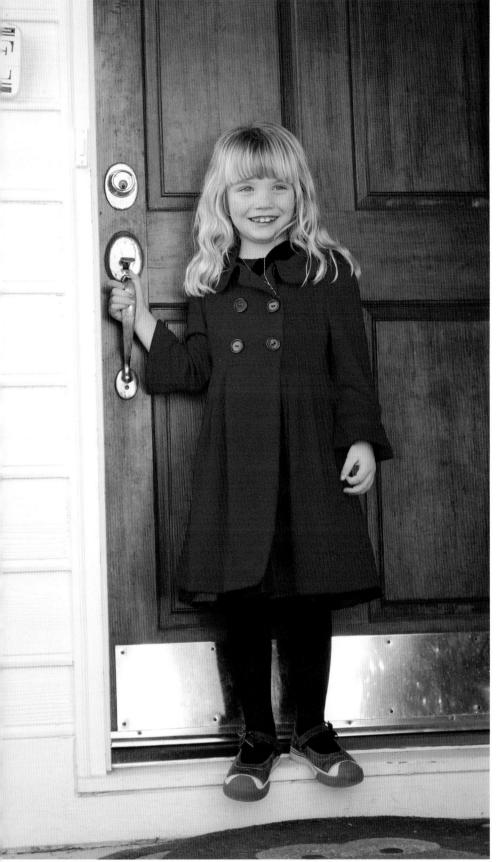

© MARTHA MORGAN

Kids

While getting kids to pose for the camera can be difficult, getting them to play is easy—after all, playing is what they do best. Taking photographs of kids at play is relatively relaxing (for you and them) because once involved in an activity, they block out the rest of the world—even if that world includes an adult mercilessly aiming a camera at them. And, of course, the more often you take pictures of kids playing, the more used to the camera's presence they become.

Give your subjects something fun that anchors them to a small area. Creative pursuits like blowing bubbles and finger-painting are particularly good because they keep your subjects at hand and elicit amusing expressions of deep concentration. A medium telephoto lens (in the 55-90mm focal length range) enables you to remain at a reasonable working distance (usually four or five feet; 1.5 meters) and still fill the frame with a small face. I shot the picture of the girl blowing bubbles (above, right) using a zoom lens at medium telephoto focal length.

Confining your kids to a specific area also works well for action pictures. Fortunately most kids love a physical challenge. Think of your daughter doing handsprings or reaching the high point on a rope swing. Kids playing will probably exhaust you (and your battery) before they run out of energy.

Before taking pictures, scout for a good location in terms of both lighting and background. For the photo of the girl blowing bubbles, I chose an area of cheerful, dappled sunlight and positioned her so the sun didn't shine in her eyes and cause her to squint. Also, by using a relatively wide aperture,

I was able to cast the background into soft focus (see page 112 for full image).

One important thing to remember is that you can't keep a child's interest in any activity once boredom sets in. Some kids are brutally honest and will tell you when a photo session is over; others will just grow progressively less cooperative. (Then, of course, the clever ones simply disappear the moment you look away.) When a session begins to disintegrate, let it end and you'll have a willing partner the next time you bring out the camera.

All kids react differently to being photographed. Some kids love it. Others (I was one of them) would rather go to the dentist than pose for a photograph. This can be a really frustrating (and expensive) thing if you've paid a professional to take a portrait of your kids, but it's just as frustrating when you're trying to get informal snapshots around the house. And it becomes a self-perpetuating problem because the greater your frustration, the more pressure you put on yourself (and them) the next time the camera comes out. In a contest of stubbornness, four-year-olds will win almost every time.

Kids resist pressure—pressure to sit still, to look pretty, to smile, or to hold a pose. These are responsibilities a teenager might be coerced into accepting, but to a five-year-old, they border on the absurd: "You want me to sit still, look pretty, smile and act happy? What planet are you from?"

Surprisingly I've found that with particularly young kids (from, say, three to six) using a digital camera actually makes picture taking much more like a game because they can see instant results on the LCD screen. I first experienced this while sitting at the dinner table with a three-year-old niece who ducked for cover under the table every time I aimed a camera at

Lighting Tip

If you're working indoors, try positioning your subject by the light of a bright, north-facing window so he or she is well-illuminated with soft light. If none of your windows are north-facing, try shooting early or late in the day when direct sunlight is softer so contrast isn't a problem. Natural light is pretty at these times of day, but it vanishes quickly, so you won't have as much time to shoot.

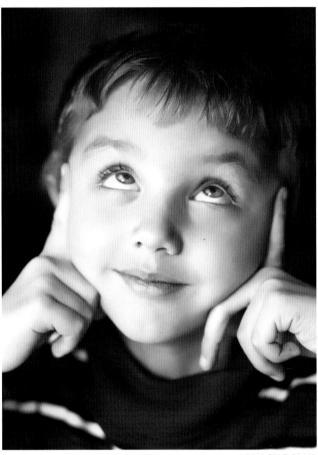

© MICHELLE FRICK

her. Once I showed her how she looked on the LCD, however, posing for the camera and looking at the instant replay became her favorite game. So while having to stop and share the image after every shot can slow things down a bit, at least you gain a willing model.

Relationships

Often the best photos of people interacting, particularly parents with childern, are the ones where neither of the participants knows they are being photographed. With no thought of the camera to inhibit their activities (or stifle their affections in the case of older kids) pictures taken of kids and parents spending time together reveal sweet and poignant moments. Capturing these brief interludes requires a bit of journalistic finesse on your part, but the results add great emotional depth to the family album.

The activity that your subjects are involved in doesn't have to be profound or even obviously emotional. Often the most tender or touching moments arise out of everyday incidents: Siblings sharing a tender moment, a parent and child cuddling in a chair, or a couple just casually enjoying a walk together. When you find your subjects involved in some natural and meaningful activity, seek a position that puts a plain background behind them. The simpler the activity,

and the less movement, the better, generally (though certainly a mom pushing the kids on a swing works better as an action photo) because it lets you concentrate more on the relationship between the subjects.

Again, a medium telephoto lens or zoom setting is ideal for photographing candidly because it lets you move to a discrete distance and still keep your subjects large in the frame. How close you can work really depends on how sensitive your subjects are, but generally it's worth sacrificing close-up facial expressions to remain at a friendly working distance. The longer you go unnoticed, the more photo opportunities you'll get; and once you get a few distant shots you might want to tighten up the circle and edge your way closer to your subjects.

Be patient and wait for that one "decisive moment," as Henri Cartier-Bresson described it, to record that instant that defines the relationship between your subjects.

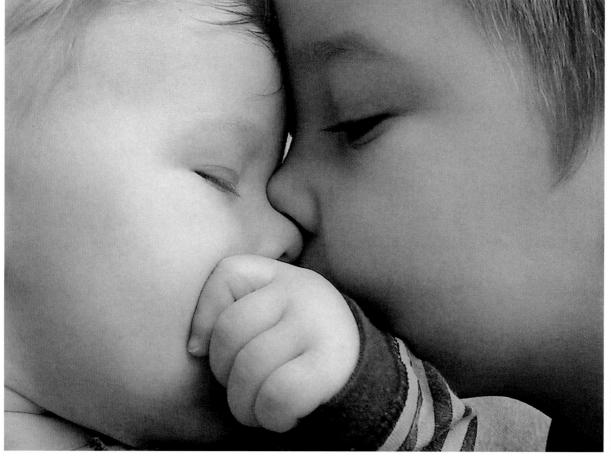

RT GANTZ

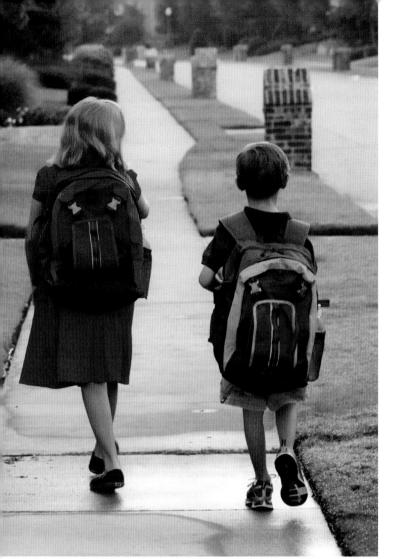

© MICHELLE FRICK

It's a wonderful thing when you watch an event unfolding through a viewfinder and an instantaneous moment of wonder happens: a butterfly briefly landing on your daughter's hand as she sits in the garden with her father.

One interesting point about photographing parents and kids together is that, while it's nice from a personal standpoint if the subjects are members of your family, from a photographic point of view, the pictures work even if they are of strangers. If you happen to see a particularly interesting or cute moment in the park between a dad and his daughter, for instance, give your journalistic skills some practice and try to capture the moment even though you may never see your subjects again. It is a good idea to ask the adult for permission, but as long as you don't invade anyone's privacy, most people don't mind being photographed and will probably ask for a peek at your LCD or even a print, and you can offer to email a copy to them.

Often the most tender or touching moments arise out of everyday incidents.

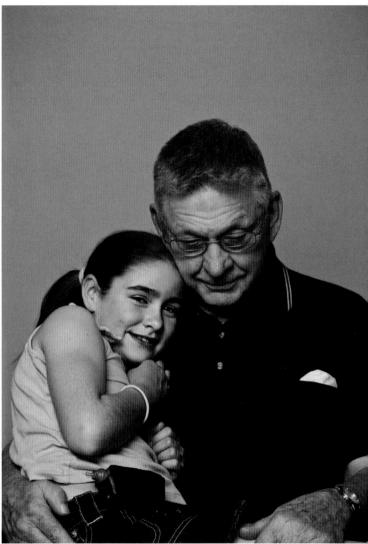

©KEVIN KOPP

Moods

While it's probably rude to photograph a person when they're experiencing their worst moments, photographing a person's many other moods can make for enticing and emotionally rich portraits. Pensive, proud, shy, aloof, exuberant, sad, joyful—for most of us, changes in mood (or "changes in attitude" as Jimmy Buffet puts it) jostle through our days like a sailboat on a restless sea. Because moods are so fleeting and often evaporate in the presence of a camera, you'll need to work quickly to capture them.

Reading people's moods, of course, is something we all do a hundred times a day. You judge your wife's mood before you ask her to bring you a tuna sandwich while you lay on the couch; you judge your boss's mood before you ask for the day off (no doubt so you can lay on the couch ordering tuna sandwiches); and you judge strangers' moods before asking to jump ahead of them in line at the grocery store (to buy the tuna, of course). You certainly don't want to bring up the subject of days off when your boss is thumping his fist on the weekly efficiency reports (you probably don't want to photograph him at that moment either).

The most obvious indicator of mood, naturally, is a person's face. You can pretty much assume that a smiling person is happy, or that a toddler biting her lower lip is pouting. The best way to heighten the emotions in a facial expression is by filling the frame with the face. By using a medium telephoto lens to frame a face tightly from chin to hairline, you can exaggerate expression. You can isolate and accent the face further by using a large aperture to get shallow depth of field. Using your camera's Portrait mode (if available) will automatically set a wide aperture. Since the eyes are the most essential and emotionally potent part of the face (or the "windows to the soul" as the poets will tell you), focus on them.

© REBECCA SALTZMAN

The best way to heighten the emotions in a facial expression is by filling the frame with the face.

Faces aren't the only barometer of mood. Body language can be equally revealing. Your ten-year-old son sitting on the back steps with his chin in his hand is the very essence of boyhood ennui. But a moment later when his best friend shows up and they are splayed out on the front lawn using each other for pillows, the picture is one of self-confidence and sublime joy just waiting to be captured. Same kid, same day—worlds apart in mood.

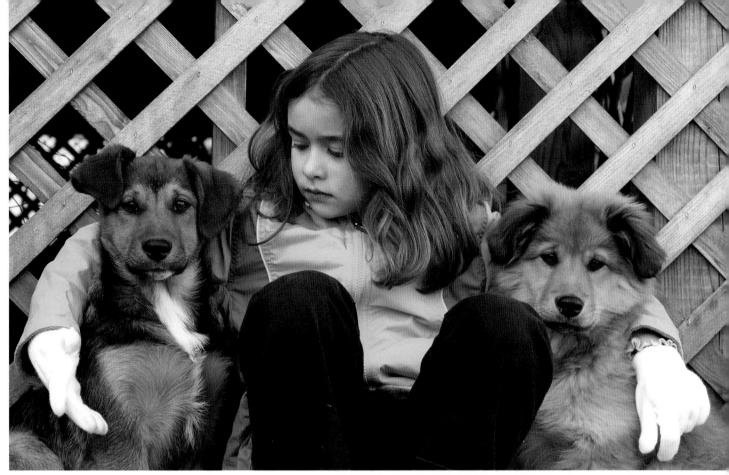

OKEVIN KOPP

Exploit a setting to reveal or emphasize a person's emotions. By including lots of space around your teenage daughter sitting alone on a rock jetty, you heighten her brooding. By moving in tightly on a granddaughter whispering a secret to her grandfather, but still showing the rocking chair they're nestled in, you use the chair to enhance the intimate and trusting mood of that moment. Would a chaise lounge or a bar stool evoke emotions as powerful as a rocking chair? Unlikely.

Lighting, in both color and quality, plays an important role in establishing mood in a portrait. Bright, warm, early morning sun lends warmth and wellbeing, while the cool tones of an overcast day instill melancholy.

Most of all, though, depicting moods in people pictures is about being ready—having the camera on, the mode set properly and the lens pre-focused on a spot near your subject. If the subject is camera-shy, use your LCD to compose the picture (if your camera has this capability) because you'll be less intrusive. The more subtle you can be in your approach, the better your chances of capturing the moment.

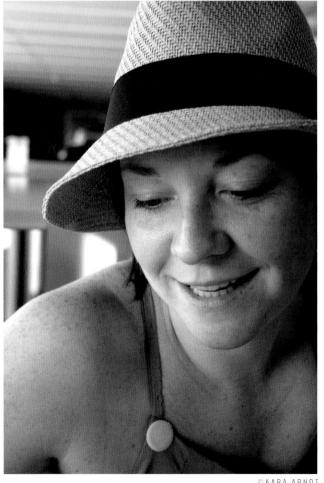

©KARA ARNDT

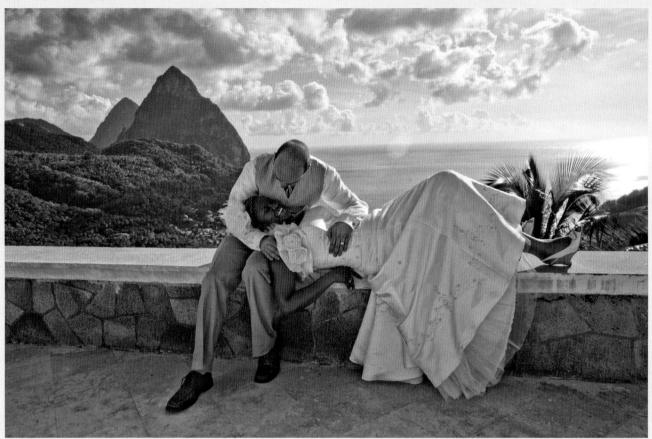

©EMIN KULIYEV

Photographing Weddings

Sooner or later it's bound to happen. You get a call from some old friends who tell you they're finally getting married, and since you're such an expert with digital photography, they'd love to have you shoot some pictures of their big day (or even video, given the capability of most digital cameras these days). And who can blame the happy couple for inviting their photographically inclined friends to shoot extra pictures? Hopefully a professional wedding photographer will also be available to provide those critical and traditional wedding photos, but you can add the intimate and informal touch to the wedding album. Besides, your only option at this point is to either hang up and change your phone number or accept the offer.

So, assuming that a professional crew will also be covering the wedding, it's important that you do not interfere with their need to get the pictures they are being paid to shoot. Most professionals approach the wedding day as a story with a beginning (at home before the wedding), a middle (the ceremony itself), and an ending (the party afterwards). You might limit your offer to capturing candid pictures of the day to supplement what the pro is contributing.

THE CEREMONY

The concept of the wedding ceremony has loosened up in recent years and some couples handle the event very creatively. Regardless of the setting or the script, once the ceremony begins it becomes a very solemn event. The vows themselves are a sacred moment. Photographing the bride and groom during the actual vows can be tricky business because you have to work with great stealth and not disturb the ceremony. You will also have to concentrate on your photo assignment and not get caught up in the emotions. You certainly can't be sniffling back tears while you're trying to shoot.

The best tactic is to shoot from one spot that you stake out before the ceremony begins and then stay there for the remainder of the ritual. In most churches the biggest technical obstacle you'll face is dim lighting, so you'll probably have to boost your ISO setting (if it's not done automatically by your camera) so that you can shoot by existing light. Even though the lighting may be dim, usually it's designed to be quite attractive. Flash

is not usually forbidden if the ceremony takes place at a church, but it's often discouraged—no one wants their ceremony looking like a paparazzi event.

There are a lot of accessible picture opportunities just before and after the ceremony—the couple arriving for instance. And, of course, the traditional shot of the bride and groom leaving after the ceremony is usually one of the most festive moments of the day.

THE RECEPTION

Going from the sanctity of a ceremony to a wedding reception is like moving from a poetry recital to a reggae concert. That same sweet couple that stood eyeball-to-eyeball in solemn contemplation in front of the congregation is now giving a demonstration of the virtues of My Big Fat Greek Wedding-style partying—and photographing that party can be a tremendous amount of fun.

When you choose to shoot is a big part of getting good candid pictures at a wedding party (or any other party for that matter). It's usually best to shoot heavily at the beginning of a reception or dinner because as the end nears people look partied out. A few hours of eating, dancing, and drinking takes a toll on appearances. Also, by the end of the day the bride and groom and their families will be tired of having their pictures taken and often begin to withdraw and reflect on the day.

Receptions and parties are a nice time to organize informal group pictures, and often you can arrange groups of friends that a professional might not know about—members of the groom's high school baseball team or the bride's college roommates. Photographing people dancing is a real challenge. Because the light is often low and the motion constant, use your flash in its automatic mode to make sure you get some well-exposed pictures.

Finally, take time to look for meaningful "found" still lifes that can be used as transition or thematic shots in an album—shots of the flower arrangements on the guests' tables, the bride's high heels kicked off under her chair, or perhaps just an empty bottle of champagne sitting in the sunlight. In the rush and madness of a wedding day these are the vignettes that will bring the day alive again—and they're often the scenes only a true artist like you would discover.

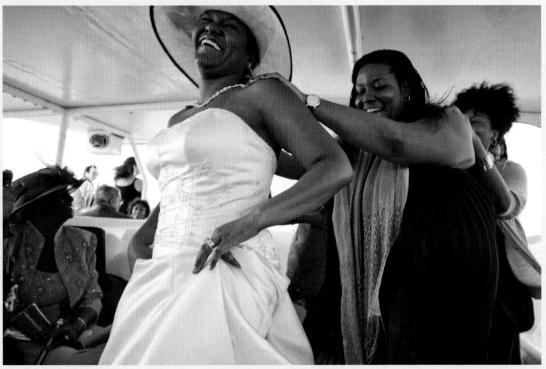

THE PERSON NAMED IN

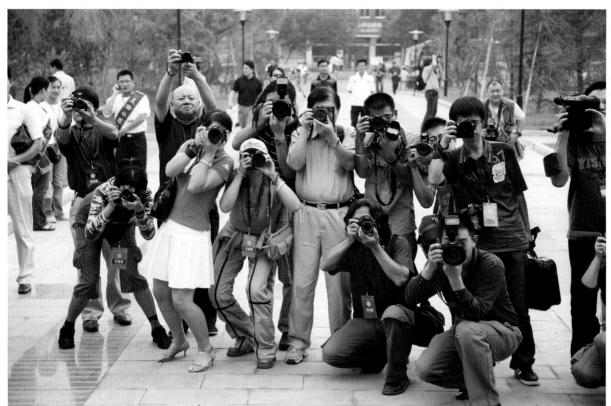

Gathering a group together for any kind of occasion—a family reunion, a company picnic, or even for the humor of it—can be an important memento for years to come.

© JACK REZNICKI

Group Photography

Once you include more than two or three people in a photograph, you step over the threshold from simple portraiture into group photography, and a whole new picture-taking dynamic opens up. Suddenly, rather than just a couple pairs of sweet and familiar eyes staring back at you, you have a crowd of people all waiting for you to impress them with your social charm and creative talent. Usually, though, their patience is short lived.

Keeping your group interested, happy-looking, and well-organized is no easy chore. Like an orchestra waiting for the conductor to raise the baton, your group is waiting for you to take control of the situation, and that's exactly what you should do in the gentlest possible way. Without becoming dictatorial (remember, they outnumber you), it helps keep things moving if you are a benevolent but firm leader. Surprisingly, the more direction you offer to the group, the more they'll like you and the more takes you'll get. And it's very important to shoot several pictures because it will vastly increase your odds of getting everyone looking at the camera at the same time.

The goal of most group photos is to capture the moment in a way that not only relates the fun of the occasion but also presents a recognizable likeness of each individual person.

Photographing several folks at once can, and should, be a fun experience for everyone (even you), and it's better to keep the mood light and have a few people looking at their shoes than to turn them all to stone. One of the blessings of digital photography is that you can instantly proof your shots, and if someone happens to yawn just when you snapped the shutter, you can shoot again. And, of course, if you are a part of the group, be sure you have your tripod handy and know how to use your self-timer mode so you can run and join the everyone for a few frames.

Explain to the group what you'll be doing and warn them up front that you're taking more than one shot. When I first worked as a newspaper photographer, I learned the hard way that the moment you click the shutter most of the people disperse instantly—and getting a gathering back together once they've strayed is like trying to corral an armload of kittens. Also, until the instant that you're going to snap the shutter, let your group converse and interact naturally. If it takes your digital camera a few seconds to get ready for the next shot, use the time to praise the group, have them squeeze together more or just try a slightly different pose.

Lighting is a particularly important issue with groups and, if you're outdoors, you definitely don't want everyone squinting into a bright sun. It's better to move them into an area of open shade, such as at the edge of a wooded area. If you can't find shade, pose everyone so that their backs are toward the sun and then use fill flash to light up their faces.

Also, while a wide-angle lens will let you work a bit closer to the group (and may be a physical necessity if it is very large, or if you're shooting indoors in tight quarters), a normal lens will offer a better perspective and will keep people at the edges from being distorted. If you're photographing a particularly large group, consider taking several overlapping shots and stitching them together later in post-production—not the simplest technique with a a large bunch of people, but certainly worth attempting.

Some of the most fun group pictures are the impromptu shots that just fall together naturally—a half

dozen fishing buddies sitting on the dock, or your trail-riding companions heading over the next hill, totally unaware of your camera. Informal group shots have a wonderfully spontaneous feeling to them, and we almost don't recognize them as group photos.

Capturing spontaneous shots like this requires that you be something of a journalist; awareness of your surroundings, quick reflexes, and a good working knowledge of your equipment are important. Unlike posed shots where the people will hang together until you've gotten your shot, ad-hoc groups dissipate as quickly as they come together, so it's important to have your camera on and ready.

Even if you see a moment begin to fade, you can often make it last a few seconds longer just by asking everyone to do something together—smile, wave, point at you—anything that keeps them together without making them feel like they're being photographed. If your presence spoils the moment, shoot anyway—even after you've tipped your hand the poses will still look more relaxed than a traditional group picture. Also, some moments in life are worth having even if they're not perfect; it's better to get a somewhat sloppy shot of all your neighbors digging out a car stuck in a snow-storm than not to have any record of the moment.

Action animates an informal shot. If the neighborhood bicycle brigade is tooling down the street, have them line up and ride slowly toward you. Stopping action that is headed toward you is pretty easy, even with a moderate shutter speed (1/125 second or faster will work), and a shot of a group in action is especially fun because it's so unexpected. Since nothing (other than your artistic reputation) is riding on these kinds of pictures, it's much easier to experiment with pose, lighting, and mood. Not all group shots have to be happy either—your son and his teammates looking forlorn after losing a football game is a great subject.

Action

Few subjects offer as much color, action, and emotion as sports. Whether you're photographing your daughter's field hockey team in the state finals or taking casual snaps of Dustin Pedroia from the cheap seats at Fenway Park, taking good action pictures is a real challenge. Much of the difficulty comes from the fact that everything happens so quickly that, if you're not ready at precisely the right instant, the picture will pass you by. If you hesitate for even a half-second while your son is breaking the ribbon at a downhill snowboarding event, what you'll end up with is a shot of his rival finishing in second place (which his parents will probably be happy to have).

One of the biggest obstacles to getting good motion pictures is getting close enough to fill the frame with action. Professionals, of course, use lenses the size of baseball bats to cover sports from the sidelines—and there is no denying that long telephoto lenses make your work easier. An alternative to a D-SLR and long telephoto lenses is an advanced compact camera with a built-in 20x, or even 26x, zoom lens. The extreme telephoto setting of such a lens will be over 600mm. For years, I photographed high school football for a local newspaper with a 300mm lens and found even that focal length was enough for most situations.

Perhaps more important than having a super telephoto lens is getting close to the action and finding creative shooting positions. At outdoor track meets and soccer games, roam the perimeters to find shooting positions close to the participants. If you're photographing an equestrian event, look for a spot near a jump that is in nice light and where the rider will be coming toward you as they clear the jump.

Shutter speed is crucial to sharp action photos. Fast shutter speeds freeze action; slow shutter speeds blur action; inbetween shutter speeds can freeze part of the subject and blur other parts. The actual shutter speed you choose will depend largely (but not entirely) on the speed of your subjects. While you might be able

to get perfectly sharp pictures of a high jumper at a shutter speed of 1/250 second, it might take a shutter speed of 1/1000 second, or even faster, to completely stop a race horse charging around a track.

Equally as important as the shutter speed is the angle from which you shoot the action—the same subject shot at the same shutter speed from several different directions will yield radically different degrees of sharpness. All other things being equal, you can stop action at slower shutter speeds when it is moving toward or away from you. Action crossing your path, either parallel or diagonally, is much more difficult to stop. While a shutter speed of 1/250 second might be enough to stop a speed skater coming directly at you, it might take a shutter speed as fast as 1/2000 second, or faster, to freeze a skater passing in front of you.

© D D U G J E N S E N

In this photo, a technique called panning was used to keep the subject sharp but blur the background. By selecting a slow shutter speed (usually 1/30 second or slower) and positioning himself parallel to the subject, the photographer moved his camera at the same speed as the subject.

© DOUG JENSEN

Perhaps the most vital quality that all good action photographers possess is an innate sense of timing—anticipation of just the right moment.

People at Work

People at work can be fascinating subjects. From butcher to baker to candlestick maker to stockbroker to deliveryman to teacher, people's jobs and work environments tell us a lot about that person.

Finding people to photograph at work isn't as difficult as it might seem; many people are genuinely flattered that you'd be interested enough in their work to photograph them. The mechanic who tunes up your car isn't asked to be photographed at work very often, but posed over the engine of a sports car with a rack of tools behind him, he'd make a great picture. Friends and family at work on hobbies or crafts—your neighbor at her potting bench, for instance—are great subjects; most people are proud of their artistic talents and enjoy showing them off.

People at work tend to be relaxed and comfortable around the tools of their craft—whether it's a computer screen, a bench full of woodworking tools, or even the steering wheel of a cab. Having props available gives subjects something natural and meaningful to do with their hands and prevents that awkward and stilted pose that most people strike when being photographed. Certain types of work environments—particularly where an unusual trade or craft is involved—also have an inherent charm because most

also have an inherent charm because most of us rarely see the "inner sanctum" of that world.

One trick for getting an interesting and comfortable pose is to ask people to demonstrate their work. The shots of the Ukranian beekeeper (above) seem completely natural because he is simply doing what he does everyday when a photographer isn't watching.

rest rk,

The hives and honeycombs not only give the subject something to do, but provide a great deal of interest to the shots. Before you photograph somebody at work, first observe their activity and become familiar with their work routine and the photogenic aspects of it.

Finally, because you may be working in cramped spaces, be sure to have a wide-angle lens available. Pay attention particularly to the foreground and background and, if possible, arrange a few props in the frame to enhance the theme of the shot.

Travel

With the possible exception of special events like birthdays and holidays, most of us shoot more pictures while traveling than at any other time. The travel pictures that mean the most are usually those that show our companions. After all, a picture of the Taj Mahal without your kids sitting beside the reflecting pool seems more like a postcard than a family photo. Their presence invokes memories of that entire day.

Some people (particularly kids, who have far fewer inhibitions than their parents) are naturally good at being photographed and looking entirely relaxed and cool, but others turn to stone the minute you aim a camera in their direction. The challenge is to get lively and fun images of your companions that look like they're actually enjoying the places they're visiting, not just tolerating your obsession with photography.

Setting up travel portraits can be a lot of fun if you're lucky enough to have cooperative—or even enthusiastic—subjects. Who cares how goofy you get in front of a bunch of strangers that you're never going to see again? So if your husband wants to pose like he's going to leap off of Fisherman's Wharf in San Francisco, let him. Better still, if you can create a running gag through all of your trip pictures—like posing your spouse as a tour guide explaining the sites—then you won't have to invent something new for each location.

There is nothing wrong with the occasional "we were really here" pose. If it captures both the location and your companions in a fair light, then go for it. In the end you'll be happier having obviously staged shots than no pictures at all. And who knows, after the hundredth photo in front of a landmark, maybe you'll get lucky and they'll stick their tongue out at the camera.

OTHOM GAINES

©JACK REZNICKI

However, what about those times when you want to immerse yourself in the local culture, whether it be within or outside of the boundaries of your own country? The idea of aiming a camera at someone you don't know—and may not even share a language with—is just something that makes a lot of people uncomfortable. But if you can work past this inhibition, if you can commit to photographing strangers as a regular part of your travel photography, you will broaden the depth of your images a thousandfold. No photograph of a landmark, no matter how beautiful, will ever compare to a well-made photograph of someone who lives in the place you're traveling.

For most people, particularly in touristy areas, having cameras aimed at them is a pretty common occurrence and they are usually receptive as long as you are polite and aren't invading their privacy. You certainly don't want to photograph a couple romantically conversing at a sidewalk café, but a waiter resting at an empty table probably won't mind at all. Think about the situations that you yourself would or wouldn't mind being photographed in and then use that as a gauge for judging when it's appropriate to shoot strangers.

In a lot of tourist areas, locals may expect to get paid a few dollars to pose—and personally, I don't see any problem with that. In Monument Valley, for example, the Navajo people who own the valley and generously open it to the public consider photographers who take pictures of them without permission to be rude. Often, of course, if you treat people with respect, you get far more than you pay for. After giving this handsome Navajo (below) a few dollars to pose at the much-photographed Ford's point, we got into a nice conversation. He was obviously very proud of the horse that he had spent years training, and spent a lot of time making sure I got a great picture of them both.

Language, of course, becomes a problem in some situations. Even if you don't speak the language, just making brief eye contact and then pointing to your

camera will get the point across—either a person will smile and nod back or turn away from you. If they accept your polite advance, take a few quick pictures and then, if you're feeling really brave, just walk up and shake hands—and then gesture that you'd like a specific pose.

One of the best results of photographing strangers is that often you make a new friend—and that opens up a myriad of image opportunities that you could never have predicted. I tend to start conversations with strangers wherever I go (even if I don't speak more than a few words of the language), and I've developed some lasting friendships over the years.

Nature

"I didn't want to tell the tree or weed what it was. I wanted it to tell me something and through me express its meaning in nature."

-WYNN BULLOCK

Introduction

 $oldsymbol{\mathrm{l}}$ t takes only a quick glance at the calendar section of the local bookstore to see that nature is one of our favorite subjects—and with good reason. Five minutes spent in the company of a clump of wildflowers or aiming a lens at a mountain stream has a powerful ability to mend the frayed edges of modern living. And we experience a rekindled sense of that serenity every time we look back at our outdoor photographs. It's not surprising then that next to photographing family and friends, we probably spend more time photographing nature than any other subject—and you certainly couldn't ask for a more diverse creative challenge.

Whether you have a specific interest such as wildlife or close-up photography, or simply like to explore in wild areas with your camera at the ready, nature never ceases to delight and inspire. In fact, part of the fun of nature photography is that you never know what you'll find and-visions of adventurous hunters wrestling giant pythons in the rainforest aside—you need never travel farther than your own backyard in search of interesting subjects. From the creepy crawly beasts hiding beneath garden stones to the stars swirling radiantly in the night time sky, even the most mundane of suburban locales provides a veritable jungle of opportunities. Plus, the urban world has its share of wild creatures and happenings. Just a short walk from downtown San Francisco, enormous sea lions have crowded boaters out of the local marina, providing an extraordinary—and very accessible—photo opportunity.

One of the enjoyable aspects of nature photography is the more you explore a particular subject, the more fascinating and diverse it becomes. Although Ansel Adams traveled widely during his career, he devoted more than half a century to exploring a single national park—his beloved Yosemite. Galen Rowell, who was one of the world's most highly regarded mountaineers in addition to one of its greatest nature photographers, devoted much of his life to photographing mountain landscapes that few of us had ever witnessed before. His book Mountain Light remains one of the finest wilderness books ever published.

Plentiful and diverse as nature's bounty is, however, nature does not yield her finest treasures frivolously. To capture the beauty of a rainbow, you must endure a certain amount of rain. To witness the unexpected color of the desert in bloom, you have to travel to the desert not knowing whether your quest will be rewarded or ignored. And to record the hundreds of images of waterfalls that are his specialty, photographer Derek Doeffinger (see pages 200-201) has spent years exploring New York's Adirondack and Catskill Mountainswith little more than a topographic map and the anticipation of good photo opportunities to lead him on.

Whatever your photographic ambitions, nature has the challenges waiting for you. On the following pages we'll take a look at some of her themes and offer points on how to capture them with your digital camera.

The Natural Landscape

When early landscape photographers like William Henry Jackson and Timothy O'Sullivan started across the American West in the late 1800's to record extraordinary vistas that few non-native people had ever seen, they brought cameras equal to the task. Their "field" cameras, built to record images on light-sensitive glass plates as large as 20 x 24 inches (50.8 x 61 cm), had to be hauled in horse-drawn wagons or carried up mountains on the backs of mules. To further complicate things, the plates needed to be

coated with a light-sensitive emulsion (the film) in totally dark tents just prior to exposure—a process that often took hours of tedious labor. Jackson once boasted that he was able to coat a single plate in a record time of just less than fifteen minutes. These same plates had to be exposed and processed almost immediately, before the wet emulsion dried and rendered them useless.

Needless to say, you had to really like a scene before you clicked the shutter. (On the other hand, if you didn't like the scene afterward, you could scrape the image off the glass, clean it and start again—kind of like an early version of digital photography.) Jackson's work profoundly influenced both photography and Ameri-

can history. His images of the Yellowstone area of the Wyoming Territory were largely responsible for convincing the United States Senate to create Yellowstone National Park—the world's first national park.

Since most compact digital cameras fit in your jacket pocket, the physical process of shooting land-scapes is decidedly less burdensome today. The goal, though, remains the same: To tell the story of an interesting setting clearly and dramatically.

A landscape photograph then is simply an image that tells a visual story about a particular place—any place. Though we're talking about natural landscapes here, landscape photography does not begin and end with nature—the local strip mall, forgotten rural railroad crossings, and the parking lot at work are all worthy landscape subjects.

Interpreting the Land

The kinds of settings you choose to photograph and the types of landscape stories that you choose to tell say as much about you as they do about what you place in front of the lens. Ansel Adams' magnificent landscapes of Yosemite Valley are not so much about waterfalls and mountains and gathering winter storms as they are about Adams' reaction to those elements. That Adams was awed by his surroundings clearly shows in his amazing photographs.

How you interpret a landscape then is your own personal statement about the world around you. Landscapes can be brash, refined, somber, gentle, or clever. They can whisper, scream, entice, or even shock. While one photographer might look at a pristine shoreline and see the cheerful beauty of sand and sun and turquoise waves, another might see only the loneliness of the deserted beach.

When it comes to natural scenery, many photographers (myself included) often think only in terms of the "grand vista" and the exotic locale. We spend so much time stumbling around looking for the magnificent panorama that we ignore the subtle scenes of mystery and magic that surround us everyday.

A landscape can be as large and profound as the Grand Canyon, or it can be as common as the leaves on the tree in your backyard. Use that creative freedom to ferret out the landscapes that others overlook and you'll never run out of interesting subjects. Varying the scope of your landscapes not only challenges your imagination, it provides variety and depth to your photographs. As you explore for the big picture, also look for simple, quiet landscapes—they often reveal the true character of a place better than a grand view.

Choosing the best vantage point is one of the toughest aspects of photographing natural land-scapes. The world isn't marked with helpful little signs telling you where to stand to get the best shots—that part is up to you. When you first happen upon a scene that excites you, examine why before you begin photographing. Is it the sun filtering through the trees in the background? Or is it the curve of the river winding through a canyon? Identifying the elements that caught your attention in the first place will help narrow down your ideas and isolate the visual ingredients needed to tell your story. In time this sort of introspection will become second nature.

Getting to know a place is another useful and crucial part of landscape photography. Sometimes you'll get lucky and stumble onto a great vantage point, but most good landscape photos arise from an intimate knowledge of the land. When I arrive at a new fishing cove in Maine or a wildlife refuge in Florida, my instinct is to start shooting immediately. Sometimes those first-impression shots are good because my reaction is instinctual. But in the days that follow, I'll almost always find I can better isolate and identify what is exciting me, and I get better pictures.

Pace is another important consideration in finding great landscapes. If time is short (as it usually is on

vacations), don't spend too much time on one view or one aspect of a landscape—you might miss other opportunities around the corner. If a place is new to you, explore it before locking yourself into one viewpoint. I can't tell you how many times I've spent hours working a landscape scene that I thought was just the coolest thing on wheels, only to hike a few hundred yards farther down the path and find a much better shot. It's a lesson I've had to relearn many times.

On the other hand, after you've spent some time exploring, if you have the time to linger, try to relax into the scene until the mood and the charm of the locale come to you. Lighting and time of day play such a profound role in most landscape photographs that sometimes the best decision is to simply stay put until the light and mood reach their peak. One of the best pieces of landscape advice I ever got came from my friend, travel shooter Catherine Karnow, who advised me to "slow down" and spend more time

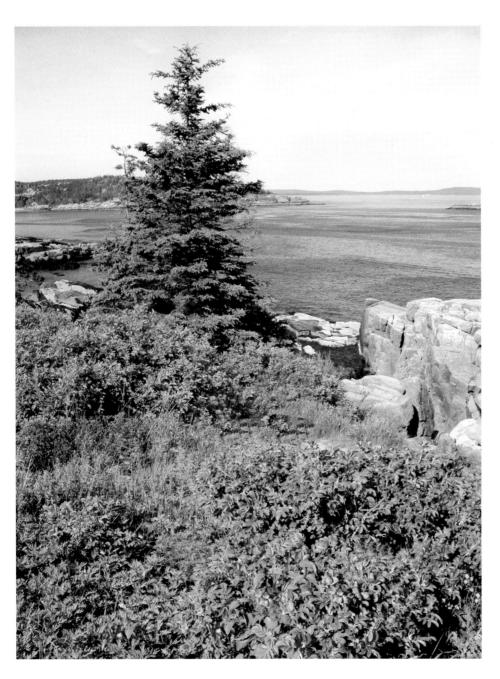

in one small area. She told me that one of the secrets to her photography is that she often covers "less than a mile—often far less" of territory over an entire day.

Finally, you might think that landscape photography is all location, location, location—but sometimes it comes down to experience, experience, experience. The more you shoot, regardless of how common the scene might be, the better your pictures will be. So practice wherever you are, whenever you have spare time. Getting a great landscape shot is tough, but on the following pages we'll look at some popular landscape subjects and how to handle them.

If you have the time to linger, try to relax into the scene until the mood and the charm of the locale come to you.

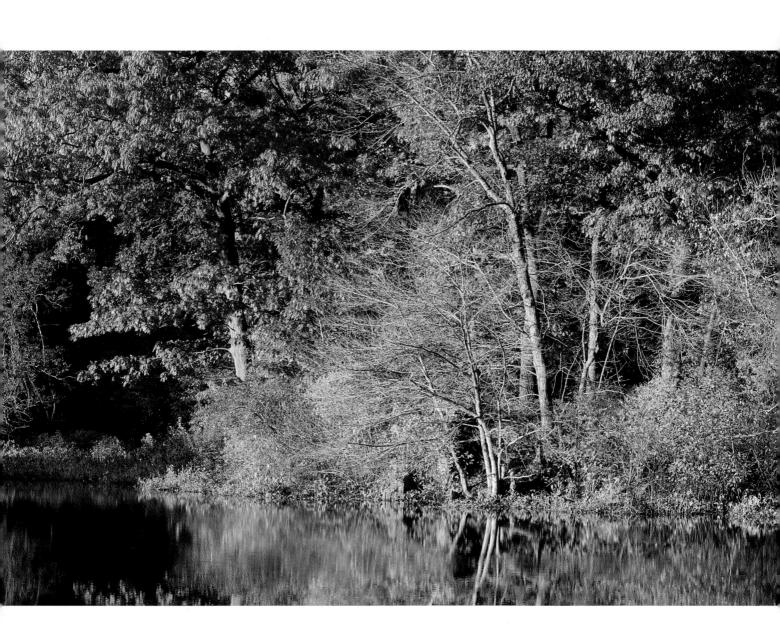

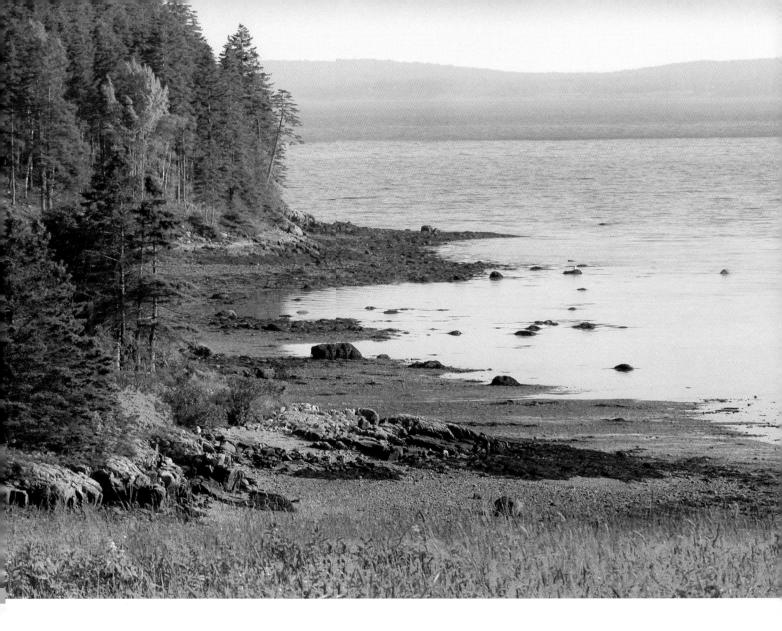

Beaches and Shorelines

There's no place I'd rather be than beside the sea, and nothing I'd rather be doing than taking photographs, so you can imagine that I'm quite a happy person when I'm taking pictures of beaches or shorelines. I'm happier still when I download my pictures and find that I've captured a place's drama or beauty (and I'm equally miserable when I haven't).

Shore areas vary greatly in character, ranging from the sugary sand beaches of Florida and the Caribbean, to the rocky coastlines of Maine and Oregon. Some beaches are so pretty that it would seem difficult not to get good pictures of them; but even in the prettiest of settings, it usually takes work—both mental and physical—to coax their beauty into your camera.

The one thing that all beaches and shorelines share is the perpetual interaction of water and land. Wind, water, and shore exist in a relentless battle of erosion and replenishment and, though they seem idyllic, the battle is never ending—it's a fascinating process to watch and photograph.

I've lived all of my life just a few miles from an area of gentle suburban beaches and tidal marshes. Although they are rarely dramatic, they never look boring because they never stop changing. The same hard-looking

shore that beams with brilliant sparkling water and blue skies at midday slips into a softer romantic landscape at sunrise or sunset. During hurricanes and winter storms, I have seen these passive beaches turn treacherous.

The drama of your images is largely determined by when you arrive at the shore area. The time of day, tidal fluctuations, winds, phase of the moon, weather, and season all affect shorelines in exciting and sometimes very beautiful ways. If you keep an online journal or gallery, consider posting images of your favorite beach shot at various times to show how different it can look.

As you explore, keep in mind that part of the reason that beaches and shorelines seem so attractive is that all of your senses are responding to the environment. The sound of the surf, the smell of the sea, and the warmth of the sand on your feet, all conspire to charm you. But your camera is limited to capturing just light and color, and only in two dimensions. So before you begin to shoot, step back a bit and examine the scene's visual elements. What are its strengths? What is the core of its drama? Is it the waves crashing into the rocks? The spray misting the air? The rippled sandbars and turquoise waters? Or are you being wooed by the morning fog shrouding the rock formations? This may seem like a rather analytical approach to finding a good landscape photograph, but in reality good photography is equal parts emotion and analysis.

Some beaches are so pretty that it would seem difficult not to get good pictures of them; but even in the prettiest of settings, it usually takes work—both mental and physical—to coax their beauty into your camera.

©KEVIN KOPP

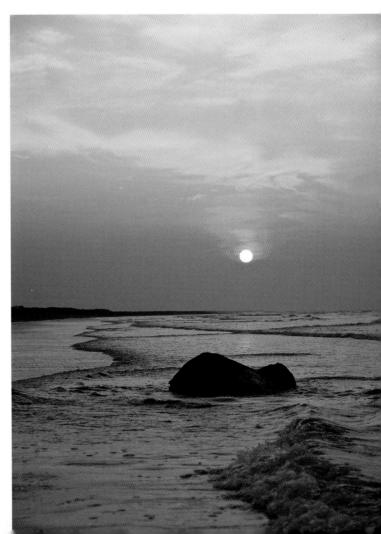

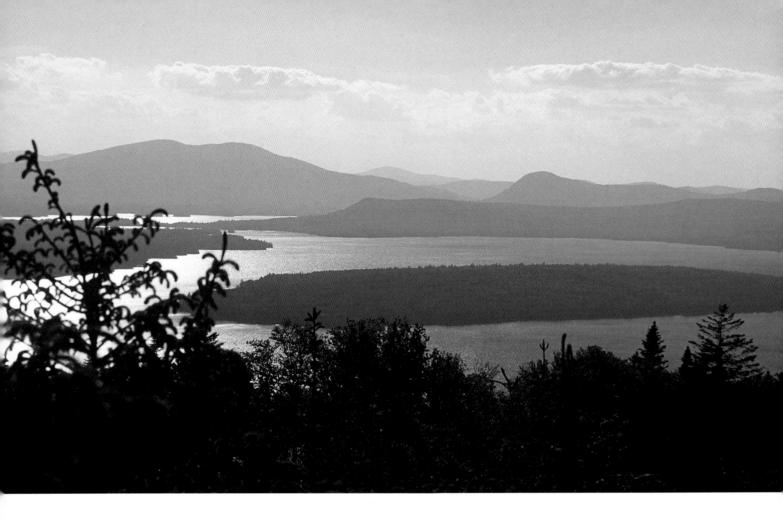

Faced with broad swatches of sea, sky, and shore that can easily overwhelm a composition, you must balance them in a pleasing arrangement. A large sky area exaggerates the spaciousness of a scene, while placing a rock formation or a long sandbar in the foreground accentuates the drama between land and sea. Often the best vantage point for finding appealing compositions isn't on the beach but rather on a bluff overlooking the sea. High vantage points provide a bird's-eye view that reveals the graceful, natural curve of a beach or the expanse of a rocky or wooded shoreline.

Although an empty beach may be pretty, you can almost always improve a picture of a seaside scene by including a foreground frame or a center of interest—a pair of palm trees framing a sunset, for instance. Try placing a small center of interest—a lone beach-comber or an overturned dory—in the frame to provide both a focal point and a sense of scale. Look at the chapter on *Design* for more ideas on creating interesting compositions.

Also, take advantage of your zoom lens. Even small changes of focal length can have a big effect on how your beach and shore shots look. For example, wideangle settings exaggerate distance and heighten the isolation of an empty beach, while a medium telephoto setting slightly compresses the scene and helps you isolate a pretty section from cluttered surroundings. Unfortunately most compact cameras don't have extreme wide-angle capability, which can get frustrating at times.

Bright skies make it difficult to see your pictures on the camera's LCD screen. Commercially made viewing hoods, like those from Hoodman, may be worth the investment to you. They definitely help you to clearly see images and information on your LCD in even the brightest light. Of course, being old fashioned and as silly as I probably look, I sometimes carry a large black cloth (the kind professional portrait photographers use) that I throw over the camera and my head to see the LCD better. Whatever works.

Finally, remember that salt water—and the air around it—will damage electronic gear, so keep your camera in a small case or a zippered bag when you're not using it.

Deserts

When I was a kid, my father worked for a publisher and one day he brought home a huge picture book about the desert that I found fascinating. Since I lived in New England where everything was green and lush and you could barely swing a fishing pole without hitting a pond or a brook, those haunting images of the stark desert landscape captivated me. While other kids my age were memorizing the names of dinosaurs or baseball players, I was dreaming of rattlesnakes coiled on rocky ledges in the Sonoran moonlight (waiting, no doubt, for the hapless pocket rat to saunter by). It wasn't until many years later that I actually came face-to-face with a real desert (and a real rattlesnake), but it did not disappoint. I knew I had found one of the great visual loves of my life.

Though it's easy to think of the desert as a lifeless, severe, and unchanging environment, in reality the desert landscape is teeming with life, and it is a place rife with both perpetual change and interesting photographic opportunities. I think the desert reveals a greater palette of color and texture than any other natural environment. It is not a place to explore casually—but it is worth the effort required.

The three most dominant visual elements in the desert landscape are texture, color, and shape—and often you can find subjects that integrate the three to create interesting compositions. Twisted, pitted, and ground by millions of years of relentless erosion, rock formations stand like modern sculptures. And painted by their ancient geologic chemistry, the colorful sandstone and limestone "hoodoos" of Utah's Bryce Canyon create a visual fantasy carved in stone. In places like Death Valley (California) or White Sands (New Mexico), the ever-shifting dunes provide a continually transforming tableau of sands, shadows, and textures that looks more like a location for Lawrence of Arabia than an American landscape.

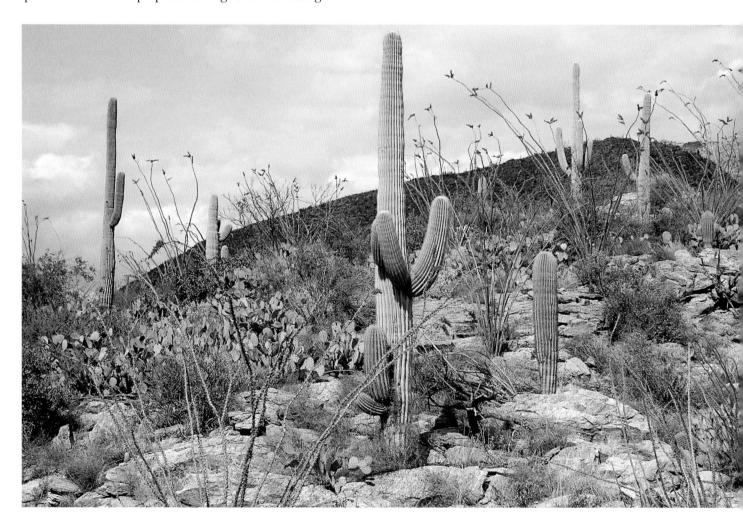

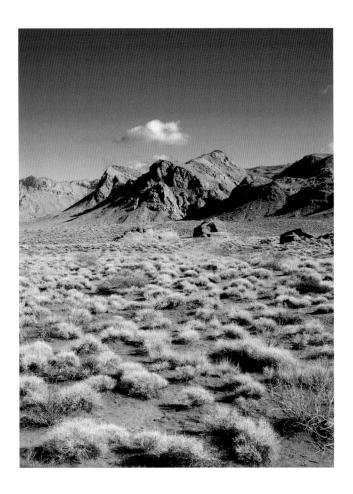

The scale in many desert landscapes is deceiving because there are few visual cues to size and distance. Other than including another person, it's difficult to translate the spaces involved. One trick is to place a small cactus or other plant in the foreground to at least create some semblance of scale.

Because the desert is such a dramatic place, it's easy to get fooled into thinking that the more features you include, the more interesting the picture will be. But as with any landscape, when composing desert scenes, try to isolate a particular concept or visual theme by simplifying the number of elements. The photo above is a simply-composed image of the flat desert floor leading to the dominant mountain in the background.

DESERT LIGHT

An image of desert light is iconic, and can also be a sterotype. Umpteen B movies have shown us some poor half-dead cowboy stumbling through the relentless desert heat as the merciless sun threatens to microwave him on the spot. Of course, he survives and fills the villain full of lead by the movie's end.

Although midday in the desert is extremely harsh and photographically unfriendly, desert light has a unique quality all its own. Go at the right time, and in the space of just a few minutes you can watch as the desert panorama repaints and reinvents itself, rapidly revealing a new palette of colors and shapes and textures. That "right time" is early and late in the day—the golden hours for photography—when rapidly changing light gives you a full menu of colors and textures to select from.

During these golden hours (also a time you can enjoy the cooler temperatures), the warm hues of the light exaggerate the already flamboyant desert colors. As the sun disappears, be sure not to miss this sudden flood of wine-red light spilling across the landscape. Because the light changes so rapidly, you should have a scene picked out and a composition ready to photograph.

Don't be too quick to leave after the last rays of light have passed. Many times I've seen other photographers pack up the moment the sun slips below the horizon only to see the sun ignite the sky with one last great crescendo of spectacularly colored afterglow. Under the vast desert sky, daylight lingers and twilight skies shimmer. Of course, once twilight fades, the desert is as dark as a cave, so bring a flashlight along for safe passage through the witching hour of snakes and other creepy crawlers.

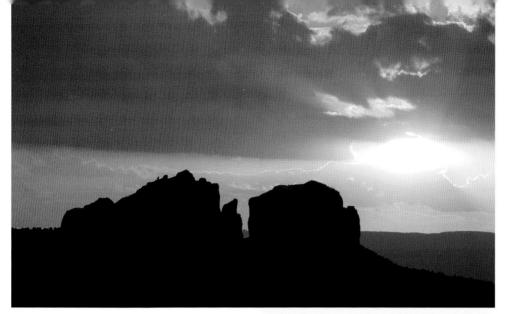

The colors of the desert sky at sunset can be a kaleidoscope as the sun falls lower in the sky, so linger a bit as the daylight fades and you may well find several spectacular opportunities for vivid images.

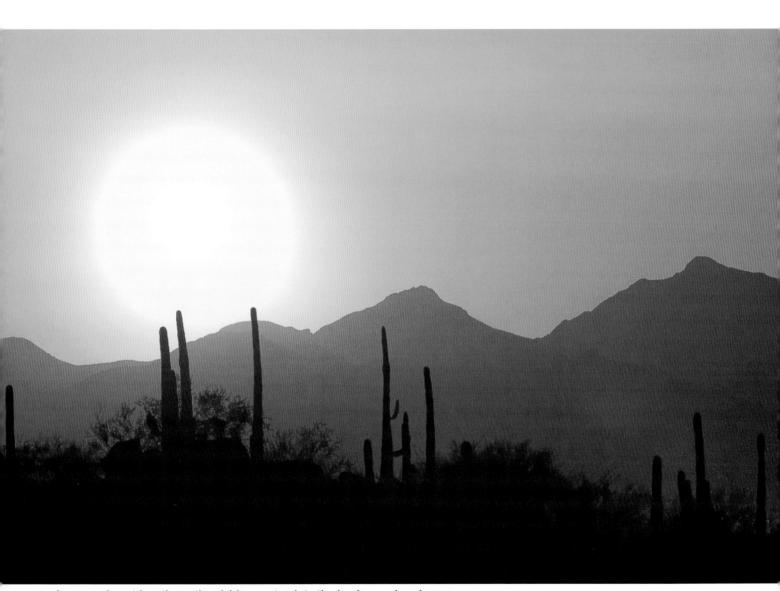

In many desert locations, the vivid sunset paints the landscape in crimson.

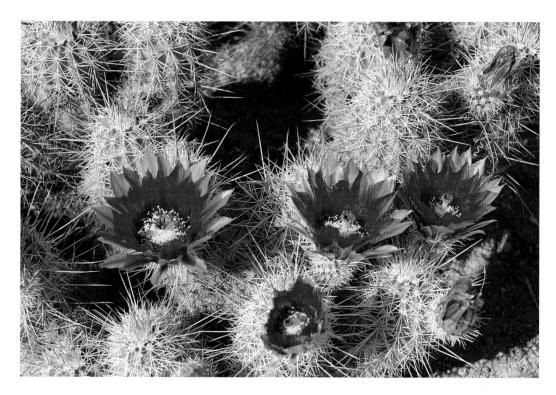

DESERT PLANTS

Plant life is a surprisingly abundant subject in the desert and, unless you happen to live in the Southwest United States, the plants you'll see there are unusual compared to what you see every day. I've spent days at a time photographing cacti in southern Arizona, and I'm always surprised by how interesting and pretty desert plants are. I always leave wishing I had more time or more daylight. If you plan on photographing cacti or wildflowers, bring gloves and a pair of kneepads—the best vantage points are down low, and your hands and knees will thank you later.

What makes desert plants visually fascinating are the unusual forms they have adopted to exploit and defend against their unforgiving surroundings. All of these plants have evolved in odd and beautiful ways just to survive. From the myriad flowering groundcovers of the Mohave Desert in Nevada and California to the forests of giant saguaro of the Sonoran Desert of southern Arizona and Mexico (which tragically seem continually victimized by human development), the sheer variety of desert plants boggles the mind.

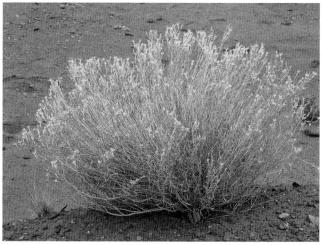

Photographing cacti and other plants is really just a matter of experimenting with interesting confluences of texture and shape. In shooting giant saguaros, for example, I love to capture the bold eccentric shapes of these desert trees. Some saguaros live to be 200 years old, and their size and the peculiar shapes of their "arms" seem to me to have been conjured by (or perhaps inhabited by) mercurial desert spirits.

As you wander and explore, experiment using low angles and wide-angle zoom settings to exaggerate the height of taller plants and contrast or silhouette their shapes against the sky. Alternately, try longer zoom settings from higher vantage points to compress spaces and make the composition seem denser.

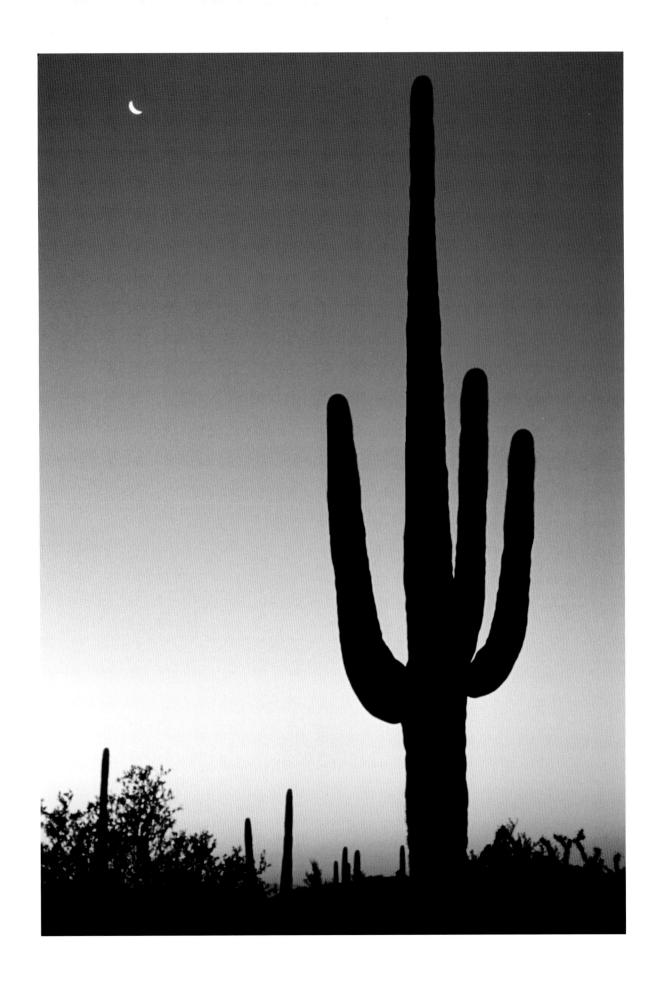

Early spring is a wonderful time to photograph desert plants, especially after wet winters.

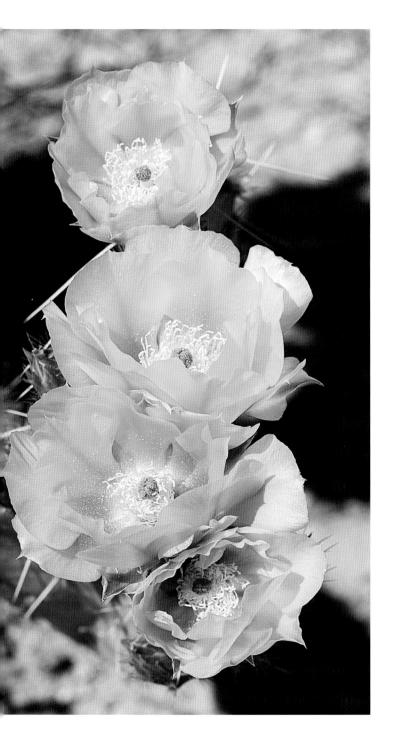

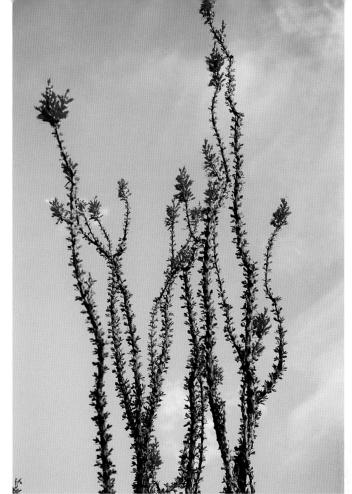

Early spring is a wonderful time to photograph desert plants—especially after wet winters—because the entire desert floor magically erupts into floral displays that jangle the imagination of even the most jaded gardener. Although I've seen seemingly dormant plants burst into bloom just a few days after a rainstorm, the best shows usually happen a few weeks after a good rain. Unfortunately, it's impossible to know just when the desert is going to come to life, but if you contact the state or national parks in a particular region, they will supply up-to-the-minute information (hopefully they won't say, "Oh, you should have been here last week!").

Most compact digital cameras have surprisingly good close-up or macro capability, so if the desert is in flower, capture individual blooms in addition to more sweeping scenes. Using a smaller aperture—higher f/number—will help you increase depth of field (near-to-far sharpness) in the Close-up mode, but you will have to switch to an Aperture-Priority mode to select your own aperture.

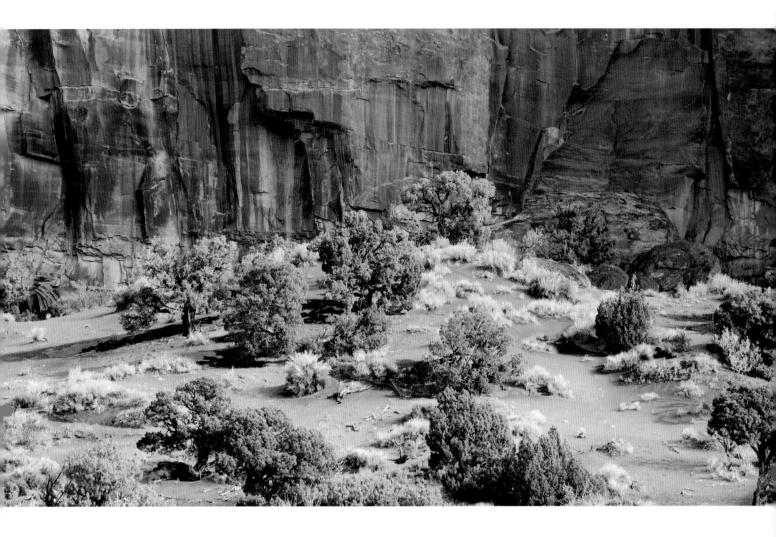

Don't get too close to any cactus when shooting or you'll find out just how they defend their space. (They don't call the cholla cactus the "jumping cactus" for nothing—if you look at it wrong it will send a spray of needles your way.) Needless to say, whenever you shoot in the desert, you'll need to protect yourself and your camera from heat, sand, and rocks. Bring plenty of water (for drinking and washing hands), a widebrimmed hat, and an umbrella to keep yourself and your camera cool. It's also not a bad idea to announce your presence (to snakes, in particular) by stomping around a bit as you amble down a trail; it's great to see desert wildlife, but it's usually best if it's not a total surprise (for either party).

Of course, it is important to keep your camera clean. Be especially careful not to let fine, windblown dust into the memory card slot when you're changing cards—and always put your extra cards into their plastic holders to keep them clean. If you're using a D-SLR, take particular care when changing lenses because the dust can get onto the image sensor and it's a nightmare to get it out. I always carry a lot of small zipper bags and microfiber cleaning cloths (that I store in plastic bags) and keep a constant eye on the cleanliness of the body and lens.

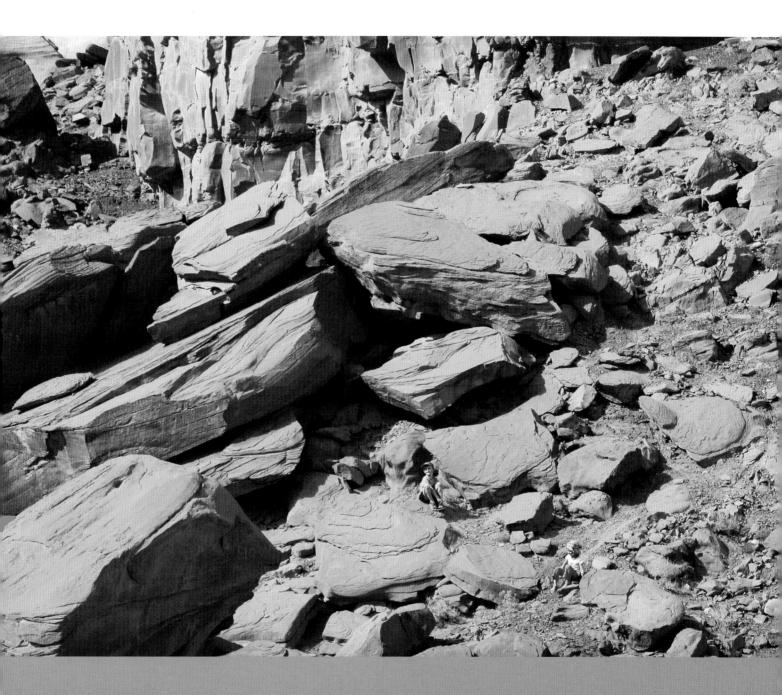

Bring plenty of water, a wide-brimmed hat, and an umbrella to keep yourself and your camera cool.

Waterfalls

Few things mesmerize us more than water responding to gravity's siren call. Perhaps it's the inner kid in us (no doubt anxious to launch a stick boat into its plunging waters), or just the fun of watching nature in action, but no matter how many waterfalls we've seen, it's hard to turn away from them. Whether it's the local brook tumbling over a few fallen logs, a mountain stream carving its downhill journey home, or one of the world's grand cascades, waterfalls inspire creativity. Indeed, when commissioned to create what was to become his most famous building (a home for Pittsburgh department store owner Edgar J. Kaufmann), architect Frank Lloyd Wright incorporated the waterfall on his client's property into the structure—and, of course, named it Fallingwater.

In most parts of the world, waterfalls are a plentiful phenomena—I've even seen impromptu waterfalls sprout up in desert canyons after a heavy rain. Most falls are relatively remote, and finding them can be part of the challenge—and the fun—of photographing them. If you're traveling in a mountainous region, or in an area noted for its waterfalls, find them by studying local tourist maps and brochures or, for more prominent or historic falls, look for pictures of them on the postcard rack. Studying cards and brochures is a great way to see how other photographers have approached particular falls.

In large wilderness areas, waterfalls are so numerous and well-hidden that it can take years to find and get familiar with them. For the past 25 years, photographer Derek Doeffinger has explored the hundreds of waterfalls in New York's Adirondack, Catskill, and Finger Lakes regions. The results of his ambitious explorations have been published in two books: Waterfalls of the Adirondacks and Catskills and Waterfalls and Gorges of the Finger Lakes. As his photos show (at right and on the following page), he has pursued his passion in every season, returning to the same waterfall time and again to capture it in the right light.

If you're exploring on foot and shooting with a D-SLR, it's best to limit yourself to one or two lenses, or even one zoom. A wide-angle lens (24mm or wider) is a good choice because it will enable you to work in tight confines while providing the inherent depth of field necessary to keep both near and far in sharp focus.

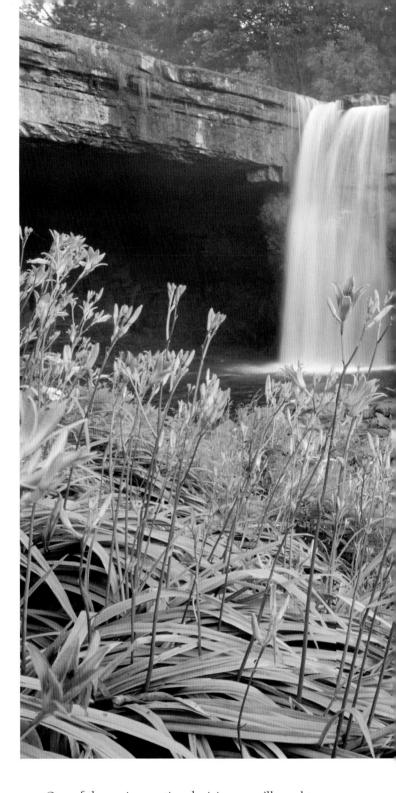

One of the main creative decisions you'll need to make is choosing a shutter speed. A fast speed (1/125 second or faster) will freeze most water motion and a slow shutter speed (1/15 second or slower) will reveal the motion. And a shutter speed of 1/4 second or slower will turn the flowing waters of a mountain stream or falls into a silvery ribbon of liquid motion. Remember, when using slow shutter speeds, you will need to stabilize your camera with a tripod or monopod—or a nearby tree or rock—to avoid blur from camera shake.

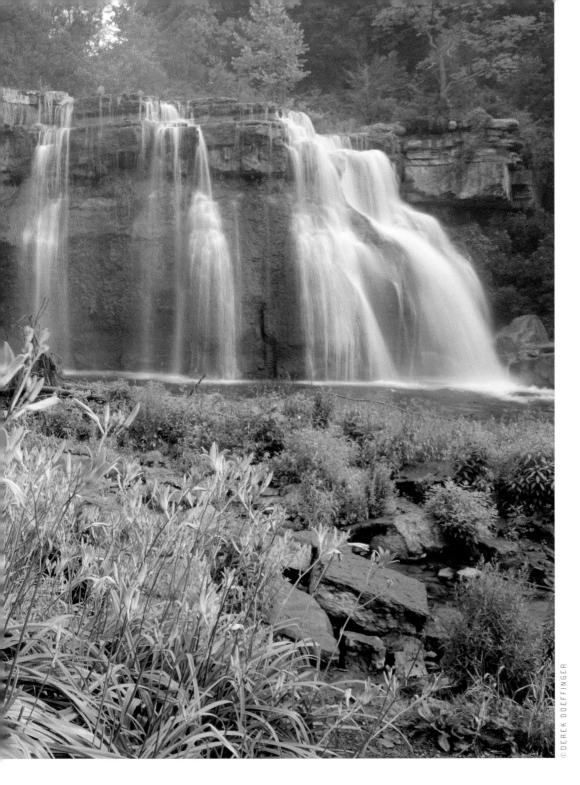

Your vantage point will have a large impact on how the falls will be perceived; photographed from their base or from the stream below accentuates their height and puts the viewer "into" the scene. Photographing them from the rim of the ravine or from a more distant vantage point offers a better perspective of the waterfall in its environment. Often, too, you can find a vantage point partway between top and bottom that provides an "eye-level" view of the falls.

One difficulty of photographing many waterfalls—particularly in wooded areas—is the contrast between sunlit water and shaded forest. The best solution is to shoot when the light is relatively even, or on cloudy and misty days when the lighting has a muted quality.

Whatever your vantage point, take special care—streams and waterfalls are slippery by their very nature and in the distraction of trying to set exposure and compose a photo, it's easy to lose your footing.

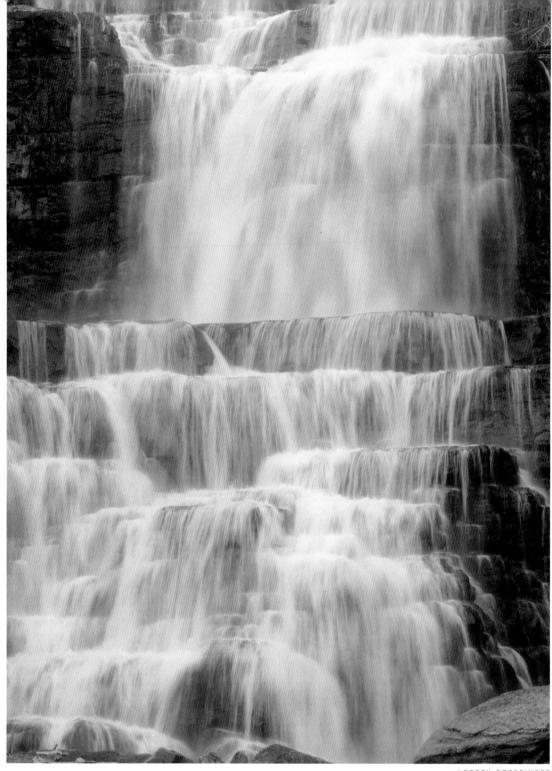

ODEREK DOEFFINGER

Often even very spectacular falls are known only to locals and backwoods hikers. One way to uncover hidden falls is to study the topographic maps created by the U.S. Geological Survey that are available in most wilderness supply stores (or you can purchase them directly from the government store at: http://store.usgs.gov/). Another way is to spend a few hours reviewing maps at www.trails.com. But the easiest way to find falls is to do an Internet search. Just go to your favorite search engine and type in "waterfalls" and the appropriate region. Waterfall aficionados are everywhere, and often publish websites with pictures and directions to their favorite falls.

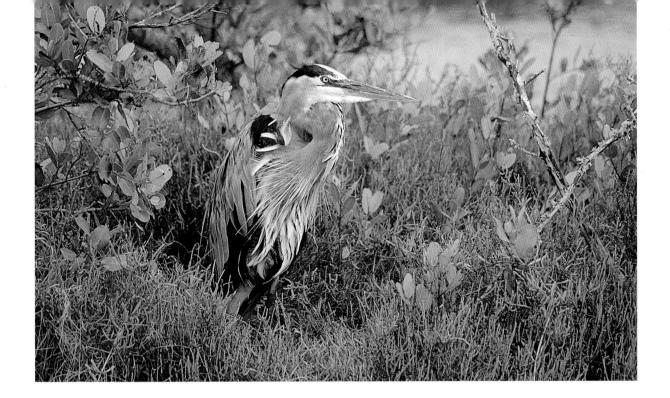

Birds and Animals

Getting a great picture—or any picture for that matter—of a wild bird or animal makes shooting pictures of an uncooperative toddler seem like, well, child's play. At least you can catch and return a toddler to the vicinity of the camera—which is probably not something you'd want to try with a wild animal. The difficulty of getting an interesting close-up photograph of a wild creature is precisely what makes wildlife photography such a challenging—and rewarding—hobby. Other than the birds and squirrels that frequent our backyard feeders, most animals recognize us and avoid us for the predators we are. So, the first thing you have to master, before you can hope to get a good photograph of an animal, is getting closer to your quarry.

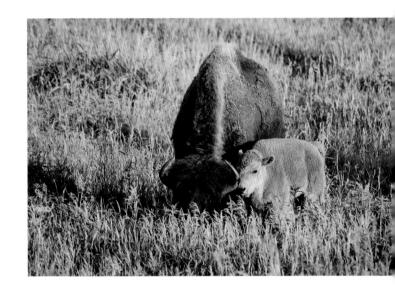

TELEPHOTO LENSES

Most amateur photographers would argue that professional photographers get good wildlife pictures because they have access to powerful (not to mention very expensive) telephoto lenses. Most pros, on the other hand, will tell you that, while owning big, long lenses is helpful, there's a lot more to getting close to animals than a telephoto lens; it takes patience, practice, and often study of the animals and environments you aim to photograph.

There's no question, though, that telephoto lenses make the job of getting good wildlife shots easier. They enable you to fill the picture area with your subjects from a substantial distance, and the longer the focal length of the lens, the larger your subject will be in the picture. Shooting from a distance also means that animals will take less notice of you, which not only allows for more natural behavior and more interesting photos, but also makes it a lot safer.

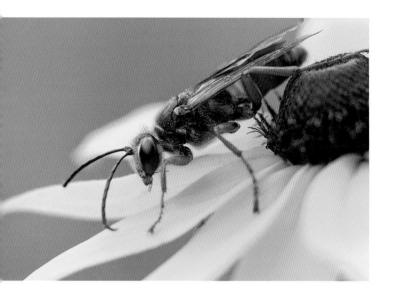

The problem with getting close-up shots of birds and wild animals with a basic point-and-shoot is that, with a few exceptions, most have a limited zoom range. However, many higher-level advanced compact cameras have zoom lenses with an extended optical range. Some of the superzoom digitals (see *The Missing Link*, page 40), with zoom ranges of 26x or more, can bring you up close to birds, insects, and animals at a comparatively reasonable cost to buying a D-SLR outfit. If you love wildlife photography, you might want to consider a superzoom camera.

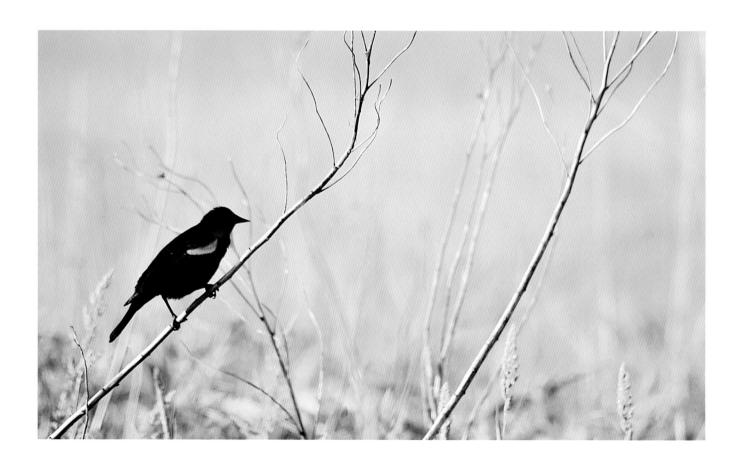

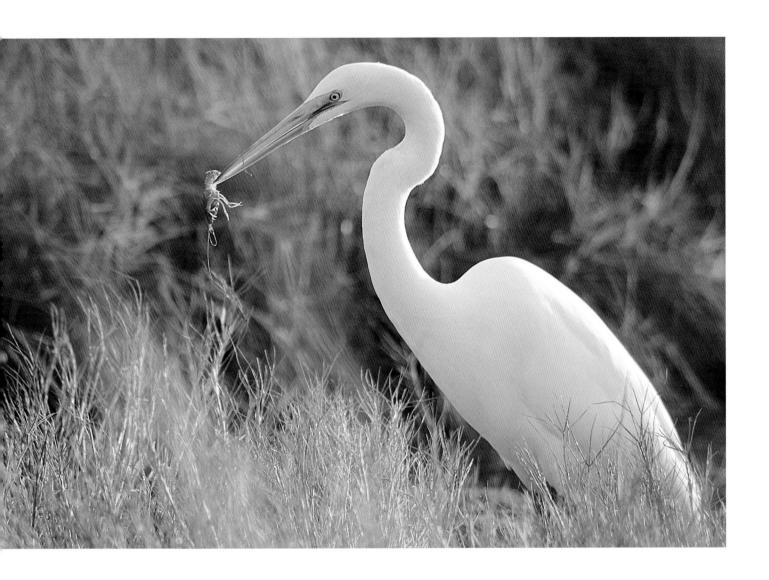

Still, a D-SLR with interchangeable lenses offers the best solution because, not only does it solve the distance problem with available lenses ranging in focal lengths from 200 to 800mm, but the autofocus system on a D-SLR is nearly always superior. Plus, the magnification factor (see page 43) gives you extra telephoto capability. Prices for D-SLRs have consistently decreased over the years, so you can now get an introductory-level D-SLR and telephoto zoom for around \$600.

Long lenses do come with inherent drawbacks, including substantial size, weight, and (except for the most expensive) much slower lens speed. Also, lenses in the 600mm range often come with their own oversized hard-shell aluminum cases that can make a day spent shooting pictures seem more like helping a friend move into a new apartment. Remember, too, that the more you magnify an image, the more you magnify camera shake—a tripod is essential.

Digital Zoom Tip

Avoid the temptation to use the digital zoom found in many point-and-shoot and advanced compact cameras. This feature crops your image digitally to make it appear large, but there is an absolute loss in quality. You can do the same thing (with better results) in your computer using the crop tool.

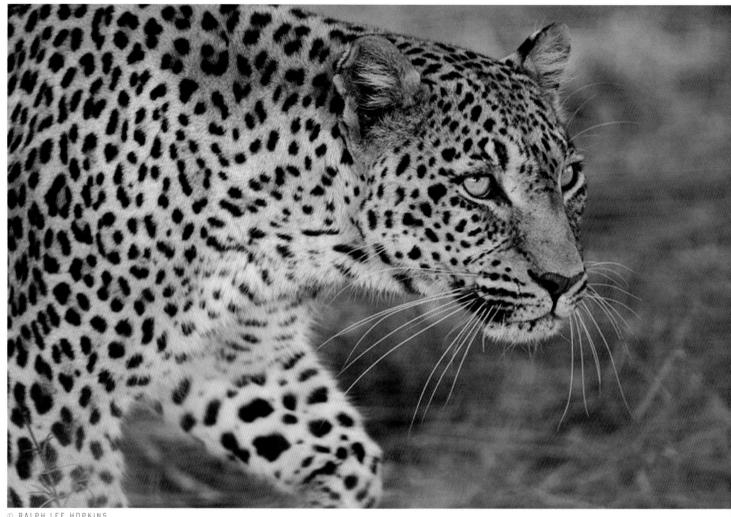

PH LEE HOPKINS

Guided wildlife-viewing tours, offered in many parts of the world, are a wonderful way to get close to animals.

WILDLIFE FACE TO FACE

All the long lenses in the world aren't a substitute for two far more important elements required in wildlife photography: patience and knowledge of your subject. If you're photographing wading birds in a marsh, for example, knowing a simple thing like whether they prefer to feed at high or low tide will help you predict when birds will be plentiful. It might also help to know that birds busily feeding are far less skittish than birds just shooting the breeze with other birds on the shore. Not to be overly dramatic, but a bit of knowledge could also save your life. Knowing that when a moose lowers its head and folds down its ears it's about to charge (as opposed to asking for a good scratching) could come in handy should you stumble onto one in the woods of Maine or Minnesota.

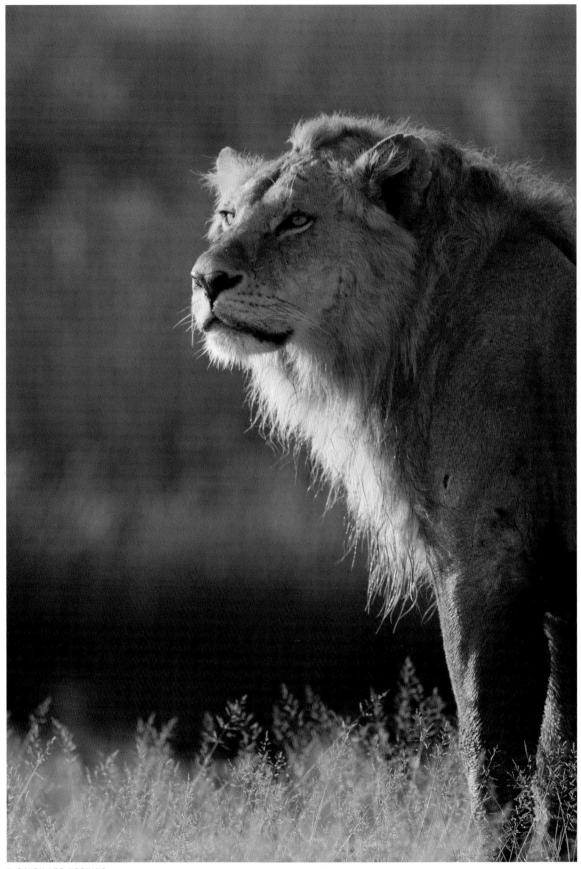

© RALPH LEE HOPKINS

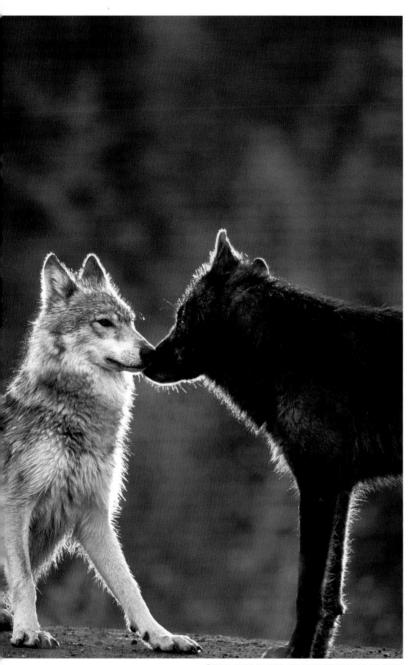

© RON NIEBRUGGE/WILDNATUREIMAGES.COM

It may not be easy to get close-up "big animal" shots like the ones on the surrounding pages. Wildlife photographer Ralph Lee Hopkins, a professional who travels across the globe with Lindblad Expeditions and *National Geographic*, has been honing his skills (not to mention his fearlessness) for the past twenty years. And Alaska-based photographer Ron Niebrugge specializes in outdoor photography, including wildlife, landscape, and travel. But even without such expertise, you too can get great photos of large animals, be it at the zoo or on a photo safari.

Guided wildlife-viewing tours, offered in many parts of the world, are a wonderful way to get close to animals. In places where lions, elephants, or bears are plentiful, professional guides will take photographers incredibly close to these animals (talk about camera shake). Such guided photo safaris are expensive, but the access they provide to dangerous and exotic animals is unparalleled. Magazines like *Outdoor Photographer* are a good source of information on reliable tour operators and wildlife guides. Also, some resorts and tour operators often work with well-known photographers on a regular basis. These photographers have an intimate knowledge of local conditions, and that can be a real advantage.

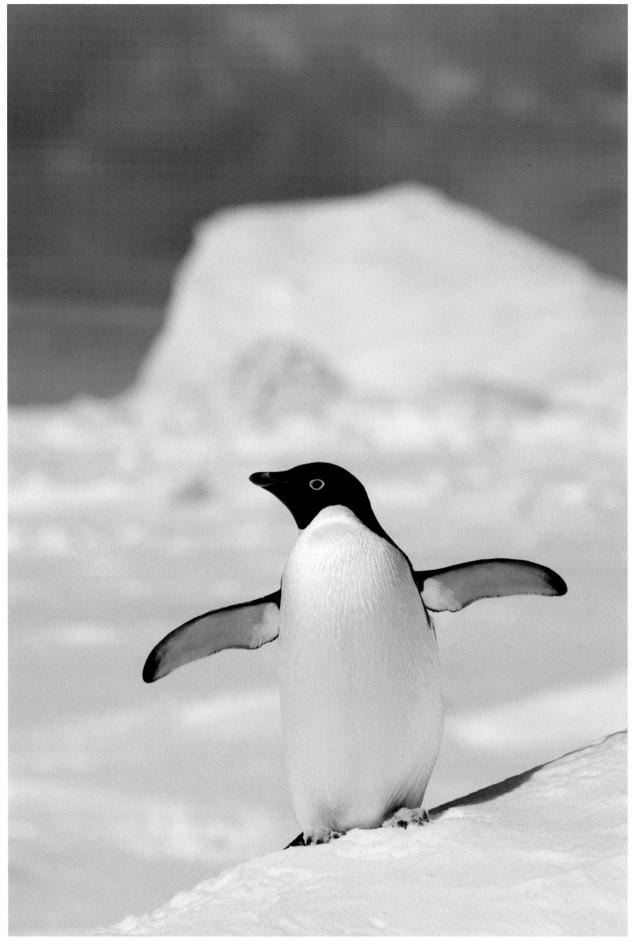

© RALPH LEE HOPKINS

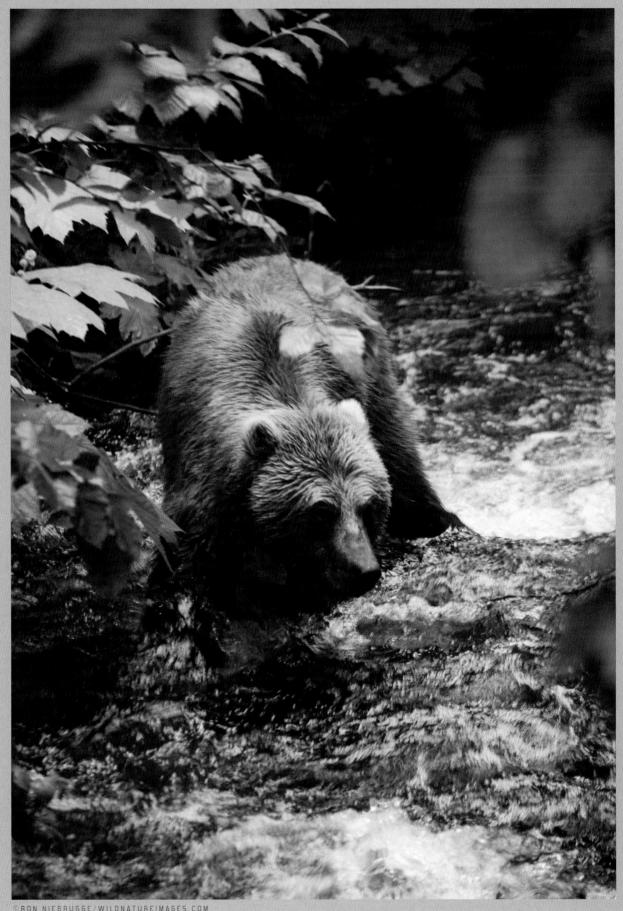

@ RON NIEBRUGGE/WILDNATUREIMAGES.CO

This is a portrait by Boyd Norton of a Silverback Gorilla named Mrithi. It was photographed for his book, *The Mountain Gorilla*. Unfortunately, Mrithi, the leader of a group of gorillas in Rwanda, was later killed by rebel terrorists.

If going into the wild sounds a little risky to you, it is possible to use private captive-animal preserves to get close to species that are nearly impossible to find or approach in the wild. If this idea appeals to you, you can find many preserves advertised on line. Although the preserves may charge a hefty fee, they offer once-in-alifetime opportunities to photograph animals that you're never likely to see, let alone photograph, in their natural habitat. As a matter of ethics, though, if you do shoot in a captive environment, it's important to label any of your photos as a "captive subject" (particularly if you're trying to sell your photos, or are entering photo contests).

You can also get very close to many birds and animals right in your own backyard. Setting up a bird-feeder next to a window and shooting from behind dark drapes provides an excellent method for getting close-ups of small song birds, even with a point-and-shoot or advanced compact digital camera. You can manipulate birds into camera position by setting up a bare branch between your window and a feeder; the birds will land there to rest between feedings, giving you a predictable place to shoot them. As the birds get used to landing on the branch, simply snip it a few inches shorter and you can control exactly where they'll land.

At home or in the field, regardless of how far away you think you are, animals will almost certainly be aware of your presence. The more time you spend in the company of your subjects, the more they will regard you as an acceptable part of their immediate environment.

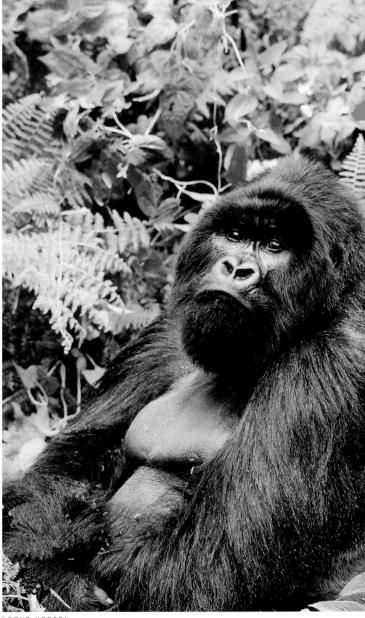

©BOYD NORTON

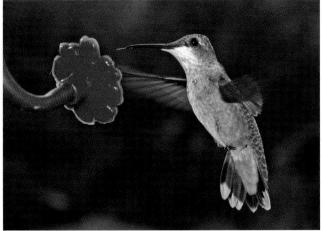

©KEVIN KOPP

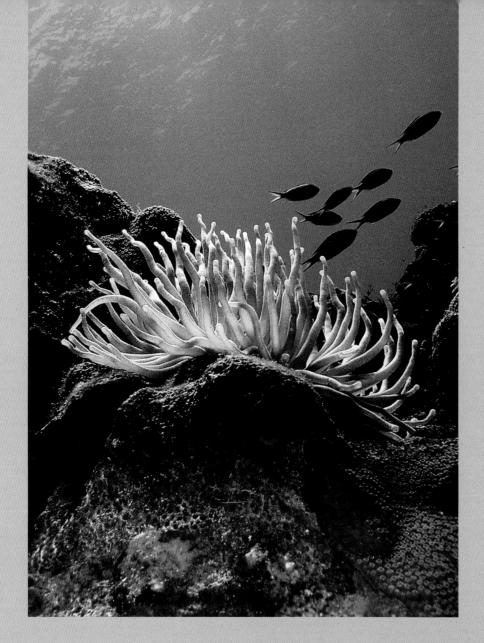

digital camera. If snorkeling at a seaside resort or going on the occasional dive trip is the extent of your underwater shooting, you can often rent the gear you'll need from dive outfitters, dive resorts, or local dive shops. If diving is a more serious part of your life, however, you might want to consider either buying a camera made just for underwater use or, if you've already invested in a digital camera, buying a housing and an accessory flash for your camera.

Underwater

While picking up shells on the shore may be the most intimate connection many of us have with sea life, there is a world of color, life, and wondrous photo possibilities just a few feet beneath the waves. From exotic fish to beautiful corals and plants, the undersea world is brimming with colorful subjects—and bringing a digital camera down to record them is much simpler than it might seem.

There are basically two ways to get a camera below the waves: One is to use a digital camera made specifically for underwater shooting, and the other is to use a waterproof housing to protect your existing As with all forms of photography, remember that it's not how expensive your gear is, but how devoted and imaginative you are as a photographer. The spectacular photos on these pages were all shot by Jim Langone (a Springfield, Massachusetts-based commercial photographer) using a digital camera in a Sea & Sea underwater housing with a Sea & Sea flash unit. He shot these images off of the island of Curacao in the Caribbean.

A few good sources for underwater equipment are: Underwater Photo-Tech (www.uwphoto.com), Sea & Sea (www.seaandsea.com), and Sealife (www.sealife-cameras.com). You'll also find lots of good equipment news and general information at the following sites: www.wetpixel.com and www.digideep.com.

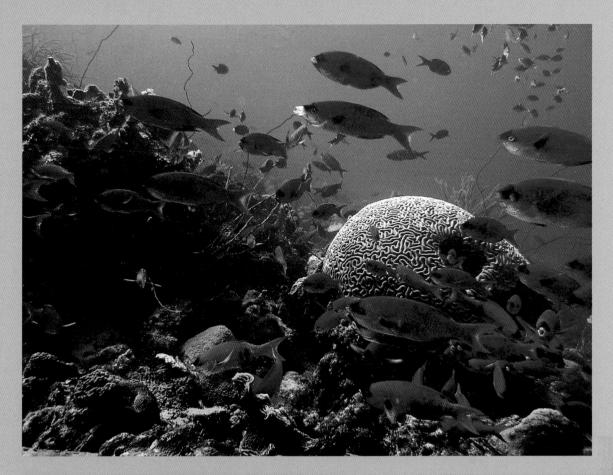

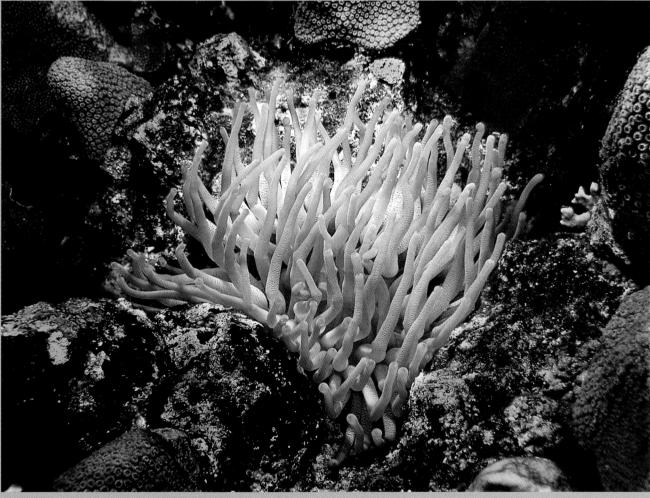

UNDERWATER PHOTOGRAPHY ON THIS SPREAD © JAMES A LANGONE

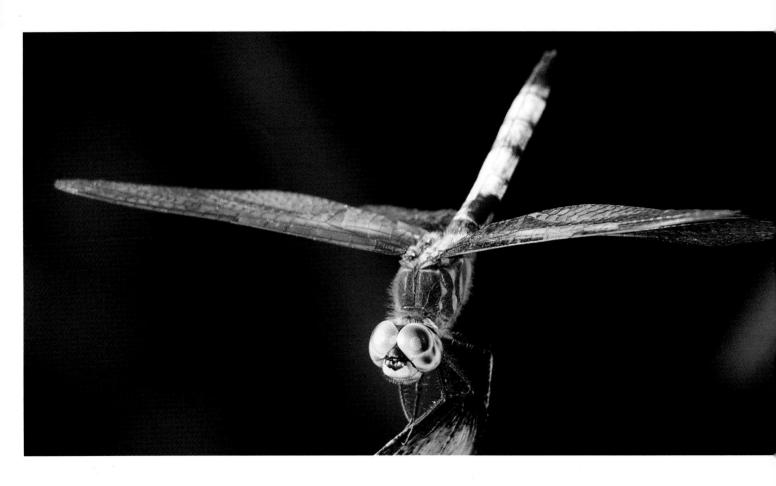

Close-Ups

As kids, we all explored the world around us with a magnifying glass in hand, fascinated by the alien appearance of magnified everyday objects. Somehow as we get older we become jaded to such experiences, but taking close-up photographs is a terrific way to journey back into this miniature world that surrounds us everyday but that we rarely explore as adults.

Until you get down on your hands and knees and start poking around the blossoms in your garden, or the Lilliputian world of the forest floor, you never know what you'll discover. Interesting close-up subjects are easy to find. Flowers, bugs, a butterfly's wing, dew drops glistening on a spider's web, the intricate veins of a maple leaf, and the colorful patterns on seashells are fascinating when viewed up close. As they say, the closer you look, the more you're bound to see.

Taking close-up photographs with a digital camera is surprisingly easy and, unless you get really involved in this part of the hobby, you won't need much—if any—special equipment. Most advanced compact digital cameras have a Close-up or Macro mode capable

of getting to within an inch or two (3 to 5 cm) of your subject. With some cameras, you can focus at these close distances without using the Close-up function. With my camera, I can fill the frame with a single violet blossom—pretty amazing for a compact digital camera.

If you're shooting with a D-SLR using interchangeable lenses, you can get even closer to your subjects using special accessories. A primary advantage for macro photography held by D-SLRs is that you're seeing in the viewfinder exactly what the lens (and the camera's sensor) sees. Most compact cameras are also capable of showing you what the lens is seeing, but only if you use the LCD monitor. If you use the optical viewfinder, you'll run into a technical problem known as parallax. Parallax simply means that there is a difference between what the viewfinder is seeing and what the lens is seeing—and when your subjects are only a few inches in size or smaller, that can be a major problem. You might frame the center of a zinnia blossom, for example, and find out later that you've only recorded the outer petals.

LIGHTING FOR CLOSE-UPS

Lighting can be tricky with close-up subjects for several reasons, not the least of which is because your subjects are so small that even minor changes in intensity, quality, or direction of light are exaggerated. If a shadow moves one yard in a landscape, you'll probably never see the difference, but if it moves a few millimeters across a flower blossom, your entire composition changes. Light changes happen much more rapidly with close-up subjects because the area being lit is so miniscule. If you dawdle, or don't anticipate changes in lighting, you may find you've missed your shot.

Quality of light is very important in close-ups, and each type of lighting has benefits and drawbacks. Soft lighting from an overcast sky (or open shade) is nice because it reduces shadows and works well for intricate subjects, but it tends to mute colors and hide textures. Harder and more direct lighting saturates colors and accentuates textures, but makes contrast and exposure much trickier.

Lighting direction also profoundly affects close-up subjects, and often dictates your vantage point. Backlighting, for example, will create pretty, fringe lighting on small flower blossoms or petals, but often casts other parts of the subject into deep shadow. If you change your shooting position to avoid the shadows, you lose the beauty of the rim lighting. And again, even small changes in camera placement will impact the appearance of your subjects.

Getting enough light on your subject is yet another important issue, and often you'll have to rely on adding lighting—either from reflectors or electronic flash. Using small apertures (high f/number) allows for greater depth of field (the near-to-far area of sharp focus), but smaller apertures let in less light, so you'll have to use longer shutter speeds to get enough light for a good exposure. But here comes the catch-22: Longer shutter speeds, in turn, increase the likelihood of a blurry picture resulting from either camera or subject motion. Also, you and your camera (and probably your tripod) are so close to your subject: that you have to be careful not to block the light—which is almost impossible to do in certain situations.

Soft lighting from an overcast sky (or open shade) is nice because it reduces shadows and works well for intricate subjects.

Close-Up Lighting Tips

You can increase the amount of light hitting your subjects—and hopefully gain a few stops in shutter speed—in several ways:

- 1. Use small white or silver cards to bounce light back into your subject; by placing the cards facing the light source (the sun), you'll be able to aim light at your subject.
- 2. Try turning on your flash (some cameras will turn the flash on automatically in the Close-up mode), but flash at close range tends to obliterate subject detail and replaces, rather than enhances, the delicate natural lighting that might have attracted you in the first place. If you've got the patience, you can soften flash by folding a few layers of white lens tissue over the flash head.

If you're working with a D-SLR, your lighting options open up because you can use accessory flash units. These units are generally much more powerful than the built-in flash, but more importantly, you can remove them from the camera body and place them in more creative positions—to the side or behind the subject, for instance. Also, by using a light-activated triggering device called a "slave," you can use several flash units simultaneously to provide more even and balanced lighting to your close-up subjects.

CLOSE-UP FOCUSING

Regardless of the type of camera you're using, accurate focusing during close-up photography is crucial because the depth of field is very shallow often a fraction of an inch. If you're using a D-SLR, switch to manual focus and aim at the exact part of the subject that you want sharp. Some advanced compact digital cameras also have a manual-focusing feature, but these typically work by fixing the focal length at a specific setting and then requiring you to position the camera at a specific distance from the subject. If you don't have a ruler handy, manually focusing one of these cameras will be difficult, even when you use the LCD monitor. This method can take some getting used to (not to mention good eyes), and requires you to have some flexibility in your shooting distance.

You can maximize depth of field by switching to Aperture-Priority mode and using as small an aperture as possible. Of course, using a small aperture requires the use of slower shutter speeds that increase the possibility that a puff of wind or a slight camera vibration will blur your subject. (You will never speak kindly of breezes again once you starting shooting a lot of macro pictures.)

A small tripod capable of very low positioning is essential for most close-up work because camera shake from handholding the camera can easily blur the picture. The problem with tripods, even small ones, when working close to the ground, is that it is difficult to keep the front leg or the shadow of the tripod from appearing in your picture. I often overcome this problem by resting the camera on a small soup-can sized beanbag that reduces camera shake and doesn't interfere with my subjects.

Close-up photography is a world unto itself and there are a lot of devotees out there. If this subject interests you, post your images to a group online-gallery where the world can enjoy your discoveries.

Using an LCD screen to compose a close-up shot has both advantages and disadvantages. Cameras with an articulating LCD screen (one that lets you adjust its position) make it easier to compose shots of flowers and other low-lying subjects because you can aim the screen up and view it from a kneeling or bending position. On the negative side, it's hard to see LCD screens in bright sunlight, making both composition and critical focusing difficult.

Keep a dark or plain background behind the main subject whenever possible; an errant blade of grass or a curled leaf will often create a distractingly out-of-focus blob in the picture. When I'm working in my yard, I feel free to pluck any offending flotsam out of my camera's way, but in the forest I leave living subjects unharmed. Instead, I use a stick or a piece of photo gear to temporarily restrain a wayward piece of greenery.

Weather

It's natural to think about taking outdoor pictures when the sun is high, the clouds are puffy and innocent, and the scent of summer fun floats on the breeze. But nice weather can lead to terribly dull pictures—particularly if those are the only days you pick up the camera. Limiting your outdoor shooting only to nice days will give your images an inescapable sameness. Making an effort—even just occasionally—to include stormy skies, fog and mist, ice and snow, and the occasional lightning streak will paint your pictures with drama and freshness.

On a more practical note, unless you happen to live in Hawaii, the odds of your having nice weather all the time are small. Finding beauty in all kinds of weather then will expand your outdoor opportunities considerably. More importantly, as weather patterns change, a single landscape or outdoor scene may quickly offer up a variety of distinctive moods. And after all, capturing nature's moodiness is what makes nature such a fascinating subject.

Remember that often it's not the weather that supplies the drama, but rather the agents of change themselves: gathering storm clouds, swelling waves, or winddriven treetops. The after effects of weather are equally appealing: the intensified colors of a desert landscape or a fresh blanket of snow in the forest. Although you may have to sit out the nasty weather, you can dine on a buffet of one-of-a-kind photo opportunities before and after a storm.

Remember that often it's not the weather that supplies the drama, but rather the agents of change themselves: gathering storm clouds, swelling waves, or wind-driven treetops.

RAIN

Rain is one of those things photographers often wish they could wish away but, like the tax bill and the common cold, it comes when it comes. And I can tell you from years of traveling to "sunny" destinations to shoot pictures of anything but rain, screaming at the weather channel in the hotel doesn't help (though I will confess it does sometimes feel good).

Thankfully there are a lot of good photographic opportunities to be found before, during, and after a rainstorm. Once you make your peace with the weatherman (hey, it's not his fault!) and venture out, you'll find that rain can be a refreshing visual companion.

The minutes before a thunderstorm lets loose can be a wonderful time to look for photos because the land often glows under a soft yellow light emanating from the gathering storm clouds. The contrast between dark sky and bright foreground is astonishingly pretty—especially if you have a brightly colored foreground subject like a red barn or a maple tree in its autumn foliage. Next time a storm gathers, whether you're thinking of photographing or not, step outside and watch as the contrast builds between sky and ground; it's one of those ephemeral situations that is exciting to see, but that you can never predict.

One of the more obvious difficulties of shooting on rainy days is that the dim light forces you to use slower shutter speeds and/or wider apertures. You may want to manually adjust your camera's ISO speed to a higher setting (some cameras will do this automatically). Bear in mind that using a higher ISO will increase the random color specks of digital noise. If your camera has a Shutter-Priority mode, try keeping the ISO at the default speed (usually around ISO 100) and use a tripod and longer shutter speeds to make up for the low light levels. Also, unless you want to use flash to highlight a foreground subject, be sure to manually turn off your built-in flash to prevent it from firing.

For the brave of heart (or those shooting from a doorway or under an overhang) rain itself can be an interesting visual element. In a heavy rain, set your shutter speed to 1/30 second or slower (with your camera on a tripod) and the rain will streak nicely across the frame. Conversely, very fast shutter speeds will freeze

the raindrops. If you want to experiment with the effects of different shutter speeds on rain sometime, turn on the lawn sprinkler, shoot the sprays of water using varied shutter speed settings, and then compare the results.

One of the immediate benefits of rainy days is that the crowds disappear. You'll have landmarks, parks, and gardens all to yourself. I'll take the slight inconvenience of a light rain in an empty public garden over a crowded sunny day anytime. You can work around or exploit the rain—crowds are another story. Of course, there will be days when the rain is so hard that not even the most devoted outdoor photographer will open the camera bag. On these days, particularly if you're on vacation, use your time to scout scenes so you're ready for the better weather.

snow

Miles above the earth in the upper atmosphere, supercooled water vapor mingles with dust particles to form snow crystals. Hundreds of crystals then band together in perfect hexagonal symmetry to form a single snowflake. Eventually, the flakes grow too heavy and gravity pulls them to earth, where billions upon billions of them create beautiful, snowy landscapes. And as much as I dislike shoveling it, there is nothing like snow to transform an ordinary scene into a Norman Rockwell vignette.

Overnight snowfalls are particularly fun to photograph. If you get up early enough, you can shoot before human activity blemishes the perfect surface of the snow-filled wonderland. Like fog and mist, snow simplifies complex scenes, reducing them to a minimalist collection of shapes, colors, and textures. Unlike fog and mist, snow sticks around longer so you have more time to seek interesting compositions.

The toughest problem in photographing snow (other than staying warm) is getting a good exposure. Because your camera's meter is designed to get accurate readings from medium-toned subjects, it will see—and record—pristine white snow as dishwater. You can

© KEVIN KOPP

correct this by using your exposure compensation feature to add an additional stop to a stop-and-a-third of exposure (+1 to +1.3).

If you forget to use exposure compensation, it's easy enough to correct the picture later with image-processing software using the Levels or Brightness/Contrast adjustments. But if you plan to go directly from camera to print, it's far better to get a correct exposure in the camera.

Observe the lighting direction and time of day. At midday, bright sun bouncing off snow is harsh and obscures its gentle, sugary surface texture. Clear blue skies give the snow, especially in shadows, a bluish cast. Shooting early and late in the day provides two benefits: The lighting is warmer and cozier, and long slanting rays of sunlight emphasize the texture of the snow.

Also, look for viewpoints that reveal the early or late sun casting long shadows across the surface of the snow. Shooting into the sun will enhance the depth of a scene because the shadows of trees or shrubs will be coming toward you. Shadows that run sideways across the frame are interesting, too, and give the viewer a sense of being in the scene. Harsh front lighting, where the sun is over your shoulder, washes out textures and details.

Shooting early and late in the day provides two benefits: The lighting is warmer and cozier, and long slanting rays of sunlight emphasize the texture of the snow.

Try to include objects of known size in snow scenes because it's easy to lose the feeling of scale and proportion with large expanses of snow.

Remember that cold drains batteries very quickly, so keep your camera under your warm coat. In very cold weather I often pop the batteries out of the camera and put them in an inside pocket until I'm ready to shoot.

If you bring a cold uncovered camera into a warm room, condensation will form on its glass surfaces (and possibly on the camera's sensor). You can prevent this by placing your camera in an airtight plastic bag outdoors—before coming indoors—and then leaving it in the bag for at least 30 minutes.

FOG AND MIST

Fog and mist make intriguing additions to any land-scape photograph—they soften edges, simplify complex scenes, and add mystery and romance to familiar locations. So, if romance and mystery are things you like, fog and mist can be wonderful visual additives. Draped in fog, once ordinary scenes can beckon like a wallflower come unexpectedly to life at the prom.

The best time to discover such scenes is early morning, before the sun has burned away the excess moisture in the air. Morning mists burn off quickly, so arrive before dawn for adequate shooting time (which may explain why I don't have a lot of fog and mist shots in my files). Early in the morning you may also encounter dramatic compositions of golden rays cutting through the silvery veil and raking across the landscape.

You're more likely to find both morning and evening mist near bodies of water, such as ponds, rivers and marshes. Open ponds in winter are a good place to look for misty landscape scenes because, as the warm air of the day passes over the cold water, a mist forms over the surface. In hilly or mountainous areas, fog often begins to tumble over the treetops in the late afternoon and, again, the long rays of afternoon light can create very dramatic scenes.

Because mist steals away details, colors, and textures, build your compositions around bold shapes and bright colors—a silhouette of a lone pine tree on a hillside or a red tugboat tied to a dock. Also, because fog and mist do simplify the landscape so drastically, very often scenes with bold shapes and colors will jump out at you even if you're not looking for them.

Underexposure is a common problem with foggy and misty scenes because both are very reflective and will trick your meter into thinking there's more light available than actually exists. The solution is to add an extra stop of exposure by using a +1 setting on your exposure compensation feature.

Additionally, in very thick mist or fog, your autofocus may have difficulty finding a sharp point of focus because most systems use areas of contrast to help them focus. If your camera is spending an inordinate amount of time racking back and forth searching for a point of focus, try instead to focus on a particular object that has more defined edges—or switch to manual focusing if your camera has that feature.

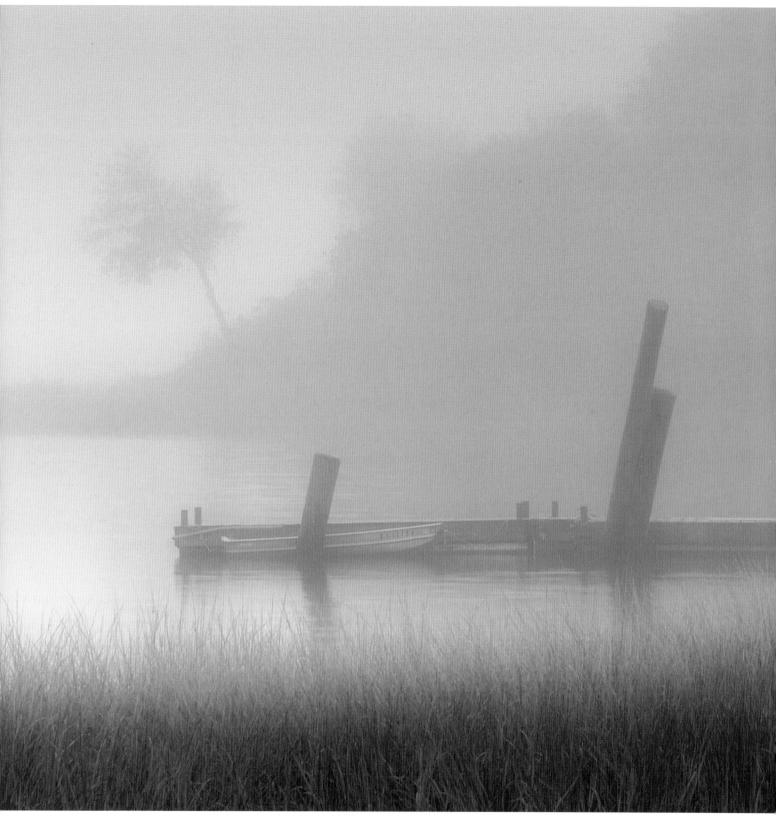

© DOUG JENSEN

If romance and mystery are things you like, fog and mist can be wonderful visual additives.

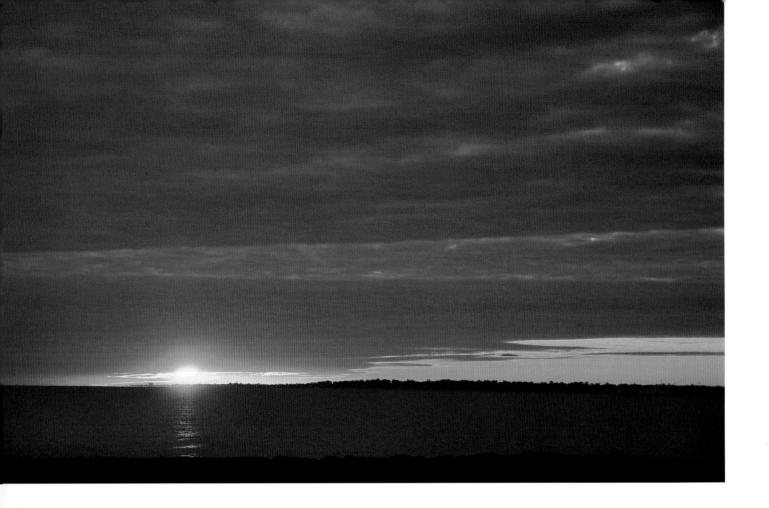

SUNRISE AND SUNSET

In 1883 the Krakatoa volcano near Java blew its top and shook the entire planet. It sent tidal waves racing around the globe, reaching even Manhattan, although greatly diminished by distance. One hundred times more powerful than Mt. St. Helens, Krakatoa spewed monstrous quantities of dust high into the jet stream and sent spectacular sunset skies more than halfway around the world. Skies glowed so wildly and brilliantly in places as far away as Poughkeepsie, New York that local fire departments sent crews to extinguish what they thought was a fire in the sky. Now that is a sunset worthy of a postcard! According to written journal accounts, those skies continued to "burn" radiantly for more than three years after the eruption.

While we probably won't witness anything like Krakatoa-induced skies in our lifetime, sunrises and sunsets still seduce photographers everywhere. Indeed, it's hard to resist the beauty of a sunrise or a sunset because, like snowflakes, fingerprints, and Miles Davis solos, no two are ever the same.

However pretty a sunrise or sunset might be, you can't expect their beauty alone to carry your photographs any more than you can expect one pretty pot of geraniums to rescue a poorly designed garden. The key to creating an interesting sunrise/sunset photo is to provide an attractive landscape in which to hang your colorful sky. Look for subjects with simple and appealing shapes that can hold their own against the colorful fat lady singing in the background. Still, because you want the sky to dominate your scene, the best foregrounds are simple ones with just a few bold graphic elements—a sailboat in a harbor, a lighthouse on a beach, or a trio of hikers on a rocky cliff.

Because the sun is so bright, it will no doubt fool your autoexposure system. It will make the sun look good, but everything else will likely appear too dark. Before taking the picture, set exposure by pointing the camera at the sky adjacent to, but excluding, the sun. Lock in the exposure (usually by holding the shutter button halfway down), recompose the scene to include

the sun, and press the shutter button to take the picture. If your camera has a Manual exposure mode, use it and, again, take your reading away from the sun itself, then recompose to include it.

A variety of different exposure settings will give you interesting results. Bracket exposures to give yourself several pictures of different brightnesses to choose from—particularly if the intensity of the sun's light is changing rapidly. Of course, if all else fails, a little adjusting in post-production will fix most exposure flaws (but you wouldn't fool with the colors, would you?).

Lens choice profoundly affects "sunscapes" because focal length determines how big the sun appears in your pictures. The longer the focal length of the lens you use, the larger the sun will appear. Larger sun images are usually more dramatic. Needless to say, whenever you include the sun in a shot, you're looking at a very bright star, so be sure not to look directly at it.

RAINBOWS

If you're lucky and venture bravely into the rain, the clouds may part and the photo gods may reward you with their ultimate blessing: a rainbow. No matter how long you wait for it, one great shot of a rainbow erases the frustration of many hours of rain.

You can often enhance the intensity of a rainbow in-camera by using a polarizing filter. If you're using a D-SLR, you'll be able to see the effects of the filter in the viewfinder; as you rotate the filter, the colors will begin to intensify and then fade if you rotate it further. Most compact digital cameras don't accept filters, but you can try experimenting with a polarizing filter (one that's large enough to easily cover the diameter of the lens), being careful to maintain that orientation while holding it in front of the lens. It's not terribly convenient, but any port in a storm is better than none.

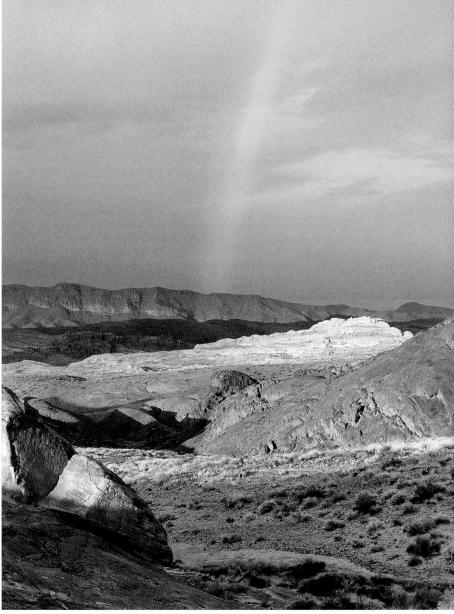

You'll have to recall a bit of grammar-school earth science to find rainbows: Always remember to turn your back to the sun as it emerges and face the darkest part of the sky. Also, if you're out shooting in the rain, always take the time to scout a good foreground location while it's raining—don't wait until the rainbow appears to find a location for your shot.

Finally, I'd be a bit remiss not to tell you that there are software filters out there that let you add rainbows to any scene. Your friends will be very impressed. You could even add two rainbows, or three, or four. There, I've told you, but you didn't hear it from me.

Time Passages

Marking the passage of time is essentially what we do every time we pick up a camera, and it is the reason that most of us own cameras. We record the growth of our children, changes in the backyard garden, and the highlights of our lives. After all, what fun would your twenty-first birthday be without Mom passing around the baby pictures of you naked in the bathtub?

The ability to freeze time allows us to look back, compare, and study various moments and see how our lives and our environments have evolved. The family album is basically a visual journey through the times of our lives. Time sweeps past us constantly like an invisible wind, and photographs can help us at least slow it down enough to notice it, even if we are helpless to stop it.

Once you become aware of time as a conceptual element, you can apply it to different nature subjects and even make it the central theme of a series of images. One of the interesting twists that digital photography adds to this mix is that, with many cameras, you can also record sound bites at the instant you record an image. So you can not only take a long exposure of waves crashing into the shore, but you can record their sound as well.

The passage of time you record can be anything from a few seconds, to fractions of a second, to a few days, to many years. Think of the difference between a city street shot at rush hour and the same street photographed at dawn. Imagine how different a meadow looks in summer, then in the dead of winter, shrouded in snow.

The most basic method for capturing small slices of time is simply to vary the shutter speed—using very brief ones to record fractions of a second (still a passage of time, yes?) to long exposures of several seconds. In the photograph of the waterfall (right) for example, the photographer used an exposure of several seconds to record water rushing over a mountain stream

in the Adirondacks. The ribbons of water visually trace time as their image moves across the camera's sensor. By carefully photographing the same scene over a period of days or weeks or even years, you can record longer passages of time—the progress of a wild morning glory vine moving up an abandoned billboard, a time-lapse

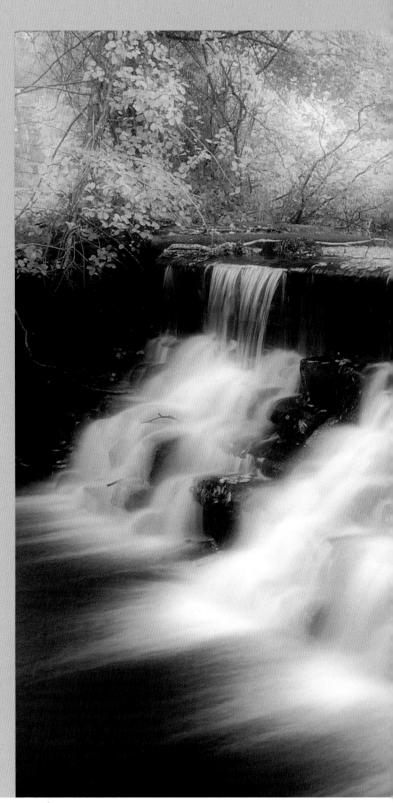

sequence of a single rosebud opening, or the growth of a special tree planted to celebrate a baby's birth. For years I've tended a perennial garden along the side of my house, and now that the garden has matured, I'm astonished to compare "then and now" photos and see how much the plants have grown.

One of the nice things about photographing time passages digitally is that the metadata recorded with your images includes the date they were shot, removing the burden of you having to remember or write down when you shot a picture. And amen to that!

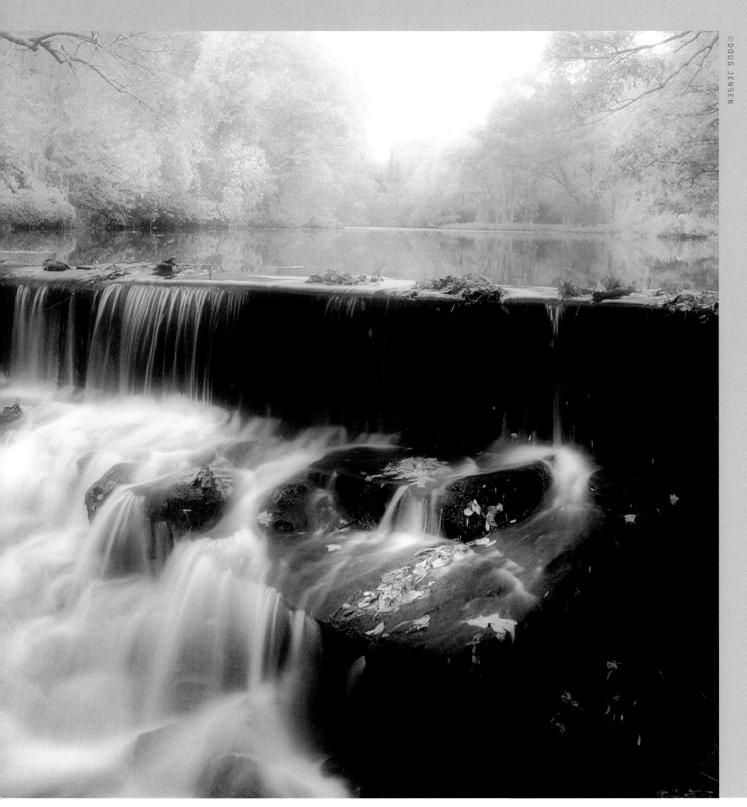

Photographer Interview

Ellen Hoverkamp

Ellen Hoverkamp's floral and nature-inspired still life photos have much in common with classic still lifes—they're beautifully and lovingly arranged, dramatically lit, and they exude color and texture. The only thing they don't have in common with most other still life photos is that none of them were created with a camera. All of her images, in fact, are created on the platen of a large-format flatbed scanner.

A lifelong artist who has worked in many different media (though photography was never one of them), Hoverkamp has taught art in the public school system in West Haven, Connecticut for more than 30 years. Her involvement in scanning actually began before the invention of desktop scanners, when she was invited to take part in a class that introduced visual artists to business and reproduction machines. Then, in 1997, she was introduced to her first flatbed scanner by a technology administrator and, inspired by a neighbor's garden, she turned to scanner technology as a way to preserve flowers. "I was trying to make lasting images of perishable items," she says. "A primary mission of photography is to document the ephemeral."

In the ensuing years that ambition has blossomed into a passion and she has gained a national reputation for her innovative scanner art. She has shown her prints in museums, galleries, arboretums—even in the annual Macy's Flower Show. But it's in the doing that Hoverkamp gets her real satisfaction: "Probably the most rewarding aspect of this project has been my dependence on others for natural materials to scan," she writes on her website (www.myneighborsgarden.com). "Friends, family, neighbors, and even people I hardly know, invite me to pick and use their flowers and vegetables for my work."

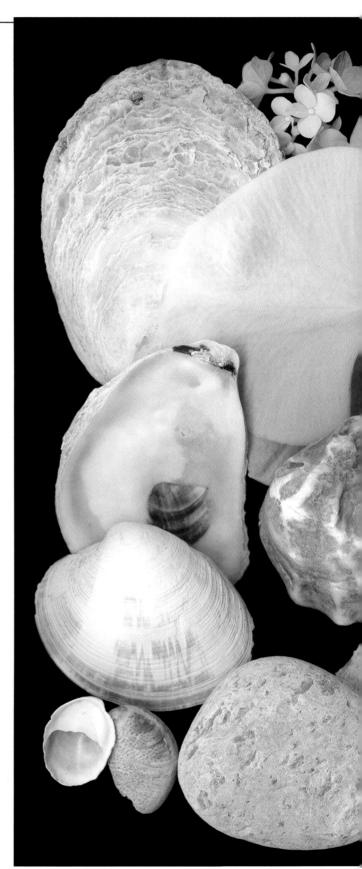

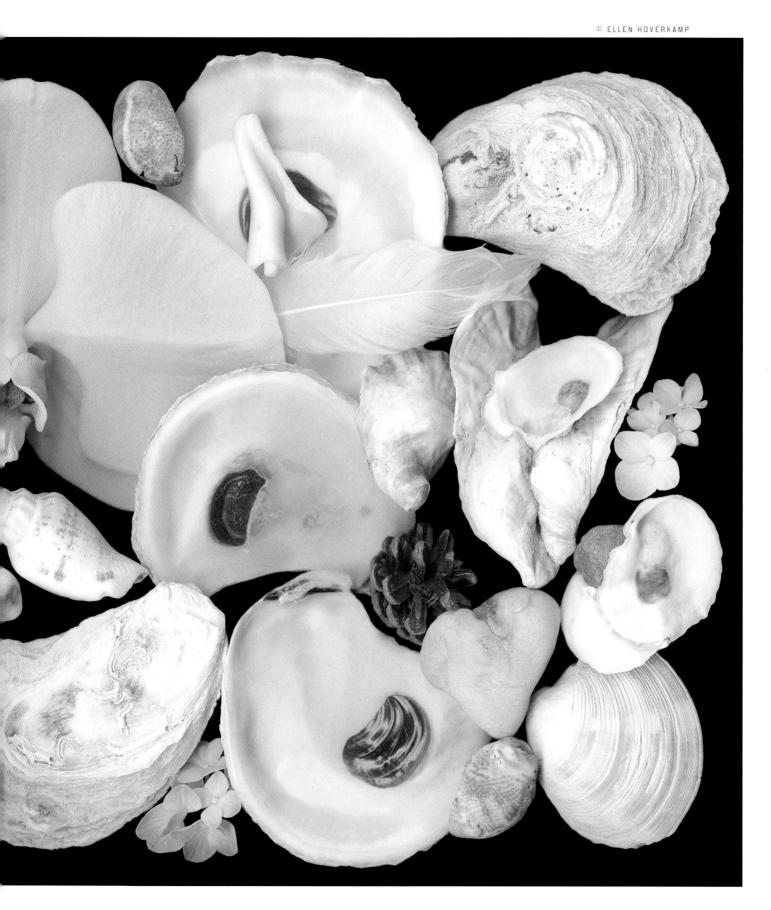

How did you get started in scanning?

Years ago I took a class with about a dozen other artists that was sponsored by a local business-machine corporation. The class was called Reprographics for the Visual Artist. We were encouraged to create our own bodies of work using all of this great technical equipment. Once we were trained on the machines we were allowed to use those machines for any creative purpose and print out at will. I was using a \$55,000 color laser copier, putting plants and other perishable items on the glass surface, and created a series of prints.

When did you get your first scanner and what was your response to being able to scan things at will?

Scanners weren't really invented until years later. When I first learned how to scan I was almost in tears. It was just like working with the color laser copier but you could see what you were doing on the monitor—it was quite an epiphany. In 1997, I scraped together enough money to buy a Pentium 1 computer and a \$69 scanner, which shipped with Photo Deluxe.

With that first scanner I started scanning flowers from my neighbor Richard's garden—which is how I named my website: www.myneighborsgarden.com. At first my experiments were kind of flat and there was a lot of highlight clipping. The scans weren't much to talk about, but I started making note cards out of the images to give them to gardeners as thank you gifts for letting me pick plants. Richard took the cards into work. Apparently people wanted to buy them. He finally said to me, "If you don't sell these, I'm going to start selling them." So I started selling note cards, which eventually led to marketing my work and the development of this project.

The concept of scanning flowers just grew from there?

A feature article in a local newspaper helped greatly to publicize my need for garden cuttings for my art. I'd give someone a package of note cards featuring pictures of their flowers. On the back it would say, "From ______'s garden," personalized with their name. They would get a memento and I'd get their flowers. Through my scans, gardeners were able to share images of things that they put their time and souls into growing. This project is a collaboration with people who are involved in growing plants and in appreciating nature's beauty.

Did you feel like a pioneer or that you were discovering something new with these scans?

I wasn't trying to invent a new art form or do anything that was catchy or new. The work came from a more personal level. I just needed to create these images, in order to feel more fully alive. This was a way that I could create imagery within margins of available time. I no longer had extended studio time for painting, printmaking, or video editing, but I could make time for scanning. Later at night, digitally retouching the images would be for me a form of mindful meditation. Art is always worth doing, but we have to fit it into our lives and our lives are always changing.

Were you aware of other people doing this work when you started?

At the time I started I was only aware of one guy that I knew about online who was scanning flower blossoms. I've since come to realize that there were other people doing this around the country at that time. I'm not the first, but I wasn't aware of my predecessors. I wasn't trying to do it to pioneer anything. For me, scanning was a tool for creating meaningful imagery.

Do you study the work of more traditional botanical artists?

Informally, yes. I've gone to the rare book library at the New York Botanical Gardens Library to look at illustrations. I live near Yale, so I visit Yale's museums. Recently I went to see an exhibit at the Yale Center for British Art by an artist named Mary Delany who made very detailed paper collages of plants in a botanical tradition on black backgrounds. Some people think that my work has a kinship to hers even though she lived in the 1700s. I love making complex arrangements and compositionally I'd say that my work is inspired by a variety of still life and botanical illustrators.

How soon after you pick flowers do you have to begin scanning?

I have an old refrigerator from the 1970s that provides a cool, moist environment for plant preservation, so I can work with garden cuttings over a period of several days.

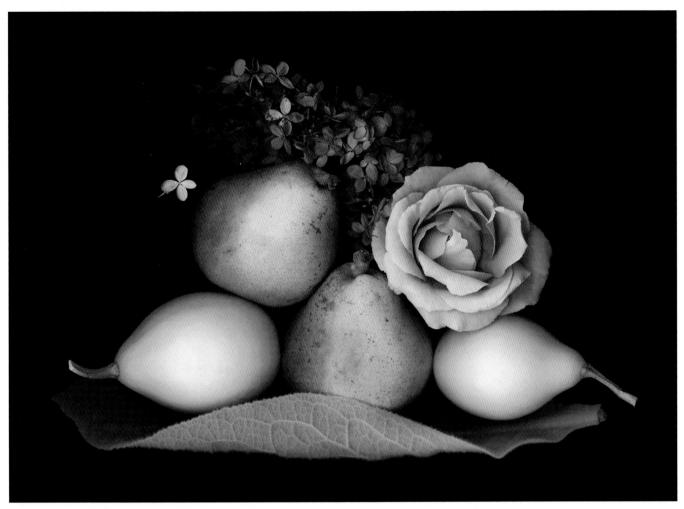

© ELLEN HOVERKAMP

How much time do you spend working on a particular arrangement for a scan?

Some arrangements come easily, like a gift; they only take around 20 minutes, but that's usually the minimum amount of time. Often it takes me up to an hour and a half, depending on how perishable the items are and some are very perishable. I've even taken a laptop computer and a small scanner to a gardener's home so that I could pick poppies out of her garden and put them right on the scanner. Otherwise, poppies may not survive the trip to my studio.

What size scanner to you use?

The scanner that I've been using for the past couple of years is an Epson Expression 10000XL. It's a large format flatbed scanner. The glass platen is 12 x 17 inches (30 x 43 cm). At first, I was self-conscious about my work not being considered photography in the traditional sense because I didn't use a camera as an imaging device. I made sure that everything included in the pic-

ture was actually placed on the glass of the scanner, as opposed to a composited image of separately scanned components. I felt a need to use a large scanner for creating more complex arrangements.

Do you think of the scanner as a camera?

Yes, I have always used a scanner as a camera. It provides light and captures that light on objects. In the early days, at a local juried group photography show, I was asked by a group of photographers about my studio lighting and photographic equipment. They were shocked when I told them that I made my entry using a \$69 flatbed scanner.

If you think of photography being defined as painting with light, this is scanner photography. Photography using a scanner as a camera is a valid niche of photography. There has been controversy about that, more so in the beginning than now.

© ELLEN HOVERKAMP

When you scan are you using the lid on the scanner?

The lid is off. I do the final scans in a dark room, but I do all of my preview scans with the lights on—it really doesn't matter. The preview scans are just for assembling the composition and they can be done with the lights on. But I have dark window shades in my studio so that even in daylight I can make it pretty dark.

Do you suspend things above the platen at all are you using a box above the platen to get more subject depth?

I don't use a box but I do build up the sides of the scanner using black Foamcore and then I rig things with wires from above. If you take a rose or a fragile peony, for example, and you let them lie on the glass they may flatten under their own weight, so you have to find ways to support them. If an object can carry it's own weight or if I can lean one object on a sturdier object, I'll do that.

You can also play interesting games with perception when you're arranging things this way. You can play with the ideas of gravity and weightlessness. For example, gravity holds objects in place on a surface, but the depiction of these objects is intended for vertical display. This reorientation can make things seem to float. You can make things appear to have a graphic sense of balance but the actual structure would be impossible to exist physically. I love to make things look like they're balancing naturally when, of course, they're not.

Do you scan other things besides flowers?

Yes, I scan vegetables. I also scan eggs—people let me raid their hen houses and I've worked with bird nests. I really love nests and I'm very into them right now. I also like scanning shells—any objects from nature. At school with my kids we'll scan anything, but in my own work I am trying to draw attention to the beauty of nature.

At what resolution do you scan?

I work in 48-bit depth at 600 dpi. That creates a file of around or just over 400 megabytes. Printed out at full size, at 300 dpi, they'll print 22 x 30 inches (56 x 76 cm) and I've even printed out at 35 x 47 inches (89 x 120 cm) with no loss of detail. The large-scale prints are very engaging to the viewer.

There is also a macro photography aspect to scanning. It's just amazing to see how much detail you can get when you go closer than the capacity of the human eye. And unlike standard macro photography where you only get a small portion of a subject, with a scanner you can get that level of detail but see so much more of the object and its surroundings.

Scanners have a tremendous depth of field, don't they?

The depth of field is very deep—probably two or three inches. And that can be further enhanced using Photoshop if I really want to push the depth of field by stacking two scans and setting the focal point differently on each scan. I'll also smart sharpen things to increase the apparent depth of field.

When people see your photos for the first time are they surprised that you're creating them with a scanner?

Strangely enough a lot of people think that they're looking at shadow boxes because the images are framed and behind a matt. People have actually asked me if the flowers are in there, thinking that they're looking at dried flowers. It's amazing.

Do you do much editing to the images?

Yes, I do a lot of retouching. I also repaint all the black with a stylus and tablet because the scans produce a black, but it's a hazy black.

Do you spend a lot of time scanning?

It's seasonal. When the gardens are in full bloom I'm scanning a lot. Typically, from one garden visit I'll try to get three to nine scans from one or two sessions, but I wait to retouch them. Mostly during the winter months, I'll go back and do a lot of retouching. It takes me two to three-and-a-half hours to retouch each image.

Is creating the arrangements a challenge?

Yes, but even in the challenge there is pleasure. I think the part that I like the least is the tedious part, the retouching. But I like the challenges, creating the arrangements. Some days it's just not happening and I'll wipe off the scanner several times and start over. But, again, there is a kind of pleasure that comes from taking control over one little area, one detail. Creating compositions from delicate plants and lightweight natural objects sometimes requires holding one's breath, moving very carefully.

What is the most rewarding part of doing this work?

This photographic project has offered me the opportunity to benefit from and bring attention to the generosity of so many wonderful people who care about nature. The intent of my work is to remind the viewer of nature's exquisite beauty.

The Image Enhanced

"Dodging and burning are steps to take care of mistakes God made in establishing tonal relationships."

-ANSEL ADAMS

Introduction

In one of the more unexpected twists in cinema history, the classic movie *The Wizard of Oz* begins in drab tones of black and white befitting its depressed Kansas dustbowl setting. But when Dorothy, Toto, and their farmhouse crash into the unsuspecting Wicked Witch of the East, they emerge into a magically transformed Technicolor landscape. The sudden change was the director's way of showing that the new surroundings had enchanting powers—and that Dorothy wasn't in Kansas any more.

In many ways, the wonderland you can create with digital photography is as filled with magic and surprises as Oz. And you, as the photographer, are the new Wizard—or at least the new person behind the curtain. With the aid of a computer and basic digital imaging software, you have the power to turn normal buildings into Emerald Palaces, the ordinary into the extraordinary and the mundane into the magnificent.

On a purely practical level, image-processing software enables you to endlessly and dramatically improve your pictures. From correcting bad exposures to eliminating color shifts, from removing facial blemishes to restoring colors in treasured family photos, there is nothing you can't alter or improve. With just a few clicks of your mouse, you can banish red-eye in portraits or replace a gray sky with a bright blue one—you could even add a rainbow to your backyard garden. And the wonderful thing is, if you make mistakes along the way, you can revert backwards as easily as shaking a drawing out of an Etch-a-Sketch (or perhaps as easily as clicking your ruby shoes together). And then you can begin again.

It is in the creative realm where the challenges and fun of digital imaging are revealed. Regardless of whether or not you have any drawing skills, the digital domain is a place where boundless creativity and personal vision rule above manual dexterity, and where imagination trumps reality. In this brave new landscape you'll be reinventing your photographs with the unabashed glee of a five-year-old with a new box of crayons—a very big box of crayons at that. Whether you want to replace real color with false color, combine several images into one, or turn the cornfields of Kansas into the poppy fields of Oz, you have the tools. As you master these many useful and creative skills you will surely come to discover the true joy of digital photography—the joy of setting your imagination free.

As I discuss image-processing and editing techniques throughout this chapter, I describe the tools and processes when using Adobe Photoshop software, which comes in two flavors: the higher level CS and the less advanced, though plenty powerful, Elements. There are a number of different programs on the market that have an array of tools for image enhancement, the sophistication of which can range from basic to intermediate to advanced. There are also programs that specialize in reading and adjusting RAW files. The names of the tools used in many of these software programs may differ from one to another, but the functions correspond to those found in Photoshop in many respects. This chapter is more about telling you what you can do with your photos in post-processing than it is a step-by-step tutorial.

Cropping

It's funny what great photographers we become after the fact. Like backseat drivers and Monday morning quarterbacks, it's easy to spot the mistakes after they've been made. Fortunately, in photography we at least have the quiet dignity of being able to spot our own errors. And, of course, being able to rethink pictures and revisit your vision is the beauty of digital imaging.

The quickest way to improve any composition is to crop away unimportant or distracting information. Perhaps you included one too many boats in your harbor

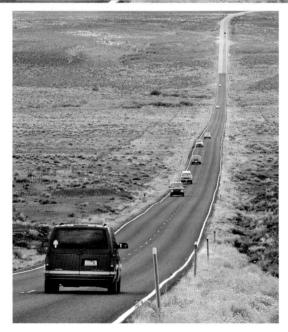

scene, skewing the composition. Or maybe in the excitement of the moment you put too much sidewalk foreground into your shot of a street musician and he now seems lost in the clutter of the crowd.

By digitally cutting away the excess visual fat, you get a second chance to re-focus attention on your main subject.

You'll find the Cropping tool in your tools palette indicated by a pair of intersecting "L" brackets that form a disjointed

rectangle. Click on the Cropping tool and an adjustable

box automatically appears on your image. Then just click and drag the corner of the box to surround the areas that you want to keep. Or, depending on your program, you may also be able to drag the crop box into position. In some programs, the area you're deleting will appear shaded but visible until you commit to the crop, so you will be able to see exactly what you're cutting away.

If you're going to print your picture on a standard-size paper $(4 \times 6, 5 \times 7, \text{ or } 8 \times 10 \text{ inches}; 10.2 \times 15.2, 12.7 \times 17.8, \text{ or } 20.3 \times 25.4 \text{ cm})$, then maintain that aspect ratio when you crop the picture. In most programs you can enter the final dimensions of the

crop and the software will let you crop only that size. You can move the crop box around in the image, but the ratio remains fixed. Unless you have a demanding need to keep the image a certain size (to fit in a family newsletter, for instance), you'll have far more flexibility by not restricting the aspect ratio.

Some photographers are reluctant to snip away parts of their precious images. Don't be one of them. The advantage of post-production work is being able to improve your images after you've shot them. Besides, you're the only one who will have seen the un-cropped image; everyone else will see only your masterpiece—beautifully composed and without a millimeter of excess visual baggage.

After you crop an image, its file size is smaller because you've eliminated data from the file. It's as if you took a traditional color print and cut away a few inches of paper; you haven't hurt the remaining information, you've only deleted what you didn't need. If you crop a substantial amount of the image away, your final print will be substantially smaller.

shape, such as a square or an oblong if it happens to suit your subject. If you change your mind after you've cropped the image, you can always Undo the crop using the Edit menu. However, it is a good idea to make a duplicate of your original on which to perform all image enhancements, just in case.

Don't be afraid to use an unusual cropping

Keeping Things Level

We've all done it: shot a beautiful sunset only to discover later that the horizon is so tilted that the sun seems to be rolling right out of the picture. No matter how pretty the scene, a skewed horizon will give viewers an instant case of vertigo. And though landscapes are particularly susceptible to looking off-kilter because the horizon line is so obvious, almost anything with a noticeably tilted horizontal or vertical line will upset our visual equilibrium—buildings, mantelpieces, or even your normally straight and tall teenage son.

Crooked pictures are also common when scanning prints and it's much easier to straighten a flawed scan than to begin all over again. Some scanner software lets you make rotation corrections in the prescan, which is very handy.

In the pre-digital days, the only cure for a crooked picture was to send the negative to a custom lab and have the composition hand-leveled in the darkroom—not a cheap or speedy option. Ah, but you live in the computer age. Fixing crooked pictures is a piece of digital cake using the Rotate or Transform tools (the exact tool will depend on which program you're using). Many programs provide you with several options to rotate your pictures. The most common include doing it by freehand, by one-degree steps, or in ninety-degree increments.

It is simple to use the Rotate tool: Just open your image and select the specific option you want to use. The program will make the rotation based on your instruction. In Adobe Photoshop, for example, in addition to rotation settings for 180°, for 90° Clockwise or Counterclockwise, Flip Horizontal, and Flip Vertical, you can choose the Arbitrary Rotate option and enter a rotation angle numerically in degrees.

With the Transform tool, you'll notice several sets of tiny handles at the corners and in the middle of the vertical and horizontal edges of the image. Click on and tug a pair of handles and twist your image around a small rotation point in the middle of the picture until it looks level. You're done.

Anytime you rotate an image, it's best to do it in one step because if you attempt to do it in stages you'll deteriorate the image; if you need a few practice runs, it's best to trash the test images and then start over with a fresh duplicate image. Also, because you're skewing the image from its original frame lines, you will notice some blank areas are now showing around the edges of the image; you can get rid of them by simply cropping them away using the Crop tool.

Image-Leveling Tips

- 1. Open the image in your imaging software and, as always, make a duplicate to work with. Some programs (like the full version of Adobe Photoshop) require that you select the entire image before beginning the Transform process.
- 2. Select the Rotate or Transform tool.
- 3. Put your cursor on one set of the grab handles and rotate the image until it is level.
- 4. Select your crop tool and crop the image to eliminate the blank border edges created by the rotation.
- 5. Save the new image under a new name.

Improving Exposure

The best way to achieve proper brightness is to create a good exposure in the camera by admitting the correct amount of light. Rarely, though, is a camera's ability to set exposure so perfect that a little tweaking with your image-processing software won't improve things. Of the thousands and thousands of digital images I've shot, I don't think a single one was perfectly exposed out of the camera. Most of them were acceptable, but there is always room for improvement (you can imagine what a pain I was as a customer back in the days when I used a processing lab).

Exposure isn't always just a matter of being correct either. Often you can change an image's mood by making it brighter or darker or, as often happens, your interpretation of a scene will change from the time it was shot. Even if you like the exposure of a particular shot, it's worth experimenting with darker and lighter versions to see if it improves the image.

Exposure problems can fall into two categories: Incorrect brightness (too dark or too light), or poor contrast (too little difference between the darkest and lightest portions of photo, or too much)—but those problems are often related and so must be fixed in tandem. Photoshop and other programs have a simple control for Brightness/Contrast (two sliders, no experience required), as well as more advanced tools, such as Levels (one notch up the technical ladder) or Curves (probably the most sophisticated exposure/contrast tool).

Even if you like the exposure of a particular shot, it's worth experimenting with darker and lighter versions to see if it improves the image.

BRIGHTHESS/CONTRAST

While not overly sophisticated, this tool is worth experimenting with when you're getting to know your image-processing program. When you select this option, a small dialog box with two sliders opens up: One slider is for brightness and the other is for contrast. As you adjust the position of each of the sliders, you can see the effects on the image (be sure you have Preview clicked or selected).

The problem with simple Brightness/Contrast controls is that they adjust the parts of an image—shadows, middle tones, and highlights—in a particular direction. If the shadow areas of an image were just fine, but you wanted to darken the highlights slightly, moving the darken slider (to bring down the highlights) would also darken the shadows and mid-tone areas. Similarly, if you wanted to brighten the highlight areas, you would inadvertently lighten the shadow areas too much.

Fortunately, the software writers sensed your impending dissatisfaction with simple fixes and have created other options.

When it comes to contrast and brightness corrections, tread gently—a little goes a long way. In this example, by pushing both sliders to extreme positions, you can see the image gets blown out, at right. Somewhere between ordinary and outrageous is the prize you're after.

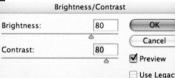

© KEVIN KOPP

USING LEVELS

A better choice for fixing both exposure and contrast is a tool typically referred to as Levels. This control enables you to individually correct the shadow (dark), middle tones, and highlight (bright) regions of your images, offering you precise control over both contrast and brightness.

In many programs when you select the Levels tool, a dialog box displays a scary-looking graph called a histogram (which always sounds vaguely medical to me). Almost everyone is intimidated the first time they encounter this odd graph, but the histogram is merely a graphic representation of all the tones in your image, ranging from shadows to midtones to the highlights.

The graph looks like a silhouette of hills. In fact, the height and width of those hills tell you a lot about

the contrast, exposure, and tonal range of

your images. If the hill to the left is

high and wide, for example, it indicates there is a substantial amount of shadow area. Or, conversely, if there is a large hilly area in the center or right side of the graph, there are large midtone or highlight

areas, respectively. If all the areas of the histogram appear relatively equal in height and width, the contrast of your image is very even.

You'll notice that below the graph are three small sliding triangles—one each for the shadows, midtones, and highlights. The beauty of these Levels controls is that they let you adjust each one of these areas independently by repositioning the triangles. As you slide the shadow triangle toward the center, for example, you'll notice that more areas of the image get darker. Similarly, if you move the highlight slider toward the center, more of the image will get brighter.

In the uncorrected shot of the mute swan (at top), the bulk of the graph is in the shadow area because the exposure meter was fooled by the brightness of the white swan, therefore underexposing the entire scene. By using the Levels tool to redistribute brightness, I was able to move the graph somewhat toward the right, bringing up the pure white of the swan without sacrificing the dark areas.

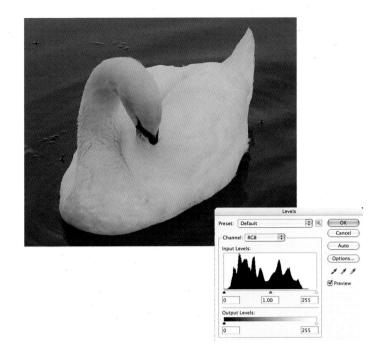

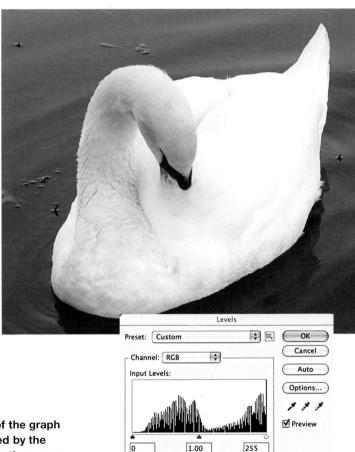

Output Levels:

255

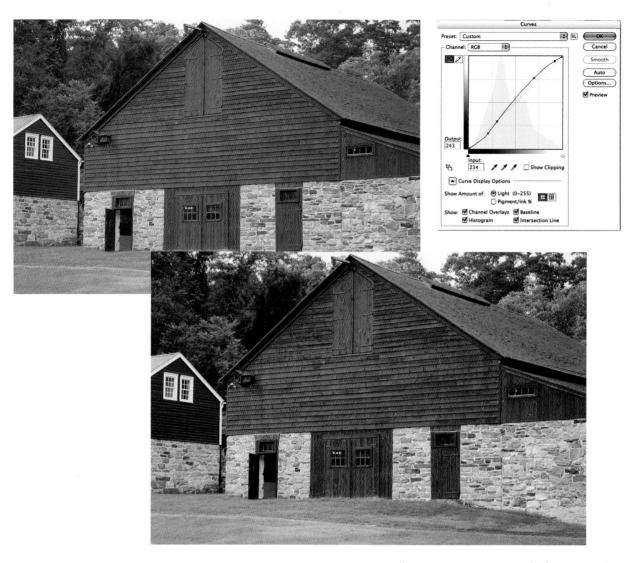

Curves

No tool for adjusting brightness and contrast is more powerful or precise than Curves. More than other options, Curves lets you finesse and massage images with a maestro's delicate touch. Though mastering the Curves tool takes time and patience, it is a skill that once mastered will give you immense control over the look and quality of your images.

The Curves diagram is a graphic depiction of the contrast range of an image that basically consists of three parts: the heel (bottom left), the slope (the main portion), and the toe (the upper area). In this configuration (called the Light mode, which is how most photographers utilize this tool), the heel represents the shadow areas, the slope is the middle tone area, and the toe represents the highlight regions. (You can reverse this and set Curves to a Pigment mode if you like, so that the highlights are at the heel and the shadows at the toe—it's largely a matter of personal taste.)

When you open Curves, before any adjustments are made, the diagram displays a straight diagonal that goes from the heel (blacks) to the toe (white areas). Between the heel and the toe endpoints, you can bend this line into any form of a curve (thus the name), which produces changes in the contrast and brightness of the image. You can plot up to ten separate points along the curve, and once you place a point on the curve, it is locked in position. As you push any point higher, that portion of the image gets lighter; as you pull a part of the curve down, that part gets darker. If, for example, you push the center of the line higher, the middle tones will lighten. If you pull down the toe, the highlights will get less bright.

Again, it takes some experimenting to fully understand the basic concept (unless, like me, you had a father who started explaining curves to you at breakfast when you were ten years old), but since you can see the results immediately, just playing with the Curves graph will teach you a great deal very quickly. Of course, there is an Auto button that will make your choices for you—and often just clicking that button and seeing what happens is also a great learning tool.

Enhancing Color Processing

 $oldsymbol{\mathrm{I}}$ f you've ever wondered what it would be like to live in a house painted in subtle stripes of, say, purple and green, or if you've been curious what your daughter might look like with (heaven forbid) pink hair, imageprocessing software was made for you. In fact, the ability to alter, adjust, duplicate, or even replace the colors in your photographs is one of the most intriguing aspects of digital imaging and one that will no doubt keep you glued to your monitor into the wee hours. Whether you're trying to overcome a distracting color cast, churn up the intensity of a sunrise, or just add some creative spice to your pictures, there is something positively addictive about repainting your images from a seemingly infinite digital palette.

There are a lot of reasons why the colors in your images may not be what you want or expect. Fluorescent lights or bad weather, for example, can create unwanted color casts; so can an incorrectly set white balance control. Also, cameras and scanners frequently have an inherent color bias that needs to be corrected. And if you're restoring the family album, you may want to rejuvenate the color of old, faded photos. Or you might just be bored with reality and decide to toss theworld-as-we-know-it into a color mix-master just to see what happens (remember, you were the one who wanted to color your daughter's hair pink). In any case, making the right color adjustments—whether for technical or creative reasons—will vastly improve your pictures.

Even the simplest of image-enhancement programs offers a fistful of color-adjustment options, and when you combine these tools with the ability to selectively re-color areas as small as a few pixels, you have a mighty powerful tool indeed. No one tool, however, is likely to be the best or for every situation, so dig around in your color toolbox and experiment with various methods—combining various tools and techniques, if necessary—until you get results you're happy with.

> This Fourth of July scene was a bit too blue/ green as recorded by the camera (top). But Auto Color added more red, warming the image up and making it look more pleasing.

AUTO COLOR

Virtually all programs contain an Auto Color correction function, and using it is simply a matter of opening an image and choosing it. This is a fast and simple solution, and while it generally will improve rather than degrade an image, it provides absolutely no user control.

One quick way to get a look at how different color balance schemes would change the look of your photos is with an option known as the Variations tool. When you open an image and then select this tool, it displays a gallery of thumbnails of the same image, each with a slightly different color shift, along with your original image. What you're shown is a selection of variations that includes slightly heavier color casts: more red, more blue, more yellow, more green, etc. You can then incrementally increase/decrease a given color shift by clicking on a particular thumbnail—increase the reddish cast of an image, for example, by continuing to click on the More Red thumbnail, or decrease it by clicking on the Less Red image. Your Current Pick (the most recent image enhancement you've clicked on) is shown side by side with your original image.

With some programs you may also be able to select specific tonal ranges of the image—Shadows, Midtones or Highlights—from which you can sample variations. If you want to see how adding more blue to the shadow regions would look, for instance, you simply select the shadows option and then click on the Increase Blue thumbnail.

You probably won't see the exact color correction that you're looking for, but the benefit of using Variations is that seeing side-by-side comparisons of several color adjustments simultaneously will help point you in the right direction. If your early morning landscape looks better with more yellow, for example, you can turn to a more sophisticated color adjustment tool and manually enhance the yellow until you see what you like.

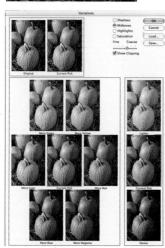

The Variations tool provides a quick palette of choices for color correction, as shown in this series of pumpkins images.

Although the Hue/Saturation tool is another simple adjustment, it is quite useful in turning up the volume of individual color ranges or creating or enhancing color casts. When you open the Hue/Saturation tool, you'll get a dialog box that shows sliders: the Hue slider affects the overall color tint of your image, the Saturation slider affects how saturated the colors will appear. The great advantage of this tool over the Auto Color or Variations tools is that it puts you in control—to decide how much to adjust.

Playing around with an image's hue and saturation is a good way to find the color limits of a given scene, and it's often the first tool I'll turn to if I want to see how extreme I can go with an existing hue range. You'll see instantly when you've gone too far because the colors will begin to look unrealistic or cartoonish (which is fine if that's the effect you like). I use this tool on almost every image I print, but I typically use it in conjunction with a selection tool to adjust only selected areas rather than the overall image (tweaking the red of a rose, for example).

COLOR BALANCE

Another quick and easy tool for changing the color balance of your photos (or, again, a selected area of a photo) is the Color Balance tool. This is simple to use and fun to experiment with because you can see the changes as you make them. If you want to see how your sunset would look with more red or less yellow, just move a slider and you'll get instant results. By moving the sliders to the right, you affect the three primary additive colors (red, green, and blue), and by sliding them to the left, you intensify the subtractive colors (cyan, magenta, and yellow). Imagine that you've photographed what you thought was a flamboyantly colored sunset only to find that the reds in the sky are not what they were in person. By sliding the red controller to the right, you will see the overall saturation of the reds increase (and substantially!). If you want a slightly more orange color, just slide the yellow controller to the left and you'll get a mix of red and yellow—or orange.

Won't altering one color affect the coloring of other objects? Yes, in fact, it will—which is yet another reason for correcting selected areas rather than the entire image. Within reason, you can increase one particular color without devastating impact on the remaining colors. Keep an eye on neutral highlight areas, such as white clouds or a white dress. If they start to show color casts you will know you have over-corrected the color balance. When that happens, simply back off of that color until the whites are neutral looking. If the object(s) you're trying to re-color still aren't picking up the color strength you're after and the neutrals are starting to pick up a tint, you'll have to switch to making selective corrections (see *Selective Corrections*, page 258).

In the Color Balance dialog box, as in the Variations tool, you will likely find options to bias the changes for Shadows, Highlights, or Midtones. By selecting one of these, you can limit your color corrections to that particular range of the image. Adjusting colors that are tied to brightness ranges is a bit trickier and less aggressive than overall changes, but again, a little experimenting is a great learning tool.

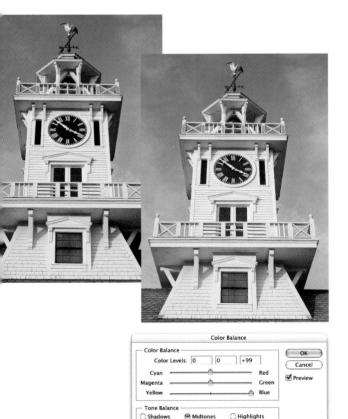

Preserve Luminosity

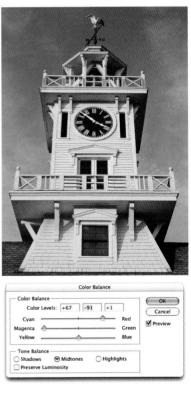

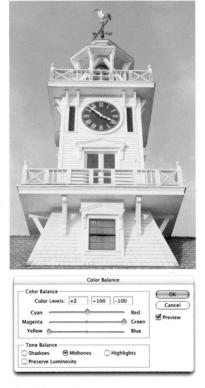

When you select the Color Balance option, a dialog box opens with three sliders, one for each of the color pairs: red-cyan, yellow-blue, and green-magenta. On the right end of each slider is one of the primary or additive colors: red, green, or blue. On the left end is the color's subtractive counterpart: cyan (for red), magenta (for green), and yellow (for blue). These paired colors counteract each other. To reduce red, for example, add more cyan, its subtractive opposite. To reduce the cyan cast, you add more red.

Sharpening Filters

It seems ironic that after you buy the best digital camera featuring the latest in razor-sharp optics, and then take the time to hold the camera very steady, that you would have to sharpen your digital images. But take heart, sharpening digital images is a part of the normal flow of preparing your pictures for output and has nothing at all to do with either the quality of your gear or your skill in using it.

Digital images are soft partly because, while they are made up of millions of pixels, they lack the contrast created by film's grain edges that helps to create a sharp appearance. Also, in order for very fine subject details (an eyelash, for example) to not get "lost" between pixels, many digital cameras use a gentle blur filter in front of the camera's sensor that prevents this, but has the side effect of gently softening your images.

Does this mean that you can take an out-of-focus picture and make it sharp? Not necessarily, but you might be able to sharpen a slightly soft image and enhance it enough to make it acceptable.

Software sharpening tools (usually called sharpening filters) enhance the appearance of sharpness by increasing the contrast along tonal edges in your images. Most image-processing programs have a number of sharpening options and, depending on the program you're using, you may find basic sharpening tools like Sharpen, Sharpen Edges, and Sharpen More. All of these methods work. There are differences in the quality of these various tools though, so it's important to select the right tool for the job.

Basic sharpening tools are very simple to use: you open an image, highlight the particular sharpening filter in the pull down menu, and the image is sharpened. If you want the image sharper still, you can repeat the step or simply choose Sharpen More. The flaw in these filters is that they apply a blanket amount of sharpening to the entire image without providing you with any control over the degree that the image edges will be sharpened—or more importantly, which edges will be affected or how wide the sharpened edge will be.

Sharpening Tip

A good option found in many programs is a sharpening tool called Unsharp Mask (also called USM), which, despite the name, is actually an effective and flexible sharpening tool. Unsharp Mask provides a set of sliding scales that allows precise control of image sharpening through these three important image-sharpening elements:

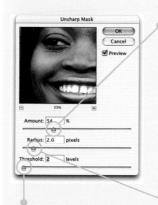

Amount (or strength) lets you set the percentage of sharpening. Most experts agree that it's best not too oversharpen—you might want to start with about a 50% setting and experiment from there. Read your software manual for the manufacturer's suggested settings.

The minimum Threshold of contrast edges that will trigger sharpening—this basically defines which contrast edges will receive sharpening.

The Radius of edges being sharpened—or how many pixels away from the exact edge will receive enhanced contrast. Typically a setting of 2 to 3 pixels is plenty.

Regardless of which tool you use, sharpening should always be done with a bit of conservatism. Oddly enough, you have to be careful not to oversharpen a picture because images that have received too much sharpening tend to develop odd-looking patterns along contrast edges and begin to look less sharp. Experimenting with different levels of sharpness by changing the various settings is really the only way to see how they work. As with most things visual, it's a very subjective process and, in time, you'll know the sharpness you like when you see it.

Finally, it's important to do all of your sharpening with the image size set to 100% so that you can see the sharpness at its actual size. Remember, too, that if prints are your ultimate goal, even the best of sharpening jobs is still at the mercy of printer and paper interactions. What you see on the monitor may not match the appearance of your prints. Still, the better you get at sharpening images on your monitor, the better your prints will look.

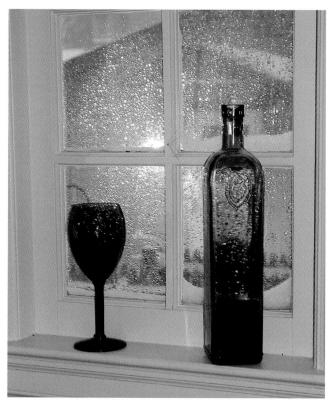

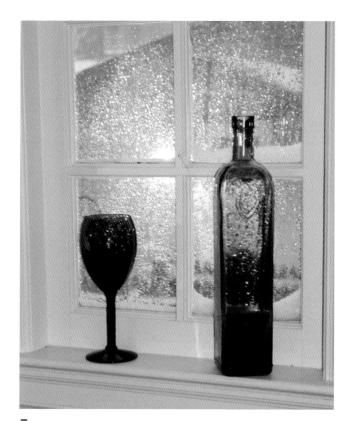

1 The image directly above does not have sharpening applied.

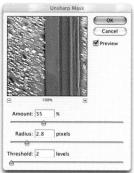

Amount: 126 %

Threshold: 1

2 In this photo, the Amount is set to 55%, the Radius to 2.8 pixels, and the Theshold to 2. Your software manual will explain more about these choices—but you can see the results change as you alter each of the settings.

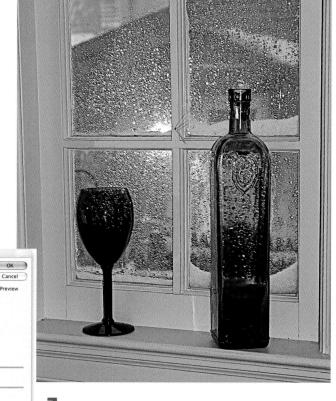

3 Here, the sharpening amount is set to 126%, which might be too high. Print your image to be certain.

Fixing Dust and Blemishes

When you scan prints and film, you also scan all the flaws on their surfaces. Dust, crinkles, scratches, fingerprints—they all come through faithful to the original. While it could be argued that keeping some of the flaws of the original helps to maintain the charm of older images (particularly if you're copying very old pictures), the truth is that surface flaws are more distracting than charming, even when it comes to family photos that are several generations old. Besides, your grandmother would be appalled to find out that you wanted to preserve that big blob of dust on her wedding dress.

Most programs offer a choice of techniques for removing surface flaws and imperfections. The simplest method for eliminating minor dust and other blemishes is the automatic dust and scratches removal feature found in most image-processing programs (and in most scanner software). The problem is that this filter works by softening the image and in the end you're left with a clean but soft-focus image lacking in fine detail. You can experiment with applying this filter to selected areas, but you may find the final image is uneven in its overall sharpness.

There are better solutions, and they're all fairly straightforward. In the old days a retouching professional would hunch over a brightly lit print and dip a single-hair brush into dye. She (back then women most often held this job) would dab dye onto each dust spot until it blended in with its surroundings—a painfully slow process that required enormous patience.

The Clone Stamp

If I were cast away on a desert island with only a laptop computer (and hopefully a solar battery charger) and just a few image-enhancement tools, the Clone Stamp tool would certainly be among the tools I would bring along. In fact, the Clone Stamp is such a valuable part of digital imaging that I can't imagine editing images without it. It's one of the first tools you should learn to use.

The job of the Clone Stamp is to replicate pixels exactly and then paste them wherever you choose. You can copy as little or as much of an image as you like, and deposit that information to any other area of your image, or into another picture entirely. The magic you can pull off with this tool is mind-boggling. If creating image montages is a part of your artistic ambition, you'll come to love the Clone Stamp's ability to import pieces of other images into

your creative meanderings. Think of the Clone Stamp as a Star Trek-like pixel transporter able to "beam" pixels wherever you need them in the blink of an eye. (Maybe they should have called it the Transporter tool.)

There are many advantages to being able to replicate a particular part of a scene exactly. From a purely corrective point of view, the Clone Stamp enables you to hide unwanted details of an image so perfectly that no one will ever detect the changes. With just a few clicks you can banish an ugly No Trespassing sign from a wooded scene by cloning a tree limb over the sign, or erase that horrific zit (her term) from your daughter's otherwise alabaster forehead with a quick digital skin graft.

The Clone Stamp is also a wonderful clean-up tool for landscape photography. I can't count the number of times I've photographed what I thought was a pristine beach only to return home to find a fast-food wrapper hiding in plain sight. With a film image you'd have to crop the intruder away, likely upsetting the balance of your composition. By using the Clone Stamp tool, though, you can simply paste a clean area of sand over the wrapper and hide the unsightly intrusion.

Again, you're not limited to cloning within one particular image;—you can just as easily open two or more pictures and clone objects from one to another. You could, for example, clone an elephant photographed at the zoo into a photo of the parking lot at your local strip mall. Because the Clone reproduces pixels exactly, it's impossible to tell them apart. And if ugly power lines have ever ruined one of your landscape shots, you'll love the ability of the Clone Stamp to

Now you can use your software's Cloning tool to do essentially the same thing, but in a fraction of the time. If you make a mistake, stepping backwards is just a click or keystroke away. And if you're lucky enough to be using an advanced image-processing program, it probably has a sophisticated Cloning tool called the Healing Brush.

about not damaging nearby areas, as well as being more clever and vigilant when it comes to disguising your retouching. Several books have been written on the art of digital retouching, and if you plan to do a lot of this kind of work, Katrin Eismann's and Wayne Palmer's *Photoshop Restoration and Retouching, Third Edition* is the bible; it was written specifically for Photoshop, but its techniques can be adapted to other programs.

TEARS AND CREASES

Reparing photo damage, especially from scanned prints that have been torn or folded, is a bit more tedious to fix than small blemishes or dust spots, but basically the techniques are the same. Because the flaws are typically larger, though, you'll need to be more cautious

erase those lines. I really loved the architecture of this small bridge in Maine (below) but the power lines were just destroying its graceful look. I made the shot anyway and spend about an hour carefully "erasing" the power lines.

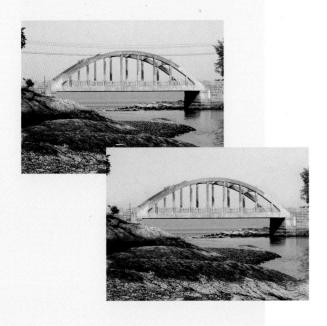

This scanned photo was saved using the Clone Stamp tool. In images like this, first identify the area that you want to reproduce by placing a target cursor over that area and then click the mouse (Option/Click with a Macintosh, Alt/Click with a PC) to specify the area you want to copy. Now place the cursor at the point where you want to redeposit that image information and repeat as necessary to fix the problem area. See the next page for detailed instructions.

STEP-BY-STEP GUIDE TO ELIMINATE DUST, BLEMISHES, AND CRACKS

1

Open your image. Eliminate edge flaws by cropping the picture; there's no sense fixing things you can eliminate. If you're working with a blackand-white (or sepia-toned) image, make an overall Levels adjustment before you begin more detailed work. Adjusting Levels after you clone areas may make your cloning work stand out like a poor plaster patch.

Use the magnifying tool to enlarge the picture to a size where you can clearly see the areas you're retouching.

3

Select the Clone Stamp tool and choose a brush Stamp size and style that matches the areas you want to retouch. Generally, a softer edge brush will hide your retouching better in areas of low detail and a harder brush works better in very detailed areas. Select a brush that's just slightly larger than the flawed area you are retouching. You will probably find that as you move through an image you will change brush sizes and styles a few times.

(copy good pixels onto flawed pixels)

6

Now, sample an area near each flaw (Alt/Click in Windows, Option/Click on the Mac) and then click or stamp to fill it in. Basically what you're doing is covering the blemish or spot with a pixel swatch from a nearby area, so it's important that your sample area matches the area you're covering. For larger repairs, I tend to resample every two or three clicks, keeping the sample area close to the repair area and keeping the brush size only slightly larger than the flaw.

5

The real trick to fixing major flaws is to be patient and work with small areas and small brushes whenever possible.

Also, keep the image magnified and occasionally decrease magnification to see your progress. As you find small fine points, increase the magnification further and retouch those areas.

6

Continue working on the entire image to make sure you've fixed all the blemishes and then return the image to its normal size.

7

Save the image, giving it a new name. Restoring old images is an art, and the more you get to know your editing software, the more useful tools and techniques you'll discover.

©HARRY B. WIGNALL

Eliminating Red-Eye

In addition to being the drink of choice for cowboys in old western movies, red-eye is that eerie red glow (it's often green in animals) in the eyes of people photographed with built-in flash. The effect happens when light from your flash reflects back from the eye's retina (which is rich with red blood vessels). Most digital cameras have a red-eye reduction mode and if you remember to use that mode, red-eye won't often be a problem.

In any event, unless you want your friends looking like extras from the film *Children of the Damned*, you should get rid of red-eye when it appears. Many software programs bundled with digital cameras have

an automatic red-eye elimination tool that acts as a reliable one-click removal system—ridding your subjects of red-eye is just a matter of calling up an image and zapping it with a single click.

Most image-processing programs also have a special Red-Eye tool, and using it is fairly straightforward. In the simplest of programs, you click on each eye, and then click OK and the program eliminates the red in the eyes. Other programs give you more control, which means more work. Basically you use a brush tool to paint over the red portion of the eye with a replacement color.

Red-Eye Removal Tips

The procedure for correcting redeye has five basic steps:

- 1. Select the Red-Eye tool from the tools palette.
- 2. Choose a Pupil size that approximates the size of the center of the eye (the red area).
- 3. Next, specify the level or percentage of darkness you want to replace in the red portion of the eye.

- Specify a replacement color using the color picker.
- 5. Finally, drag the cross-pointer across the red pupil. If the result is not dark enough, increase the percentage of darkness.

There is another simple method for eliminating red-eye that I often use with great success. To begin, I simply select the center area of the eye using a basic selection tool and then I desaturate the color (using the saturation slider

in the Hue/Saturation dialog box) until the red color of the eye is gone. It works surprisingly well and takes only a few seconds. Whatever method you use to remove the red, remember to first duplicate the original image file and then enlarge the image so you can see the eyes clearly. By the time you reduce the image to its normal viewing size, any minor flaws in your painting technique will be impossible to see.

Replacing Skies

There you are in the Vermont countryside: a beautiful red covered bridge, pretty maple trees with autumn leaves, a sparkling river—and, curses, a boring featureless sky the color of aging whipped cream. Nothing is more frustrating than coming across a first-rate landscape scene with a second-rate sky. And unless you've got lots of time and can wait for a change in the weather, you're stuck with the sky you're dealt.

Happily, image-processing software has solved this pesky problem forever. By keeping a library of interesting sky pictures in your files, you can borrow a sky from another photograph and replace dull skies with just a few keystrokes. With a little practice, you can create new-and-improved skies that are completely undetectable.

Replacing a sky is pretty simple, you'll need just two things: an image that needs a new sky transfusion and a better sky to replace it with. Begin by choosing an original scene that has a simple and clear separation between sky and foreground. Unless your selection skills are very good, using scenes with complex sky-foreground borders (a tree with a lot of naked branches, for instance) can be tricky, so practice first with simple foregrounds. You can borrow the replacement sky from another scene, or you can build a library of interesting sky-only images to choose from.

If reality is your aim, it's important that you choose a new sky that visually matches your subject. If you choose a sunset sky full of fire and brimstone and place it into a midday scene of a wildflower meadow, your sky will look false. Instead, look for skies that have a tonal and lighting similarity to your main subject or foreground, such as puffy white clouds for a sunlit beach scene. If you *want* a false-looking sky, that's fine too—this is, after all, about exercising imagination.

Sky Replacement Tips

1. Open the scene that contains the sky you want to replace. Using your selection tools, select the sky

area, being careful to find precise edges between foreground and sky. Feathering the selection tool by a few pixels will keep the foreground/sky edge gradation more gentle looking. Also,

it's a good idea to save this selection so that you can reload it later if needed.

- 2. Open the image containing your replacement sky and select the sky area, using whichever selection tool works best.
- Use the Copy command to copy the new sky.

- 4. Return to the original image and click anywhere in the selected sky area; then use the Paste Into command to place your new sky into that image. If the opacity is set to 100% for the new sky, the sky in the original scene will be completely replaced.
- 5. If your new sky doesn't fit exactly, use the Transform tool to stretch (or shrink) your sky to its new home. Alternately, you could use the Move tool to move the pasted sky around until you find a pleasing combination.
- **6.** Finally, save the image in its layered form so you can modify it later if you choose to make additional changes.

Black-and-White Conversions

With so much emphasis on color digital photography, it might seem that black-and-white photography has been forgotten. But as the great photographer Minor White once wrote, "Black and white are the colors of photography."

But still, you might ask, "Why would I want to convert pretty color pictures to plain old black and white (commonly referred to as grayscale or monochrome in the digital parlance)?" As Mr. White implied, there is a special bond between the photographic process and working in shades of gray that is dear to the hearts of photographers. Indeed, for many photographers, color is more of a distraction than an enhancement. In their vision, by reducing the world to a series of gray tones, they peel away the falseness of superficial color and enhance reality. Black and white has a way of revealing subtle tones, surface textures, and design features that color often obliterates.

Most software programs have several options for monochrome conversion. Some are simple, and others can be more involved, depending on the amount of time you want to spend and just how particular you are about the quality. But anyone can learn to make fantastic monochrome prints from a digital file.

The most basic of these various options is a oneclick operation, usually called something like Grayscale mode, that instantly transforms the image from color to monochrome. Simply open your color image, select this mode, and the image file will be converted. This selection offers the least amount of control and is also the least creative.

Another quickie method is to desaturate the color using the Hue/Saturation tool. In effect, you drain the color out of your picture by moving the Saturation slider. You can then use the Brightness/Contrast or Levels controls to tweak the contrast of your gray values. You have more control with this method because you can adjust the degree of desaturation to eliminate part, but

not all, of the color, which results in some fun effects. In the series of photos on the opposite page showing the side of a fire truck, I desaturated the red hues in the lowest photo while adding saturation to the yellows.

Yet another conversion method is to use the Channel Mixer tool. This method lets you first convert your image to monochrome, then individually adjust the red, blue, and green channels of your image. I've done a lot of conversions using this technique and some are quite good.

But the tool that usually produces the best results and offers the most options for creativity is the Black & White conversion tool (in Photoshop, it is found both as an Image Enhancement dropdown and as a New Adjustment Layer option). At the top of this tool's dialog box is a pull-down menu that lets you select conversions that resemble the look of black-and-white film images exposed through various lens filters (blue, yellow, green, red, etc.). There is also the capability to create your own custom conversion by adjusting each of six separate color channels (even though the image is in shades of gray, you can still adjust the individual color channels as monochrome tones). An example is the monochrome version of the fire engine to the far right.

Finally, if you're very passionate about black-and-white photography, you should consider a specialty software product. There are several available, and one like Nik Software's Silver Efex Pro can work as a plugin filter with Photoshop or Aperture software. These programs provide a tremendous amount of control over tonality and contrast, and even let you imitate the look for more than 20 different black-and-white films.

In the end, many variables are at work (your conversion decisions, paper, ink, your printer, etc.) and the method you choose may not be crucial. Just in case you stumble onto the perfect combination of steps though, it's a great idea to keep a notebook handy to track the individual steps in your experiments.

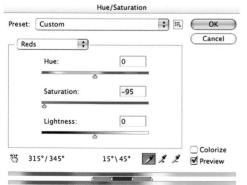

Black and White					
opening of the same	•]	ОК		
	2	%	Cancel		
an en de constituit de la		5	Auto		
	100	%	☑ Preview		
۵		_	i in saleinin saleinene		
	144	%			
۵		2			
	60	%			
		2			
M	60	%			
		_			
	90	%			
۵		_			
- ×					
		100 a 144 a 60 a 90 a 60	100 % 144 % 60 % 100 %		

The various sliders in the Black & White conversion tool allow you to make fine adjustments that produce deeper and richer monochrome versions of your color images.

Using Hue/Saturation, you can choose to remove the color from specific color channels, or boost the saturation of others.

Selective Corrections

While most of what we've talked about involves making changes to the entire image, often you'll only need to enhance tiny portions of an image. In fact, the more experienced you get with image processing, the more you'll come to love the ability to make small, precise changes to your pictures.

The trouble with making any type of blanket correction—color, contrast, brightness, sharpening, etc.—is that you often correct things that don't need to be improved. In fact, when you make a wholesale fix to correct a small problem, you're actually doing unnecessary harm to the rest of the image.

If you're bumping up the blue of the sky in an outdoor scene, for example, and you add blue to the entire image, you may be sending a row of pretty yellow daffodils in the foreground to their greenish doom (blue + yellow = green). Similarly, if you're trying to brighten a person's face, you probably don't want to increase the lightness of the entire image and wash out the already bright background.

The solution is to limit your corrections to the areas that need correcting—while protecting the remainder of the image. Do this by making selective corrections. Select only the area you want to correct, and then apply the correction just to that area (see *Making Great Selections*, on pages 260–261). In this way, you

Selective Corrections Tips

Whenever you select and change a small area, it's usually a good idea to feather the selection with a few pixels (you'll have to experiment to find the number of pixels, but from 2-4 is a good starting point) so that the corrected area blends into its surroundings more naturally.

can make an unlimited number of small corrections to your scene and none of them will interfere with the surrounding image. It's a method pros use everyday and it's easy to learn.

Finally, as you gain experience at selective corrections, you'll save time if you develop a workflow rather than applying a random smattering of adjustments. Typically, I begin by making my enhancements using Layers, usually starting with a Curves adjustment to set the contrast range. Then I use Hue/Saturation to make small adjustments, and I might also make some minor alterations using Color Balance. Then I'll begin the work of selective corrections.

I shot this photo of the beautiful Caramoor Gardens in Katonah, New York, late on a summer afternoon. The light was soft, but somewhat cooled by a lot of shade trees. I wanted the image to look and feel warmer, and I wanted the colors of the flowers to be more vibrant. At right are the steps I took to enhance the scene.

Workflow Steps for Image Enhancement

RAW Conversion

Since the photo was shot in RAW format, I began the process by increasing exposure in my RAW conversion program to slightly lighten the image without overdoing the highlights. I then increased the color temperature to give the entire photo a warmer look. I also increased vibrance. I then opened the image in my image-processing program, where all corrections were made on new layers.

Adjusting Brightness and Contrast

I set the brightness and contrast I wanted using a Curves
New Adjustment Layer. All other color adjustments hinge on this.
I raised the heel slightly to open some dark areas, and dropped the toe slightly to put detail in the background wall. I also cloned some of the debris from the right side of the frame.

Sharpening and Saving a Copy

Finally, I used USM (Unsharp Mask) to sharpen the image. I then saved the file in TIFF format and renamed it. All these alterations only took a few minutes to accomplish.

Selective Adjustments

Using selection tools (see next page) and the Hue/Saturation New Adjustment Layer, I then adjusted the colors until they had the slightly exaggerated warmth and richness that I wanted. In particular, I saturated the greens of the lawn and the red flowers.

Next I used the Dodge tool (lighten) to open some selected shadow areas and to bring up some highlights in the darker shrubs. I used the Burn tool (darken) to bring down some small highlights in the yellow wall.

MAKING GREAT SELECTIONS

Making an overall correction—such as Levels or Color Balance—on an entire image is kind of like painting your whole house because you don't like the color of the front door. Enhancements are much more effective and usually far simpler (and less detectable) when you apply them to a specific area of an image—darkening just the sky, for example, or slightly saturating the color of someone's dress.

Correcting or changing individual elements of a scene gives you a level of precision in retouching (or altering) images that can literally be taken down to the level of individual pixels. Although you might not find too many occasions to alter individual pixels, you will often find yourself editing tiny areas of an image, like perking up the sharpness on someone's eyes to make them stand out.

Image-enhancement programs offer a variety of selection tools to help you select even the most intricate object—though some objects are much harder to select than others (separating a tree from the sky, for instance). Learning to use these tools requires varying levels of skill and/or patience, but mastering them is one of the most important editing skills you can acquire since you will use these tools on virtually every image that you enhance. And the greater your skill and finesse with them, the more professional and satisfying your results will be.

Anything you can do to an overall image (sharpening, blurring, painting, adding noise, etc.) you can also do to even a tiny selection. Very often, for instance, I will use a selection tool to lighten just the shadow in a landscape and then use another selection to sharpen a nearby rock.

Here are some of the more common selection tools and suggestions for how and when to use them. In most programs, these tools and the selections they create can be modified in some very sophisticated ways (such as feathering edges or making selections within selections), and your software manual will be a big help in learning to use them. Also, you can usually modify a selection after it is made—expanding or contracting it by a specified number of pixels, for instance. The tools that follow are specific to Adobe Photoshop programs, but similar tools exist in most editing programs:

Marquee Tools

Marquee tools are the most basic and simplest of the selection tools and come in a variety of shapes,

including rectangular, elliptical (oval), single-pixel wide row (horizontal), and single-pixel wide column (vertical). The Marquee tools offer a very quick and simple method to surround a regularly shaped area—a barn door, for example. By simply placing the cursor at one corner of the shape you want to select and then dragging it until you've captured the shape, that area is selected. Once

you've made a marquee selection you can move it freely around the image to fine-tune its position.

Lasso Tools

Marquee tools are fine for regular shapes, but they are of little use with objects of irregular shapes. Lasso tools let you outline very intricate shapes. The basic

lasso lets you freehand trace virtually any shape—a person, a flower, a winding road. The Polygonal Lasso is useful for selecting irregularly shaped geometric objects—a rowboat, a barn, a fence. The

Polygonal Lasso uses "anchor points" so you can make precise angles when turning corners or selecting very specific outlines in tight spaces. Think of the anchor points as creating your own version of connect-thedots. The Magnetic Lasso further refines your ability to select areas. You can loosely trace an object and with its "magnetic" properties it attaches itself to the contours of the subject you're tracing. Like the Polygonal Lasso, you can create anchor points. It works by identifying the contours of an object and is best for objects whose borders are clearly distinguishable from their surroundings (a white cat in a coal bin). It works less well on objects with borders of similar tonality to their surroundings (a black cat in a coal bin or a white dog on a white sheet).

Magic Wand

I call this the "holy cow" tool because the first time I teach people how to use it, that is usually their immedi-

ate response. The Magic Wand is the tool that most beginners use for capturing very complex shapes (largely because it does its job so well and is easy to use), and it is a very important tool to learn.

Regardless of the complexity of an object's shape, this tool, based on a range you set, selects colors of a similar brightness to those in the spot you click on. For grayscale images (fancy talk for black-and-white pictures), areas selected are based only on brightness. If the explanation seems a bit foggy, using the tool is fairly straightforward. For instance, if from your picture of a harbor scene with boats and docks and buoys, you wanted to select just the blue water, you simply click anywhere in the water and the Magic Wand selects most, and maybe all, of the water the first time you click. This can be a fast way to select large intricate areas of similar color.

d to sere in to maybe look a to lor.

There are several settings that help you refine exactly what the wand will and won't select, including a tolerance setting and whether you want the areas you're selecting to be contiguous (connected) or not. Very often when I'm using this tool I will refine the tolerance setting as I get closer to other objects. For example, if I'm selecting the sky around a tree and the selection begins to creep into the tree, I will reduce the tolerance to the point where it stops at the edge of the leaves—selecting the sky right into the tiniest folds of the leaves, but not picking up the leaves.

Color Range

This is perhaps the most sophisticated tool for making complex selections across an entire image. As the name implies, the tool works by selecting areas of similar color. You tell the program which color to select by sampling specific areas in the image with the Eyedropper tool. You can continue to add to (or subtract from) that selection and view the areas being selected in a preview window, and by using a tolerance setting, you can control the range of colors being selected. This is a precise tool for making amazing selections. If, for instance, you want to select all the greens in a landscape (leaves, grass, flower stems), you can modify their color or brightness without touching any other part of the scene. It takes patience, but there is simply no other tool that can do the same thing. Color Range is well worth the time invested in learning to use it correctly.

Making moderately complex selections with the Lasso and Magnetic Lasso tools gets easier with patience and practice. I spent about an hour doodling with the Magnetic Lasso on these lobster floats and eventually got just the selection I was after (directly above). Enlarging the image helps a great deal.

Once you have made your selection, you can experiment with creative uses, such as placing the selected portion into a different image, as in the example at right.

Creative Blur

Normally your goal is to make your photographs—or at least the main subjects in them—as sharp as possible. There are times, though, when softening an image (or part of an image) is the better creative option. In portraits, for example, gently blurring wrinkles away or hiding minor blemishes creates a more flattering appearance. You can also gently blur landscapes and travel scenes to evoke a mood or just to create visual variety in a photo album or online gallery.

Most image-processing programs offer a choice of several blurring filters. Photoshop, for example, includes Blur, Blur More, Motion Blur, Smart Blur, Gaussian Blur, and more. The best choice is Gaussian Blur because it gives you the most control over the amount of blur that is applied. The Smart Blur does offer some degree of control, but it's generally used as a special effects filter for overall use rather than as a fine-tuning filter.

Like other blur filters, Gaussian Blur reduces the contrast between adjacent pixels to create the illusion of softness. But Gaussian Blur allows you to determine how much blur to add. Typically you'll see a preview of the effect in the preview window of the filter's dialog box. As you adjust the radius setting (how many pixels away from each contrast edge will be softened), you'll see the degree of blur changing. There is no right or wrong pixel radius; you just have to experiment until you see an effect you like.

Blur is kind of like flattery. If you use too much of it, people suspect your motives—so be stingy when it comes to applying it, especially if you're painting it over the entire image. You wouldn't want to become known as the Eddie Haskell of image processing.

I didn't want to go too far with blur in this image, but wanted to match the fun atmosphere of a summer carnival.

Selective Blur Tip

As with many image enhancements, the most effective way to apply blur is to add it only to specific portions of an image. In close-up photography, for instance, you can blur the background to separate your subject from its surroundings; or you can use it to gently blur the foreground to focus attention on an important element in the center of the field.

Many programs have a Blur (or Soften) tool that works like a Paintbrush tool—you select the brush size and then sweep it across the areas you want to blur. Because you can control the brush size and apply the blur to precise areas, this can be a very

accurate method of creating selective diffusion. The Blur tool is particularly adept at softening tiny details like wrinkles around the eyes, but you have to apply it carefully so that different areas (both lower eye lids, for instance) have the same degree of blur.

To quickly blur the background, select the subject then invert the selection to select the background. Now apply the Blur filter to the background.

Layers

The Layers function in Photoshop (and similar nondestructive tools in other programs) is probably the most useful and creative tool in image processing. It provides a wealth of flexibility and control both in enhancing images and in creating complex composite pictures. In fact, much of what is done in digital imaging, both creatively and technically, could not be done without using Layers. If you are entirely new to digital imaging, the concept of using Layers will seem foreign at first, but you will soon find yourself reveling in their possibilities and usefulness—particularly if making composite images is something that sparks your imagination.

So how do you use Layers? The most frequent analogy used to describe a layer is that each one is like a transparent sheet of acetate that contains one element (or one adjustment) of an image. You can place multiple layers on each image file, and think of them as the transparent (and/or partially transparent) layers of a thick visual layer cake. All images start off with one layer (the "background") that is not transparent because it contains the main image and is at the bottom of the other layers.

The various layers in any image are easy to see because they are displayed in the Layers palette. If you were to stand above that stack and look down, you would see the entire image with all of its elements in place (at right). Some elements in the stack would be opaque and block portions of other layers that are underneath them, and some would be partially transparent showing you varying degrees of what was underneath them. One of the very fun aspects of using Layers is that you can rearrange the stacking order of the layers so that you can play with which elements are blocked and which are revealed.

It would be possible to write an entire book just on the subject of Layers, but here we'll simply present a few basic concepts to get you started. Speaking of books, though, the absolute best in-depth explanation of Layers (and image-enhancement in general) that I've seen is ithe latest in the series of *Adobe Photoshop Studio Techniques* by Ben Wilmore and Dan Ablan. While the information is aimed specifically at Photoshop, the concept and potential of layers can be applied to any layers-oriented program. It's a book well worth owning.

There are many intricate uses for Layers, but they are used primarily in one of two ways: either to create an Adjustment Layer for modifying the image, or to add new objects to a composite image.

ADJUSTMENT LAYERS

Making image corrections on a layer rather than on the background image itself is extremely useful because it lets you correct certain aspects of an image without putting the background image at risk. Let's assume, for example, that you are working on a landscape image and decide to adjust the Hue/Saturation settings to get richer colors. You could just go directly to that menu in your program and make adjustments to your image without creating a new layer. Once you make that adjustment, however, it affects the entire image and you're stuck with it. If you decide you don't like the adjustment later on, you have to start the image all over again. You'll get old before your time working this way.

By creating a New Adjustment Layer, however, you can make Hue/Saturation adjustments in their own layer. If you decide you don't like the effect, you can either temporarily shut the layer off (using the eyeball icon which acts as an on/off switch) or drag that layer to the trash to get rid of it permanently. Or you can double click the tiny Hue/Saturation icon in the layer and re-adjust the settings. Also important, New Adjustment Layer will only affect the layers that are below it in the stack, and it will have no effect on the layers above it—which in itself offers a tremendous degree of image control because it lets you apply certain enhancements only to selected layers.

In Photoshop, there are actually two ways to create an adjustment layer. You can either select New Adjustment Layer from the Layer menu and then select a specific adjustment—or you can click on the Create New Adjustment Layer icon at the bottom of the Layers palette (a half black, half white circle). In either case, a new layer will pop up in the Layers palette and it will automatically be labeled. Now any adjustments you make to the image will live in their own layer.

If you decide that you don't like that adjustment, nothing is lost. You can simply turn off that layer or drag it to the trash. The beauty of this method for making adjustments is obvious: You can make an infinite number of corrections to an image without actually committing to them until you're certain that you like them. Often my images contain as many as two or three dozen individual adjustment layers and I can play endlessly, turning layers on and off to see how the various adjustments combine. Be forewarned: Whenever you add layers to an image, you dramatically increase its file size.

Once you are satisfied with the look of the image and have made all the adjustments you are going to make, you can "flatten" the image to compress all the layers into the background and make the changes permanent. Often too, even if I do flatten and save a finished version of the image, I will save a layered version so that I can tweak it later on.

LAYERS FOR COMPOSITE IMAGES

Layers are also the primary tool for creating composite images. Each time you add a new element to an image, a new layer will be created automatically and placed in the Layers palette. Try it. Open two images and then use a selection tool to select an object from the second. Then copy and paste that object into the other image and you will see a new layer containing the pasted object pop up in the Layers palette. Some software programs let you paste an image directly into an existing layer.

Layers Tips

The primary benefit of layers is that they let you make non-destructive edits of your images. If, for example, you open a new layer to adjust an image's color balance and then decide you don't like what you've done, you can simply delete that layer (before

you "flatten" the image layers) and it's gone. You can turn layers on and off at will to see how they interact with the other layers, and then decide which changes you want to retain. Learn to love layers: They are the best and most useful tool that Photoshop has to offer.

To make things even more flexible (notice I didn't say complicated), you can also change the opacity of each of the individual layers by adjusting the Opacity slider. In most programs, there is also an assortment of blending modes that further alter the way individual layers appear (and again, I refer you to the Wilmore/Ablan book for an in-depth explanation of layer blending modes).

One important thing to know is that you can only have one layer active at a time, so only the layer that is highlighted in the palette is active. Remembering this fact will often get you out of the woods when you try to use a tool on an image and nothing happens (or when it's happening to the wrong part of the image): Check to be sure the layer you think you're working on is the active layer.

The key thing to remember whenever you are adding elements to an image is this: Each new picture element lives on its own little layer island; you can do anything you want to it and change it without affecting the rest of the image. And if you want to see how the overall image looks with and without that layer in the stack, you can simply turn it on or off by clicking the "eyeball" icon next to the layer.

The only true way to learn about layers is to experiment with them—so don't be afraid to open an image and start playing. Just be sure to make a duplicate of the image first.

on an Idea

"Pick a theme and work it to exhaustion."

-DOROTHEA LANGE

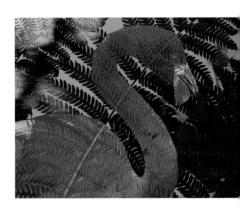

Introduction

I have a good friend named Phil Bowler who is an extremely talented and respected jazz bassist, and I've seen him perform in concert many times. When he takes off into one of his intense and intricate solos at some seemingly invisible sign from his band mates, it's as if he is making the music up at the very instant that his fingers dance along the strings of his big double bass. And, in fact, he is making the music up. He's improvising on a theme, inventing ideas and experimenting with new directions at the very speed of sound. It's quite a performance to witness.

But what we don't see or hear when we see a jazz musician perform are the thousands of hours spent mastering the rudiments, playing the scales, or "getting their chops down" as they would describe it. Before they can take an eight-note bar and bend and twist and stretch it inside out, they learn to play it note for note, beat for beat, until it becomes a part of their being. Learning how to create great photographs—both in the camera and in the digital darkroom—is very much like learning to play a musical instrument: you have to master the basic techniques before you can soar to places unknown.

In the previous chapters we've looked at the basic skills that it takes to turn an average photograph into a very good one. In this chapter, you'll learn to solo, to go beyond the techniques themselves and create ideas that are yours and yours alone. You'll get a brief glimpse at the almost infinite variety of ways that you can take a traditional tool and re-invent its purpose and make it your own. Some of these ideas and techniques have been done to death, they may even border on corny, but it's through experimenting and taking chances that new ideas are born. Or, as my friend Phil puts it: "When one improvises, one enters the world of creating."

As a visual artist, it's important that you learn to improvise on an idea—to take your vision to the next level, to watch it grow at the speed of light. Not everyone will get what you're going after or see the beauty that you see. But there is one thing you can count on: In the same way that jazz musicians chart a path that is truly their own, you too will be exploring directions that are entirely yours. And it wouldn't hurt to have a little Sonny Rollins playing in the background while you work.

Hue and Saturation

As we saw in *The Image Enhanced chapter*, the Hue and Saturation sliders can be simple and effective tools for adjusting the tint and saturation of a picture. When the sliders in the control are "pushed" to extremes, however, even the most average subject begins to resemble an Andy Warhol experiment (and who knows, perhaps your extreme pictures will get you that 15 minutes of fame he promised). If you're a lover of intense color, Hue and Saturation extremes will keep you busy for days.

In truth, there probably aren't a lot of practical uses for such extreme color variations, but at times I'll find a photograph that I like in terms of composition, but that is lifeless in terms of lighting or light quality. By zapping the colors with the Hue/Saturation tool, I make the image more about the colors than the subject—and that can be very effective for graphic designs. If you're

designing a website, for example, you might use a series of vibrantly churned variations of the same shot to act as icons or links—or even just to add some eye-catching graphics to a homepage.

What I find really interesting about using extreme colors is that they work best with very simple subjects. For example, the shot below was taken of a colorful sculpture at a nearby arboretum. The formation of the circles was interesting, but the photo turned out to be a little bit dull. However, you can have a lot of fun by experimenting with the Hue/Saturation tool, pushing the sliders first one way and then the other, saving the results when you see an image that strikes your psychedelic fancy. You can even create one variation, save it, and then make another variation from that starting point.

This is the original image.
On the opposite page you can see more variations using the Hue/
Saturation tool. There are few limitations to the color experiments you can perform with this tool.

FVIN KND

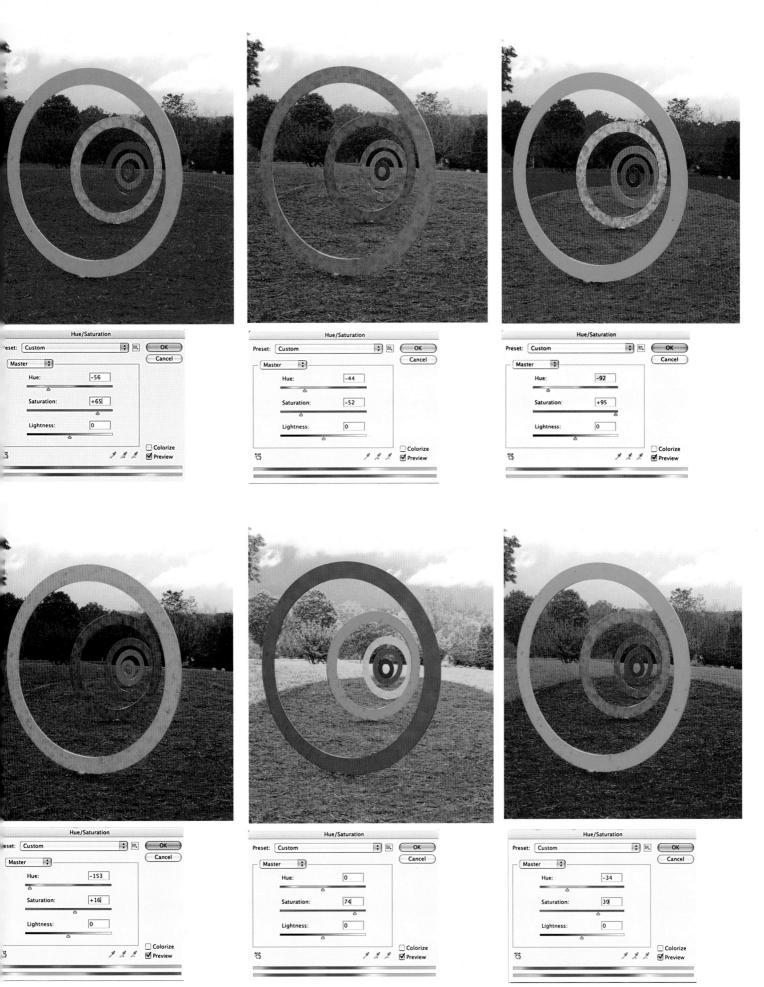

Gradient Mapping

Gradient Mapping is a tool found in recent versions of Photoshop's CS and Elements programs, and has equivalents in other programs as well. This is a quirky little tool that I like to experiment with when I'm bored. It's pure eye candy. Even if you end up not liking the look it gives a particular image, it's fun to play with. Basically, a gradient is a blending of two or more colors in a particular pattern and there are a variety of samples in the software, but you can also create your own custom color blends. You can even add other enhancement effects on top of a Gradient Map.

In Photoshop, you'll find the Gradient Map in two places, as an Adjustment dropdown selection, and as a New Adjustment Layer selection. If you use the Adjustment Layer method (see page 264), you can adjust the opacity of the layer as well as play with various layer-blending modes. Because the gradient colors tend to overwhelm the image tones (though that can be interesting too), you will probably use the opacity or blend modes with every image.

Gradient Mapping maps a particular gradient blend to the grayscale values of the image. Suppose that the gradient has a yellow-to-blue coloring and you're applying it to a landscape scene that has a full range of tones from highlight to shadows. The gradient map will apply one color to the shadow areas (let's say yellow) and the other color (blue) to the highlights—and the middle part of the gradient will fall into the midtones. The fun really comes when you're using a gradient map of multiple colors. It's impossible to predict where the colors will fall and where the blends will be.

Posterization

Posterization is a technique that I spent years learning to master in my darkroom. It was time consuming, expensive, and tedious—though the effects were often worth the effort. The technique involved making multiple enlarged copies of a film negative and then printing them in succession and in perfect registration in almost total darkness. Today you can posterize an image with the click of a mouse while you chat on the phone. Somehow that just doesn't seem fair, but it sure is convenient.

Posterizing Tip

When you select the Posterize tool, you will be asked to choose a specific quantity of tonalities. You can choose a number anywhere from 2 to 255, but there is little posterizing effect above 10, because there are still too many separate tones for your eye to view. I like to select a Level of 5 or 6, while a Level of 2 will produce the most drastic change in the picture, as demonstrated below.

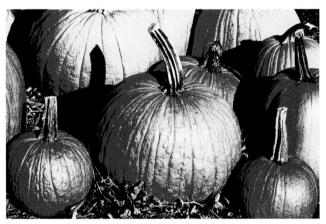

The Posterize tool groups certain tones together and then divides the tonal range of an image into distinct bands. Instead of an image having a smooth transition of tonalities, it ends up with three of four or five (or more) distinct bands of colors and tonalities. The technique is a nice way to turn a fairly ordinary image into a nice graphic representation—posterized images work very well for greeting cards, newsletters and any time when a bold graphic look is more important than detail.

Color Infrared

For years photographers seeking a psychedelic look in their color images experimented with a "false color" film called Kodak Ektachrome color infrared film. It was impossible to predict what the colors would look like with the film since one of its layers responded to invisible infrared light, but the results were often interesting. The images shown here, while shot digitally, look remarkably like those I formerly shot on color infrared film.

Filters

If you're the kind of person who likes to bake a cake by tossing in a little bit of this and a little bit of that just to see what new flavors you can invent, you're going to love filters. Like a rack of visual spices and flavorings just waiting to be sprinkled onto your images, filters can change and enhance images in ways you may never have imagined.

Filters, in fact, are probably the first thing most people try after they install their image-processing software. By simply pulling down a menu and selecting a particular filter, you can add any of dozens of visual effects, ranging from gimmicky to beautiful to just plain strange. Many filters, of course, have practical technical applications (such as sharpening or blurring) that can solve numerous artistic problems, but there is nothing wrong with using them just for fun.

Also, in addition to the filters that came with your editing software, there are many filter packages that you can buy as plug-ins.

Filter Basics

Filters are generally divided into several categories depending on the manufacturer. Adobe Photoshop CS and Photoshop Elements, for instance, include these basic categories—all of which have many sub-categories: Artistic, Blur, Brush Strokes, Distort, Noise, Pixelate, Render, Sharpen, Sketch, Stylize, and Texture.

On the following pages I've run a few simple images through various filters. Your software manual will provide a list of all the filters available to you.

Some Software Filters For Photographers

Alien Skin

Auto FX

FM Software (Fred Miranda)

Neat Image

Nik

Opanda

PictoColor

Pixel Genius

SilverOxide

The best way to learn about a filter is to try it. Open an image and apply a series of different filters to see how the basic image changes. Many filters also have dialog boxes—some of them rather complex—that let you control or exaggerate the effects of the filter to a very precise degree.

Pointilize filter applied to image. Hue/Saturation altered for the final effect.

Liquify filter

Glowing Edges filter

Sponge filter

2

The image above was created in three stages:

- 1. Apply Sumi filter
- 2. Adjust the Hue and Saturation sliders
- 3. Manipulate the Curves

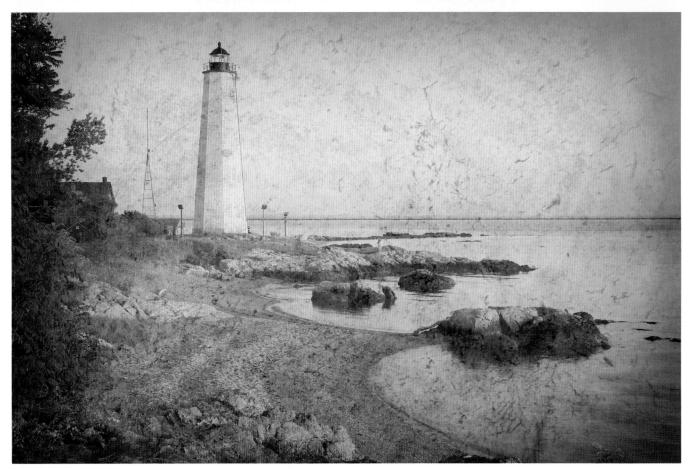

One of the simplest ways to add a fine-art twist to your images is to use a texture overlay. This beach scene reminds me of an old postcard that might turn up at a yard sale.

© KEVIN KOPP A purchased taxture

A purchased texture called Cherish Warm was placed over this black and white winter scene to give a nostalgic look.

Texture Overlays

m Y ou need just two things: your original photograph and a texture image. You can buy textures (I purchased these from the Flora Bella Collection, which can be found at: www.florabellacollection.com), or you can create them yourself by just taking a close-up of any textured surface—an old piece of barn wood, a piece of artist's canvas, or even a shot of an old stucco wall. Then just open both images separately and drag (using the Move tool) the texture on top of the background image. Be sure that the texture image and the background image are the same size and resolution. Finally, use the Opacity slider in the layers palette to create a blend between texture and image, using an opacity setting that lets you see the texture without overwhelming the photograph. Once you have the look you like, simply flatten the layers and you're done.

Creative Background Replacements

In *The Image Enhanced* chapter, we looked at replacing dull skies with interesting ones using skies from another photograph. You can do the same thing with any relatively simple object. Just use your favorite selection tool to select the background area and then paste in a new background.

Use the Gradient and Pattern tools to insert a new background, as I have done on several of the shots here. These experiments show how various gradients and patterns work as a replacement background, but as you experiment you'll find that some new backgrounds complement your subjects nicely. I find exercises like these a great way to get to know image-processing tools and prepare for making more complex composites and corrections later.

Shape Distortions

Most image-processing programs provide a variety of ways to distort shapes. The tools can be a real help in correcting leaning or tilting buildings or even just nudging the dimensions of a scene to fit a particular size layout (in a newsletter for example). Of course, if you are playing in the land of extreme enhancements, you can exploit these tools to alter the shape of an object beyond mere correction, and the results can be eye-catching. This image began as a fun snapshot taken at United House Wrecking in Stamford, Connecticut—a strange and wonderful antique store full of fun visual treasures. But nothing could be stranger than some of the distortions I created from the original image.

This is the straight image with no shape corrections.

This variation was created using the Scale selection in the Transform tool.

Spherize selection in the Distort filter.

Skew selection in the Transform tool.

Warp selection in the Transform tool.

Pinch selection in the Distort filter.

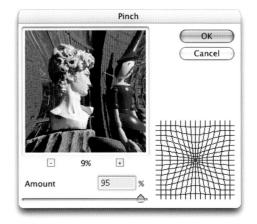

Polar Coordinates selection in the Distort filter.

Combining Images

The ability to combine many different images in an infinite number of ways is one of the most addictive allures of editing images. In pre-digital days, the only way to combine images was either by printing multiple images onto a single sheet of paper in the darkroom or by using a slide duplicator to combine various images. While some artists—like the great darkroom master Jerry Uelsmann—are able to create richly sophisticated and clever montages this way, there are limits to what can be done with traditional means.

In the digital darkroom, the only limit is your imagination. Using tools that range from very simple (copy and paste) to very complex (layer blending modes and masking), it's possible to create new image combinations from dozens—or, if you have the patience, thousands—of individual image elements. Once combined, the various elements can be resized,

reshaped, made more or less transparent, moved, re-colored, curved, bent, twisted, stretched—in short, anything that your mind's eye can envision, your computer (given enough RAM and enough hard drive space) can create.

Your ability to combine things in sophisticated ways requires a good grasp of individual skills and tools. Any visual riddles that you aren't able to solve while compositing can probably be unlocked by examining each of the specific tools you're using—or exploring the capabilities of tools with which you aren't yet familiar. Be sure to use the software instructions as a resource when you come across a stumbling block in your image editing. This will help you to pair your creativity more effectively with the tools at hand.

The Yale Montage: Step-by-Step

Goal: The Old Campus is the sentimental heart of Yale University and I wanted to combine a series of images in a way that would capture the romance, charm, and history of the area.

Plan: When I started creating the image, I knew that I wanted to include these five elements: Harkness Tower, the statue of Nathan Hale (a graduate of Yale), Connecticut Hall, a current Yale student, and Phelps Gate (the formal entrance to the campus).

I created the accompanying montage of Yale University's "Old Campus" section from five individual photos. The montage was relatively simple to create. Here are the basic steps:

I began by opening the shot of Harkness Tower and fiddled with the Levels and the Hue/Saturation until the building had a golden color and enough brightness to remain the dominant visual element.

Color Bal		75			Ок
Colo Cyan Magenta Yellow	r Levels: +3	0	-33	Red Green Blue	Cancel Preview
Tone Bala		. 01	lighlights		

3

Working from the image of the tower as the background (from step 1), I carefully selected the tower using the Polygonal Lasso tool. I used the command to place the statue behind the tower. I then chose the mode, which created the purplish-blue color of that layer. The opacity for that layer was set to 88 percent. I used the Move tool to position the image accurately in the upper left-hand corner.

4

I opened the image of Connecticut Hall, adjusted Color and Levels, and used the Polygonal Lasso tool to select the front of the building. I copied this area and pasted it over the main image of the tower.

2

I then opened the photo of Nathan Hale's statue, cropped it slightly, adjusted the Levels to brighten the image, and then selected and copied the entire image.

5

Because I wanted the building to face the center of the montage from the right, I flipped the pasted image horizontally. I then rotated the selection slightly until I liked the angle, and used the Move tool to position it. I also added a very slight amount of Gaussian Blur to this layer to soften the details.

Next I opened the image of the young woman playing a Celtic harp. I used the Lasso tool with a pressure-sensitive pen on Wacom Intuous tablet to "select" her from the background. I feathered that selection by two pixels.

I copied that selection and pasted it into the montage and then flipped it horizontally so she would be facing into the composition. I then used the Move tool to carefully place her at the bottom left.

8

Finally, I opened the image of Phelps Gate, did a Levels correction and a Hue/ Saturation correction, then copied and pasted the entire image onto the collage. I used the Transform (Scale) option to size the image to fit into the upper right hand corner, and I repositioned that layer so that it was "under" (and therefore behind) the image of Connecticut Hall.

9

With the entire montage in place, I tweaked the colors and brightness values of various individual layers and then saved a "working" version of the collage with the layers open in case I wanted to make corrections later. I then flattened the image so that all of the layers merged to the background and saved the image under a different name. Total time for the collage was probably about three hours.

Index

A 35mm-equivalent (see also. blemishes (see also, restoration) 237, 250-253, 262 magnification factor) 43, 58 blur 35, 82, 90, 92, 98, 101, 112, 140, 160, accessories 41, 42, 50-51, 56-57, 61, 71, 212 176, 200, 218, 219, 248, 260, 262, 273, 282 action photography (see also, sports photograbounce flash (see flash, bounce flash) phy) 41, 42, 52, 92, 93, 166, 175, 176-177 bracketing Adams, Ansel 69, 183, 185 manual 138, 149 Adobe Photoshop 15, 17, 18, 64, 65, 95, 235, automatic exposure bracketing 161, 227 237-283 buffer 43, 76 aerial perspective (see perspective) built-in flash (see flash, built-in flash) ambient light (see lighting, ambient light) animal photography (see wildlife photography) camera bag 47, 51, 87, 100, 222 Anti-Shake technology (see image stabilization) camera handling 82 aperture 39, 56, 61, 69, 79, 82, 90-93, 96, 98, camera support (see also, tripod) 50 112, 126, 161, 167, 170, 197, 218, 219, 222 camera types Aperture-Priority Mode (Av or A) 39, 56, 92, advanced compact 36, 39, 176, 190, 96, 197, 219 204, 205, 211, 214, 219 artificial light (see lighting, artificial light) basic compact 38 autoexposure 92, 226 digital SLR 25, 36, 37, 40, 41-43, 58, 60, autofocus (AF) 37, 84, 88, 113, 205, 224 61, 66-67, 73, 88, 96, 176, 198, 200, 205, automatic exposure bracket (AEB) 214, 218, 219, 222, 227 (see bracketing) fixed-lens superzoom 36, 40, 58, 204 available light (see lighting, ambient light) Micro Four Thirds 41, 67 card reader 49 baby photography 163, 164-165, 228 cataloging images (see organizing image files) backgrounds 55, 60, 84, 88, 92, 93, 96, 105, CCD sensor (see sensor) 108, 111, 112, 117, 118, 126, 167, 176, 178, 186, CD 45, 46, 51, 65, 70, 100, 101 192, 219, 226, 232, 258, 262, 264, 276, 277 center-weighted metering (see metering) backlighting (see lighting, backlight) cell phone 32, 45, 49, 69 balance (see also, composition) 103, 113, 118, 190, 234, 250 classes (see educational opportunities) ball head tripod (see tripod) cleaning 41, 100, 198 battery 39, 40, 41, 52, 87, 101, 161, 166 Clone Stamp tool 250-252 Bayer pattern 33, 37 close-up photography 39, 55, 57, 58, 82, 84, 94, 96, 183, 197, 203-204, 208, 214-219, 262, 276 beaches 46, 51, 101, 115, 117, 122, 152, 185, 188-190, 228, 250, 255, 276 CMOS sensor (see sensor) birds 42, 52, 56, 203-205, 206, 211 color balance 74, 81, 246, 247, 258, 260, 264 black-and-white conversion 256-257 color cast 140, 245, 246, 247

149, 150, 157, 161, 223, 224 color correction 74, 81, 245, 246, 247 exposure modes 35, 39, 40, 56, 61, 90-92, color temperature 80, 81, 159, 160, 259 101, 161, 227 compact disc (see CD) face detection 41, 69 CompactFlash (CF) (see memory card) composition 59, 82, 87, 103, 104-105, 107, file formats 43, 73, 81, 101 108, 113, 118, 121, 122-123, 124-125, 132-133, 138, 146, 161, 190, 191, 192, 195, 216, fill flash (see flash, fill flash) 222, 224, 232, 238-239, 250 filters compression 35, 44, 73, 74-75 lens 41, 81, 222, 227, 256 contests 26-27 sensor 33, 37, 66 continuous shooting 41 software 41, 227, 248-249, 250, 256, cropping 17, 38, 39, 103, 125, 133, 205, 262, 273-277 238-239, 241, 250, 252, 281 flash Curves 74, 242, 244, 258, 259, 275 accessory flash 40, 41, 54-55, 56-57, 71, 156, 212, 218 delete (see erasing images) bounce flash 56, 57 depth of field 25, 39, 56, 59, 60, 82, 90, 92, 93, built-in flash 38, 40, 52-53, 55, 56-57, 95, 96-97, 112, 126, 138, 170, 197, 200, 219, 235 155, 218, 222, 254 deserts 129, 137, 183, 185, 191-199, 220 diffused flash 56, 57 diffused flash (see flash, diffused flash) fill flash 55, 149, 175 diffusers 57, 156 pre-flash 55, 56 digital magnification (see magnification factor) remote 43 Digital Technology Timeline 62-67 flash modes 39, 54-55, 71 digital zoom 38, 205 flash power 38, 57 distortion 278-279 flash sync (see Slow Sync Mode) downloading 33, 35, 44, 46, 49, 51, 100-101 Flickr 18-19, 49, 61 dust 17, 41, 198, 222, 226, 250-253 flower photography 55, 88, 95, 96, 103, 155, 173, 183, 195-198, 214-217, 230-235, 258 E editing 15, 17, 22, 25, 51, 64, 75, 90, 94, 160, focal length characteristics 55-61 223, 235, 237, 250, 252, 260, 264, 273, 278, 280 focal point 108, 110, 190, 235 educational opportunities 70-71 focusing 31, 59, 84-85, 92, 96, 219, 224 electronic flash (see flash) fog 132, 137, 149, 153, 189, 220, 222, email 37, 49, 63, 74, 101, 169 224-225, 261 enlarge(ment) 35, 37, 49, 79, 133, 184 frames per second (fps) 41 Epson 51, 65, 66, 70, 233 framing 41, 82, 115, 126, 190 erasing images 17, 87, 107

exposure compensation 53, 55, 67, 94, 95,

G		
Gamma (see Levels)	Lasso tools 260, 261, 281, 282	
gear (see accessories)	Layers 258, 259, 263-265, 272, 276, 283	
gradient mapping 75, 270, 277	LCD monitor 38, 41, 46, 51, 54, 66, 82, 84, 87	
grain (see noise)	107, 138, 150, 161, 167, 171, 190, 214, 219	
grayscale (gray tones) 64, 256, 261, 271	lens 58-61	
group photography 174-175	fixed 38, 39, 40	
guide number (GN) 57	normal 59	
н	telephoto 40, 60	
hard drive 51, 64, 74, 76, 280	wide-angle 59	
HD (high definition) video 24-25, 40, 41, 42,	zoom 36, 38, 40, 60	
44, 45, 172	Lensbaby 61	
histogram 75, 150, 243	leveling 240-241	
horizon 58, 117-118, 131, 150, 153, 157, 160,	Levels 74, 95, 223, 242, 243, 252, 256, 260, 280	
192, 240	light direction 146-151	
hot shoe 56	light intensity 33, 37	
Hoverkamp, Ellen 230-235	light meter 88, 94, 113	
I	light sensitivity (see ISO)	
image editing (see editing)	lighting,	
image preview (see live view)	above light 151	
image processing (see editing)	ambient light 53, 55, 92	
image review (see also, LCD monitor) 17, 51,	artificial light 134, 143, 146, 159, 160	
66, 87	backlight 55, 90, 95, 114, 148-149	
image stabilization 39, 41, 60, 67, 82, 159	close-ups 216-218	
indoor photography 52, 53, 54, 55, 59, 79, 80, 92, 143, 155, 157, 158-159	dim (see lighting, low)	
infrared 272	dramatic 157	
intervalometer 43	front light 147, 223	
ISO 35, 38, 39, 41, 43, 57, 78-79, 101, 138,	harsh 151, 156	
159, 172, 222	low 35, 52, 78, 90, 101, 146, 172, 222	
J	side light 150	
JPEG 35, 46, 64, 73, 74, 75, 101	linear perspective (see perspective)	
K	live image preview (see live view)	
kid photography 21, 69, 84, 88, 98, 107, 111,	live view 66	
163, 166-169, 170, 179	long exposure 137, 161, 228	
L	lossless 75	
landscape photography 17, 21, 39, 43, 59, 60, 81, 92, 94, 96, 98, 117-118, 126, 131, 133, 134, 146, 148, 150, 152-153, 157, 184-193,	lossy 74	

 $220,\,224,\,226,\,240\text{-}241,\,250,\,255,\,261,\,262$

m Macintosh 63, 64, 65, 100, 251 Marquee tools 260 66, 67 74, 75, 76, 100, 198 Memory Stick 45

macro photography 197, 214-219, 235 Magic Wand tool 260-261 magnification 34, 58, 60, 66, 96 magnification factor 35, 43, 58 Manual Exposure Mode (M) 61, 92, 161, 227 measuring light (see metering) megapixels 34-35, 36, 38, 39, 43, 45, 62, 65, memory card 33, 35, 44-47, 49, 51, 64, 65, menu system 35, 54, 69, 70, 100 metering 38, 39, 41, 43, 82, 84, 88, 92, 94, 113 Micro Four Thirds (see camera types, Micro Four Thirds) microdrive 47 mist 149, 152, 153, 220, 222, 224-225 monopod 50, 78, 82, 159, 200 mood 81, 107, 143, 146, 153-156, 164, 170-171, 175, 186, 220, 242, 262 motion blur (see blur)

motion detection 38, 41

nature photography (see also, wildlife photography; landscape photography; flower photography) 21, 57, 124, 133, 182-229, 230-235 night photography 54, 55, 82, 98, 107, 134-141, 157, 160-161 noise 35, 43, 57, 79, 137, 159, 222, 260 normal lens (see lens, normal)

online communities 18-19, 26-27, 49, 70-71 optical zoom (see lens, zoom) organizing image files 46, 101 overexposure 53, 75, 88

Paiva, Troy 134-141 pan-tilt head tripod (see tripod) patterns 115, 122, 123, 124-125, 214, 248, 277 people photography (see portrait photography) perspective (see also, vantage point) 58, 59, 60, 96, 104, 105, 129, 132, 133 photo sharing 18-19, 49 photojournalism 65 Photoshop (see Adobe Photoshop) photosites (see also, pixels) 33, 35, 37 picture editing (see editing) pixels 17, 33, 34-35, 38, 39, 43, 62, 65, 66, 74, 75, 245, 248, 249, 250, 252, 255, 258 plug-ins 64, 273 portable electronic flash (see flash) portable storage device (see hard drive) Portrait Mode 170 portrait photography 39, 55, 60, 81, 88, 96, 112, 150, 155, 156, 162-181, 237, 262 post-processing (see editing) posterization 271 pre-focusing 171 printing 29, 37, 38, 39, 49, 63, 64, 65, 66, 73, 74, 101, 116, 169, 223, 232, 234, 238, 239, 248, 249, 256, 271 Program Mode (P) 92, 98

quality (see resolution)

rain 47, 51, 69, 183, 197, 200, 222, 227 rainbows 227 RAM (random access memory) 280 RAW 35, 40, 41, 43, 45, 46, 73-76, 81, 237, 259 reciprocal exposure settings 92, 93 red-eye (reduction) 38, 55, 237, 254 resolution 25, 34-35, 36, 37, 38, 39, 41, 43, 44, 64, 65, 66, 67, 69, 74, 82, 101, 234, 276

restoration 22-23, 237, 245, 251, 252-253 rule of thirds (see also, composition) 118-119

5 scale 104, 133, 190, 192, 223 scanner 62, 73, 230-235, 240, 245, 250 Secure Digital (SD) 45 selective focus (see also, focusing) 84-85, 112 sensor 25, 33, 34, 35, 37, 39, 41, 43, 58, 62, 65, 66, 67, 74, 76, 78-79, 90, 93, 137, 198, 214, 223, 248 shapes 98, 122-123, 124-125, 150, 153, 157, 192, 195, 222, 224, 226, 260, 278 sharpening 17, 35, 235, 248-249, 258, 259, 260 shorelines 122, 188-190 shutter lag 37, 41 Shutter-Priority Mode (Tv or S) 39, 92, 98, 222 shutter speed 38, 39, 55, 82, 90-91, 92, 93, 98-99, 101, 107, 161, 163, 176-177, 200, 218, 219, 222, 228 silhouette 114, 122-123, 148, 195, 224, 243 silicon crystals 33, 62 slave unit 56, 218 Slow Sync Mode 55, 160 snow 21, 94, 108, 154, 220, 222-223 software 15, 17, 22, 43, 49, 64, 73, 75, 76, 79, 81, 94, 160, 223, 227, 236-283 sports photography 21, 39, 42, 43, 52, 60, 76, 99, 176-177 spot metering (see metering) stabilization (see image stabilization) stitching 175, 280-283 subject placement (see composition) sunrise117, 152-153, 157, 188, 226-227, 245 sunset 118, 122, 150, 152-153, 189, 190, 193, 226-227, 240, 247, 255

telephoto lens (see lens, telephoto)

texture 17, 21, 52, 122-123, 124, 146, 151, 155, 156, 191, 192, 216, 222-223, 224, 230, 256, 276

TIFF 259

travel photography 28, 36, 46, 49, 60, 126, 150, 152, 153, 157, 160, 179-181, 183, 200, 208, 222, 262

tripod 50, 55, 60, 79, 81, 82, 101, 138, 157, 159, 161, 174, 200, 205, 219, 222

U underwater photography 212

TTL 56

vantage point (see also, perspective) 47, 105, 117, 122, 125, 129, 146, 186, 190, 195, 201, 217 video display (see live view) viewfinder direct 41, 42, 46, 52, 54, 60, 82, 84, 88, 105, 113, 214, 227 electronic viewfinder (EVF) 40-41

waterfalls 15, 115, 183, 200-202, 228-229 wedding photography 22, 55, 57, 163, 172-173 white balance 39, 41, 56, 69, 75, 80-81, 101, 140, 154, 156, 159, 245 wide-angle lens (see lens, wide-angle) wildlife photography 43, 56, 60, 183, 186, 198, 203-211 Windows 64, 252 workflow 100-101, 258, 259 write speed 45

z zoom lens (see lens, zoom)